An Improving Prospect?

An Improving Prospect?

A History of Agricultural Change in Cumbria

David Johnson

AMBERLEY

In memory of many generations of my Johnson and Pitchfork ancestors who tilled the land.

First published 2016

Amberley Publishing
The Hill, Stroud
Gloucestershire, GL5 4EP

www.amberley-books.com

Copyright © David Johnson, 2016

The right of David Johnson to be identified as the Author of this work has been asserted in accordance with the Copyrights, Designs and Patents Act 1988.

All rights reserved. No part of this book may be reprinted or reproduced or utilised in any form or by any electronic, mechanical or other means, now known or hereafter invented, including photocopying and recording, or in any information storage or retrieval system, without the permission in writing from the Publishers.

British Library Cataloguing in Publication Data.
A catalogue record for this book is available from the British Library.

ISBN 978 1 4456 5555 0 (print)
ISBN 978 1 4456 5556 7 (ebook)

Typeset in 11pt on 14pt Sabon.
Typesetting and Origination by Amberley Publishing.
Printed in the UK.

Contents

	Acknowledgements	7
1	Setting the Scene	9
2	The Idea of Improvement	23
3	Lime Burning and Agriculture	47
4	Agricultural Improvement and Change 1660–1760	77
5	Agricultural Change in the Age of Enclosure: The Mechanics of Improvement	107
6	Agricultural Change in the Age of Enclosure: The Response of the Landed Estate	143
7	Innovation, Experimentation and Depression: The Changing Fortunes of Agriculture, 1850–1937	179
8	Epilogue: An Improving Prospect?	221
	Notes	237
	Bibliography	261
	Index	279

Acknowledgements

The author acknowledges his gratitude to those who have helped, wittingly or otherwise, to bring this book to fruition. They include archivists and searchroom staff of the Cumbria Archive Service in Barrow, Carlisle, Kendal and Whitehaven, and record office and library staff elsewhere, for their unfailing willingness to produce document after document, obscure book after obscure book. The author and publisher would like to thank all those individual people and organisations for permission to use copyrighted material in this book: acknowledgement is made alongside each illustration. Every attempt has been made to seek permission for copyrighted material used, but if material has inadvertently been used without consent or acknowledgement, we apologise and will make the necessary corrections at the first opportunity. Unless otherwise acknowleged, all photographs were taken by the author. I should like to thank Lucy Frontani for transforming rough maps and plans into finished artwork. It is important to stress that any errors of fact or interpretation lie firmly at the author's door.

1
Setting the Scene

The aim of this book is to consider how farming in Cumbria changed over time; how landowners, estate stewards and tenant farmers responded to changing circumstances, whether due to political and economic forces, climatic deterioration or technological developments; and the extent to which the practice of farming, as well as the land itself, has changed for the better. It considers methods utilised to increase productivity from the medieval era onwards, along with catalysts for change – the driving forces behind change and the stimulants to the adoption of new techniques and strains. Inherent in the book's title is the concept of improvement, and its question mark suggests it is not a clear-cut issue. Present-day organisations like Natural England, primary advisers to the government on land management and the natural environment, or Defra, the government's Department for Environment, Food and Rural Affairs, which has statutory control over agriculture, conservation issues and land management, have a very different take on what is meant by agricultural improvement from that of eighteenth- or nineteenth-century propagandists. Indeed, it could be argued that their views are diametrically opposed.

Some would say that farming in this country hardly changed for centuries, not until the coming of the so-called Agricultural Revolution. Others reject that whole concept. Certainly there were dramatic changes in the late eighteenth and nineteenth centuries in many aspects of farming, but change did not just come about at one specific time. Looking back through history, we can recognise repeated periods of advance, intercalated with spasms of retrenchment

and decline. Advancement was without doubt a feature of almost industrial-scale sheep farming during the monastic heyday; a Tudor 'revolution' can also be argued for; and the prehistorian may well hold forth on the Neolithic Revolution in farming. However, the heartfelt plea 'to get away from the idea that pre-industrial farming was "static"' must surely be heeded: no period within English history has been static[1].

The ways in which agricultural land is managed on a daily basis nowadays are a reflection of a range of variables. Across the county, variations in topography are obvious. Topography is, in large measure, determined by the underlying geology and by erosional processes that have modified the landscape – in Cumbria, notably repeated glaciations. In turn, topography – with aspect and altitude – influences climate and weather patterns, as well as soil characteristics. These natural attributes have a profound impact on soil and land potential, on what individual farmers can do and how they do it. Thus, farming and improvement must be viewed in their geological, topographical, climatic and soil contexts. This is not a harking back to the dark days of geographical determinism, discredited during the quantitative 'revolution' of the 1970s, but an acceptance that physical constraints do impact on farming and land use. This point has been eloquently made for the pre-early modern period[2], but it applies just as strongly to all periods.

The geographical scope of the book is the modern county of Cumbria as a whole. Its remit includes those civil parishes formerly part of the West Riding – Sedbergh, Garsdale and Dent – and Furness, formerly Lancashire North of the Sands.

Geological and Topographical Context

There is a clear relationship between geology on the one hand and topography and altitude on the other, with the 250m contour generally dividing the mountains and fells of the Lake District from the surrounding river and coastal plains, and the 300m contour separating the lowlands of the Eden and Petteril valleys from the Pennine edge. In a similarly generalised manner, the 250m contour can be taken as the divide between the Howgill Fells and the valleys of the Lune and the Rawthey; while, less distinctly, the 300m contour bounds the dissected limestone plateau embracing Orton, Crosby Garrett and Shap.

Setting the Scene

The highland core of the Lake District is made up of the oldest rocks in Cumbria – basement rocks of the Ordovician and Silurian periods, 488–416 million years old, which consist of the Borrowdale Volcanic Group that stretch across the central fells sandwiched between Skiddaw Group beds in the northern fells and the Windermere Group in the Furness Fells and adjacent areas. Volcanic rocks cover an area of about 800km^2 and produce the most dramatic landscapes in Cumbria[3]. The High Street, Helvellyn, Scafell and Wasdale ranges, and the fells in between, vary in altitude from 400m to nearly 1000m, and are characterised by very distinctive topography, with steep or near-vertical, glacially cut valley sides; rock- and crag-strewn upper slopes and high plateaus; and sinuous valley floors rendered flat by silts deposited in glacial lakes or millennia of riverine deposition,

Simplified solid geology (based on British Geological Survey mapping).

very often with natural benches along the edge of the valleys and above the level of flood water on which settlements were founded.

Skiddaw Group beds form the upland zone, extending from Blencathra and Skiddaw in the east through Buttermere and Crummock Water to the Ennerdale Fells in the west. This group largely consists of much-altered mudstones, siltstones, sandstones and slates, which are less resistant to erosion and so break down more readily than the volcanics to form the more rounded and less craggy fells typical of the northern Lakes. However, there are exceptions that will be obvious to anyone who knows those fells. The break between upland and valley bottoms often tends to be less severely marked than in the central fells; the presence of flat valley bottoms is, however, evident across the area.

The generally lower southern fells, stretching from Dunnerdale in the west through the Furness Fells and Windermere across to Shap and the Howgills in the east, are composed of mudstones, shales and sandstones. These have been worn down to leave the mix of broken craggy topography seen in Furness or the smoothly rounded forms that typify the Howgills. Altitude varies considerably across this zone, as does the nature of the break between hills and valleys: in Furness valley sides can be as steep, if not as high, as in the central fells; while, in the Howgills hills, slopes and valley sides display varying degrees of convexity higher up and concavity lower down.

The basement zones are bounded on all but the south-western edge by Carboniferous strata, 359–299 million years old. Most prominent of these are the expanses of limestone underlying the distinctive plateau that runs from Kirkby Stephen and Orton along the eastern fringe of the Lake District, and then wraps round the edge of the northern fells as far as Egremont, also outcropping in southern Furness, Cartmel and an elongated strip southwards from Kendal to Silverdale. While each of these areas has its own distinctive landscape characteristics, certain topographical elements are common to all: a broadly plateau-like top, anything from 100m to over 300m high; prominent, often wooded, limestone scars with scree slopes below; and much less surface water.

Beyond the limestone belt, a narrow strip of younger Carboniferous Millstone Grit occurs from the Appleby area round the northern edge of the main upland zone to be replaced by even younger Carboniferous Coal Measures, mainly seen in the coastal zone between Maryport and Whitehaven. In both zones topography and altitude are much more subdued, with rolling hills and open valleys.

The distinctively red soils of the Eden Valley at Morland.

Carboniferous beds also make up the Pennine escarpment with a swathe of limestone outcropping between Brough and the northern county boundary, topped by the Millstone Grits of the higher slopes and Pennine moors.

Sandwiched between the limestone areas to east and west are younger rocks of the Permian and Triassic periods, 298–200 million years old, seen in the Eden Valley and along the coast from Whitehaven to Barrow-in-Furness. Perhaps the most distinctive visible rocks in this zone are the red Penrith Sandstone beds that give vernacular buildings and soils in that area such an unmistakable signature, although other types of rock occur – sandstone, as well as mudstones, shales, and a type of rock known as Brockram occurring around Appleby, Hoff, Brough and Kirkby Stephen: this consists of a mix of Carboniferous limestone and sandstone[4].

Climate and Weather Patterns

Given its varied altitude and topography, Cumbria's climate and weather are not only notoriously fickle but also display marked differences in detail across the county. Rainfall totals in the Lakeland

core are sometimes legendary, notably in the fells towards the west, where the orographic effect of onshore weather systems meeting the mountains leads to rapid condensation and increased precipitation, not to mention increased wind speeds. Towards the east, especially in the river valleys, rainfall amounts and frequency are much reduced until the prevailing winds come up against the Pennine escarpment. Similarly, average temperatures vary from east to west in response to changes in altitude and the decreasing influence of warming sea currents.

For the period 2000–12, the upland core experienced rain on over 200 days each year, and snowfall on over twenty; average daily temperatures varied from 3 degrees Celsius in December to 14.5 in July; average annual rainfall ranged from 1,000 mm on the coast to 1,779 at Shap[5].

Even at sea level, with zero orographic effect, totals are high, although the highest levels fall in the uplands: even though Keswick is relatively low in altitude, its situation surrounded by fells accounts for its high annual rainfall. Data would show Great Dun Fell, close to the highest point in the Pennines, having equally high totals. In terms of rainfall frequency, the coast and Eden Valley, in the lea of high ground and towards the east of Cumbria, predictably have the lowest values and, again, the fells the highest.

For average temperatures, in some respects there is broad parity across the county – average annual maximum daytime temperatures on the coast are very similar to those for Shap for example; and all but the Pennines have broadly similar average maximum temperatures through the summer months. Average minimum temperatures show rather more variability through both winter and summer months. In all temperature variables, coastal stations record higher values than those inland, while the highest altitudes record significantly lower values. It comes as no surprise that the Pennines are coldest throughout the year.

As noted earlier, climate and weather patterns – and extremes – have a direct and inescapable impact on farming. Apart from rainfall amounts and vagaries, farmers take particular note of frost incidence and the probability of snowfall: along the coastal plains, they can expect five to ten days per annum with air or ground frost, compared to between fifteen and twenty in the high fells and Pennines, or ten to fifteen across the rest of the county. Similarly, they would expect to endure two to four, six to ten, or four to six days respectively of falling

snow or sleet in January. The length of the growing season varies in similar proportions: 270–290 days on the coastal plains, 240–270 in the Eden Valley and below 180 in the uplands.

Clearly, the range of opportunities open to farmers in the uplands is quite different from that in the lowlands, and it was ever thus. Those who work on the land respond accordingly and develop systems that are suited to where they operate: here, too, it was ever thus.

Soil Potential

Soil is both a reflection *of* natural landscape – rock type, hydrology, climate – and an influence *on* landscape. Soil characteristics have a strong impact on what will grow, and how successfully plants will grow, in turn exerting control on how farmers can utilise any given space. This generalisation is as true today as it has been throughout history, although with the corollary that today's farmers can resort to biotechnology and other scientific disciplines to overcome problems presented by nature.

The Cranfield National Soil Resources Institute identified twenty-seven broad types of soil across the country in a way that linked soil to environment and landscape, rather than just producing a scientific list of soil types with little direct relevance to reality[6]. Within Cumbria, seven types are predominant. In the Lake District fells and the Pennines, Types 19 and 25 are either blanket bog or acidic peaty soils that are wet to very wet, with low or very low fertility levels. At best they provide the farmer with low-density sheep grazing but much has been put down to forestry plantations; agricultural potential here is minimal.

Along the lower slopes of the Pennine escarpment, Type 10 has more potential: here the dominant cover is a slightly acidic sandy soil, freely drained but still with relatively low potential. Permanent pasture is the most suited to land use but, with sufficient inputs, cropping can be practised. Around the fringe of the high Lakeland fells, Type 17 consists of acidic loam or clay soils, again with low fertility, which are mainly utilised as permanent pasture and forestry.

Fertility levels and soil potential decrease in direct proportion to increases in altitude. In much of the Eden and Petteril valleys, and on the lower slopes and valleys around the outer fringe of the fells, soils are loams or clays (Type 18) but with lower acidity – so they are deemed to have 'moderate' levels of fertility. Land use

here is mixed pastoral (grass crops and arable), depending on local variations in wetness and potential and the level of inputs. Type 6 is found in east Furness and Cartmel, in the limestone districts, and in parts of the Eden Valley. These, too, are classified as being slightly acidic loams with limited fertility, although generally freely drained. Pasture, scrub and deciduous woodland are widespread, along with low-density grazing.

Finally, the coastal plain in north-west Cumbria has a cover of Type 21 lime-rich loams or clays with moderate fertility, suitable for both cropping and pasture.

Soil acidity levels, given as pH values (below 7 is acidic, above is basic or alkaline), are critical to what a given soil can support and, in very broad terms, the Lakeland fells and Pennines have pH values below 5, often as low as 3.5, compared to 5 or 6 on the coastal plain, upper Eden Valley, Furness and the lower hill slopes, and 6.5 to 7.2 in the Lower Eden Valley[7]. The light sands of the Penrith area and the glacial outwash soils around Brampton are both inherently acidic and of low potential without the use of inputs. Developing strategies to overcome high acidity levels was a recurring theme through the centuries for Cumbria's farmers and land managers.

Land Classification

In 2010 a series of regional maps was compiled showing Agricultural Land Classification grades[8], highlighting variations across the country in terms of the agricultural potential of land based on a range of physical attributes: climatic (temperature, rainfall, exposure, frost risk, aspect); topographic (gradient, relief, flood risk); soils (texture, structure, depth, stoniness, chemical properties). Within Cumbria, no land is classified as Grade 1 (Excellent), and only isolated patches in the Eden and Petteril Valleys, as far south as Appleby, and the area west of Wigton, are at Grade 2 (Very Good). The vast bulk of the Eden Valley, the coastal plain, lowland Furness, lower Lunesdale and much of Cartmel are deemed to be Grade 3a (Good to Moderate); while a narrow strip round the fringes of the Lakeland fells and along the foot of the Pennines is Grade 4 (Poor). Not unexpectedly, the Pennines, Lakeland fells, upland Furness, the Howgills and other upland areas in Westmorland are in the lowest category, 5 (Very Poor). Grades 1 to 3 are deemed to be Best and Most Versatile (BMV) land[9]. A further way of classifying landscapes at subregional

level was devised in 1996, dividing England into 159 National Character Areas (NCA) based on broad landscape features, natural environments and cultural components of landscape[10]. Twelve NCAs have been recognised in Cumbria and the close correlation between the distribution and spatial extent of these and the Agricultural Land Classification zones is strong.

The preceding sections have summarised the situation as it is now, a time when land managers have at their disposal an array of artificial inputs, ever-more sophisticated technology, and advice from a range of organisations, statutory and non-statutory, to help them beat nature into submission and so to achieve the best possible outcome from the land under their control. However, despite all this, nature invariably has the upper hand and, while the concept of determinism – that what farmers can do with the land is primarily decided by natural forces – is generally out of academic favour, the inescapable reality is that these forces cannot be ignored. However, what of farmers and estate owners in times past who did not have access to modern technologies? That very question is the focus of this book.

National Character Areas in Cumbria (based on Natural England mapping).

Time Frame and Contemporary Sources

Inevitably, when researching at a county scale there will be discrepancies in the quality and quantity of historical written sources, and the researcher is at the mercy of what is available. Survival rates vary from area to area and, generally speaking, there is a negative relationship between time-distance and the number of relevant surviving sources. This certainly applies to the medieval period: no sources on estate management or agricultural matters, coucher books or cartularies, have been located for Shap Abbey and, although the degree of archival survival for Furness Abbey appears substantial, even this pales when compared with that for Fountains Abbey or Bolton Priory in the Yorkshire Dales. A few early references have been sourced, but they merely provide the briefest of cameo snapshots. Similarly, the geographical coverage is unavoidably uneven.

Research for the book has followed a number of channels. Original documentary sources from across the county tend to be dominated by the landed estates, large and small, especially where estate stewards were in regular correspondence with their often absentee employers. What rarely survives in an accessible form are return letters to the stewards. The Lowther Archive stands out with its long-lived comprehensiveness, as do papers from the Musgraves of Edenhall, but other sets of documents for smaller estates can be of considerable value where they relate to estate or agricultural affairs[11].

Estates frequently employed legally binding methods to ensure that tenants knew exactly what was expected of them – farm leases were frequently formulaic and generic on larger estates but more individualistic on smaller properties, with stipulations about husbandry methods, permitted improvements, and procedures if a tenancy was given up. Such detail, found in agreements, deeds and indentures, adds much to the understanding of how land was managed and overseen.

Contemporary published accounts, albeit largely from the late eighteenth and nineteenth centuries, offer a useful insight into the state of rural affairs in cases where the diarists or writers concerned compiled detailed and wide-ranging descriptions rather than collections of personalised trivia or publications aimed at the burgeoning tourist market. William Hutchinson (1794–97), John Housman (1800), John Hodgson (1805 and 1811) and John Moore (1819) travelled and observed during the troubled times

of the French Wars or their immediate aftermath; John Watson (1845), William Dickinson (1850) and Crayston Webster (1868) were concerned with farming in Cumbria during the High Farming era; while Fiennes (1698) and Garnett (1912) wrote in quite different times. Published reports researched by county surveyors for the short-lived Board of Agriculture specifically examined in minute detail just about every aspect of farming in Cumberland (Bailey and Culley 1794), Westmorland (Pringle 1794) and Lancashire North of the Sands (Holt 1795), as did board secretary Arthur Young, perhaps the foremost protagonist of agricultural improvement, after his long journey through the north of England (1770).

Prominent among the panoply of soil improvement strategies employed over the centuries was the process of liming: adding quicklime to the soil or as top dressing on grassland. This writer has undertaken a detailed field survey of lime kiln sites across the whole of Westmorland and along the Pennine edge of Cumberland[12], which itself complemented earlier work in the Yorkshire Dales[13]. The Cumbrian survey was not just conceived to record the present state of lime kiln sites, and to submit the results to the County and National Park Authority's Historic Environment Records (HER), but also to use the results as a tool for understanding the spatial and temporal extent of agricultural liming across the survey area and, by proxy, across Cumbria as a whole.

Cartographic sources consulted take various forms: maps of the Ordnance Survey (OS) 1st Edition Six Inch Series (1:10,560) give complete coverage for the entire county, and maps accompanying enclosure awards give broad coverage across Cumbria. All accessible maps and awards have been consulted for Westmorland, Furness and the Pennine edge. The level of detail they contain is variable, although all awards contain invaluable information at a local scale as well as an insight into moves to enclose and divide up formerly open stinted pastures and commons. Enclosure maps invariably mark 'ancient enclosures' applied to those tracts of farmland in use before the time of those then living. It was common, notably in the late eighteenth and nineteenth centuries, for landowners to commission detailed maps of their estates, or parts of their estates, if land was subject to agricultural improvement or being bought or sold.

Liming, needless to say, was far from the only available strategy and throughout the book other methods are examined and exemplified.

Modern Sources

The spatial and chronological range of modern published studies on aspects of farming and land management in Cumbria is impressive. Various researchers have focused on the yeoman class of small- to medium-scale farmers – Cumbria's statesmen – and on the intricacies of land tenure. Angus Winchester's seminal book *Harvest of the Hills* explores the role the small farmer played in exploiting upland resources along with detailed analysis of customary tenant-right, a theme taken further for the eighteenth century in a later work[14]. Searle's approach was to reassess in a positive light the contributions made by the small farmer in land management, again with particular reference to the upland commons[15]. Others have taken a different approach to the yeoman class, choosing to concentrate on the decline of the statesman[16].

Ian Whyte has been prolific in analysing the rationale for and mechanics of upland enclosure and associated improvements to upland farmland[17], while Blake Tyson has provided a useful exemplar of enclosure in north-east Westmorland[18]. Specific aspects of landed estates have been considered in detail: for example, the Netherby Estate in Eskdale and the Rydal Estate between Ambleside and Grasmere[19].

However, the concept and practice of agricultural improvement and the day-to-day ways in which land was husbanded across Cumbria through the centuries have received less attention.

Arrangement of the Book

As the book's subtitle suggests, what follows is not presented as a definitive exposition of agricultural change in Cumbria, but as a personal slant on those processes. Inevitably the book concentrates more on some elements of change and on certain geographical areas than others. The writing of this book derives from the author's longstanding interest in all historical things rural, which may, in turn, derive (subliminally perhaps) from a childhood spent in a rural farming area, and from many generations of direct ancestors who were farmers or farm workers. A further undoubted catalyst is a lifelong love of landscape and an obsession with trying to read – to deconstruct – rural landscapes, be they 'empty' mountains or intensively cultivated farmscapes.

The book begins by considering what is meant, now and in the past, by improvement and how it can be perceived; and it touches on the achievements of agricultural improvement in general, before examining the actual mechanics of improvement and change within the county through the centuries. Later chapters examine who the catalysts for improvement and change were – tenants, small estates, or the owners or stewards of large, landed estates – by reference to case studies from across Cumbria; and the impact that external factors, positive and negative, had on farming. The book concludes by looking at the situation in our own time and addressing the question inherent in the title. Where individual farms are referred to, their national grid reference is given at the first mention: those with no reference have not been convincingly located on the ground.

2

The Idea of Improvement

The modern definitions of what constitutes improved, and semi-improved, grassland are very much at odds with what the pioneers of agricultural improvement had in mind. Additionally, a land manager today intent on maximising productivity and economic output would regard improved grassland very differently from someone whose primary concerns focus on nature conservation and biodiversity. Nowadays, improved grassland is deemed to have been modified for the benefit of agriculture by regular applications of organic and/or inorganic inputs, and by having been ploughed and reseeded with a limited mix dominated by competitive species such as rye grass (*Lolium* spp.) to maximise land potential and income. It is, in essence, species-poor, but is (arguably) necessary to support today's cattle and sheep breeds that require a high-protein diet. To the ecologist and conservationist, grassland that is species-poor and subjected to regular inputs is not regarded as improved. They would, rightly, be alarmed by the dramatic decline in the area of species-rich grassland across England and Wales: from 1930 to 1984 it decreased by 97 per cent[1]. This statistic alone could act as justification for Natural England's policy, which has been in place since 1990, to convert species-poor 'improved' and silage grassland back to species-rich hay meadow[2]. Use of the words 'restoration' for the process and 'traditional' for what is being recreated neatly summarises the modern conservationist approach to what constitutes improved or unimproved farmland.

Early Days

In the past, the matter was viewed very differently indeed: the concerns of the medieval peasant, both pre- and post-Norman conquest,

centred on the business of daily survival and on ways of eking out more than the mere minimum needed to feed the family and meet manorial obligations. Post-conquest, they may conceivably have been distantly aware of the Norman French word *emprower* – the notion of making a profit from something – which is what the more outward-looking peasantry would surely have kept in mind. No doubt many were innately conservative and even suspicious of new ideas, but for those with vision the benefit of adopting innovations and adapting to external pressures must have seemed obvious. This very basic human process of wanting to get on has been described as 'an intrinsically natural and practical solution' for the medieval farmer[3].

Even before 1066, much of the country already had a rural economy that was managed in an ordered and structured way[4], and there is no reason to think this did not also apply in Cumbria. In Craven, neighbouring Cumbria to the south-east, there is increasing archaeological evidence of isolated settlements on limestone terraces between the 200–300m contours, surviving as the remains of clusters of rectangular buildings with broad dwarf walls that would have supported a timber or turf upper structure, associated with enclosures of variable size and shape that could represent gardens, stock garths, pastures or cropland, depending on their size and proximity to the farmstead[5]. In each case, excavation has shown that these settlements were solidly constructed and in no way mere peasant hovels. To what extent they were elements of a landscape-scale land-management system cannot (yet) be determined, but suites of radiocarbon dates confirm a protracted period of occupation as well as widespread external trade or exchange links, and locally based craft activities throughout the Anglo-Saxon and Anglo-Scandinavian periods. Interestingly, only one radiocarbon date out of the many obtained from these sites post-dates AD 1000, which may hint at a general settlement shift from isolated farmsteads to nucleated sites within the valleys in the late tenth century.

Many sites in the Yorkshire Dales such as these were previously assumed to have been of late prehistoric – Iron Age or Romano-British – or later medieval date, although with no factual justification, and the same assumptions have been made for similar sites across Cumbria that could just as well prove to have origins in the early medieval period. Several isolated sites in the Duddon Valley, surveyed but not yet excavated or scientifically dated, could fit this mould as well as sites elsewhere in Cumbria[6].

Whatever dates might apply to such sites, it is clear from field evidence that the landscape was being managed in a systematic way prior to the Conquest and that land around the farmsteads had been subjected to some form of improvement. Small garths, often adjacent or close to rectangular buildings, are often completely stone free, which may suggest they had been used as gardens that were enclosed to keep out livestock. The network of larger enclosures seen around many of the sites hints at the management of livestock from one 'field' to another or seasonal exclusion of stock from enclosures where hay was harvested. Thus, early field clearance and the use of cleared stone to construct low field walls, and some form of seasonal land rotation, are still discernible in today's landscape: all these can be described as improvements.

To what extent some of the improvement processes seen in lowland England were ever applicable in Cumbria is a matter for debate, although increasing population levels through the Medieval Warm Period in Cumbria's lowlands and valleys would undoubtedly have acted as the catalyst for agricultural expansion and intensification of land use. The latter could have involved reducing the length of fallow periods and improving the quality of grassland by manuring.

Woodland assarts at Troutal, Dunnerdale.

We come back to those farmers who had vision and drive and who – with or without the prior consent of the local manor court – nibbled into hitherto unused land, carving assarts, thwaites and riddings out of woodland to increase the size of their land holdings, especially in more wooded Furness and parts of Westmorland. Many formerly tied tenants became free tenants, possessing the resources that enabled them to lease more land and pay for the practicalities of clearing and enclosing new woodland assarts or encroachments on to the common. Given that medieval freemen paid customary rents that were fixed for long periods by the manor court system, this was not an insurmountable problem.

Transhumant stock management regimes are known from the Anglo-Saxon and Anglo-Scandinavian periods in Cumbria and Craven, and could well have much earlier origins. The basic premise of this system was that livestock was driven away from lowland or valley settlements to spend the summer months in higher, but not necessarily upland, pastures at some distance from the permanent steading. This kept the animals out of enclosures where hay was to be cut in late summer and gave lowland pastures the chance to regenerate, while livestock was able to benefit from fresh grass growth elsewhere. The summer pastures were centred on shieling huts, many of which had small associated garths; place names that often indicate such shielings contain the element 'scale'. In the valleys of the Lakeland fells, such names are very common[7], but they are also found along the Pennine edge. Within Kirkoswald parish is a dispersed settlement near Renwick called Scales, with four discrete farms having scale in their modern name. North of Renwick is the nucleated hamlet of Scale Houses; examination of the relevant OS map shows a series of very narrow, slightly aratral enclosures running across the contours that are survivors of an earlier strip-field system. It has been postulated that many years of natural manuring by livestock at the original shieling here improved the soils and pasture to such an extent that permanent settlement eventually became viable[8], based on cropping below the settlement and grazing on High Moor above and possibly Middle Moor to the west.

Elsewhere, probable medieval shielings survived as permanent farmsteads at, for example, Southwaite in Mallerstang[9], Heggerscales in Kaber, Scale Beck in Great Asby, the two now-ruinous Scale farms in Grisdale, and Bowscale in Ulpha. Other shieling sites were too remote or too marginal in terms of land potential, so

Bowscale, Ulpha, recorded from 1646–1946.

disappeared long ago to survive only in the archaeological record: a site in Crosdale Beck on the south-west flanks of the Howgill Fells has been excavated, and pottery finds suggested a medieval provenance[10]. There is a high degree of probability that the long line of farm-based settlements at the foot of the Pennine escarpment all the way from Cumwhitton in the north to Murton in the south originated as pre- or post-Conquest shielings, or vaccaries maybe. They were sufficiently improved over time by careful husbandry and piecemeal enclosure to have developed into nucleated settlements as the margins of cultivation pushed ever nearer the Pennines. Even a cursory examination of detailed mapping highlights a definite pattern of a long line of large villages on the east bank of the Eden and a parallel line of smaller settlements below the escarpment.

Large tracts of medieval Cumbria were in the hands of monastic houses, which had a major impact on farming both directly and indirectly. Directly, the powerful Cistercian abbeys of Fountains, Furness, Byland and Holm Cultram controlled vast areas; smaller foundations, such as the Augustinian Lanercost and Cartmel Priories, the Benedictine St Bees and Wetheral Priories, and the Premonstratensian Shap Abbey, were endowed with lands sufficient

for their maintenance. All houses had extensive estates within their home territory and further afield[11], either worked in-house by lay brothers and paid farm labourers or by tenants.

Apart from lands across Gilsland, Lanercost was granted extensive grazing along the Pennine edge, especially on Gamblesby and Glassonby Fells either side of the present A686. On Ousby Infell further south, a transhumant form of sheep and cattle management was practised, centred on seven granges, vaccaries and bercaries (cattle and sheep estates respectively), such as at Ainstable and Haresceugh. Wasdale Head, and Gatesgarth at the head of Buttermere, were seigneurial vaccaries[12]; while there were also summer shieling huts such as those granted to Lanercost on Baron Side on the lower slopes of Ousby Infell[13]. Lanercost charters record the granting of arable lands where spring-sown oats with some winter wheat and rye were grown, protected from livestock by *agger lapidus* – the stone-cored bank that can still be discerned in today's landscape.

Shap Abbey had extensive areas of woodland and pasture land, as well as enclosed arable land and significant numbers of livestock, and it maintained five granges (including Bampton, Milburn, Reagill and Sleddale), and over 610 acres (250 ha) of pasture land at the

A stone-cored bank below Burney Hill, Milburn.

The Sea Dyke at Skinburness. The sea lies to the left of the road, reclaimed land to the right of the dyke.

abbey's original site at Preston Patrick[14]. Holm Cultram Abbey in the far north-west drained large areas of coastal marsh to create grazing for sheep, enabling it to become a major player in England's wool trade. To protect its reclaimed coastal pastures, the abbey had protective dykes constructed, notably at Skinburness. Disastrous storms between 1301 and 1304 swept away the newly chartered market town and port, as well as access roads, making its survival an ever-present concern, but one worth persevering with in order to benefit from its rich coastal salt marshes and inland pastures. A gift to the abbey (1236–46) included rights to 'sow and reap in the marsh within the Dyke'[15]. In addition, the abbey was granted estates in the Forest of Inglewood, along the Eden and Caldew and across Allerdale. In 1250, for example, Holm Cultram was to benefit from the grant of pasture land sufficient to maintain a flock of 700 wethers with a vaccary and a bercary at Edenhall. Fountains and Furness Abbeys held Borrowdale, each establishing granges (one and nineteen respectively) as well as vaccaries at, for example, Langstrath, Stonethwaite, Grange-in-Borrowdale, Watendlath and Keswick. Much of the valley floor south of Derwentwater was drained and brought into use as sheep grazing or, in a more limited

way, as arable land, growing cereals within small, walled enclosures. Furness Abbey, needless to say, held vast swathes across Low and High Furness and many of the present farms and hamlets were granges; it held forty-six in all.

Byland Abbey, on the edge of the North York Moors, was granted large estates around Crosby Ravensworth, Asby, Musgrave and Warcop; Fawcett Forest, Borrowdale, Bretherdale, Bannisdale and Wasdale; Brough, with year-round grazing rights in Stainmore; and Sleddale and Shap, all administered from a grange at Bleatarn near Warcop and from others at Asby and Hardendale in Shap[16]. Granting of pasture land to the abbey north of Shap, in 1177–80, included a placed named *Tranaterna*, which might now be Trantrams, a rich expanse of grazing between Thrimby Out Scar and Greenriggs. The current place name 'Abbey Park' is suggestive of the former grange site. Other still current place names in Warcop could have similar associations with the grange: charters record the granting of arable *ploughlands*, a name still borne by a farm on the west bank of the Eden; while Sourlands Hill between Bleatarn and Warcop, divided by hedgerows into narrow, aratral (reverse S-shaped) strip-fields running

Aratral hedgebanks under modern fence lines on Sourlands Hill, Warcop.

Huber Hill, Warcop, with the near-vertical risers of three lynchets visible.

across the contours, may have gained the reputation for having heavy acidic soils, requiring much toil to make them workable. Even today, the soil is clayey and inclined to be wet, but the hill has been maintained as permanent pasture. Huber Hill, on the east bank of the Eden below Warcop, was another ploughland granted to Byland: cultivation terraces are still clearly visible on its east-facing slopes. As with other monastic houses, Byland was granted the right to enclose its new arable lands and to fold sheep on its cropland: folding was an age-old means by which fallow land was manured by confining sheep overnight in a pen[17].

What cannot be downplayed is the massive impact that monastic ownership and estate management had on the pre-existing landscape by draining coastal and inland marshes, converting rough ground into well-tended pastures and meadows, enclosing areas with banks, ditches and walls to create or extend ploughland, vastly increasing the size of the total sheep flock across the county and, in essence, introducing commercialisation and integrated land management on a previously unimaginable scale.

Furthermore, it was almost certainly the case that monastic tenants or those on seigneurial lands adjoining monastic estates would have

noted the benefits of improvements made at the behest of monastic houses in terms of increased output and income; they would surely have strived to employ the same methods, albeit on a smaller scale, on their own tenements. An agreement from High Furness in 1510 enabled tenants of the abbey to take in and enclose new lands to increase the size of their holdings in return for paying extra annual rent at the rate of 6s 8d per 1.5 acres enclosed[18]. This is but one localised instance of processes that were then underway across the county, bringing about transformation of the countryside, increased economic specialisation in farming and increased commodification[19]: goods and services, formerly provided by tenants as an obligation to their lord, were both slowly transformed into commodities with monetary value. It became a self-fulfilling process, with assarting and piecemeal enclosure leading to improved husbandry and thus increased output, in turn feeding the desire or perceived need to take in more land to develop the 'business'. The rate at which this cycle grew clearly varied spatially, and no doubt some areas were passed by altogether, either owing to their physical remoteness or conservative backward-looking attitudes. Cursory examination of OS mapping or satellite imagery emphasises the widespread extent of medieval arable fields fossilised in the modern landscape as narrow, aratral strip-fields, often running at right-angles to village cores with associated back lanes, and sunken holloways running away from the settlements. Among the most impressive examples of these landscapes are those to be seen at Great Asby and Maulds Meaburn in Westmorland and at Blencarn, Melmerby and Gamblesby below the Pennine edge in Cumberland.

Many townships in Cumbria had medieval townfields – groups of ploughland strips protected against livestock by ring fence or ring garth walls, dykes or hedgerows – that remained open and internally undivided until the era of parliamentary enclosure[20]. Some of these townfields can still be traced in the modern landscape. Murton's are a particularly good and accessible example. It had three open townfields, two of which were eventually subdivided into narrow enclosed strips, which have survived to the present day: between Town Foot and Sweety Briggs to the north of the village was the Great Field with seven medieval furlongs; between Bridge End and Hunter Howe on the south side was Moor Field with four. Little Field, south of Murton Hall, had two. Hilton Field to the south of Murton was much larger with twenty furlongs. To the north of

Murton, the 52-acre (21-ha) Keisley Field lying between Keisley Bank and the modern Murton parish boundary remained open until the enclosure award of 1859 allowed for its subdivision[21]. Elsewhere in Westmorland, early-nineteenth-century awards brought about the subdivision of open fields at Soulby near Kirkby Stephen, Martindale, between Ullswater and Haweswater, Bolton on the Eden, and Mintsfeet, now subsumed within Kendal's northern suburbs.

As outlined in Chapter One, however, farmers are not immune from natural forces: in the medieval and Tudor eras, this was certainly true. The travails of much of the fourteenth century can only have had a negative impact on farming. Repeated raids by the Scots between 1315 and 1325 can be closely correlated with a downturn in climate as the Medieval Warm Period was replaced in a matter of just a few decades by markedly cooler and wetter conditions. 'Years with no summer' led to harvest failures and, in turn, to famine, cattle murrain and epidemics of contagious diseases such as typhus and dysentery, culminating in the various plagues that beset the latter part of that century. If the catalogue of disasters was not enough, high rates of taxation to claw in money for wars added insult to injury for the fourteenth-century villager. The end results, from a negative perspective, were massive decreases in livestock numbers, a much reduced and weakened human population, landowners deprived of their pool of labour and unable to fill vacant tenancies, and a breakdown of the market system. From a landscape perspective, much marginal land that had been brought into cultivation or improved pasture was abandoned, and there was a general reversion of cropland to pasture in non-marginal areas nearer population centres. It would have been through these decades that many of Cumbria's medieval ridge-and-furrow arable lands and lynchet systems saw a plough team for the last time. The climate became too wet and cool for crops to ripen, the soil often too wet and heavy to plough, and the demand for food crops decreased.

As is often the case, even the bleakest cloud has a silver lining and positive outcomes of the fourteenth century's setbacks can be discerned. Indeed, it has been shown that regions where pastoralism was more economically important than cropping, prior to this dreadful period, suffered less during the century's protracted economic troubles[22]. Once the Black Death and other outbreaks of plague had run their course, those who had come through it all relatively unscathed found themselves living in a very different world, one where

their labour and strengths were in vastly increased demand from landlords, both seigneurial and monastic. Again, those with vision and entrepreneurship grasped the opportunity to take on vacant tenements, often on their own terms, and to start, or resume, the long process seen from the late fourteenth into the sixteenth centuries of increasing the size of holdings. This was by legal engrossing (taking on land adjacent to their core holding) and enclosure or approvement, by illegal encroachments onto common or unused land, and by assarting, clearing woodland to create new pasture land. They now had, more than ever before perhaps, the wherewithal and the rationale for undertaking improvements on their holdings, especially as many were able to exchange their former restricted and unfavourable copyhold tenancy agreements for the enhanced status of the free or leasehold tenant. It was this group of men who were later to be referred to as the yeomen, or possibly husbandmen, who were to make up the statesmen class of small, independent farmers so typical of Cumbria and parts of the neighbouring West Riding[23].

Evidence of the new relationship between lord and tenant is illustrated in Brough-under-Stainmore: the Cliffords took control of vast areas in Westmorland in the early fourteenth century and adopted the policy of leasing out to tenants much of what had been demesne land, and these new tenancies included what were then termed 'new improvements'[24]. This was prior to the travails of that century and, despite constant setbacks, the estate continued with the policy of enclosing, improving and renting out land into the following century; estate accounts for the 1420s confirm that Brough had its share of progressive tenants, who accumulated tenements hitherto vacant to increase the size and potential of their own holdings.

Even as late as the eighteenth century, up to two-thirds of tenancies across manors in Westmorland were held by customary tenure, with tenants' rights protected by ancient law[25]. This gave them security of tenure, including the right to bequeath tenements to their heirs, in return for inheritance fines: with this knowledge and security, they felt able to invest in improvements for the long term, felt strong enough to resist lords of the manor intent on enclosing common land to the exclusion of those with common rights, and possessed a definite feeling of group identity in acting together with their neighbours for the common good. There was also recognition, on both sides of the courtroom table, that illegal encroachments could readily be legalised through the manor court system by payment

The Idea of Improvement

The ruins of Bow Scale, Sedbergh, with a stone-cored bank running left to right below the sheep.

of fines. In a sense, it was the equivalent of obtaining retrospective planning permission today. A sitting of the Sedbergh manor court in 1457 presented eight tenants for enclosing *Les Intakes*, including John Holmes of Bowscale, presumably locating these encroachments at Bow Scale, now just a ruined field barn (SD697 928), to the east of Sedbergh itself[26].

The Cliffords reappear in the record between 1579 and 1589 over disputed enclosures and rights of pasture and turbary on Milburn Fell/Forest. At the end of that decade, George Clifford had granted leave to Richard Sandford of Howgill Castle, lord of the manor of Milburn, to enclose and improve part of the Fell, but Clifford's claim to ownership of the Fell was disputed[27]. Arbitration found in favour of Clifford, enabling his estate to enclose that part of the Fell called Middle Tongue, below Great and Little Dun Fells, for its sole use while Sandford was granted permission to enclose other parts of the Fell. The area concerned can be traced on modern maps and on the ground: it lay between Crowdundle Beck to the north, Mudgill Sike to the west and Knock Ore Gill to the south. The eastern boundary was not stated but could be the high drystone wall running north–south

Milburn Pasture. Boundary walls run left to right below Great Dun Fell and top to bottom on the left.

from Hanging Shaw. Within those bounds lie 3km^2 of fell pasture in a roughly squared and walled enclosure, later to be called Milburn Pasture. When the walls were erected is not recorded but their structural characteristics – above-average height, more or less vertical sides, lack of coursing and rounded corners – are suggestive of an early, and certainly pre-parliamentary enclosure, date. This could conceivably be the 1589 Clifford enclosure boundary, though the east wall sits on a low bank with an external ditch, which are clearly older features, and a substantial and long linear bank bisects the southern part of the pasture on the western slopes of Burney Hill, parallel to Hill Plantation. This, too, predates the walls. Close examination of the various internal walls indicates that the perimeter wall was built first and the interior subdivided in more than one phase. As a direct result of the Milburn Fell Pasture enclosure award of 1857, that part of the original Milburn Pasture, between Red Carle and the main tributary of Crowdundle Beck, was walled in, although the present configuration of walls does not match that shown in the map accompanying the award[28]. Milburn Pasture stands as a microcosm of how land management has been modified through the centuries in

response to changing economic or social circumstances and stimuli. In modern times, one now-redundant internal wall has been allowed to go to ruin and much of the combined enclosures of the pasture are slowly but inexorably reverting to their pre-improvement state, as soft rush (*Juncus effusus*) and mosses reassert their hold. However, it is still grazed by sheep and store cattle.

Detailed evidence from much of Cumbria for this long period is somewhat contradictory. On the one hand it has been shown that the period 1375–94 to 1574 witnessed an increase of 64 per cent in the number of manorial tenants in Grasmere and Windermere, data which are perhaps at odds with the general assumption that there was an overall decline in population numbers in the country. However, in Cumbria as a whole, a growth in population of 43 per cent between 1563 and 1603, in the Barony of Kendal of 7.8 per cent in the hundred years from 1563, and in Furness of 3.2 per cent over that same period, do comply with accepted demographic trends[29]. By the time of Elizabeth's reign, it was not uncommon for tenants and subtenants to have become 'hopelessly marginalised', despite the fact that manor courts were laying paines against subdivision of holdings to prevent their becoming too small to support a family and consequently being overworked with severely reduced productive capacity, which could so easily have been translated into distress for the families concerned. This legislative strategy was seen in Crosthwaite and Lyth in 1579, in Loughrigg in 1580 and in Furness in 1586[30]. In Crosthwaite and Lyth the number of farm tenancies stood at 119 in 1560 but dropped to only sixty-five by 1829; in the same period Mallerstang saw a decrease from seventy to thirty-eight[31]. The latter numbers were far more in tune with what the land could support, given prevailing physical attributes. Ravenstonedale, for example, had only two holdings larger than 25 acres (10 ha): 90 per cent were less than 10 acres (4 ha) and half were no more than 5 acres (2 ha). Such small holdings could not provide for the needs, never mind aspirations, of their tenants. Even relatively minor events tipped them over the edge into a state of distress.

Needless to say, distress was far from unknown in Cumbria. Parts of Westmorland, for example, suffered severe distress in 1587–88 as inclement weather caused harvest failure and a surge in grain prices, which happened to coincide with tumbling prices for wool. Many tenants were unable to feed their families from home produce, and could not make enough from selling their fleece crop to afford the

high cost of grain. These distressing circumstances were to persist on and off for another ten years[32]. Apart from anything else, who would think of investing in improvements in times such as these? Priorities lay elsewhere. Westmorland in the sixteenth and seventeenth centuries has been described as among the lowest counties in England in terms of tax assessment levels, being 'poor and remote'[33]. Harvest failures, high prices, food shortages and starvation were, as in the early fourteenth century, aggravated by further Scottish raids in the 1590s; and the following century saw significant population decline in 1623–24, harvest failure in 1622 and 1630 across Westmorland, and plague in 1645–47, followed by a smallpox epidemic in the 1650s[34].

The Mechanics of Improvement

This chapter began by emphasising that the modern definition of improved land is far removed from historical meanings of the term. It has been shown that the act of improvement was inherent – at least from the monastic era – in those forms of land management in which the religious and lay brothers were engaged. They would not have known the term 'improvement', but did have very much at the forefront of their long-term endeavours the economic advancement of their foundation's possessions. They may not have been able to articulate the concept of 'land management', but in essence that is exactly what they were involved in.

The same could also have been applied to seigneurial estates through the medieval period, although with the corollary that forward-looking magnates were concerned to maximise revenues from their estates, either through the manor court system's entry fines, heriots and amercements, or by commodification of their farm activities. Central to this latter process, especially on estates where the lord was absent for much of the time, was the seneschal or steward, who acted as mediator between lord and tenants, as arbitrator when disputes arose, as manager ensuring that the estate was efficiently run and that tenants adhered to their obligations and, perhaps, as diplomat persuading the better tenants to stay on the estate, while at the same time urging the lord to reduce annual rents at times of economic downturn as an inducement for them to remain. It was the steward's responsibility to see that husbandry stipulations were followed – for example, that no tenant should plough up pasture land without consent, or over-crop existing arable land to maintain

fertility and productivity levels. The steward would also use manor court rulings to ensure tenants kept field boundaries and drainage ditches in good order. It was his duty to evict those tenants whose standards of husbandry were not acceptable.

It has been said that a steward 'shone bythe] reflected light' of his master[35], although it must equally have been true that a negligent lord was often saved by an efficient steward. Those stewards who were well read may have known of the anonymous treatise *Seneschausie*, thought to have been written in the reign of Edward I (1272–1307), which promoted the benefits of having the land 'marled, folded, manured, improved, and amended ... for the good and bettering of the manor'[36]. At more or less the same time as this work was composed, Sir Walter of Henley wrote his treatise *Le dite de Hosebondrie*, in which he urged, 'good son, cause manure to be gathered in heaps and mixed with earth, and cause your sheepfold to be marled every fortnight with clay land or with good earth'.

For sure, manuring – or dunging – and folding are forms of improvement that were recognised as being of paramount importance in maintaining productivity, and their origins can quite easily be seen in the early medieval period, if not earlier. Apart from the fact that most medieval farmers would have had no option other than to spread midden refuse and animal dung periodically across their cropland and enclosed pastures, the benefits of muck or slurry spreading are perfectly valid today. Field walking with a keen eye on freshly ploughed land, which shows earthwork traces of either medieval ridge and furrow or lynchet terraces, almost always reveals a scatter of medieval pot sherds from long-past manuring events: broken pots were thrown onto the domestic midden along with all other waste and periodically spread across cropland.

Marling is also a process known from the medieval era, although it is not always clear if the writers, modern or contemporary, were fully clear about what marl is. Technically, it is a type of calcareous (lime-rich) clay, often found at shallow depths on low-lying land on floodplains or former lake beds. It is variable in colour, ranging from buff to red or blue. Lime-rich clays were often dug in pits in glacial till deposits, and they were often termed marl, although technically they were not true marls: in the lower Eden Valley, for example, the ever-present soft red sandstones were referred to as 'red marl'[37]. As far as the farmer was concerned, such pedantic distinctions were neither here nor there: if what he spread on his fields had the desired

effect, then that was sufficient. The key ingredient was the calcium carbonate contained within the clay, which had very similar effects to the application of lime, as will be discussed later.

Two age-old anonymous rhymes point up the perceived value of marling as an agent of improvement:

> He who marls sand may buy the land;
> He that marls moss suffers no loss;
> He that marls clay throws all away.

The message in this ditty is clear: as marl is a form of clay, it is pointless adding it to clay soils but, when mixed in with light, sandy soil, it gives that soil increased body and water-retaining properties. The other, quoted as early as 1603, simply states that 'a man doth *sand* for himself; *lyme* for his sonne; and *marle* for his graunde childe'[38] – the message to take away here is that adding sand to a heavy soil has short-term effects, and liming has a longer-term beneficial impact, but the benefits of marling last through the generations. It has to be said that there are those, including this writer, who would dispute this latter contention.

By the sixteenth century, the concept of improvement had become more widely appreciated as applied to farming and estate management that were designed to return an annual profit; the term was increasingly used then, and it began to take on the added dimension of imposing a legal and a moral duty on the steward or landowner[39]. Those who were responsible for looking after the countryside now had a duty not just to produce crops or livestock products but to ensure that their estates were well tended: profit must go hand in hand with moral benefit. In succeeding centuries, as we shall see, improvement took on even more intangible dimensions, in Cumbria as elsewhere.

A very different approach to early improvement was to take in and enclose land from the so-called waste, which was not waste in the modern sense of having neither use nor monetary value but land that was not directly utilised for intensive agriculture. Rather it had value for peat cutting, ling and bracken harvesting, game, stone and mineral resources, and low-density summer grazing, all of which were managed by the manor courts. The Statute of Merton of 1235 enshrined the right of lords of the manor to enclose or 'approve' 'woods, wastes and pastures' for their own benefit, on condition

that they ensured that tenants holding common rights would still have sufficient pasture for their needs, and that the lord 'doth no hurt' to his tenants. These provisos were maintained by the Act of Improvements of Comons and Waste Groundes in 1550[40]. In time, the formerly illegal practice of tenants enclosing by encroachment, and paying fines later, was formalised as an accepted judicial process. As an example, in the regnal year 1588–89 a survey of the manor of Hoffe and Drybecke undertaken for the Appleby Castle Estate found that 500 acres (202 ha) of Hoff manor consisted of common land – Hoff High and Low Moors to the north of Drybeck village – maintained for the collective good of customary tenants[41]. By the end of the following century, the commons were being subdivided and enclosed for the use of individual tenants. By a memorandum of 14 February 1718, Philip Longwood was admitted tenant of 'one improvement or parcel of ground' on Drybeck Common/Moor that had been 'lately enclosed' by the late William Shipherd: the area concerned was named as Skelbeck Bottoms, now Scale Beck. Though the common was entirely carved up by formal agreement in 1830 into a series of regular, linear compartments, there is a discrete area of smaller, more irregular fields around The Wraes (NY661 141) that may have contained the 'parcell' in question.

Restoration of the monarchy in 1660 had the unintended effect of acting as the catalyst for major advances in agriculture and the economy more widely. After a long period of political, social and economic uncertainty and instability, landowners and tenants alike felt able to invest for the long term in buildings, soil improvement and aesthetic embellishments to their property. Whereas this process has been recognised across the West Riding and north-east Lancashire from the early seventeenth century, it happened somewhat later in Westmorland and Cumberland, as well as Craven[42].

The founding of the Royal Society soon after the Restoration and the scientific, literary and religious transformation associated with the ethos of the Georgical Committee came with a renewed desire to innovate and improve across many fields of endeavour. On the land, enclosure and improvement were given a 'new moral legitimacy', with improvements to landed estates being seen as both morally sound and patriotic[43]. Treatises on husbandry and estate management mushroomed in number and quality even during the Commonwealth[44], reinforcing the benefits of techniques long since in use, such as enclosure, draining wet land, floating of water meadows,

Sheep grazing a rich crop of clover at Cliburn.

marling and liming, and bringing to the attention of landowners and stewards new crops from continental Europe, especially from France and the Low Countries. Root crops like turnips and new strains of carrot, and pasture crops like nitrogen-fixing clover, lucerne and sainfoin (St Foyn originally) brought dramatic changes to British farming[45].

Examination of late-seventeenth-century probate inventories from Westmorland reinforces the reality of this renewed investment climate by demonstrating significant increases in the value of livestock, with the total value of recorded cattle numbers rising by 90 per cent between 1661 and 1690, and a rather later similar increase in the sheep population[46]. Not only were Cumbria's statesmen active in developing their tenements, but a marked concentration of gentry families has also been noted during the same period in the Eden Valley and its tributaries, and to a lesser extent in the Lyth Valley and Furness, some of whom had risen from the status of yeoman[47]. Owners of several landed estates in Cumbria were also drawn into this reforming and improving zeal, as will be seen in Chapter Four.

However, the extent to which late seventeenth-century agricultural change came about in Cumbria is open to interpretation: in

Winchester's view, rapid and profound change was hampered by the predominance of customary rather than freehold tenure, notably in the central upland core, although in his opinion poverty was not widespread among the statesmen. Searle, on the other hand, described Cumbria even in the eighteenth century as basically a peasant society living not far above subsistence level, with minimal reliance on external markets[48]. A contemporary view, from 1766, put a similar slant on the matter, although that writer was undoubtedly not a disinterested observer when he noted that the majority of farmers – Cumbria's statesmen – had holdings valued at between £10 and £50 per annum, rendering them 'petty landowners[who] work like slaves, they cannot afford to keep a man servant' and thus had to endure a 'miserable way of living' without the ability to save anything[49].

In reality the situation would have varied from one area to another: remote valley head and upland plateau farms, with marginal conditions and limited potential, would have been very different in every way from lowland farms with every climatic and topographical advantage.

Conclusion

This chapter has explored the manner and rationale of agricultural change in Cumbria from the pre-Conquest era to the middle of the seventeenth century, and has considered how these changes can be perceived, with hindsight, as improvement. In the early medieval period, at least in those parts of Cumbria assimilated into Anglian Northumbria – namely the Eden Valley, Furness, and the Barony of Kendal, one can visualise the same gradual transition from isolated farmsteads to nucleated settlements that is being recognised from archaeological work in neighbouring Craven. In time, these locational changes would have brought about significant social and economic transformation as farming became more collectively, and possibly administratively, organised, rather than being dispersed in scattered sites based on individual family units. What brought about these changes in the uplands of the north-west is not yet fully explained, but it could have been a response to the introduction of more technically advanced ploughs, able to cope with heavy lowland soils, or to the adoption of new strains of grain crop. Perhaps for the first time since the Neolithic 'revolution', the occupants of Cumbria were in a better position to manipulate the environment to their own

advantage, instead of being at the mercy of the vagaries of weather, soils and topography. It is quite likely that the arable ridge-and-furrow and strip lynchet systems that are fossilised across many parts of lowland Westmorland had their genesis in the pre-Conquest period, as climate improved through the early decades of the Medieval Warm Period. The traditional thesis that such systems emerged after the Conquest is in need of a rethink.

Various processes are known from the medieval era, and must equally have their origins positioned earlier, that generated an increase in the amount of land brought into agricultural use on a needs-be basis. Assarting, approvement and illegal encroachments are evidenced in the manor court record, as is transhumant livestock management. The margins of farming were pushed outwards and upwards through the Medieval Warm Period, only to be knocked back during the endless setbacks of the fourteenth century. Nevertheless, even so, the progressive peasantry saw an opportunity from those catastrophes to develop their own little agricultural empires, often based on the conversion of crop land to permanent pasture: commercialisation and commodification were their orders of the day.

The role of monastic houses cannot be overestimated in transforming vast tracts of the county, both on demesne land close to the mother house and on distant estates. Furness became the second-richest Cistercian monastery in England; Holm Cultram the richest in Cumberland; and a significant but unquantified proportion of Cumbria was at one time or another under the control of what can deservedly be described as shrewd and highly efficient monastic entrepreneurs.

In the Tudor and Stuart periods, farming became ever more organised and market orientated, albeit with pronounced regional variations brought about by variations in accessibility and land potential between fell and lowland. The Restoration of 1660 lifted the lid on years of pent-up frustrations and lack of a positive investment climate; the dissemination of the Georgical Committee's ideas and exhortations, the application of science to farming, and the introduction of new strains and techniques all brought about profound change in the ways in which land was managed in Cumbria, as across England. The rising statesman class of proudly independent yeomen and the landed estates fostered what can justifiably be seen as a metamorphosis in farming in many parts of the county. More enclosure of the waste, engrossment and emphasis on improvement

as a duty all formed integral elements of this developing process of change, which gained momentum across Cumbria during the following century. That will be the focus of Chapter Four but, first, we will divert from the chronological theme to examine what became one of the most fundamental elements of agricultural improvement – the process of liming.

3
Lime Burning and Agriculture

Of the methods used to bring waste land into agricultural use or to improve existing farmland, liming was one of the most basic and widespread in Cumbria, as much as in any other upland landscape, especially if reserves of raw limestone were not too distant from where lime was to be applied. This writer's field-surveying of lime kiln sites, allied with searches of estate and farm papers and

Distribution of lime kiln sites in Westmorland.

mapping, has enabled a comprehensive picture of lime burning to be compiled; where lime was produced, what the locational factors for the siting of lime kilns were, who was behind the industry, and where, when and why lime was used, are now more clearly understood than previously. The fieldwork element extended across the whole of Westmorland, where a total of 653 sites were surveyed with details being submitted to the HERs[1]. All sites in Sedbergh, Garsdale and Dent were visited and, additionally, fifty-eight sites along the Pennine edge of Cumberland; and selective sites were visited in the rest of Cumberland and in Furness, although not surveyed in detail. The distribution map of kiln sites in Westmorland highlights clear spatial patterning, with lacunae on the high Pennine moors and in the fells of the central Lake District for perhaps obvious reasons.

In a rural region like Cumbria, lime had a multitude of vernacular uses and, until the 1950s, was seen as an essential product, touching people's lives in many guises. Lime mortar was the key ingredient in building and, as will be seen in later chapters, farm and estate building accounts have much to say about the purchase and application of lime and allied products, thereby providing an understanding of the scale of new build, rebuilding or repairs to farm houses, barns and shippons in different periods[2]. Investing money in buildings was a key sign of economic progress and a commitment to improvement in the wider sense. Aside from mortar, lime was required for external rendering or harling of walls, for the annual ritual of internal whitewashing or lime washing, and for tiering roofing slates to prevent the ingress of rain.

Lime was also utilised in rather more esoteric ways. A tip for farmers in 1764 showed how to transform '90 gallons of putrid stinking water' overnight into water as 'clear and sweet as the best spring water', simply by adding four large spoonfuls of unslaked lime, although it was not stated whether this was meant for cattle or the family[3]. Lime spread on pastures as a top dressing was commonly known to be an effective palliative for several livestock diseases like redwater in cattle, lactation tetany in cattle and sheep, and a degenerative bone disease in sheep called 'cripple disease'[4]. Driving cattle through the smoke of a fire sprinkled with lime, a process known as 'need-fire', was thought to cure, or prevent, cattle murrain, some outbreaks of which may have been foot-and-mouth.

The Benefits of Liming

For ever and a day, farmers have added inputs to the soil to improve the quality of whatever they were growing, whether grass to be grazed *in situ*, hay or arable crops. Their fundamental objective was to produce more per plant and per field, either to feed their families directly or as a surplus to be sold for generating income. It goes without saying that farmers would not expend energy and financial resources applying something that did not bring about quantifiable changes in quality. For most of recorded history, these inputs consisted of midden deposits – a mix of animal dung, food waste, broken pot sherds and whatever else was thrown onto the heap, spread across the fields at regular intervals. Manure unsullied by household waste was a major input in its own right, along with sheep folding as discussed earlier, human waste (*stercus humanum*) and animal liquid waste (today's slurry), pigeon dung from at least 1534, fire ashes from at least 1567, shredded rags from 1631, horn and animal bone shavings and dried animal blood from 1655 and ale dregs from 1656. What these had in common was that they can all be perceived as fertilisers; in other words, they added organic nutrients and minerals to the soil. From at least the Anglo-Saxon era, marl was also applied and there is ample evidence from parts of Britain that lime, specifically burned lime or quicklime, was in common use as a soil input from the sixteenth century[5].

Technically, neither marl nor lime is a fertiliser. They do not add nutrients and minerals that directly aid growth. Their function, and benefit, is to act as a catalyst to render fertilisers more effective and to change basic soil characteristics in several ways. Firstly, in heavy clay soils, lime breaks up the solid clumps by a process called flocculation. The clumps impede downward drainage through the soil, making it waterlogged, cold and anaerobic; flocculation breaks down particle size, accelerating infiltration and thereby creating more soil pores and increasing oxygen content and soil temperature. The soil becomes more easily ploughed, root penetration is easier and deeper, and the soil can support a much greater population of worms, fungi and bacteria, all recycling nutrients back into the roots. Plant growth benefits and so does the farmer.

Adding lime decreases soil acidity levels and increases pH; as any farmer will know, very acidic soils do not produce a good crop. Place names containing the element 'sour' or 'hungry' hint at land that was

Unimproved acidic pasture, Long Rigg, Crosby Ravensworth.

cold, acidic and unproductive. Souland Gate at Dacre (NY466 257), Sour Howes on Applethwaite Common (NY42 03), Sowermyrr east of Gosforth (NY084 040) and Hungerhill south of Bampton (NY514 174) may share this etymology. Lime also reduces the negative effects of high nitrogen levels in the soil; too much nitrogen or liquid waste can lead to soil becoming 'sewage sick' and, in more recent times, the rate of lime application needed to be doubled to return such soil to optimal condition. Lime has the property of fixing ammonia in soil and can help control the release of potash and other essential nutrients. At the most basic level, lime (calcium carbonate) puts back into the soil the natural calcium that is drawn out and is so vital for maintaining soil balance: lime is lost by being drawn out through plant roots, and by leaching, especially in wet areas like Cumbria. Where cattle are dominant, lime is removed from the soil by their eating the grass: bones, after all, are calcium and meat-bearing store cattle need a strong bone structure. Furthermore, as dairy cows were selectively bred to produce ever greater milk yields, the effect on soil was to accelerate the rate of uptake of calcium.

In practice, lime was spread on pastures as an occasional top dressing to sweeten the sward or was mixed into the soil on fallow

or crop land to make it more workable. Rates and frequency of application varied enormously from area to area and period to period, and there was no common consensus at all among farmers, stewards or agricultural commentators. In some instances there were complaints that lime was 'burning' the soil and reducing its long-term fertility but the probability is that too much was being applied too often. One nineteenth-century tenant farmer at Winder Hall (NY492 245) learnt the hard way that applying lime too vigorously could rebound in a disastrous way. It was reported in 1881 that he had stopped breeding sheep for a number of years prior to that date, as he had come to realise he had applied too much lime to his pastures[6]. The direct result was that his sheep were prone to 'scour'; in other words, they developed debilitating diarrhoea. Whereas he was able to associate overdosing of lime with this ailment, he was not in a position to know the likely scientific cause and effect: it is, even now, not uncommon for some soils in damp areas to have a naturally occurring surfeit of the mineral molybdenum (Mo), which is not necessarily disadvantageous in itself. However, unwittingly adding lime to raise the pH of such soils aggravates the situation by increasing the uptake of Mo through grass roots, and it is this which is now thought to be one cause of scouring in sheep and cattle[7].

A statement made in 1849, after a thirty-six-year career in farming, neatly sums up how lime was perceived by many influential personages: without liming, or marling, and drainage, farming simply could not 'be carried on in perfection'[8]. It is also known from contemporary accounts that where farmers wished to lime land too steep for it to be spread from horse-drawn carts, they resorted to the laborious practice of carrying it up in baskets, or swills, professing the view that the 'further you carry lime the more potent is its effect'[9].

Lime Kilns as a Farm Asset

Insufficient statistical data are available to enable valid comparisons, and from documentary evidence and analysing where the majority of lime kilns are sited and when they were operational, the conclusion has to be that the use of lime on the land far outweighed its use in building. There is a large corpus of evidence that having a lime kiln and/or outcropping limestone bedrock on a farm was a strong selling

point when tenements came on to the market either for sale or to let. A few examples from across Cumbria will illustrate this point.

In 1785 yeoman Michael Robinson demised to John Metcalf Carleton of Hillbeck Hall (NY792 157), his landowner, all his 'rights of Lime Stones' in a quarry on Great Ormside Common (now Moor) which included the right to erect a lime kiln and to quarry the stone for a period of fourteen years, though Robinson retained the right to remove from the quarry any 'refuse Lime or ashes which are not saleable' and to use those products on his own allotment on the common[10]. Generally speaking, lime ashes – the mix of burnt lime and fuel residue remaining after each kiln firing – were sold cheaply to local farmers for top dressing pastures. Consequently, in this case, the quality of the residue must have been exceptionally poor but, in Robinson's opinion, still worth using. What is pertinent here is that the common had been formally enclosed by an award of 1773 and that Robinson had been engaged in the dual occupations of lime burning and improving his allocation of land under the award by the application of lime. The agreement did not indicate if he could sell lime to other farmers.

A decade or so later, in 1798, an unnamed farm at Farlam, near Brampton, was advertised for sale with 'an Abundance of excellent Limestone, and a good Lime Kiln' as well as coal supplies available in the vicinity[11]. High Fell Gate farm (SD391 778) was sold in 1813, with the 'advantage of a Lime Kiln erected thereon ... andan] extensive bed of good Lime Stone'[12]. Similar advertisements in just one edition of one newspaper in 1816 drew attention to a farm to be let at Cumwhitton with 'lime and coal obtained at moderate expense'; a farm at Southwaite to be let 'at a short distance from lime'; and Spittle House farm (NY375 385) in Castle Sowerby parish, to be sold or let 'within a quarter of a Mile of Lime and Coal'[13]. The quarry concerned is on Hewer Hill and it was set aside in the enclosure award of 1769 as a public quarry 'for getting Limestones and burning Lime upon'[14].

Aikbank Farm (SD549 810), at the north end of Farleton Fell, was put up for sale in 1824 in a series of seven lots, of which four included the right to get and burn limestone, two the right to build a new kiln and one a half share in an existing kiln[15]. Ground evidence shows that limestone was extensively quarried at the north end of the fell and the sites of eight kilns can still be seen. The tenancy of Crag House Farm (SD557 765) on the southern edge of Dalton Crags was

One of eight lime kilns on the lower slopes of Farleton Fell, Beetham.

advertised in 1843 with an 'excellent and well-accustomed LIME KILN ... with an abundance of good Lime Stone' at which the new tenant had the right to burn lime for sale[16]. This kiln stood next to the farmstead. Finally in this short selection, Town Head Farm at Winton (SD787 105) was advertised in 1861 with ample supplies of limestone and use of a kiln on the nearby common[17].

Perhaps the key point to be made from sales and lettings such as these is that agricultural liming was widely perceived to be essential to good husbandry; otherwise, the selling and letting agents would not have put so much emphasis on the presence of either kiln or quarry. It should be borne in mind, though, that these examples span the decades between the 1780s and 1860s, during which improvement was regarded as a patriotic duty and, later, when farming arguably reached its pre-twentieth-century scientific and technological apogee. Liming was a key component of the improvement ideal. What we cannot know is the extent to which a kiln or ready access to stone made any difference to the sale or lease prices of these farms or, indeed, if we are just seeing an early form of sales spin.

A rather different perspective is provided by contemporary indications of the level of interest shown by landowners, or their stewards, in lime kilns on their estates. Landed estates were wont to

commission estate or farm plans, if land was to be sold or bought, if a full estate valuation was underway, or for a specific aspect of estate management. Those located for this survey range in date from the 1770s to the 1890s, much the same as for sale/lease notices[18]. Of the sample of twenty-six plans viewed, there is an even split between those where kilns were depicted on estates as opposed to farms, with one being a township plan. In some instances the lime kilns were marked with a square or circular symbol and labelled as 'lime kiln', but others used a pictorial depiction of the kiln. Their significance is that whoever commissioned or compiled these plans considered it important to mark and label lime kilns, whereas other minor features were not given prominence; kilns were not included as a whim or random act of surveying and cartography. This feeds the argument back to the value attached to liming in the late eighteenth and nineteenth centuries.

There are documentary references, too, within manorial and estate records to the building of lime kilns or the getting of limestone to feed kilns for local use. In some cases, the records point unequivocally to the production of agricultural lime, but in others the end uses are either not stated or specify building work on the farm or estate in question. In 1741 the manor court for Kirkby Stephen issued an order that arose from a ruling of the Lord Chancellor in the previous year. The court order enshrined the right of customary tenants to open up quarries on their own tenements or on common land to 'get Stone for Building repairing or improveing' their lands and tenements without having to seek further permission[19]. The building reference here may have meant houses, general farm buildings or enclosure walls – all in themselves essential parts of farm management and improvement – but it is not clear, owing to lack of punctuation, if the 'repairing' was linked with the 'improveing', that is of the land rather than buildings. The latter term, though, is beyond doubt: tenants were being given the right, or had existing disputed rights, to take limestone, with the implication that the stone was to be turned into lime to improve the soil on their tenements.

The same set of court records, on 16 October 1821, brought a case against Mr Fawcett of Fell Gate Farm (SD693 924) in Sedbergh, who had 'erected a lime kiln and quarrys stones upon ... the waste within the manor of Kirkby Stephen and carries the same into Ravenstonedale'[20]. Whether or not he had the right to get and burn the stone is one matter, but the main issue at stake is that the court

records here, as in most manors, forbade the export of products from the manor in question for use elsewhere. The outcome was not recorded.

In 1768 Andrew Huddleston of Hutton John entered into a legally binding agreement with William Pollock and Isaac Mayson for the lease of a limestone quarry at Gospelhow, near Penruddock, for a term of seven years[21]. As a condition of the lease, Huddleston and his farm tenants reserved the right to get limestone there and to burn it for their own use. Six years later, a further agreement imposed the same conditions on two new lessees, but only for one year. Surviving Huddleston papers make frequent mention of the use of lime on the land, as will be explored later.

Huddleston's interest in improving the productivity of his estate, his knowledge of lime burning, and perhaps his standing in the community, are further illustrated by a letter written to him in 1779 by Wilson Wood concerning the intended, or feared, actions of Huddleston's neighbour Mr Fletcher. The latter had taken on the lease of a quarry in the manor of Torpenhow and had 'erected a very considerable Lime Kiln upon the Waste', intending to feed it with stone taken from the common[22]. Wood was concerned that Fletcher intended to contravene manorial custom by selling lime out of the manor – otherwise, why would he have built such a large kiln. Wood begged advice from Huddleston and wondered if he should order the kiln to be demolished. There are two quarries – Bowscale had two kilns and Borrowscale one – in this area, which was not subject to formal enclosure until 1811. It may be valid to assume that Fletcher had worked out there was a ready market for lime and, as the neighbourhood had a dispersed settlement pattern, most of the lime will have been intended for agricultural liming. Needless to say, we do not have Huddleston's reply.

The next Andrew Huddleston clearly had the desire to advance his understanding of lime burning technology far beyond what a landowner of his standing might ever need, and this was undoubtedly driven by his improving zeal. A series of letters passed between him and Robert Lucock in 1845 in connection with the former's plans to build a large new kiln. Lucock wrote in considerable detail, advising Huddleston how to pack and successfully fire the kiln, and arranged the delivery of nearly 5,000 firebricks for lining the firing bowl from his Broughtonmoor Brick and Tile Works[23]. Considering the purchase and rail freight costs, and the cost and logistical challenges

of carting them by road from Dalston station to the estate, assuming that is where the kiln was being constructed, he obviously had a great deal of faith in the value of burning lime.

If the kiln was indeed built on the estate, it may have been a replacement for one at Highgate Farm, which was mentioned in a farm lease in 1841, or the 'excellent LIME KILN ... with abundant Lime Stone' stressed in an advertisement for re-letting Highgate in 1857[24].

Hutton John was by no means the only estate that produced its own lime, but no evidence has been seen that any other landowner came near the level of personal enthusiasm and commitment of Huddleston to perfecting the techniques of lime burning.

Lime Kiln Place Names

Close perusal of early mapping and farm leases informs a fuller picture of where liming was undertaken. If a map marked a lime kiln within any given field, the assumption can be drawn that the lime produced was applied to that and nearby fields. Similarly, if a map shows kilns on open moorland or near the edge of upland common land, it will in most instances follow that those kilns had been employed in reclaiming the 'waste' on which they stood, or in top dressing pastures just below the intake wall. However, evidence from field surveying across Westmorland, and the North Yorkshire Pennines, leads to the conclusion that even early OS mapping missed some kiln sites. This may have been because the field surveyors were not totally thorough in mapping isolated tracts, or because they did not always recognise sites that had long since gone out of use. There are many entries on first-edition maps of 'limekiln disused', which clearly shows that the surveyors could see that the ruins in front of them had been a kiln, or that the local tenants were able to tell them so. However, if a kiln had been out of use for decades or more, or had been completely robbed out, the surveyors may well have ignored what seemed to them just another hollow or another heap of rubble in the middle of a field.

On the other hand, it is not uncommon for clues to be provided from field names shown on maps, or named in leases. Care is needed, as a field named 'Kiln Close' could just as easily have contained a corn-drying kiln. The typical stone-fronted lime kilns that are still such a prominent feature across Cumbria are of a type that did not

The penannular earthwork of a sow kiln above Newbiggin, Cumrew.

evolve until, at the earliest, the late seventeenth century. Prior to that the typical lime kiln took the form of a clamp, consisting of a bowl normally set into a natural slope or bank with an upcast rim round most of its perimeter, apart from the lowermost part above the flue. Stone and fuel were stacked in alternate layers within the bowl, and then domed up above the rim, sealed with turf or clay and allowed to simmer for several days, the length of time depending on prevailing weather conditions, before being broken up and the lime carted away. Once such a clamp kiln – often referred to in archival sources as 'sod' or 'sow' kilns – had been abandoned, the turf grew over within a season or two and all that remained was a shallow hollow or, if the lease had stipulated that the clamps should be filled in and levelled off, nothing remained except, perhaps, the faintest of depressions where the infill has settled. To the untutored eye, such kilns are invisible but place-name evidence can reveal their existence.

An undated plan of New Hall Farm (NY838 107) in South Stainmore marked and named all the fields on the farm, and named the owners/occupiers of surrounding land, but no other ancillary features were marked[25]. However, there is the pencil annotation in one field of 'Quarry ... Lime Kiln'. For whatever

reason the plan was drawn, there was clearly some significance in adding the kiln's existence.

Fuel Supply

Having ready access to suitable limestone was an obvious prerequisite for producing lime, although it is too simplistic to assume that kilns were always built at or very near to the stone source. This writer's field survey in Cumbria found that 12 per cent of all kiln sites were not on or near limestone bedrock; in the Central Pennines survey, the equivalent was 21 per cent[26]. In many cases kilns were built close to the fuel source rather than to the stone, especially if the fuel was available within a reasonable distance of where the lime was to be used. In the early days, across England wood was the main fuel but, even during the medieval period, timber supplies were depleted by a range of industries and crafts, to the point that measures were implemented to control the rate of felling and usage. Legislation aimed at reducing the impact of air pollution in London from lime kilns consuming timber was introduced by a proclamation against the 'infection and corruption of the air by such burning of kilns', which banned the burning of lime while the Queen was in residence[27].

Coal was certainly in use as a kiln fuel during the monastic era, when it was generally known as 'sea-coal', or 'smith's coal', to distinguish it from charcoal. In much of Cumbria, however, timber capable of reaching the high temperatures needed for the stone to turn to lime was in short supply and no convincing evidence has been located to confirm that coal was mined in medieval Cumbria. If the available evidence is reliable, lime burning in the county had a later genesis than in the North or West Ridings or north Lancashire, precisely because of the dearth of reliable fuel sources.

As so often happens, though, needs must: alternative fuels were brought into use, with varying degrees of success. The low level of technology employed in clamp kilns was less demanding of fuel than later stone-faced kilns, and materials unsuited to the latter could be used in clamps. Gorse was one such material, although it tends to burn with a greater flare than wood so was harder to keep under control; bracken was widely used but gave off much higher temperatures and burned with 'surprising Force', again challenging the limeburner to prevent the burning process running away with itself[28]. Both gorse and bracken grow in profusion across much of

Lime Burning and Agriculture

Cumbria and there is every possibility that some clamps relied on them as the primary fuel. No systematic field survey of clamp kiln sites has been carried out in the county, although this writer has unexpectedly stumbled across a number while seeking later kiln sites; at least two sit below now-gorse-covered slopes.

In the early nineteenth century, in west Cumberland away from the coalfield, one contemporary commentator advocated the adoption of wood as kiln fuel, owing to a lack of coal that, he noted, was holding back the burning of lime for agricultural use. He suggested using faggots (bundles of tightly-bound sticks), although his equation – 600 faggots, each of 36 lbs (16 kg), needed to produce 480 Winchester bushels of lime – seems only marginally cost effective at best, given the labour involved[29].

Another alternative to wood and coal was peat; however, this was, in a sense, a fuel of last resort. It burns with more smoke than flame, and with relatively low thermal efficiency, thereby extending the time needed to complete one burn. It was also very labour intensive – the turves had to be cut, carted and then left to dry, which was a challenge in upland climates. Nevertheless, it was widely used as a kiln fuel in Cumbria. The Levens Hall estate certainly brought turf in to feed its kilns[30]. Surviving accounts from the 1690s record disbursements for '30 Load of Peates to theunspecified] Lime Kilne' in 1693; an unspecified quantity of peat for the lime kiln on 'parkhouse' and '40 Loads of peats for a Lime Kilne for Force Mill' on the River Kent on 29 June 1695; and '40 load of Peat for Force lime kill', the same amount for 'peats for a lime kill at parkehouse' in 1696 and 1s 3d paid for 'bearing peates downe Mosse for Lym kill' in 1699. At this date, the kilns may have been clamps, although the estate later replaced Park House kiln with a masonry kiln, of which there are scant remains.

Almost exactly a century later, Levens Hall Estate was still making use of peat in burning lime in its kilns, but not exclusively. In July 1794 the steward wrote to his master, saying that he intended to fire up a kiln and was engaged in leading peat to it, adding that, if the weather held, he would lead in coal as well. Another letter the following month reported that he had 'two stacks' of peat ready at the kiln[31].

In 1803, at the beginning of a time of great patriotic fervour where the need to boost agricultural output to feed the nation was a developing rhetoric, a farmer from Graham's Onset Farm (NY515

Graham's Onset farm, Bewcastle.

802) north-west of Bewcastle wrote a detailed essay for the Board of Agriculture on the use of peat in lime kilns[32]. He had stopped using coal in his kiln because he felt peat performed the task just as well and at a cost nearly 60 per cent lower than coal, even though coal was available only 3km away. He claimed that a kiln fired with peat was ready to draw within 24 hours, compared to up to three days using coal; these claims are rather difficult to comprehend and even he said he found the time difference surprising. It might not be surprising that he knew of no other area using peat in this way, other than Dumfries. It is also not surprising that by the middle of that century peat at Graham's Onset had been supplanted as a kiln fuel by coal[33].

Recent geological work has described in detail two discrete coalfields in Cumbria, the Lune and Rawthey valleys, and the East Cumberland Coalfield with four discrete working areas, in addition to the West Cumberland Coalfield between Maryport and Whitehaven[34]. Documentary sources support the notion that several coalfields were very closely tied to lime burning, namely the Barbondale, Rawthey Valley and Baugh Fell South fields, and all the Pennine edge fields. The general consensus was that most of the coal

reserves away from the coast were predominantly of low quality and were worked only on a limited scale, despite the large number of adits and shafts and the longevity of some working areas, and that their high sulphur content made them unsuitable for house coal. Coal was mined on Barbon Fell and in the Rawthey Valley from the 1600s, and at Farleton from at least 1565; one discerning traveller in the early 1690s noted there was ample coal within 3km of Kirkby Lonsdale and that coal was being mined on 'Colepit Hill' on Casterton Fell to the east of that village, and had been mined in that vicinity since the time of Charles II[35].

Another observer, a full century later, saw coal 'being wrought' in Casterton, presumably on the Fell, for use in lime kilns, but his phraseology seems to suggest that the mining he saw was relatively new; perhaps the earlier seams had been worked out and new pits were being sunk by the early nineteenth century[36]. An insider's opinion of the quality of coal in the area was provided in a deposition concerning legal matters on the Underley Hall Estate near Kirkby Lonsdale, copied in 1843 but referring back several decades: James Windle had worked at Barbon and Casterton coalpits as a collier and banksman, and he summed up both as being of 'inferior value', with the Casterton ones worked just to supply three lime kilns[37]. Close to these coalpits are the sites of eight lime kilns, of which three, probably of late eighteenth-century date, still stand more or less complete, so these will undoubtedly be where Windle had worked.

Similarly, poor-quality coal was won on Hutton Roof and used in local lime kilns to produce lime for agricultural purposes after Crags and Hutton Roof Park were enclosed and subdivided in 1822[38]; six lime kilns once stood below the Crags. The first shaft was sunk in the early eighteenth century by George Atkinson at Moor End Farm (SD569 776); it was sunk to a depth of 30m and needed constant pumping, meaning it could never have been seen as a profitable venture. If he owned, or leased, the large kiln that still stands in Hutton Roof Park, he no doubt calculated that it was more cost effective for him to struggle with his own pit than to buy in coal to feed his kiln.

Further north, coal was won on Hartley Fell to the east of Kirkby Stephen. Whereas one contemporary observation claimed that mining here had died out by around 1780[39], letters from Sir Philip Musgrave's steward to his employer at that time tell a rather different story. One letter, early in 1776, said the steward had a 'poor fellow

Lime kiln in Hutton Roof Park.

trying to get Coals' on the Fell with little hope of any commercial success, but that he would be satisfied if he could merely 'procure Limekiln Coals' for agricultural use on their Hartley Castle lands[40]. Further letters report that the steward had managed to let parts of the Fell for coal mining but, again, it was of a quality suitable only for lime burning; in 1783 he had re-let the main colliery to another 'poor man' and let it yet again in 1788. The earliest relevant letter informed Musgrave in 1773 that he had let out Hartley Colliery on a new lease to a local man to get coal for burning agricultural lime, so the pits were clearly in use prior to that year.

The Appleby Castle Estate owned extensive mineral rights in Mallerstang, leasing coal shafts and pits together on twenty-one-year agreements in the eighteenth century, which included the liberty to quarry limestone for the burning of lime. Given the location of these pits, and the former existence of two kilns close to the roadside, this lime could have been sent anywhere within the valley, probably mainly for agricultural use[41]. It would seem that, elsewhere within Mallerstang, it was the practice for anyone to get what was called small-coal, 'which they burn with limestone', presumably for on-farm use[42]. One such family were the Atkinsons of Bluegrass Farm (now Dalefoot, SD782 042) close to the pits and kiln, who exploited four named levels around 1830: for the levels to have had recorded

names perhaps suggests that they were more profitable than some other more isolated pits[43].

Coal was also won on Coalpit Hill on the higher part of Crosby Ravensworth Fell from at least 1621 and in the early eighteenth century, although at what scale and for how many years are unknowns; it is likely that amounts were small and it may have been mined to feed lime kilns at the northern end of the Fell[44].

It was further north still, along the Peninne edge, where coal mining was organised on a much larger scale: in Stainmore by the Appleby Castle Estate in the eighteenth and nineteenth centuries, tied in with lime burning; by the earl of Carlisle's estate at Croglin Colliery on the Fell, also producing lime coals for their kilns above Croglin in the eighteenth century; by the Musgraves at Hartside Colliery on Haresceugh Fell and Burned Edge Colliery near Croglin for burning in their kilns in Cocklake and Clints Quarries around the same time; and at Renwick Colliery on Renwick Fell, owned and leased out by Queen's College, Oxford, which produced lime coal for kilns on Green Rigg[45]. The contemporary view of Pennine coal was not altogether positive, and one observer described what he termed *crow coal* mined on Hartside and the flanks of Cross Fell as only fit for burning lime[46].

One contemporary comment linking coal production with lime burning is difficult to comprehend. In 1820, on the one hand, coal was said to be 'most easily procured' and lime to be used 'in some abundance' in Stainmore; yet, according to the same source, lime could never be extensively used there until the coal could be 'more easily obtained'[47]. These two statements would seem to be irreconcilable and the former at odds with documentary accounts from local estates of large-scale lime burning in the two centuries concerned.

Detailed colliery accounts for the Musgraves' colliery during the short period of 1758–63 allow a month-by-month analysis of the seasonal patterns of coal output in terms of total 'gott' and 'for Lime Kiln'[48]. Over that period, a total of 12,836 loads of coal were brought to the surface and despatched – although the accounts do not specify of what a load consisted – out of which around 20 per cent was destined for the estate lime kiln. Where the balance went was not stated, but an unquantified proportion would have gone to other kilns in the general area. Coal was mined throughout the year in 1758 but, in the ensuing three years, there was no output during the

autumn, winter or spring months. Lime-coal sales were confined in all six years to the summer months, which accounted for two-thirds of the total. There was no point producing agricultural lime unless farmers were in a mind to apply it and, if one short set of statistics proves anything meaningful, liming in the Kirkby Stephen area was not a winter activity. The mismatch between 1758 and the other five years is difficult to understand. It is conceivable that tenants had been required, or had decided, to apply more lime in that year or adverse weather factors may have been the key for the later years. Rainfall data are not available before 1765, so no evidence-based hypothesis can be proffered to suggest that conditions worsened from 1759.

Patterns of Lime Production

Whereas one colliery's seasonal output of coal over one half-decade enables only very tentative comments to be made, far more informative are the detailed lime kiln accounts – production costs and sales output – for several lime-producing sites on Lowther properties in Westmorland. As is so common, the survival of estate papers is partial and the picture that emerges is necessarily disjointed, but those for the 1780s are extant and very thorough. They are also of undoubted significance in that, for several years, lime customers were indicated, so it has been possible to plot their numerical range and spatial distribution. However, they are not the only papers with relevant information. John Gibson, steward to Sir Michael le Fleming at Rydal Hall, wrote to his master in 1773 to the effect that he had 'set the men to building the Lime Kiln'; the location of the kiln was not stated nor the use to which the lime would be put, but other letters speak of agricultural liming[49]. That Gibson had ordered a kiln to be built can reasonably be taken as confirmation that he was engaged in a programme of estate improvement.

Extant lime accounts for the various kilns either belonging to or leased by the Lowther Estate in Westmorland indicate the sheer quantity of lime being produced in the 1780s, and the dominant use it was destined for can be extrapolated from the data. Profit and loss accounts for four kilns in production across the estate in 1786 do not show particularly profitable operations[50]. A kiln at Morland made a profit of £3 10s after production costs of £3 8s were settled, most of which was the cost of coal rather than quarrying, leading and burning the limestone; a kiln at Milburn, almost certainly in Thrushgill

Quarries, made £2 1s 8d; Burrells Kiln in Hoff parish, probably the large kiln that still stands in Rowley Wood Quarry, made £1 6s 8d; and Ormside Kiln £6 11s 8d, almost as much as the other three combined. In the previous year, Ormside Kiln began burning on 18 April, which ties in with the Hartley dates, and over the season 3,019 bushels were sold[51], at 8d per bushel, giving a total sales income of over £100. However, production costs, which included rental for the kiln, came to over £90, returning a gross profit of £9 10s 6d. As will be discussed in Chapter Five, the 1780s fell within the early years of a long period when improvement was almost obligatory for the progressive and patriotic landowner, and economics did not necessarily loom large in the decision-making process: the overriding priority was to bring about quantifiable progress, and Lowther stewards and agents kept meticulous accounts.

In 1786–87, the wage bill for Milburn, Hillbeck and Ormside kilns combined was £26 10s 8½d; Ormside kiln incurred an annual rental of four guineas, and considerable quantities of coal had to be purchased and their cartage paid for[52]. Of the 155 cart loads of coal taken to the kiln on thirty-four days between March and October, all but eleven were bought in the four growing-season months. At the Ormside kiln, in 1785, 2,917 bushels were burned during the 'Summer Burning', with 102 at the 'Michaelmas Burning' on 29 September; this date presumably corresponded to the accepted rental period, which ended around then. Further sets of accounts for individual Lowther kilns provide much more detail of seasonal variations in the production of lime, as they itemised monthly lime sales rather than lime burned, although survival of data is again partial[53].

Immediately apparent from these accounts are variations both from kiln to kiln and in the length of the production season. Lime burning at the Pease Hill and Ormside kilns extended later in the year than at Hillbeck, although none was operational through the winter months – at least, in the years shown and with the exception of Pease Hill's sales in February 1786. Impossible now to explain is the huge difference in April sales between the three kilns: Pease Hill sold well over 1,000 bushels in April 1785 and over 800 in 1784, but Ormside managed less than half that amount in 1785, but did about the same in 1784. Hillbeck, by contrast, sold only twelve bushels in April 1785. It is possible that now-unidentifiable variables had been at play, such as urgent running repairs to this kiln or localised and

Kiln	Year	Month	Bushels sold	Max. no. of customers
Hillbeck	1784	May	1241	24
		June	1460.5	20
		July	381	21
	1785	April	12	3
		May	1831.5	20
		June	1435.5	17
		July	318	17
Pease Hill	1784	April	853.5	12
		May	1140.5	14
		June	949.5	12
		July	559	13
		August	227	10
		September	799	15
		October	373.5	19
		November	521.5	14
	1785	March	144	4
		April	1132	13
		May	730	16
		June	952	11
		July	266	6
	1786	February	654	10
Ormside	1785	April	371	11
		May	1541.5	14
		June	1004.3	12
		October	102	2

Table 1: Lime sales from three Lowther kilns, 1784–86. (CAS[C]D/LONS/L12/3/12/1, /7 and /8)

temporary difficulties in obtaining the stone from the quarry adjacent to the kiln.

It is germane to add that individual purchases ranged from 1.5 bushels at the bottom of the spectrum to nearly 400; an amount as small as 1.5 will have been used on buildings for minor repairs or limewashing, but the larger quantities can only have gone on the land. Even if a large new building were being constructed, no mason would have bought 400 bushels at one time. The occasional annotation in the accounts provides extra hints as to who was buying the lime: for Pease Hill in February 1786, there is the comment

'cotton factory buying quite a bit', but that was just one of ten customers that month.

This particular set of accounts has much to say about who was buying the lime, including for what purposes and where it was used. Customers were not just given as a monthly total but each one was named; to have named the people involved would have been of little value unless surnames could be linked to places, but here it is mainly the farms that are named. Customer accounts for Pease Hill and Hillbeck Kilns for 1784 and 1785 listed forty-three individual farm names, of which all but twelve have been identified on the ground, in addition to unlocated customers in thirteen townships; those for Ormside Kiln (1785–87) locate twenty-four individual farm customers and eleven townships; those for Milburn Kiln for 1786 list eight farms and six townships.

Of the places where lime was sent from the Ormside/Hillbeck/Peasehill kilns, the vast majority were individual farms. The lime sold to unnamed customers in the various townships could just as easily have been for building work as for agricultural use. For the identified farms, however, the conclusion can be drawn that the vast majority was destined for agricultural liming. As can be seen on the maps, lime was carted over considerable distances, adding to the overall cost of buying in lime, as costs were based on mileage plus weight or volume.

Distribution of customers of Pease Hill and Hillbeck lime kilns, 1784–85.

68 *An Improving Prospect*

Distribution of customers of Ormside lime kiln, 1785–87.

Distribution of customers of Milburn lime kiln, 1786.

It is impossible to know with certainty which routes were used for delivering lime from kiln to consumer, but the maximum distance from Hillbeck Kiln to its most distant customer was 15km, and from Ormside and Milburn Kilns 10km; the location of Pease Hill Kiln has not been fixed but, given the fact that it shared many of its customers with Hillbeck Kiln, it must have been in that same general area.

In 1786 the Lowther Kiln at Milburn supplied eight farms as well as customers in six villages in the surrounding area – Blencarn, Culgaith, Dufton, Kirkby Thore, Long Marton and Newbiggin. Again, it can be assumed that the lime purchased by farmers was primarily intended for liming as opposed to building works. The maximum distance between kiln and customer was 8km to Dufton by the shortest road route, and 7km to Culgaith and Long Marton. These accounts do not specify cartage costs, as they were the responsibility of the purchaser rather than the producer, although other sets of estate accounts do indicate such costs, as will also be seen later. Lowther papers from the mid-nineteenth century specifically stated that tenants were liable for cartage and the costs thereof, rather than the estate.

Lime was also produced in significant quantities for local use in the limestone districts of Cumberland: along the Pennine edge from Denton and Farlam through Castle Carrock and southwards to the Westmorland Border; at Ireby and Uldale between Bassenthwaite and Wigton; at Allhallows south-west of Wigton; and at Hodbarrow, Millom[54].

Leading Coal and Lime

Because of the lack of coal resources across much of Cumbria, and the growing demand for lime for various purposes that is recognisable from the later seventeenth century, the inevitable reality was that coal was transported over considerable distances. That which was produced in the West Cumberland coalfield was exploited and consumed within a relatively short distance of the collieries, and across generally low-lying and level ground. In the east Cumberland coalfield lime tended to be produced close to the source of fuel, as also in Lunesdale, so here the cost issue was transporting the lime. Across much of Westmorland, however, coal had to be transported from a limited number of collieries to a very large and dispersed

spread of lime-burning sites. Apart from the direct costs of leading coal, there were hidden costs that, initially at least, did not lie at the door of the customer purchasing coal. Preeminent among these was the deleterious impact of constant packhorse or wheeled traffic on road surfaces and the constant strain the necessary repairs put on the townships through which the roads ran. Sir Philip Musgrave's steward at Edenhall, Christopher Dobson, was in regular contact by mail, keeping his master informed of all that was going on across the estate; in a letter sent in October 1770, he wrote of 'some thousand Carts in the year passing and repassing with Lime Kiln Coals' between Edenhall and Penrith, thereby putting a 'real burden' on the roads[55]. There are no extant accounts to verify the possibility but his intention may have been to give Sir Philip a gentle early warning that the estate might have to fund reparations, as the fault lay at its door. Alternatively Dobson may have been preparing Musgrave for an increase in total cartage costs, as he had taken it upon himself to reduce the weight per cart load by 20 per cent, presumably in an attempt to reduce damage to the roads[56].

Dobson, as we shall see in Chapter Four, was a determined agricultural improver, keen to maximise the inducements that were available to estate tenants. Some were, quite understandably, reluctant to respond to his exhortations to apply more lime because they had to pay 12*d* per Carlisle bushel for lime delivered to their holding. Dobson had successfully persuaded them not only that their pockets would benefit from increased oat yields but that, if the tenants themselves carted the lime from the estate's kilns in Kirkoswald parish, they would be required to pay only 4*d* per bushel at the kiln. As Dobson wrote, the tenants were indeed duly liming – and benefitting – more. The tenant of Dolphenby Farm (NY576 311), on what had been Dolphenby Moor, clearly took advantage of the bargain, as over 100 bushels of lime were carted in from Kirkoswald every day using six carts, taking full advantage of unseasonably cold weather that kept the road surfaces dry and hard[57].

Prior to the establishment of the various turnpike trusts, road maintenance was a parish responsibility, and one that was resented, although in a situation like that at Edenhall the parish can hardly have been deemed liable. New roads laid out as part of the process of parliamentary enclosure had a beneficial effect, as they tended to have more resilient foundations and surfacing, making cartage not only quicker but also cheaper. As one commentator noted, these new

roads gave 'facility of transit for lime'[58]. A further letter from steward to absentee landowner, in 1781, concerned the possible purchase by the estate of a farm, far from Edenhall or Hartley, at Lupton in south-east Westmorland. The farm tenant had told Dobson that he covered his annual rent by leading coal from Burton in Lonsdale to Kendal, much of which was destined for lime kilns on Kendal Fell, with four single-horse carts constantly on the go, but he also added that, by 1781, there were many other carters doing the same job[59]. Perhaps the tenant was attempting to plead poverty in the hope of gaining a reduction in rent if Musgrave were to buy the farm. A good part of this journey ran on turnpike roads.

Definitive confirmation of the scale of traffic carting coal from Burton into Westmorland is provided in a three-year lease, in 1800, of a lime kiln in Stainton to Robert Thextone, who was a limeburner living in that township[60]. Along with rights to quarry stone at the kiln, he was also accorded the right to take 1,000 loads of coal at 'the Coal Pits at Black Burton', a name by which Burton in Lonsdale was locally known. Contemporary travellers' descriptions occasionally used figures measured in thousands to give the impression of vast multitudes, but here the numerical value was established in a legal document. Two decades earlier, one such traveller had expressed his astonishment at seeing the large 'number of small carts laden with coals, and each dragged by one sorry horse' from Ingleton and Black Burton to the Kendal area 'for fewel, and burning lime in order to manure their land'[61].

A sitting of the Quarter Sessions in 1683 petitioned that any carrier of coal out of South Stainmore should be levied a toll of 2*d* per horse load of coal carried through the township, which would go towards the cost of road repairs[62]. One route in particular came under extreme pressure carrying coal to Orton through Kaber or Winton over Whyber Hill to Soulby and Whygill Head to then undertake the long haul over Little Asby Scar to Sunbiggin Tarn. Extant estate accounts do not always differentiate between the purchase cost of coal and transportation costs. For example, in February 1695 the Lowthers paid for four loads of coal from Stainmore, although the transport cost was not quoted, and then 3*s* for two loads of coal in the following month. Four years later Thomas Wilkinson was paid 18*s* for the 'leading of seventy-two Loads of Coales to the Lime Kilne', but this source was not stated; and between March and June 1699 469 loads of coal were paid for, none of it for domestic use, and

the accounts itemised many other substantial deliveries either side of that quarter. Two entries, for 1696, do give the origin of the coal – not in Stainmore but in a smaller coalfield at Reagill: in January, coal was purchased at 3*d* per load and carried by John Walker, and in February it was purchased at 4*d* when 123 loads were brought from Reagill by James Robinson[63]. In each case, the coal was transported by horse-drawn cart, probably single-horse carts. If the 469 loads had been charged at 4*d*, the total purchase cost would have been £7 16*s*; if cartage at 2*d* per load was on top of that, the overall bill would have increased by 50 per cent, a not inconsiderable amount.

Equally unhelpful in its vagueness is an entry in Musgrave's accounts for 1700 of £3 15*s* 4*d*. This amount was paid for coal, 'burning a Lime Kilne and Leading Lime etc', but there is no breakdown of individual cost headings, no indication of what 'etc' included or where the coal had been bought or where the kiln was sited[64].

Edenhall accounts for the late 1730s itemised regular purchases of coal, in most cases not distinguishing between purchase and transport costs, but one rare entry did say more: 190 loads of coal were purchased in March 1739 at 4*d* per load, with cartage costing an additional 6*d* per load. In all, the 450 loads bought in September that year would have incurred transport costs in excess of £11[65]. In 1738 the coal was sourced from Warnell Fell in Sebergham parish and in 1739 from Renwick Colliery on the Pennine escarpment: if the coal was transported to Eden Hall itself, the former entailed a journey of 30km, and the latter a journey of 26km, but along a much more challenging route. Adding up the time needed for each leg of the return journey and loading time at the pits, each load (whether packhorse or cart was not stated) must have taken a full two days if weather and road conditions were good, and maybe three if not. Data such as these emphasise the costs estates were prepared to incur in order to obtain fuel for burning lime.

The accounts for Robert Lowther's estate at Maulds Meaburn included payment to Henry Dodd for thirty loads of coal for 'burning a Lime Kilne' in 1711[66]. Yet again, the size of the load was not given or the coal's origin or if the payment included cartage. Eight years later, a further thirty loads were bought for the lime kiln at 5½*d*, as opposed to the lower unit cost in 1711: whether the rise was in purchase cost or carting is unknown. An entry for 1721 is rather more illuminating. On this occasion, twenty loads of coal

were brought in at a unit cost of 1s 1d per bushel. This coal was sourced from Stainmore and so presumably the previous deliveries also came from there. Two routes could have been used, partly following what are now unmade tracks: from Maulds Meaburn via Crosby Ravensworth, Gaythorne Plain, Great Asby and Bleatarn Common, or through Drybeck, Rutter Mill and Bleatarn Common, then eastwards. The former route is a minimum of 25km and the latter 22km. Given the nature of roads in that period, it is difficult to see how such a journey could have been achieved within one day, especially in the winter months. Depending on the state of the roads, the length of ascents and, presumably, the pulling power of a horse, a single-horse cart was said to be capable of carrying between 12 and 24 cwt (600–1200 kg or 24-48 bushels) by one contemporary source, but only 6 or 6.5 cwt by another[67].

These two sets of Musgrave and Lowther accounts tally with those discussed earlier for Hartley Colliery, where lime coal sales had been restricted to the months April/May to September between 1758 and 1763, suggesting lime was only burned during the summer and early autumn months. The purchases of coal for lime kilns at Edenhall and Maulds Meaburn, however, tend to slightly extend the burning season there.

By a quirk of fate, full accounts for leading coal to the main Lonsdale estates at Lowther itself have survived for 1784, noting on a daily basis how many loads were carted from the collieries on Windmore Edge and Loadman Ground to the estate kilns at Hillbeck and Peasehall (or Pease Hill) during the full lime-burning season[68]. It lasted from mid-March to mid-October; and the number of loads taken away varied within each month and week, with no discernible patterns emerging. A very low total of sixty-six loads for August may reflect that farmers were more concerned with their crops as they approached harvest time, yet September's total was much greater at over 400 loads. There was, of course, a time delay between delivering coal to a kiln and drawing lime from it, so the September deliveries may have been aimed at stocking up so that lime could be spread on the soil after the crops had been gathered. Daily totals varied quite dramatically: on Wednesday 16 June, seventy-nine were despatched but only five the following day; on Monday 6 September, seventy-three loads were taken away but none on the following day; and on 8 September, only four. Further extant Lonsdale accounts starting in June 1794 itemised disbursements for leading coal to named

lime kilns – Hackthorpe High Kiln and the unidentified Dog Kennel Kiln – and lime from them to Shap and Lowther village[69]. Leading lime and coal was consistently undertaken through the weeks from 3 June to 5 July, followed by a break when cash payments were almost exclusively for harvesting activities before leading resumed on 8 August. The latest entry for leading coal to the kilns in 1794 was on 15 November, so in this year lime burning will have continued towards the end of that month. The cost of leading lime from the kilns during this period was as much as double that for leading coal to them, although, over the whole period of these accounts, there was no consistency in costings. In mid-May 1795, one day leading coal was costed at 6*d*, whereas in late June the year before a fraction under 10*d* was paid; in September 1794 leading lime to Lowther was rated at 1*s* 7*d* for three days and to Shap at 3*s*: the estimated rates per mile were 3*d* led to Lowther and 2.4*d* to Shap, if the village centre is taken as the point of delivery.

These latter rates can readily be compared with those recorded from the Appleby area earlier that century when leading lime was charged at a flat rate of 2*d* per load, each ideally made up of 4 bushels costed at the kiln at 8*d* per bushel[70]. Expansion of the turnpike road network removed many of the cost-incurring constraints that had hitherto faced carriers and had the added advantage of boosting agricultural improvement. For example, the Act for repairing the Keighley to Kendal Turnpike 1753 specifically exempted from tolls 'Lime, Dung, Mould, or Compost, of any Kind whatsoever, for the manuring or improving of Lands'; while the 1790 Amendment removed tolls on coal led from pits in the Ingleton-Bentham area into Westmorland[71].

Where water transport was a viable, quicker and cheaper alternative to the cart or packhorse for transporting lime from kiln to point of use, it was employed to great effect. One such route was to carry lime by boat from the southern end of Windermere; another was along Ullswater, carrying raw limestone to be burned in kilns at the southern end[72]. This latter trade was in use at least from the late seventeenth century, as in 1697 a 'Great Boat', 'loaded with Limestones', was overcome in a storm and sunk with the loss of its four-man crew. The Lancaster to Kendal canal was another important catalyst for boosting lime production at Kendal; a promotional pamphlet from 1791 claimed that farmers would be able to save £5 per ton on lime transported by canal rather than by road, as they would no longer

have to cart it for 'manure' from Kellet near Carnforth in north Lancashire, a journey of over 20 miles (30km)[73]. The main rationale behind building the canal was to carry coal north from Lancashire and limestone south from Kendal Fell and Warton Crags, and the initial haulage rates were set, in 1792, as 1½d per ton/mile for coal going north, ½d for limestone and 1d for lime, both heading south[74]. As with road haulage, lime was a much more difficult product to carry, given its natural volatility, hence the increased costs for both forms of transport. Though this 'external' trade may well have been the key founding principle, a perhaps unintended consequence was increased production of lime for building and agricultural use within Westmorland; there is no doubt that the coming of the canal was an important catalyst for boosting the take up of liming in the county.

Conclusion

The widespread practice of liming in Cumbria was adopted as a prime means of both improving the quality of crop and pasture land, and bringing new land into use, but at a later date than in the North and West Ridings. The available evidence would seem to suggest that problems of fuel supply were largely responsible for this. Gorse, wood and peat were used, but they were not capable of supporting large-scale lime burning and, clearly, without being able to readily burn limestone in kilns there could be no lime for farmers to use[75]. In a few localities, such as Casterton and Barbon Fells and the Pennine edge, coal was won early on from adits or shallow pits and used locally in lime kilns; these coal seams tended to have a high sulphur content, rendering the coal unsuitable as house or fire coal, but good enough for kilns. Elsewhere in the county, coal had to be carted over great distances, and at considerable expense, from Stainmore or Burton in Lonsdale over inadequate roads.

Until transport costs became more affordable, moving limestone to kilns or lime to consumers was out of reach for all but the largest landed estates. Improvements in road surfacing, and the coming of the canal at the very end of the eighteenth century, directly led to incremental growth in the amount of lime being produced and the amount being applied on the land. Agricultural liming thus became one of the key ingredients in improved methods of husbandry in Cumbria.

Surviving estate financial accounts, letters and memoranda books provide graphic evidence of the scale of operations in getting coal and firing it in kilns owned or leased by landed estates, with the bulk of lime destined for agricultural use. Albeit for only a limited period of time in the 1780s, it has been possible tentatively to work out seasonal patterns of lime-coal getting and lime burning and, by analysing extant customer lists for lime, these seasonal patterns can be extrapolated to seasonal patterns of agricultural liming. As might be expected, and as far as these particular data sets show, the season extended from spring to autumn.

In the next chapter, we return to the chronological theme after Restoration in 1660, when the idea of improvement took on a whole new dimension, magnified in scale and extent, through the latter decades of the seventeenth century and the first half of the eighteenth.

4
Agricultural Improvement and Change 1660–1760

The new sense of economic optimism and political stability permeating the land after restoration of the monarchy in 1660 manifested itself in Cumbria in various ways. Members of the farming class and landowners now felt confident enough to invest in rebuilding their houses and the latter decades of that century have come to be known as the Great Rebuilding, testified by the number of properties with late seventeenth-century datestones[1]. Old houses were taken down and rebuilt, or refronted and increased from one (or one and a half) storey to two. Existing ancillary buildings received the same treatment: thatch was replaced with slate or flagstone, rooflines were raised, length was increased, outshuts tagged on – all of these signs that can be read today in the fabric of many a barn. Alongside these infrastructural changes came renewed investment in the land, although one perhaps outdated view suggested that, because tenants lacked the resources to invest in their land, there was little improvement in farming in Cumbria during the seventeenth century[2]. Documentary evidence for tenant farms at this time is limited in both volume and usefulness, but a case can be made for quantifiable change in the latter half of the century.

Restoration acted as the catalyst for unleashing ideas and pent-up energies. It led to the almost immediate creation of the Royal Society and the development of the Georgic movement with an almost revolutionary flourishing of literary, scientific and religious thought. The society's first Georgical Committee, appointed in 1664, was tasked with obtaining information on farming 'both to enrich every place with the aides ... and withall to consider, what further improvements may be made in all practise (*sic*) of Husbandry'[3].

Enclosure and agricultural improvement were imbued with a new 'moral legitimacy'[4]; improvement of landed estates was now a moral and patriotic duty[5]. Much of the impetus and many of the ideas were brought back to Britain from the near continent by Royalists who had been exiled or who had fled during the Commonwealth. They had had more than enough time to observe how farming was practised, especially in Flanders, and were keen to reinvigorate their properties based on the best of what they had observed abroad. To what extent these ideas permeated counties as far north as Cumbria is arguable, and the number of influential treatises on farming published between 1660 and 1700 was actually smaller than that between 1600 and 1660[6]. Nevertheless, post-Restoration changes are readily identifiable in Cumbria. To put them into context, it is useful to summarise, largely from documentary sources, the state of play prior to 1660.

The Situation prior to Restoration

One of the earliest sources concerning land improvement is an agreement recorded in a manor court sitting for Ravenstonedale in 1579. Sir Thomas, later Lord, Wharton of Wharton Hall in

Bent Hill, Ravenstonedale.

Mallerstang (NY770 062) had been engaged for a number of years in emparking extensive areas of farmland on his estate, which resulted in the eviction and relocation outside the newly built park wall of sixty-nine of his tenants[7]. In Wharton's view, they were resettled on perfectly good land 'newly improved from the waste' and with 'newe Improvements' in place[8]. One of the dispossessed tenants, Edward Milner, was granted '23 acres new improvement' at Whitwall and on Ash Fell. Much of Ash Fell is still unimproved (rough) pasture, although an improved and later subdivided enclosure on Bent Hill is externally bounded by a curvilinear dry stone wall that could conceivably be of sixteenth-century date.

Manor courts attempted to ensure that tenants adhered to rules laid down 'from time immemorial' that were designed to maintain what later estate records referred to as good husbandry or 'husbandry according to the custom of the manor'. Frequent transgressions appear in court records where this tenant had more livestock on the common than he was entitled to – he was guilty of 'breaking the stint' – or that tenant had attempted to graze on the common stock he had not overwintered within the township; while others had dug peat or turf on the common, contrary to custom[9]. Equally common were cases of tenants failing to keep their fences/walls in good order and failing to 'scour their ditches'. Life and work went on as they always had done, and it is simply a manifestation of human nature that some would try to circumvent the courts by ignoring regulations they found irksome.

Whereas manor court rolls provide the briefest of insights into the organisation and control of farming and land management, a rather more comprehensive picture can be compiled for those landed estates for which records have survived. Sir John Pennington of Muncaster Castle compiled a Commonplace Book, at least from 1491 to 1511, containing a wealth of detail. Such books have been likened to personal scrapbooks or notebooks, and perhaps served as *aides-mémoire* for their owner. The Penningtons possessed lands and tenements across those townships close to Muncaster as well as further afield in Bowness-on-Solway and Beaumont in the north of Cumberland and at Preston Richard in Westmorland and Pennington in Low Furness[10].

The book is rich in details of rents and farm accounts, which make it obvious that Muncaster's main source of income was derived not from annual rents but from sheep, which were largely overwintered

Unenclosed summer grazing on Ulpha Fell.

in the Duddon Valley, specifically at Ulpha, Birks below Dunnerdale Forest, and Gaitskell (now Gaitscale) between Cockley Bridge and Wrynose Pass[11]. The estate practised transhumance, summering the flocks on Ulpha Fell to the north; the scant remains of small dry-stone shelters – or 'bields', to use the dialect term – and stock enclosures scattered across these fells will have played a vital role in this practice. From 1494–99, the total number of ewes averaged 1,551, with 524 followers (lambs), but from 1500–09 the flock had grown to 1,735 and 633 respectively. Wool – especially 'best wolle' – was the main end product but the book details numerous sales of breeding 'yows' to tenants: from this, we may assume that Sir John was intent on helping tenants to improve their livestock base. Whether uppermost in his mind were the benefits that would accrue to them or the possible future increase in annual rents that he could impose is immaterial: improvements would inevitably have come about, and to have archival evidence from such an early period is, for Cumbria, rare.

Income also accrued at Muncaster from livestock in the form of sales of skins and hides – an entry for 14 August 1499–1500 noted payment of 11s for 'xj hyd' – but seemingly little of the estate

demesne was laid down to crops at this time. It was Pennington's practice to source whatever oats, bigg (four-rowed barley) and wheat he needed from his tenants, very often as his manorial due.

On the opposite side of Cumberland, Lord William Howard of Naworth Castle maintained a series of household books in the early to mid-seventeenth century, mainly to keep a tab on estate finances[12]. The vast majority of entries have no direct relevance to estate management or husbandry, but they do contain some tantalising clues. There were frequent payments for building work, such as a new 'cow house' at Carlatton in 1612 or a new barn at Corkeby in 1618; for large-scale hedging in 1633; for 'spreading manure in Hall Flat' in 1621, along with other payments simply entered as 'improvements', with no suggestion as to what they might have been. Mid-century household accounts for most years had separate pages for 'Buildings and Reparacons', which included *inter alia* repairs to a granary and barns, dry-stone walling and hedging. However, the amounts disbursed were never substantial, giving the impression that repairs were only undertaken when absolutely necessary and that new build was frowned upon. As an illustration of this, only £11 in 1651–52 and £12 in 1653 were expended on buildings and repairs, compared to £99 spent on purchasing cattle in 1653 and £131 on cattle and horses in 1658–59[13].

Lowther of Lowther and Whitehaven

Equally succinct, and to an extent unhelpful in understanding change, is the very detailed memoranda book of Richard Lowther and one of the Sir John Lowthers; particularly succinct is Richard's, which provides little more than basic lists and monetary values[14]. The latter records have nothing to say about building work, estate maintenance or improvements, and largely confine themselves to listing payments for work done on, for instance, sowing and harvesting bigg, oats, wheat and peas, and accounts concerning sheep husbandry and wool sales. Other pre- and post-Restoration Lowther papers, however, are far more illuminative, providing an unambiguous picture of how the estate was not only expanded by widespread purchases of manors across Westmorland but also actively improved to raise the value of each holding and of demesne land, no doubt with the aim of boosting estate income from annual rents and increased sales of demesne produce. Two comprehensive

archival sources are worthy of close examination, namely a set of observations on the state of Lowther properties dated 1640–73, and the account books of three heads of family covering the period 1604–55[15]. The following discussion is largely based on these two sources.

The observations are a compilation of improvements undertaken on Lowther Estates in Westmorland during the time of the recorder and the two previous generations, and it is apparent that both the Lowthers and their stewards had been fired with the improvement ideal long before Restoration. In 1608 the core of the estate was the manors of Lowther, Hackthorpe, Whale, Helton and Newton, but successive Sir Johns were active in buying up manors and blocks of land, notably during the 1630s and 1650s, substantially increasing the overall spatial extent of the estate with properties in over sixty townships across Westmorland. The second Sir John embarked on a major long-term programme of building after 1637 – new and renovated barns, kilns, oxhouses – and enclosing, walling or hedging new parcels of ground, in addition to improving water supply to his new enclosures. One entry in the Account Book for 1641 (folio 104) bears the personalised annotation, 'I built the oxhouse the barne above it, and kilne upon Whalebanke which I wrought out of Whale quarrie' at a total cost of £200. Whalebank is now Whalemoor and a lime kiln (a successor to the one Sir John ordered to be built) still stands at the quarry.

Great store was put in the benefits of liming, as illustrated by other annotations: 'I lymed Rowland feild and made it thereby much more frewtful ... I lymed and mended the hayclose and had grate increase of corne' (folio 271); and 'I lymed and much improved the Edge and the Parkes by lyminge which bore exceeding Corne for manie yeares thereby and a little helpe of manure' (folio 272). Some of the field names can no longer be located as, inevitably, names change through the generations, but Rowland Field is still named on modern mapping. Sir John's motives or, perhaps, his driving passion are encapsulated in the comment, 'I naturaly Loved much the improvement and meliorating of grounds knowinge it noe lesse good husbandry to impro[ve] the waste and barren ground, as to purchase new ...' (folio 272). With these few words he expressed what to him was the obvious view that improvement was not something quirky or unusual but essential if a well-run estate were to achieve its optimal potential through increased output, rental income and produce sales.

Agricultural Improvement and Change 1660–1760

These were ideals at the heart of the Georgic movement, and this particular Lowther must be seen as an almost evangelical pioneer of the concept of agricultural and estate improvement.

It was by no means all plain sailing. In 1642, for example, some of his new enclosure walls were torn down during the night, presumably by those opposed to the notion of landed estates 'grabbing' ever more common land and thereby depriving tenants of access to it and the ancient customary rights they had hitherto enjoyed (folio 273). He also bemoaned the high financial costs of his improvements. It was noted in the observations that in 1652 and 1653 he had 'plowed and lymed that part of the New Parke next Craggs and fenced with a great cast Earthen hedge' to keep deer out but it had cost 'two greate lymekilns which … above 40li besides two years manure I had at Hayclose House' (folio 274). Forty pounds was a substantial investment at that time but it clearly paid off, as the resultant harvests of oats and bigg were the 'goodliest and strongest' he had ever seen. Little indication is provided of the state of the land prior to enclosure though one entry, for 1656, is very specific, noting that one part of the New Park had been turned from stony, bracken-infested land of minimal agricultural value to 'good land' (folio 278).

The Lowthers not only manured and limed to improve productivity but also adopted the age-old practice of watering some newly enclosed meadow ground, perceiving that to be the cheapest and most profitable method of maintaining fertility. Thrimby Ing, Whale Ing, Flatts and Dowlands were given this treatment in 1654 (folio 275). Watering was a method that is normally associated with chalkland and was common practice in the West Country and East Anglia from at least the sixteenth century, so how the Lowthers became aware of it is an interesting question. It involved allowing watercourses to overtop their banks and flood adjacent meadows in a controlled fashion. In early spring this provided two benefits: it replenished mineral nutrients and allowed warmer river water to reach grass roots held in still-cold soil, provoking the plants into earlier growth than otherwise would have happened.

Even more detail of improvements at Lowther is contained in Sir John Lowther's *Long Vellum Book*, starting in 1656[16]. This itemised building work, such as a new barn built in 1672 on Howcarle to the west of Melkinthorpe on a tract of common land then in process of enclosure and improvement, and one repaired at Cliburn in 1669. There are frequent disbursements for the purchase

and leading of fothers (cart loads) of coal and 'Great logges' for firing up estate kilns destined for liming newly enclosed ground around Lowther itself; and there is unambiguous evidence that the estate possessed some knowledge of how to match soil inputs with soil type. An entry, dated 27 March 1669, noted that coarse sand had been mixed in with the soil, rather than lime, on two new parcels of ground as the soil was clay, but the corollary was added that 'lyme be more proper for mixt ground, and that which is dry and broken earth or moorish'. However, this is at odds with what was later to become general practice across the country of liming clay, as the release of lime in the soil breaks down the clumps found in heavy clay (see Chapter Three). In 1669, however, these links were not known. Details of watering were given for the newly enclosed Thrimby Field next to Greenriggs in 1657 at a total cost of £50: Sir John had ordered this to be done 'for the better watering and some medow for winter to use at pleasure', meaning that sheep could be turned out in this enclosure earlier in the year than in other, dry pastures.

Receipts for the closing years of the seventeenth century continued the theme of producing lime in-house for spreading on the land, some of the coal being sourced relatively close by at Reagill, with other loads carted all the way from Stainmore. Lowther Estates possessed the funds to make this a viable proposition, but this emphasises the point made earlier that the lack of coal across Westmorland and the very high costs of leading it from Stainmore put lime burning beyond the reach of many. Perhaps the crowning glory from this period was the complete rebuilding of Lowther Hall on a grand scale with vast ornamental gardens, achieved by John, 1st Viscount Lonsdale in 1691[17].

It was not just seventeenth-century Lowthers who were instrumental in improving their estates, as similar efforts continued through the next century. Robert Lowther of Meaburn Hall (NY624 171) maintained a set of accounts covering the first two decades of the eighteenth century, although his expenditure on farming could either have been for improvements or for general husbandry tasks[18]. Disbursements break down into several categories: 'dressing' specified parcels of ground, frequently not stating what the pastures were dressed with while, at other times, being specific – 'breaking the dung and spreading the Mould' on 25 May 1713; paying for purchases of 'ion' for top dressing meadows in 1715, and for two bushels of 'hott Lime for Laying aboute ... Young Spruce Firs', also

in 1713. As with most landed estates, the laying out of plantations was perceived as providing an ongoing source of income from game sports, with the woods providing cover for the birds, as well as a ready source of timber for on-estate building work and, ultimately, a significant source of sales income when each plantation reached maturity. Secondly, references to purchasing coal for 'burning a lime kilne' and one entry for 220 bushels of lime and burning a 'kil' (lime kiln) are more likely to have been intended for producing agricultural lime than mortar, as there are no entries thereabouts for building work, and the sheer quantity purchased at one time would tend to rule out the latter. Robert Lowther, or his agent, was also clearly intent on improving the quality of breeding stock by introducing new blood. In 1722 the accounts relate that men were despatched from Maulds Meaburn to Lancaster and Gisburn to purchase cattle at the fairs there, including thirteen heifers and four twinters bought on one day at Gisburn from no fewer than eleven separate dealers, and in July of that year to buy eighteen 'Scotch Cowes' and a 'Scotch bull', probably at Penrith. The men in question must have known how to strike a good bargain and how to recognise good-quality bloodstock. It seems odd, however, to have sent them all the way to Lancaster and Gisburn to select worthy animals rather than at more local drovers' fairs or overnight stances, especially given the time and expense incurred in driving the animals all the way north again. They clearly appreciated the logic.

Improvement was also high on the agenda of the Lowthers' representative on their Whitehaven estates, at least during the time of Sir James Lowther in the early eighteenth century, if the main thrust of one letter to him from his steward, John Spedding, in 1728 is typical[19]. It ranged across a number of business matters but focused in detail on a meeting he had had with a 'Lancash' man, a Mr Peck, that had been sent for by severall Gent' in that part of Cumberland. The lowland plains of Lancashire, and Cheshire, had for centuries relied on marl as the chief soil input, as lime, marl's competitor, had to be imported at great expense by cart or even ship from North Wales. Peck was brought north to seek out suitable marl deposits in west Cumberland and Spedding thought it only proper to invite him to do the same on Lowther demesne land in Cumberland. At Abbey Holme he identified a vein 7 or 8 feet (2.1–2.4m) thick 'pretty good', and one 8 or 9 feet (2.7m) thick of the 'best he[Peck] has seen anywhere': it was 'very rich' in his view and well worth exploiting.

Thus, Spedding informed Lowther that he intended to experiment with it wherever suitable deposits could be located, in the expectation that 'it may be one of the best means of making corn and hay more plentiful amongst us'.

As is so often the case, return correspondence is not available, so there is no way of knowing how Lowther responded; neither is there any later documentation to report how successful the trials might have been. However, both parties would undoubtedly have put great store in marl as, apart from paying for the labour costs of digging it, no other expenditure was involved. Unlike lime, the estate did not have to pay for fuel to burn it or for the costs of getting the raw stone or the costs of burning it. Marl merely needed to be hand-dug, and then loaded onto carts and led to nearby fields to be spread.

Meanwhile, marling was undertaken at Lowther itself shortly after Spedding's trials, so we may assume that they had indeed been successful. 2 kilometres to the north of Lowther Newtown is an area still known today as Buckholme and one field there was known as Buckholme Flatts. In dialect a holm(e) is a water meadow, while 'flatt' simply refers to level ground: this field is not exactly flat but it is not far off it, and it was a meadow. A survey

'A survey of Buckholm Flatts as they were marled in the Years 1732 and 1733. A – the Marl pit B – marled in 1732 C – marled in 1733 D – course ground not marled'. (CAS[C]D/LONS/L5/3/1/22/1. Reproduced with the kind permission of Lowther Estate Trust and The Hon. James Lowther).

Agricultural Improvement and Change 1660–1760

of the Flatts was undertaken and a plan drawn c. 1734 showing which parts of it had been marled in the previous two years[20]. The map has no scale but the vast majority (20 acres, 8 ha) was marled in 1733 with a further 2 acres having been treated the previous year, and a marl pit was also marked on the survey plan; the field totalled 27 acres (11 ha).

Further sets of Lowther accounts itemise in detail estate expenditure. Annual account books kept by William Armitage tend to be rather perfunctory in nature, leaving out what he deemed unnecessary detail, but the occasional entry is more useful: in May 1759 he paid for stone for building a lime kiln at Warren House at Lowther (NY538 239) and in June and July for coal to burn in the kiln to produce lime to be applied on the nearby Warren House Ground, confirming that the Lowthers had an enduring sense of the value of improving the soil and of the role that lime could play in that[21].

Sequence of tasks	Cost heading	Labour cost (£)		
1	stubbing & cutting wood	35	19	7
2	carting out stubbed wood	incl.	in	no. 1
3	setting up sods to dry	4	8	0
4	getting up stones	6	14	0
5	ditching & draining	4	14	1½
6	sledging wood to burn sods	3	0	0
7	ploughing & levelling kills	4	19	2
8	burning 51 acres	29	11	1½
9	spreading 51 acres of ashes	6	7	6
10	loading stones		8	8½
11	leading stones	6	9	10
12	opening drains	incl.	in	no. 5
13	harrowing & rolling	1	7	9
14	opening & scouring drains	incl.	in	no. 5
15	51 days bird watching on rape	1	4	6
16	reaping rape	14	17	9
17	burning rape straw	1	11	2
	13 bushels of rape seed	2	2	0
	carriage of rape seed	3	17	6
	hire of horses & carts	1	15	0
	paid for paring 51 acres	35	10	9
	paid for turning rape seed		15	10

Table 2: Cost headings for improving Rough Ground, Lowther, February 1763–June 1765. (CAS[C]D/LONS/3/5/90)

Another set of accounts, being very specifically headed 'Account of Improvements' for work on two parcels of ground, is far more illuminating[22]. It has not been possible to locate one of the parcels, namely Burnt Earth, but the other, Rough Ground, was purchased in 1763 with the sole intention of bringing it up from its previous poor state: this extensive tract was indeed rough ground lying immediately to the south of Lowther village. The accounts list every item of expenditure, for purchase costs and payments to hired-in labourers and 'own Husbandmen', over a period of nearly thirty months after it was acquired.

Surviving data like these are extremely rare and all the more valuable for that. They enable a full task-by-task picture to be built up of the practicalities of bringing low quality land to a much improved and productive state. Within Rough Ground, the first step in the process was to remove trees and shrubs, felling them before grubbing out the roots. This was very labour-intensive, hence its very high cost. The timber and roots had then to be carted away, either to be burnt as waste or used on the estate for fencing or whatever. Men were next brought from off the estate to pare the whole enclosure: this involved using a special paring spade to peel off the turf and vegetation layer as individual sods. This, too, was very labour intensive and costly. The sods were stacked to allow them to air dry for a period of weeks or months, depending on weather conditions. While this was coming to an end, other men were set to grub out stones from the soil and, presumably in this case, pile them in heaps across the field. The whole area needed to be well drained, so a network of new open ditches and sub-surface drains was cut and, in readiness for burning the dried sods, cutlengths of timber were brought back in by horse-drawn sledge. The next job listed should have been burning the stacks of sods to produce potash but, for some reason, it was listed after ploughing but it would have been impossible to plough the whole enclosure with stacks of sods at regular spacings. Once the burning was completed, the ashes were raked out evenly to allow rainwater to wash the potash into the soil as an initial fertiliser. Only then, it seems, were the heaps of stones loaded onto carts and taken, away. The accounts do not indicate where they were taken, but they may well have been used for walling around Rough Ground. Next in the sequence of tasks, the ploughed land was harrowed and rolled and what can only have been existing ditches were opened up and scoured.

Agricultural Improvement and Change 1660–1760

The newly improved enclosure was ready to be sown, and it was in its first year with thirteen bushels of rape seed that cost £2 2s. It may now seem illogical but the seed was purchased from Leeds and brought in sacks at an extra cost of £3 17s 6d for leading and £1 15s for hire of horses and carts. Given the state of roads at that time, the return journey must have been a lengthy endurance test. Once sown, the field had to be protected from scavenging birds – hence the payments for fifty-one days' 'bird watching'.

These accounts also speak volumes about the determination of landowners such as Lowther and his agents, and their ability to look to the long-term future and not just the following harvest. The total expenditure on bringing Rough Ground into full production was £365 11s 0½d. That seems a staggering amount but, if worked out on a per-acre basis, it amounted to just over £7 for each of the 51 acres (20 ha). To be set against this, however, was income from sales: after the first harvest eighty standard (Winchester) bushels of rape were harvested and sold to a Mr Walmsley based in Preston for £115 10s, and seven (cart?) loads of ashes from rape straw were sold for a net income of £6 5s. Thus, in the first year, expenditure exceeded income by over £243 but, assuming ensuing harvests were as good as or perhaps better than in 1763–64, Rough Ground would have broken even at the end of year two and made a profit thereafter. This is surely a prime example of forward thinking and astute business management: after all, by this time landed estates were perceived by their owners as business entities, designed to maximise income for the benefit of the estate as a whole and the family in the future. In addition, it had become even more a part of the national landowning psyche that improvement and advancement were not just a patriotic duty but also a moral imperative.

No other landed estate in Cumbria has documentary material as accessible and packed full of detail concerning the mechanics and implications of agricultural improvement as those for Lowther Estates, particularly for the seventeenth century, and they should be seen as a treasure trove for the researcher. This is not to say that there are no relevant extant records for other properties; indeed, there is evidence from elsewhere in the county that the improvement ideal had caught on before the middle of the seventeenth century, although some of the sources are short on detail. An inventory into the death of a yeoman from Mansergh in 1630, for example, listed among his possessions a close of arable land called 'Marledale', which one

may assume had been improved or – at least – maintained by the spreading of marl[23].

Thirty years or so after Restoration, Sir John Lowther (1655–1700) commissioned a comprehensive perambulation of Cumberland, undertaken by Thomas Denton of Warnell, and presented to Lowther in 1688[24]. Exactly why he was asked to do this is not fully understood, and he far exceeded his brief, but his detailed observations and descriptions are most perceptive, although reading between the lines provokes the suspicion that he may have had a hidden agenda or that he was writing what he thought Lowther wanted to read. He made detailed comments about the use of lime in agricultural improvement across the county, especially in Papcastle, Broughton and Warnell, remarking that the practice had converted barren cropland and 'enriched them exceedingly', thereby helping to 'fill their barns with abundance of corne'. Newby near Little Strickland and Bolton on the Eden were both 'remarkable for excellent corn growing in plenty, especially wheat'. In his own manor, he stressed the number of limestone quarries on Warnell Fell as well as the local sources of coal such that the township was able to supply much of this part of Cumberland with agricultural lime. He noted improvements wherever he spotted them, was complimentary about estates and townships that impressed him by their high standards of husbandry, using words like 'famous' and 'great husbandry', and altogether painted a picture of almost rural bliss. Denton was no disinterested observer and his effusive style may generate a degree of cynicism but, when the gloss is stripped out, his observations do present an image of a county where farming was flourishing and anything but backward and inward-looking. Of course, we do not know how much he chose to leave out that would have been less than pleasing to his patron.

Another branch of the Lowther family held the Holker Hall Estate in Cartmel from 1697–1756 and the picture that emerges here contrasts markedly with that at Lowther Hall: the Agent was inefficient, and evidence, from surviving farm leases, of 'progressive' farming is scant[25].

Musgrave of Edenhall

The Musgrave Estate was centred around the family's former seat at Hartley Castle, east of Kirkby Stephen, and at Eden Hall near the

confluence of the Eden and the Eamont, north-east of Penrith[26]. In the late seventeenth and eighteenth centuries, Sir Christopher (1688–1735) and Sir Philip (1712–95) were the heads of family and oversaw, largely through their stewards, the running and development of their properties.

Manorial custom was slowly replaced by individual farm leases and it was often a bone of contention whether legally binding indentures should be long, short or indeed non-existent. Short-term leases, and especially annual leases, gave little incentive to tenants to invest their often meagre income and their time in permanent or long-term improvements as – so the argument went – they would be investing for the benefit of whoever might take on the lease in future years. Any form of legally binding agreement could tie the unwitting tenant into conditions that might have been to his ultimate disadvantage. Most, if not all, landed estates developed fixed-term leases but Musgrave properties varied their lengths from farm to farm[27]. An agreement dated 27 March 1661 gave Christopher Blane a twenty-one-year lease of a parcel of ground within the Edenhall demesne and his only binding stipulation was to provide boon work according to past practice; a similar lease was granted to Richard Denney on 20 January 1677. However, on 25 November 1698, Anthony Carr of Carleton Village was granted a lease on Sceugh Farm (NY543 299) within Edenhall for only seven years, whereas Richard Matthew of Langwathby took on the lease of the same farm on 20 January 1736 for a period of nine years. He was bound into a range of stipulations: forbidden from ploughing more than one-third of existing ploughland in any one year; he had to ensure that the farm was 'sufficiently dunged and manured according to due course of good Husbandry'; he was forbidden from ploughing up any pasture land during the final three years of his lease; and on termination was required to spread, or leave, all stored dung on the farm.

This 'course of good Husbandry' was a throwback to the days when the manor court system was still strong, when tenants were instructed to follow those aspects of husbandry in use from time immemorial. The conditions imposed on ploughing were to prevent a new, and possibly irresponsible, tenant from converting too much pasture to crops and from working arable land to exhaustion. This pattern endured at Edenhall, although as time went on extra conditions were applied: Samuel Carleton of Langwathby, who took on a fourteen-year lease of Dolphenby Farm in 1752, was

Intensively farmed land at Dolphenby, Edenhall.

also required to maintain all buildings, ditches and hedges, and to ensure his arable land was 'sufficiently dunged limed or manured', again according to established practice[28]. On the other hand, he was accorded the right to kill and take rabbits 'on the hill' along with grazing rights on Dolphenby and Bramery Moors within Edenhall manor. A further lease, for Bramery High (now Udford, NY575 301) and Low Farms (now Honeypot, NY558 302), dated 17 April 1765, gave an extra right – to kill moles – but also extra conditions, namely to control gorse, bracken and other invasive growth. This pattern of modifying conditions of lease is seen across various landed estates.

The Musgrave archive for the period under review in this chapter is sparse on the management of non-tenanted demesne land and even less forthcoming about improvements; what little has survived is sets of accounts[29]. Payment was made in September 1727 for 'water furrowing and draining' and for bringing in manure, both of which could be seen as matters of day-to-day husbandry or as efforts to improve the quality of land being treated; and between 1735 and 1742 for buying trees for developing the estate's timber reserve at Edenhall. Income was derived from sales of wheat, barley, bigg and

rye, straw, wool, hides, skins and tallow, and of timber and bark, the latter destined for local tanneries.

Edenhall's steward at this time clearly recognised the opportunity judiciously provided by its geographical position, which was close to one of the major droving routes from Scotland via Carlisle and down the Eden Valley. Not only could they readily obtain new 'Scotch' bloodstock from the fairs at Penrith and Brough but they were also able to let pasturage to drovers, either for overnight stops or for longer periods, to allow the cattle to regain condition prior to their being sold at the fairs or driven further south. Droving was barely established as a major long-distance economic activity at that time and the steward was staking the estate's claim from the beginning: as early as 1712, overnight grazing was rented out to drovers long before the main north-south traffic in cattle developed. William Jonston, drover, bound himself to reimburse Sir Christopher Musgrave the sum of £1 8s in return for 'the grass of 260 drove cattle', according to an estate account book[30]. It got off to a slow start and income fluctuated from season to season, but the overall trend was clear and continued thus beyond the 1760s. The most successful year was 1739, the result of five discrete droves renting pasturage in five discrete enclosures across Edenhall during the same season.

Fleming of Rydal

Also from the 1650s, and for the following hundred years or so, the account books of the Flemings of Rydal Hall near Ambleside noted the purchases of various loads of lime, 'manner' (manure), 'manure & ashes' and 'Ashes lyme', although the locations where these materials were applied were not given[31]. Nevertheless, single entries do allow certain points to be made: those charged with managing the estate saw improving the quality of farmland as important, and not placing all their faith in one soil input. Manure had an obvious proven record and the only cost incurred in spreading it was the labour requirement; lime, too, had proven benefits as we have seen, but it was a relatively expensive commodity to purchase and to cart; whereas lime ashes, applied alone or previously mixed in with manure, was a very low-cost by-product of lime burning that had no other commercial use than on the land, as it was contaminated with coal residue.

Other Fleming accounts are rather more forthcoming about the end uses of lime: in the winter of 1690 Michael Fleming, son of the then landowner, had authorised payment for 'two Lime-Kills, laid in ye Low–Park and Stonethwait' and '6 dayes leading of manure, at 2d½ ye day'[32]. Paying for two lime kilns does not mean that he had ordered two to be constructed. Rather, at that time, most lime kilns were still clamps. What Fleming had paid for were the burnt-lime contents of each firing. The various entries mentioned here also provide an insight into the seasonal organisation of husbandry on the estate's demesne land: lime and manure had been spread during winter in 1657, 1691 and 1763 when arable fields lay fallow and meadow land dormant, whereas lime ashes were spread – or at least payments were recorded – in May 1762 and 1764. It may be premature to draw too strong a conclusion from just a few years' data, but there is a hint here that top dressing with ashes was considered appropriate, as plants were beginning to put on their summer growth while the manure and/or lime was felt to be more suitable for winter, so that nutrients could be slowly absorbed into the soil before growth began. Other improvement-related payments were made for 'Stoneing ye Meadowes', which would have involved the laborious and back-breaking task of riving large stones and cobbles from the ground, heaving them into carts and leading them away to be discarded or used for walling.

Outwith the demesne, the Flemings or their stewards were equally concerned that tenants should engage in soil improvement, and entries in mid-seventeenth-century account books itemise substantial disbursements for manure at Old Hutton and Holme Scales to the south-east of Kendal, as well as detailed records of payments for lime ashes and manure across the estate[33]. Seasonality is very clear from these latter accounts: in 1762 thirteen payments were made between May and July, in 1763 five in May and in May 1764 three, all clearly applied as a top dressing. Unfortunately, the accounts do not provide any information about where it was being laid and it is impossible to calculate or even estimate application rates.

Grahme of Levens Hall

Similar sets of accounts paint a parallel picture of husbandry on the Levens Hall Estate on the River Kent during the closing years of the seventeenth century. James Grahme's steward kept up a

Agricultural Improvement and Change 1660–1760

copious correspondence with his often absentee master, as stewards were obliged to do, and went to great lengths to keep Grahme fully informed of what he was engaged in. The vast majority of correspondence concerned building work at the Hall. There is hardly anything about husbandry: perhaps Grahme was not really interested in the day-to-day running of his estate, although the steward, Hugh James, was not directly responsible for farm management[34]. Even so, James did at times include farming matters, writing various letters in 1694–95 to discuss draining and manuring operations. Despite the estate having several of its own lime kilns, there is no indication in the letters that liming was a favoured practice.

Tim Banks was responsible for keeping the accounts at Levens and these are more revealing, if rather brief[35]. Payments were made for leading lime and manure and for purchases of manure – for example, for forty-four cart loads from Ellen Swainson in January 1696 – but there is no indication where it was all applied: no doubt Banks knew the details full well, so felt no need to waste time writing it down for posterity. One entry is particularly frustrating, as he wrote no more than 'pd Brigsteare Improvement' with no explanation whatsoever. There are also very few signs in the accounts of forestry work on the estate, which at first sight may seem odd given the emphasis that many landed properties put on developing timber resources, although the large-scale planting of softwoods really dates from the following century. One entry, in 1696, noted the payment of £1 for '60 younge Hollins', as well as yews and 'firs'[36]. The hollins would have been holly bushes planted for winter fodder; the yews must have been for aesthetic improvements to the home estate; and the firs may have been European larch, first introduced to this country in 1629 but only widely planted from the 1750s, or Norway spruce – historically sometimes referred to as fir – which was known in England from the mid-sixteenth century but was not widely adopted as a plantation species until the early 1800s. So, from this perspective, Levens can perhaps be regarded as something of a pioneer estate.

Pennington of Muncaster

The Muncaster Castle Estate was not large and extant late seventeenth-century accounts relate more to general husbandry than to tasks that could be construed as improvements, and they were mainly for the Home Farm (SD096 966) and Langley Park Farm (SD096 929) in

Waberthwaite[37]. On the other hand, the accounts do provide an insight into the nature and scale of farming on the estate at that time. From 1660 onwards the main farm products sold off the estate were oats, bigg and some wheat, as has been seen to be the case across Cumbria, plus beans and peas, cattle and sheep. Livestock numbers fluctuated quite widely from year to year, as did output of arable crops. Variations in harvest were no doubt the result of changing weather conditions, with very wet or cool summers seeing a downturn and warm, sunny ones the opposite, although a dramatic drop in cereal and bean production in 1670 may reflect a policy decision to move away from arable to pasture. In terms of harvesting the hay crop, there were marked fluctuations in the 1690s, becoming more evenly balanced during the latter years in the sequence and nearer to the overall thirteen-year mean value of seventy-one man-days; the decline in the hay crop in 1694 and 1695 also probably reflects inclement summers. Fluctuations in livestock numbers are less easy to explain, unless outbreaks of disease were to blame: thirty-two cattle were listed in the accounts for 1664, compared to sixty-nine in 1663 and ninety-two in 1671.

Apart from these cost headings, disbursements were also made for day-to-day tasks such as leading manure, walling, hedging, controlling bracken, sowing, ploughing, and fetching lime, without stating whether it was destined for the land or for building work. However, no payments were made for spreading lime so the latter use is the more likely. There were also frequent payments for work at this or that locality without indicating what the nature of the work was. Only one entry between 1660 and 1708 can unequivocally be described as improvement: in 1708 Henry Jackson was paid for seventy-five days of 'hacking, Mowing & burning Whins'. The location was not given, but his task had been to clear gorse so that the area in question could be brought into productive use.

Buccleuch Estate in Furness

Much of the archive of the dukes of Buccleuch's English estates awaits cataloguing and the full extent of documents that may be of relevance to how their Furness estates were managed requires further long-term work[38]. Generally speaking, what is accessible consists of mundane accounts with minimal explanatory detail, but a survey undertaken by Stephen Penn in 1732 is of great value. He had been

commissioned by John, 2nd Duke of Montagu (1690–1749), even though he did not control the Furness estate until two years later on the death of his stepmother, who has come down through history as Elizabeth, 'the Mad Duchess of Albemarle'. The duke was perfectly well aware that he would inherit her properties and the assumption is that he was preparing the ground in advance. It is believed he undertook a tour of his Furness properties in the mid to late 1730s, and so must have held them in high regard[39]. The survey took the form of a bound atlas consisting of large-format, beautifully crafted coloured maps and plans that depict in enormous detail what the land uses were in each of the mapped areas[40]. Three of the maps are of special interest, as they concentrated on land uses connected with farming and forestry rather than on coastal sites or those with industrial or mining potential. It seems that the survey was intended to supply a not-quite-blank canvas on which the duke could set his steward to work to undertake improvements across the estate with the aim of increasing overall income, as evidenced by annotations on some of the maps.

All three maps, and a coloured drawing, focused on Coniston Water (then Thurston Water). Two show the entire lake and lands extending from both shores into the surrounding hills. They mark

Former arable land at Low Peel Near, Coniston Water.

and name individual farms, and distinguish between common land, woods, enclosed pastures and arable land, showing extensive cropland down the eastern side from Monk Coniston to Waterhead, and at Blawith, Nibthwaite, Torver and Coniston itself on the western side[41]. Another is of the south-eastern corner of the lake, around Peel Near[42]. It also uses colour to depict the extent of pasture, arable land (surprisingly extensive) and woodland between the road and the lake shore. The OS six-inch map, surveyed in the mid-nineteenth century, shows a very different picture from Penn's map of 1732. On the latter, almost all of the land was woodland, whereas in 1732 it was confined to the nose of High Peel Near, two small copses further north, a narrow strip along the lake shore, and a small parcel next to the road annotated 'copswood fell'd last Spring', 'copswood' meaning a coppiced wood. It is pure speculation but nevertheless probable that the duke saw greater income-generating potential from timber than from tenanted farmland that really was only low-value agricultural land. The third map showed the south-western corner of Coniston Water, between the lake shore and the top of Blawith Fell, south of Brown Howe[43]. As with the others, colour shading and symbols distinguish between the various existing land uses, including extensive tracts of ploughland, some of which has since been converted to forestry.

Infrastructural Improvements

The willingness of landowners and yeoman farmers to invest in their lands after the Restoration is mirrored and amplified by their level of investment in buildings, whether renovations, extensions or new build. The evidence presented here is but a fraction of the scale of building work that was undertaken, and is a reflection of what records have survived. Individual farmers would not have kept detailed records of what for many of them was too mundane to commit to pen and ink. Estate records, on the other hand, did do so, whether for domestic or agricultural buildings, maintenance or improvement to local roads and farm tracks, or walling of enclosures and plantations. All were integral components in the business of improving the image and value of landed estates.

Perhaps the most frequently occurring records relate to the construction or rebuilding of barns, and the number that was erected between 1660 and 1750, and their often impressive scale,

are testament to the state of farming in early-modern Cumbria. One of the earliest recorded rebuilds was at Rydal Low Park, where Sir Daniel Fleming had an existing barn demolished in 1659, only six years after he came into possession of the estate[44]. The history and development of most vernacular buildings can be read in their external fabric: raised roof lines on side walls, the shadow of steep thatched rooflines in gable walls, blocked-up doors and other apertures, and straight vertical joints in the masonry all tell of how a building has been modified and enlarged to meet the needs of changing circumstances. Low Park Barn is no exception. It was heightened in the late eighteenth century and in the following century a loose box and turnip store were added as outshuts; originally built to house forty-four cattle, and with storage space for hay to feed them through winter, it was later reduced to thirty-three stalls. In 1692 a second barn – Birket Barn – was built in Low Park[45]. In 1688 the Flemings had a new barn built at Coniston Hall with housing for thirty-two cattle, draught oxen and horses. They did not restrict their building work to the demesne: the accounts for one of their outlying properties, New Hall (SD463 971) in Nether

Former bank barn, built in 1688 at Coniston Hall, but considerably modified in the nineteenth century.

Staveley, included payments for building work there on a 'barn or cowhouse', which included two days' labour for 'liming the inside of the barn'[46]. Legislation relating to the welfare of cattle at this early date was at most rare, and this reflects well on the way the Rydal Estate was managed.

Elsewhere, Sizergh Great Barn was first built in 1569 but substantially modified, in stone, in the mid-seventeenth century; it was large enough to house forty-eight cattle, oxen and horses, and it is described as the largest barn in modern Cumbria. On the Levens Hall Estate building maintenance work was also spread widely, as far as records from the 1690s suggest, including at Barrowfield (SD483 908) west of Kendal, Park House at Heversham (SD495 826), the Bemire and Low Barns, and a new barn at Helston[47]. Whether or not these barns were built entirely in stone was not always stated, but one entry in the Edenhall accounts for 1699 did clearly specify 'for repairing a Barne with thatch and getting Ling'[48]; and an entry for the Musgraves' Hartley Estate records payment for 'sheep bones for sclating of the demisne Barn Hartley' in 1724[49]. Sheep bones were used for pegging slates to roofing timbers before the advent of wooden pegs.

The Great Barn at Sizergh.

Broughton Tower in Furness (SD214 879) was purchased by Roger Sawrey in 1657 and he immediately set to rebuilding the house, re-roofing a barn, repairing the brewhouse and other outhouses, and erecting stone walls[50]. At the same time he also undertook 'plowing and improving powsmith medow'. In a sense Sawrey encapsulates the late-seventeenth-century improvement ideal: having only recently bought the property, he was minded to spend £130, a considerable sum at the time, within two years of taking possession to bring about changes to the fabric and agricultural landscape and potential of this small estate.

On a very different scale was the building work ordered by successive Lowthers on their Lowther Castle and Whitehaven lands. Correspondence between Sir John Lowther and his agent Thomas Tickell in 1686 concerned the rebuilding of Sockbridge Hall (NY503 270), south of Penrith, and the sourcing of a quarryman and a limeburner to supply the masons with building stone and mortar; and in 1699 he had a 'great barn' built there[51]. Three years later Lowther ordered major repair work at Hartsop Hall in Patterdale (NY398 120). However, it was at Lowther itself where building work and aspirations reached their apogee. Starting in 1696, substantial work was undertaken on the estate's home buildings; the existing village was demolished and re-sited to create Lowther Newtown, designed by Robert and James Adam; and the whole landscape between the River Lowther and Newtown was landscaped anew with parkland replacing farmland[52]. Improvement – aesthetic as well as practical – was uppermost in Lowther's mind but his priorities are illustrated by comparing relative costs. On Lowther Hall he expended over £18,000 but on barns and outhouses only £150.

Lesser properties

Owners of smaller estates also moved with the times and undertook improvements for both aesthetic and financial reasons. In the north-west of Cumbria, for example, Sir Patricius Curwen (1602–64), one of a very long line of owners of the Workington Hall Estate, was reputed to be a 'prodigious' user of agricultural lime[53]; and the Sawreys commonplace book has a few useful entries such as 'Dreeninge and Fencinge ye low Grounds' at a cost of £20[54]. They were not just sitting back and passively collecting rents or accepting

the status quo on their demesne, but actively investing in the future even before Restoration.

On the Dallam Tower Estate in Heversham and Milnthorpe, the landowner, Edward Wilson (1719–64), had laid claim to a third part of annual rents derived from 'new improvements'. This illustrates the commonly held opinion among the landowning class that one of the key reasons for agricultural improvement was what they considered to be the justifiable imposition of increased rents on tenants, who had increased the value of their holdings. However, no details of his work are certain[55].

Celia Fiennes (1662–1741), the pioneer female traveller, kept a diary during her 'Great Journey' on horseback, which took her to Cumbria in 1698[56]. Around Kendal she noted how rich was enclosed land growing peas, beans and lentils, flourishing with crops of corn (although not wheat or rye) and with pastures all 'green and fresh'; and on the shores of Ullswater she observed that both pastures and cropland were 'very fruitefull'; while on the way from Kendal to Bowness she had clearly been amazed and impressed to see so many pack animals loaded with hay, 'turff' and dung on local journeys, with lime probably brought from rather further afield. Yet Fiennes was not averse to painting a rather less favourable – dare one say less picturesque – image than Thomas Denton, writing, as she did, of people around Windermere living in 'sad little hutts' and between Penrith and Carlisle in hovels 'daub'd with mud-wall' and no better than a barn. Denton's view of Cumbria was somewhat romanticised and written to please his Lowther patron; Fiennes was definitely more plain-speaking and probably more honest overall.

Even had she felt inclined to journey into the remote moors of North Stainmore, it is doubtful she would have been told of an intake near Swindale Head on the boundary of Musgrave and Helbeck Fells. Here lie the remains of a farmstead carved out of the moor and improved by draining and the application of lime from a purpose-built lime kiln. It is far from any other habitation, has long since been abandoned, and can never have been above marginal status, but someone took it upon themselves to settle here and to make a go of farming. Tarn House (NY809 190), as it was called, is known to have been in existence as a place name by 1702; when it was first created is not known but, if the now-ruined kiln was built at the time of the farmstead, it cannot have been much earlier than 1700. In its early recorded life it was home to husbandmen with, at times, colliers

Agricultural Improvement and Change 1660–1760

The abandoned Tarn House farmstead on Helbeck Fell.

and farm 'hinds' (live-in labourers) and at its end to shepherds. The intake is not extensive, the walled enclosures are small, and the prospect can never have been bountiful, but even a tenement as small and isolated as this should be seen as a minor part of the seventeenth-century development of farming in Westmorland, pushing habitation and farming to the margins long before the era of parliamentary enclosure here. In the 1901 census Tarn House was not recorded.

Constraints

To have archival evidence from across Cumbria to confirm that improvement and progress in farming were underway during the second half of the seventeenth century is all the more unexpected, given the nature and scale of constraints that landsmen faced, whether economic, meteorological or medical. We have seen earlier that farm leases were often a real source of dispute between landowner/steward and tenant. The latter quite understandably resented the imposition of short-term leases, more so if they came with binding stipulations that acted as a major disincentive and deterrent[57]. Why should a tenant expend his time, effort and hard-won income on improvements that

later tenants would benefit from at no or minimal cost? If individual tenements were subdivided into smaller, barely viable units, the problems and rancour were magnified. Two examples will illustrate this point.

Holeslack farm (SD492 884), south of Kendal, was let in November 1681 to a farmer from neighbouring Sedgwick for a period of three years, and yet a second indenture, the following month, awarded him a lease of the same property for seven years[58]. Whether the tenant had complained against the initial term or the landowners had second thoughts is impossible to judge but, given that a sale notice for Holeslack in 1780 advertised it as having only 26 acres (around 11 ha), one could quite understand if the tenant felt disquiet. The second example, from 1722, was of a nine-year lease of Skelsmergh Hall (SD531 959), also in the Kendal area. The incoming tenant, Thomas Gilpin, had the benefit of a slightly longer lease but he was bound by a set of conditions. Whatever pasture land he might plough up had to be 'sufficiently manured according to the Custome of the Country and according to good Husbandry'[59]; and Gilpin was also required to burn lime on the premises for 'improveing the Land', although the landowner retained responsibility for providing the coal needed for firing the kiln.

Increasing lengths of tenancies were also evident on the Naworth Estate: Gillalees Farm (NY569 712), south of Bewcastle, was let in 1735 for a period of seven years and the lessee, John Routlidge, was required to keep the farm in 'good order' and to manure the land according to the established method of husbandry in the area, but was forbidden from converting any pasture to cropland without first gaining consent[60]. Twenty years later, Jane Bacon was able to take on the lease of Shankend Farm in adjacent Spadeadam for twenty-one years. As the eighteenth century progressed, however, tenancy obligations were to become more stringent, as will be seen in the following chapters.

Fluctuations in climate left their mark on Cumbrian farming in the hundred years under review in this chapter, and the unrelenting creep of the Little Ice Age reached its maximum intensity in the Late Maunder Minimum (1675–96), when average annual temperatures reached depths unknown in the historical era. The years 1665–1700 witnessed temperatures significantly below the long-term (1659–2007) running mean of 9.43° Celsius, and only the years 1720–40 saw average temperatures rise above the mean[61].

Agricultural Improvement and Change 1660–1760

Local contemporary weather data are rare and thus all the more revealing. Oswolde Rumney of Mellfell, Watermillock (NY430 238), had noted in his diary that 'A marvellous great frost' had occurred continuously from 1 December 1607 to 15 February 1608, with Ullswater frozen over for the entire period[62]. A serious outbreak of cattle distemper was recorded in Ravenstonedale in 1747, which endured for so long that official letters were despatched from the Crown forbidding the holding of cattle fairs in a desperate attempt to stop the further spread of distemper[63].

Large estates and more prosperous yeomen no doubt had the resources to withstand setbacks such as dreadful weather and outbreaks of disease; for the humble small tenant, he of the statesman class, it would have been a very different, and often crippling, story. Pity then the 'poore and oppressed' tenants of Hutton John, who submitted a humble petition to Lord Howard of Naworth Castle around 1655 in which they bemoaned 'in the tyme of their calamity, deep distress and languish of Spiritt' their need to present their grievances against their 'merciless Implacable Landlord'[64]. Whatever ills they felt themselves forced to endure – and the petition did not elaborate on them – they were patently at the end of their tether and resorting to desperate measures.

Farming had shown quantifiable progress in the hundred or so years after Restoration and had unquestionably changed – at least where the landed estate and larger yeoman class were involved. Nevertheless, their ability to benefit from new ideas and methods was limited by their individual circumstances and, it has to be said, their position in the farming hierarchy. What had been achieved overall in Cumberland and Westmorland during the period 1660–1760 bore no comparison to the next hundred years, to which the following two chapters turn. Whether or not Westmorland's yeomen were all 'comfortably placed' in the late seventeenth century is a matter for debate[65].

5

Agricultural Change in the Age of Enclosure: The Mechanics of Improvement

Catalysts for Improvement

If the seeds of agricultural change had been hesitantly sown in the early seventeenth century, and visibly nurtured after Restoration, the hundred years from 1760 were to witness a blooming of the improvement ideal across the country as a whole, and more noticeably from the closing years of the eighteenth century. A range of interrelated phenomena stimulating change can be identified, some regional and some national.

It has been said there was a five-fold increase in the number of farming manuals and a ten-fold increase in journals between 1780 and 1850[1], with the greatest number of new book titles appearing in the 1790s[2]. They all propagated new and often tested ideas, but the extent to which they permeated down to the 'lowly' statesman or husbandman must have been limited. Some titles were manifestly targeted at the landowning class: Nathaniel Kent's manual was entitled *Hints to gentlemen of landed property*, presumably with the hope that landowners would lead by example, or by coercion[3]. George Winter dedicated his to the duke of Beaufort, and Richard Parkinson's list of subscribers included thirty-six aristocrats, but very few directed their endeavours at the ordinary man: one anonymous manual stands out by addressing the 'ordinary class of practical farmers'[4].

Whereas the 'ordinary class' may have baulked at the considerable expense of purchasing theoretical manuals, and may have been too conservative in outlook to bother with what was almost without exception based on experience elsewhere in the country, there was a greater likelihood that access to agricultural periodicals was made possible by exchange and sharing, especially when the concept of the village reading room mushroomed in the mid-nineteenth century. Arthur Young's *Annals of Agriculture* was published between 1784 and 1815 and contained a profusion of practical and experiential advice to all involved in farming. The *Journal of the Royal Agricultural Society of England* (RASE) first issued in 1840, *The Agricultural Magazine* issued 1799–1811, and *The Farmer's Magazine* published 1800–1837 in Scotland and afterwards in London, all provided advice and hints to farmers and land managers intent on good husbandry and improvement.

Published works would have been beyond the reach of many farmers but local agricultural societies brought practical advice and innovation almost to the doorstep. In 1800 England had only thirty-five such societies, and Cumberland none, but the numbers expanded exponentially so that, by 1845, there were anything from 360 to 700 in existence[5]. Many societies staged annual shows with a broad range of prizes, and it was government policy to promote the establishment of local societies by landowners for the benefit of their tenants and the farming industry in general[6]. Whereas some of the county agricultural societies may have seemed too remote and exalted for the 'ordinary class', the more locally focused farmers' clubs were undoubtedly more relevant; certainly, the number of entries submitted for annual prizes by farmers supports this contention. Apart from county societies such as the Westmorland County and the Cumberland, Cumbria had a range of societies; it can be said with confidence that they were far more relevant to the 'ordinary farmer' in the past than the distant and remote RASE, which had, in 1854, only a handful of subscribers in Cumbria out of a national membership of 5,260[7]. The contentious point has been made that the influence and effect of agricultural societies declined after 1850[8]; however, the number established after that year might suggest otherwise.

At a national level, moves to establish a government agency to promote agricultural change effectively began in 1790 through the efforts of the great agricultural missionary William Marshall,

Society	Date founded	Other dates
Abbey Holme		1850s
Appleby & Kby Stephen	1841	1891
Barrow in Furness		
Bolton Fell End		
Brough	1848	
Burton in Kendal	1833	
Cartmel	1872	
Cockermouth		1850s
Crosthwaite & Un'barrow	1859	
Cumberland & Westmorland	1846	1850s
Dalston		
Dufton	1863	
East Cumberland	1833	
Hawkshead		
Hesket Newmarket		
Holm Cultram & District		1842
Kendal	1799	1867
Kendal Farmers' Club	1864	
Keswick	1860	
Kirkby Lonsdale	1862	
Lunesdale	1839	1868 (closed)
Millom & Broughton		
Milnthorpe		
North Lonsdale		1877
Orton	1860	1865/7 (closed)
Ousby		1864
Penrith	1836	1846
Penrith Farmers' Club		1881
Shap		1861
Stainmore	1895	1908
Staveley	1851	
Temple Sowerby	1864	
Vale of Eden	1888	1902 (closed)
West Cumberland		1850s
Westmorland & Kendal	1868	
Westmorland County	1846	
Wigton		
Windermere District	1853	1911
Workington	1805	

Table 3: Selected agricultural societies in Cumbria.

and the Scottish landowner Sir John Sinclair, who convinced a sceptical parliament to found the Board of Agriculture and Internal Improvement three years later, a body of which he was to be the first president. Arthur Young, another zealous proponent of improvement, was its secretary. The board did not enjoy a happy life: profound differences in opinion, to put it mildly, between Marshall and Young, together with lacklustre support from government and the lack of relevant knowledge and experience of some board members, prevented it from living up to its expectations and it was dissolved, rather ignominiously, in 1822[9]. What it did achieve, however, was a series of over eighty county reports that looked in detail at the state of farming in each. Not all were of high quality and the board had been criticised for appointing surveyors who lacked the necessary attributes and for requiring surveyors to complete their work in an unreasonably short space of time[10]. Nevertheless, those that were of sound quality are invaluable, especially when their findings can be compared with contemporary archival sources. Three reports covered what is now Cumbria and each will be considered later in this chapter.

As the eighteenth century progressed, scientific principles were slowly applied to farming practices, especially concerning soil inputs and crop strains. Still prominent among inputs was lime: of thirty farm manuals published between 1760 and 1840, all but three dealt with the processes of liming and twenty-one extolled its benefits. However, at the start of this period, no-one fully understood the science behind liming, and some contemporary observers condemned its use without knowing the full facts. Some farmers were wont to apply too much, too often, resulting in the soil, or crops, being scorched and there was no consensus on rates of application and no knowledge of what lime actually did to soils. Perhaps the first person to try and answer this was Francis Home, who believed that lime attracted oils from the atmosphere that dissolved in contact with the soil, a somewhat bizarre concept[11]. An anonymous contributor took this a step further by claiming that lime acted as a 'provocative' agent in the soil by forcing it to release its natural fertility; while a further attempt to explain the science conflated the two ideas into the notion that lime attracted 'oils, acids, and salts, from the earth and atmosphere'[12]. In reality, however, they were scrabbling in the dark, unlike John Donaldson who was content to admit he did not know: he just accepted that lime worked 'some how or other'[13].

Prominent scientist Humphry Davy was the first to make a breakthrough in explaining the secrets of agricultural chemistry, but even he was not able to understand fully how lime impacted on plant growth: he knew that it did and he was able to articulate this but not the science behind it[14]. His major contribution here was to lay the foundations for those who did eventually crack the problem some three decades later under the RASE's 'practice with science' banner[15].

The pre-eminent role played by a group of influential people, many of them Scottish and all male, known to us as the 'Improvers' cannot be underestimated. Reference has been made earlier to men imbued with the improving ideal but their role and significance really came to the fore during the second half of the eighteenth century. For any self-respecting landowner there had to be a renewed and reinvigorated emphasis on improvement in its widest sense, improving the soil, introducing new crop and livestock strains, planting woodland for aesthetic and financial reasons, improving estate buildings, and making farming a 'locus of innovation and experiment'[16]. No estate owner could hold his own among his peers unless he had wholeheartedly taken on board and implemented the Georgic ideal placing himself at the cutting edge of modernity[17]. After all, if the king, George III, or, to give him his *nom de plume*, Ralph Robinson, believed that farming was the 'greatest of all manufactures', how could mere landowners not agree and emulate his passion[18]?

There has been a long-running debate as to how influential the Improvers really were, and some would argue that the impetus came from estate stewards or even progressive tenants rather than from an often absentee landowner[19]. In reality it would be unwise to generalise, as the situation varied from estate to estate and from one generation to another: further evidence of the extent and impact of improvement and change in Cumbria will be presented in this chapter and the next.

Undoubted missionary zeal and the passion of prominent Improvers, with the pace perhaps being dictated by Arthur Young, reached their apogee during the French Revolutionary Wars of 1792–1802 and the Napoleonic Wars of 1803-1815. This was a time when Britain faced economic catastrophe in the face of French naval blockades and the country was compelled by circumstances to not 'dig for victory' but 'dig for survival'. Land that had not been put to the plough for centuries was suddenly once more under crops; vast areas of so-called

waste were reclaimed for farming, including much that at best could be seen as marginal. Land managers were exhorted to force 'wasteland' to submit to the 'yoke of improvement'[20]. Prices of farm products soared, providing landlords and tenants alike with extra money to invest and improve, and the impetus to develop new methods was strengthened immeasurably. The transport infrastructure – new or improved roads as well as canals – was transformed. Agricultural production doubled in volume between 1795 and 1815.

Contemporary Observations

Arthur Young, one of the key driving forces behind the concept and implementation of Improvement, undertook an extended tour through the north of England with the specific aims uppermost in his mind of reporting on the state of farming across the region and suggesting where and how improvement might be achieved. To him, 'waste' land, meaning land not in directly and observable productive agricultural use, had to be brought into play for the general good. His findings were published in 1770[21]. He did not mince his words if he encountered something to his distaste: having travelled from Brough to Askrigg, passing over the moors from Nateby to Keld, he condemned the roads as 'dreadful and 'impassable' and the landscape as nothing better than 'melancholy' but, ever the optimist, he identified tracts of 'very improveable' land. In reality, however, his notion of what could be coerced into production differed from the generally accepted view of those who really knew the land and its realistic potential[22].

Nevertheless, setting aside his prejudices, his observations do tend to focus more on the objective than the subjective, noting details of local soil types, crops, basic methods of husbandry and comparative land values[23]. To the south of Carlisle he found a farming economy based on a rotation regime of fallow, wheat, oats, peas or turnips, and barley, followed by three years of clover, although the use of turnips as fodder for sheep and cattle was not yet widespread in Cumbria. He seemed surprised that grassland was not generally manured, whereas what potatoes he saw were 'well-dunged'. At High Hesket he picked up on the impact of variations in soil type. Generally in the Eden Valley, small farms averaged £30-120 in annual rent whereas at High Hesket they were generally let for £10-100: the latter was held back by heavy clay soils and high levels of stone content.

The Mechanics of Improvement

In the Penrith area the rotation was basically the same as further north, but land values were higher, averaging £80-150 per annum. Here he commented on the relatively recent uptake of liming, which was the main soil input rather than manure. His descriptions of Borrowdale, Haweswater, Windermere and Ullswater are almost poetic, with the use of descriptors like 'sublime', 'charming verdure' and 'truly noble' with 'cultivated enclosures' all around the latter. When he reached Lowther Hall, his language was less than complimentary and it remained thus as he journeyed southwards. The Lowther Estate employed a rotation system based on two years of oats, then barley and oats again, and then grass, before returning to oats; Young found this 'execrable', which is somewhat at odds with annual rentals there, which ranged from £40-400. Surely, if the estate's tenants were not making a good income from that cropping regime, they would not have risked taking on holdings with such high rents. He found the countryside southwards from Shap to be 'one dreary prospect', despite the soil's huge potential, although the approach to Kendal pleased him more with its 'noble range of fertile enclosures'.

Comments like these emphasise his single-minded obsession with improvement at all costs, even where climatic and soil conditions militated against cultivation and intensive livestock rearing. Two

Banner Rigg from the south.

small areas east of Windermere illustrate this point admirably. Today, Orrest Head is either mixed woodland or rough pasture; Banner Rigg, just to the east, has a mix of rough and semi-improved pasture. In Young's day, both had enclosures with either grass or corn rising to their tops and he described the latter as a 'fine cultivated hill'. That (romantic) impression is certainly not gained today. They are beautiful and still grazed, but not at all what he saw.

It was Young's view that land with low annual rents must equate to tenants who were a 'pack of slovens', as high rents were a 'spur to industry' and self-improvement and therefore welcomed by hard-working and progressive farmers[24]. While it is difficult to agree with such strident sentiments, it must have been impossible to argue with him to the contrary.

More down to earth – maybe even prosaic – observations were made by the commissioners appointed by the Board of Agriculture to report on the state of farming in Cumberland and Westmorland[25]. Like all commissioners, these men were tasked with answering thirty-five prescribed questions, so their opportunities to be subjective or overly critical were limited by the parameters set[26]. This did not stop them from being disparaging, notably towards the statesman class of small farmers on customary tenure rather than formal leases. Whereas, in those authors' opinions, gentlemen farmers displayed a 'spirit of enterprise', the statesmen were 'rarely aspiring' and were content with their lot and not inclined towards undertaking improvements. Of one tenant in Uldale, north of Skiddaw, who saw no need to re-seed with new strains of grass or clover, commissioners Bailey and Culley concluded his attitude was no less than 'barbarous'.

Cumberland's commissioners provided details of where and to what extent liming was practised, and how its effects were perceived by farmers. They encountered some who believed it to be harmful to the soil, and to grass and crops, but in their considered opinion lime was of great benefit if used sparingly: too much applied too often was not. They also described in some detail how farmers reclaimed peat land by deep ploughing in autumn, followed by further ploughing at right angles to the first in the following spring. They left it fallow through the summer, then dressed it with lime followed by manure, or with a compost and lime mix at a ratio of five loads of compost to one of lime. Costs varied from 10s to £9 per acre, depending on the methods employed. They also noted the application of seaweed and sea mud as soil improvers along the coast and even mussels,

presumably crushed, in the Ravenglass area spread at the rate of five to six cart loads per acre.

In short, Bailey and Culley felt that farming in Cumberland was held back by a range of obstacles: there were too many small farming units, constrained by outdated customary tenure; a general lack of formal tenancy leases; and an absence of agricultural societies. Improvement could be brought about, but only if new practices were adopted, including more sensible rotation systems, new stock breeds, enclosure of common land of which 151,000 acres (61,000 ha) were improvable in their opinion, watering of meadows – a practice hardly seen in the county – draining of wet land, and flood control near rivers. In a sense, they were reporting what the board's commissioners wanted to read and they were definitely toeing the 'party line', so their comments should be seen as partisan; nevertheless, much of value is highlighted in their report.

Pringle, commissioner for Westmorland, estimated that three-quarters of the county was still 'waste' consisting of considerable areas of lowland commons that were capable of improvement, as well as fells and moors. He agreed with Bailey and Culley that many farms were small and worked by hard-pressed poor statesmen, but he presented numerous examples of progressive husbandry and attention to detail. Among the more unusual methods was one observed between Kirkby Lonsdale and Burton in Holme, where wheat was grown in abundance. To ensure it got off to a good start the seed was first soaked in brine, then washed in 'chamberlye' (human urine) before being dried with lime, all to prevent rust, before being sown in September; lime was applied generally in measured quantities; deep draining was increasingly in use, as was paring and burning on newly reclaimed moorland. The picture he portrayed was, on balance, positive.

Furness was surveyed and reported on by the commissioner appointed to cover Lancashire, John Holt[27]. He had much to say about reclamation of coastal and estuarine areas, emphasising the work of John Wilkinson of Castle Head (SD421 797) near Grange-over-Sands, and he noted Low Furness's 'excellent wheat lands' and High Furness's 'fertile vales'. He also drew attention to the marked difference in stocking levels, with Seathwaite Fell in High Furness only capable of supporting four or five sheep per acre in contrast to Low Furness's seven or eight, and in stock quality: the former tended to fetch 10s 6d per head, the latter 16-21s. The reasons

are obvious, given topographic, climatic and soil differences. One practice enshrined in customary law in Furness may, at first sight, appear restrictive and outmoded but, in reality, made perfect sense. Outgoing tenants were bound by custom to leave behind a specified number of sheep: wethers (castrated male sheep), hoggs (sheep from six months old to their first clipping) and twinters (sheep that have lived through two winters). Sheep rearing then, as now, was based on hefting, whereby ewes learn which part of the open fells is theirs to roam across and pass that knowledge on to their offspring. If each new tenant had to bring in all his own animals, they would have to learn this anew; by inheriting some hefted stock he would save himself, and his neighbours, a good deal of effort. However, for the departing tenant there was a get-out clause. If he did not, or could not, leave stock behind, he could pay a cash equivalent, although it is difficult to conceive of many taking advantage of this option.

William Marshall was less than flattering about Holt's attributes, describing his skills as those of an 'inexperienced tourist'[28]! From his own observations, Marshall was considerably more positive about Cumberland and Westmorland, describing the Eden Valley and its main tributary valleys as among the most fertile in the country;

The Lune Valley at Crook of Lune, with the Howgill Fells beyond.

Lunesdale having lands of a 'superior quality', and Kendale in general having arable land of 'great fertility and in a productive state of management'[29].

Commissioners and appointees to the board all adhered to the same agenda, and had the same ultimate aim of advising on how well the land was managed and how the so-called waste could be brought into the market economy. Other contemporary observers and diarists were not in any way constricted. They wrote what they saw and felt. Some tended to describe what they perceived to be Cumbria's natural beauties – or curiosities – while others were more perceptive and offered their readers an insight into the local economy.

Antiquarian and topographer William Hutchinson produced, among other works, a history of Cumberland, which contained a mix of historical and then-current information on a township basis[30]. He made very similar observations to those of the board's commissioners, without their narrow focus: for Edenhall, east of Penrith, he wrote of 'neatly' enclosed lands concentrating on barley, oats and rye with peas, turnips and some wheat alongside common grazing lands; for Melmerby, below the Pennine escarpment, he observed oats, barley and potatoes, but not turnips or rye, whereas in Ousby not that far away turnips were grown as well as copious quantities of hay. Further north along the Pennine edge, for example in Cumrew, he had seen 'great flocks' of sheep grazing the fells in summer but brought down to the lowlands for the winter. He was unkind to Ainstable and Melmerby, both townships at the foot of the Pennines. In Ainstable much of the land was worked by small farmers and, predictably perhaps in his jaundiced opinion, was 'bewildered and wild', in clear contrast to that farmed by larger units. Perhaps he was just trying to express the romanticised view that the fells were untamed and impressive; much of Melmerby, on the other hand, was 'deplorable' and that word surely can only have one interpretation.

Hutchinson's contemporary, John Housman, was a land surveyor with his feet more firmly planted on the ground, and his observations were definitely rooted in reality[31]. Clearly he had set out to provide an, albeit brief, summary of the landscape and its land uses. He described husbandry practices, commented on the state of roads and discussed manuring and liming, reporting that problems of sourcing coal had prevented the adoption of liming on a large scale in Westmorland, even at the time he was travelling.

An anonymous contributor to a national journal, targeted at an educated readership, wrote of Furness at the start of the nineteenth century where, until recent times, farming had been in a 'spiritless state', although the draining of marshland, the grubbing out of invasive bushes, the assiduous use of manure, and the practice of liming were beginning to transform the farmed landscape[32]. One age-old practice was seemingly on the wane, namely the encouragement of holly bushes as a valued source of winter fodder for sheep; he gave no reason for the change. In the same year a local magazine published an account of the parish of Orton between Shap and Tebay. The correspondent described how Orton Moor, formerly common land, had been (partly) enclosed and brought into productive use by paring and burning and liming, with turnips sown in the first year followed by two years of oats[33]. Enclosure of the moor had been resisted by those who had enjoyed ancient common rights there[34] and, reading between the lines, the correspondent may have been sympathetic to their cause, as he dryly noted that, after three successive crops, it would once again be unproductive. He was probably correct. He also echoed what the anonymous contributor had written in that liming – in this case at the foot of the Howgill Fells – had only recently been taken up but was already being used enthusiastically on pasture land. The same local correspondent wrote in the following year (1804–05) that farms across Kirkby Stephen township were very fruitful in both grass and corn crops, and that pasture and meadow land had in recent years greatly benefitted from the application of lime and manure[35].

Thomas West was an antiquary and a churchman who authored an historical account of Furness in the late eighteenth century[36]. He can perhaps be accused of bias in the same way as Hutchinson. He bemoaned the antipathy to change among the farming classes and railed against the working class: who would bother to invest in land that others would benefit from was one of his mantras, one, it has to be admitted, with more than a grain of truth in it. In regards to Broughton township he was positive, as there were visible signs of recent improvement in the landscape.

Finally in this brief survey, a paper written by John Moore in the early nineteenth century for a learned journal can be perceived as more true to reality than some of the less-balanced accounts[37]. He journeyed from Lancashire as far north as Keswick and, in his own words, was a person 'fond of agricultural pursuits', and that is evident

The north side of Latrigg, the only possible part that could have been ploughed.

from the observations he made. Between the county boundary and Kendal he remarked how well managed were the farms and how extensive the production of grain crops; he observed how common were carts laden with lime applied as summer top dressing on local pasture land. 'Well-sized' sheep were to be seen everywhere eating off fields of good clover. North of Kendal, barley was grown even on land that many would have considered too high, and farming there was 'spirited' in nature. Approaching Lowther from Shap, he waxed lyrical about the quality of the corn and turnip crops, saying he had seldom seen better corn anywhere. Interestingly, around Penrith he had clearly been impressed by the cultivation of what can only have been the Aberdeen Yellow Bullock turnip (*Brassica rapa* ssp. *Flavescens*), which was hardier than the common white turnip (*Brassica rapa* ssp. *Rapa*). St John's, east of Keswick, was highly cultivated and he had been surprised to see oats and barley being grown at an altitude of 300m on Latrigg, one of the southern foothills of Skiddaw. He was perhaps more than surprised by this, as he questioned the wisdom of growing crops at such altitudes; he agreed that the farmer concerned was a man of spirit, but he doubted he would make any money out of it, as he had to lead manure at his own (great) expense. Had the farmer been cultivating Latrigg during

the Napoleonic Wars, it would be understandable, given the dig for survival mentality of those years but, once the wars ended in 1815, severe economic recession set in and so it is difficult to comprehend his reasoning.

In Lorton Vale and Swinton, south of Cockermouth, Moore once more questioned farming practices, drawing attention to the damage being done on the hillsides by paring and burning by local farmers, who harvested bracken, which grew here luxuriantly, burning it for potash to create new fields. Wheat was already successfully rotated, with barley or oats mixed with grass and clover seeds in the Vale, and they wished to extend the cultivable area, as was also being done on 'considerable allotments' at Whinlatter, an area now entirely given over to coniferous plantations, certainly a more realistic use of low-quality hills than grain crops. Moore's relatively short paper provides a much more reliable description of farming in the areas he visited than some of the other, less rigorous and more one-sided sources summarised here.

Before examining a range of methods used to bring about improvement during the era of parliamentary enclosure, it is, again, pertinent to consider constraints faced by farmers in Cumbria.

Farm Leases

The often short length of leases and the binding stipulations that accompanied many of them continued to be a running sore through the entire period under review in this chapter. There was certainly no consistency in length, and stipulations varied from lease to lease. In 1784 John Dargue, father and son, leased land for a term of nine years; among the stipulations was the obligation to set aside 3 acres of 'faugh' (fallow) every summer and to till and lime it in the accepted manner, husbandry designed to ensure the land was not over-worked[38]. A slightly earlier lease on the Sizergh Castle Estate also bound the incoming tenant to leave some land under fallow and to lime or manure it in the accustomed manner, but he was required to sow it with wheat or turnips in his first year and, were he to plant turnips, with oats or barley in the second. He was further obliged to install drains in the wet part of the enclosure at his own expense, then to pare and burn it and put it down to cereals for two years. Whatever was under grass when he took on the lease was to be sown with oats in his first year and barley after that[39]. Such tight

Hall Intack Farm with the original steep thatched roof line visible in the gable wall.

restrictions took no account of year-to-year changes in weather or economic forces, but landowners could get away with it during times when farming was profitable and holdings hard to come by. Similarly restrictive conditions were imposed on George Fawcett when he took on Hall Intack Farm (SD717 972) in Ravenstonedale in 1779[40]. The lessee was bound by the agreement to burn a 'sufficient quantity of lime at his own Expence', although the lessor was to reimburse the purchase cost; furthermore, the land formerly under potatoes and turnips was to be laid down to bigg or barley in the first instance, followed by 'bean bigg' in the second, and what was currently under oats was to be similarly sown in the third. Hall Intack stands at the upper end of an enclosure that was patently improved at some point in the past; however, it has lain in ruins so long that the field itself is reverting to its pre-improved state and it is difficult now to imagine it ever having been put to the plough.

When three farms on the Rydal Hall Estate were let as a combined unit in 1792, the lease was advertised as eleven years on the death of the previous longstanding tenant. While the full tenancy stipulations have not been found, the sale notice merely stated that they were

to be worked according to the 'best manner of husbandry', as was customary in the area, with a maximum of 20 acres (8 ha) to be ploughed each year[41].

In 1802 Bluegrass farm in Stainmore was let by the earl of Thanet's estate at Appleby Castle to Thomas Whelpdale for a term of seven years[42]. He was closely tied in to following a rotation system – pasture followed by two years of fallow, then two of cereals then beans or clover – and was required to spread specified quantities of lime and dung. In short, he had little latitude to manage the farm in ways he thought most appropriate.

During times when economic fortunes were less favourable and good tenants hard to find, landowners could not afford to be too demanding when tenancies came up for renewal. However, the owner of the relatively small Bank House estate in Barbon (SD635 821), Lunesdale, re-let in 1817, imposed strenuous conditions on the new tenants of one farm there[43]. It was only 42 acres (17 ha) in size, and the lessees were described as husbandmen, so not at the upper end of the economic scale. Nevertheless, they were required at their own expense to lead from the kiln and spread 100 bushels of lime, mixed in with sludge 'that arises out of the two Puddles in the Lane', on Low Meadow in their first two years and on pastures in the third. Furthermore, they were to lay 1,000 bushels across the farm as a whole, including the 100. The landowner stood the cost of buying the 100 bushels, but the lessees could hardly have benefited as their lease was only for a term of five years, unless it was their intention to renew the lease on expiry: whatever the case, in the years of recession that followed the end of war in 1815, they were taking a huge gamble.

Far more sensible were the terms for renewal of the lease for Bleaflatt farm in Ravenstonedale (NY736 037) in 1835, also a time of rural distress[44]. The farm was re-let to the existing tenant for a further three years and he was forbidden from ploughing up any land then under grass; however, if he wished, he could convert cropland to meadow. He was to lay sixty bushels of lime mixed with soil each year across the farm. He was also justifiably obliged to maintain all walls. Pringle noted in his report to the Board of Agriculture that, within Ravenstonedale, farm leases ran for anything from three to twenty-one years, but that some estates still did not employ leases at all. Bailey and Culley found a similar situation in Cumberland

where leases, if they existed at all, were generally for five, seven or nine years[45].

Whatever the length of a lease, the inescapable reality was that landowners could now set their own husbandry conditions; in short, in their mind, they were no longer fettered by the strictures of ancient customary law.

The Impact of Weather

From 1760 to 1817, average annual temperatures were below the long-term running mean of 9.43°C for thirty-four years; only in 1779 and 1781 were values significantly above the mean, and there were particularly cold spells in the late 1760s, 1784 and 1816–17[46]. Climate patterns are cyclic anyway, but the eruption of Laki in Iceland in 1783–84 severely affected northern Europe, causing frequent storms, a very long hard winter, and harvest failures[47]. The eruption of Tambora in Indonesia in 1815 had a similar impact and, across England, the following year was christened 'the year without a summer'[48]. Spring 1827 brought exceptionally cold weather that endured for weeks and losses of livestock were widely reported: one farm in Ennerdale reported losses of 300 sheep, and one at Buttermere several hundred[49]. Wide fluctuations were seen in annual rainfall totals, too: twelve years suffered above-average rainfall between 1760 and 1817, with 1771–75 and 1789 being extraordinarily wet, and only 1779–88 below average[50]. These are all data derived nationwide, but there is supportive evidence from local sources. John Moore noted that the winters in Cumberland had been 'uncommonly severe'[51]; and Bailey and Culley provided rainfall data for Keswick for 1789–95, over which period it averaged 1,775mm, considerably above its long-term average of 1,521mm[52].

Harvest failures have been noted nationally for 1796–97 and 1816, and major outbreaks among livestock in twenty years between 1769 and 1853. Thomas Rigg of Applegarth (SD626 846) felt moved to write a long account of what he termed an epidemic among cattle in Lunesdale in the 1830s, though another contemporary wrote that Westmorland mostly escaped this outbreak[53]. Meanwhile Curwen noted in some detail a serious outbreak of foot-and-mouth disease in Westmorland in 1839, an epidemic so serious that farmers resurrected the age-old practice of need-fire[54].

Distress

The termination of any drawn-out period of war inevitably had negative consequences, even on the victorious nation. Over a very short period of time, many thousand soldiers and other personnel were discharged and effectively thrown onto the streets. The economy needed time to recover and to adjust to peace and could not begin to absorb the huge pool of labour. This was the case when the Napoleonic Wars came to an abrupt end in 1815, but this was not the first instance of nineteenth-century rural distress.

Lord Carrington, president of the Board of Agriculture, replied by letter in 1800 to the earl of Thanet concerning distress among the farming community in Westmorland[55]. Carrington assured Thanet that the board was taking the matter seriously, although his letter did not spell out what form the distress took or what had brought it about. Reading between the lines, it may well have been due to an increase in the number of small and unviable farm holdings. The advice that the board offered to prevent a reoccurrence of the problem was further 'Inclosure of the Waste', presumably in its view to make available more farm land. Carrington urged Thanet to promote this course of action at the next sitting of the Westmorland assizes, as it had been so successfully applied in neighbouring Yorkshire. Thanet's original plea and his response to the advice have not been located.

One result of peace in 1815 was the resumption of overseas trade, the nation having endured a French naval blockade for many years, and a negative side effect of this was a flood of cheap corn imports from North America, which severely undermined market prices and hit British crop farmers hard. The result was agricultural depression that was not confined to the immediate aftermath of the wars. Select committees sat between 1820 and 1822, taking evidence from across the country of the degree of distress among rural communities. Though regions where pastoral farming outweighed arable, such as Cumbria, suffered far less than regions dominated by cropping, there was still some distress. The report of one select committee, in 1824, found that labourers' wages in Cumberland were still at a satisfactory level, unlike in many southern counties, and, indeed, were higher than in Northumberland and Yorkshire[56]. Prices remained depressed into the 1830s, again with pastoral regions faring best owing to continued high meat prices, and further select

committees were formed to assess the situation nationwide by calling forth witnesses from each region.

A select committee sitting in 1833 heard the testimony of William Blamire, MP for East Cumberland, who himself owned an estate of 700 acres (280 ha). He reported that the aggregate value of agricultural produce from his county had fallen, mainly because a lot of marginal land brought into use during the wars had since been abandoned and was reverting to nature; and much land had been over-worked during wartime, to the point that it was by then 'almost valueless'[57]. Despite this, Cumberland was still a net exporter of grain, especially to Lancashire and Northumberland, with many ancient enclosures growing more grain than ever. On the negative side, nevertheless, farm rents were, in Blamire's opinion, too high in both Cumberland and Westmorland and a rising population meant ever more people were competing for tenancies, thereby putting inflationary pressures on rental values: he suggested enforcing an overall rent reduction of 10–20 per cent. In Cumberland a typical rent was £2 per acre, whereas the land was worth only £1 6s or £1 7s. Despite pressure of population, Blamire considered that the number of statesmen had fallen since 1815 and that, as a group, they were worse off than before. In reality, however, this decline had been apparent even prior to the French Wars. He asserted that many statesmen had invested too heavily during the wars, borrowing or mortgaging their holdings, and were now struggling to pay off their debts. Their situation was rendered more fragile by national monetary policy and by a succession of cold, wet summers and poor harvests (in 1799, 1801, 1810 and especially that dreadful year, 1816).

Further sittings looking into the state of farming were held in 1836, although no evidence from Cumbria was presented; the sittings enquiring into the extent of distress held in 1837 once again heard from Blamire, but committee members could not agree on what to include in their report and so settled on a fudge by submitting evidence rather than recommendations[58]. This time Blamire assessed farming in eastern Cumberland as 'extremely depressed', more so than many other counties, largely because desperate tenants on marginal land had worked it to the bone, and many of them were only keeping on their tenancies because they had no other option. Many smaller statesmen had been reduced to a 'pitiable state' by twenty years of depression, and the actions of some landowners were not helping. In an attempt to improve land quality and, in the long-term, land values

and therefore rents, they were investing in drainage schemes and giving tenants allowances for using new chemical soil inputs instead of cutting rents. Tenants simply could not afford these higher rents in the short term, and would struggle unless imports were curbed and government economic policy changed.

Blamire was obviously a member of the establishment, and of landed gentry stock, so one might justifiably read what he said with a dose of cynicism; yet his evidence to both committees shows him to have been a person in sympathy with his constituents, and his reading of the situation was probably very close to the truth. It was also supported by more local, and potentially less biased, sources. A local newspaper ran a heartrending story in 1830 under the headline *Agricultural Distress*: 'In the present state of Agriculture, when the occupier of a small farm is incapable ... to meet, in any way, his expenses'. Many were driven to apply for assistance under the Poor Laws as rents, tithes and taxes far exceeded farm income, and a 30 per cent reduction in rent was needed[59]. Many farms lay empty, either up for sale or to let.

Submissions to the Poor Law Commission in 1834 showed how serious the situation was, at least in Westmorland[60]. In response to Question 36 – Is agricultural capital increasing or decreasing? – nine out of thirteen townships reported a decrease or stasis and only Long Marton reported otherwise. There, large-scale enclosure had brought about a 'probable' increase.

Land Tax

No doubt one of the taxes that Blamire had in mind was Land Tax. This was first levied in England in 1697 to raise finance to defend the nation against Louis XIV's belligerent gestures[61]. The government imposed a tax quota on each county, divided up among parishes and administered by local commissioners, who in turn appointed tax assessors and collectors, some of whom were prominent tenants within the areas they were assessing. This clearly provided opportunities for self-interest, but also put them at the mercy of unscrupulous landowners, who were wont to exert pressure to reduce their own tax liability. When the tax was barely one year old, Lord Lonsdale wrote to Sir Daniel Fleming at Rydal, instructing him to levy at the flat rate of 3s in the pound[62]. The manner in which the tax was set up created disparities from one county to another:

the average number of acres per pound of tax levied in 1815 for England was seventeen, for Yorkshire forty-two and Lancashire fifty-seven, but for Westmorland it was 166 and Cumberland 262[63]. The methodology was reformed and improved in 1798, and any 'proprietor' valued at less than £1 per annum was exempted[64]. Land Tax returns need to be treated with caution, and trying to compare pre-1798 with post-1798 data is fraught with difficulties but, if viewed in a nuanced manner, they can provide a degree of insight into tenancy patterns, size of land holdings and wealth/status. The system was again reformed, for the better, in 1815–16.

A letter to *The Gentleman's Magazine* in 1766 was scathing about the impact of the tax and its author no doubt spoke for many whose social status deprived them of a voice[65]. He wrote that Cumberland only had thirty or so large landowners and the vast majority owned land valued at less than £50 per year: 'these petty land owners work like slaves, they cannot afford to keep a man servant' and relied on family labour. They had a 'miserable way of living ... and save nothing'. In short, he raged, they could not raise enough funds to pay Land Tax. An entry in the personal diaries of William Fleming, a farmer at Rowe Head in Pennington (SD266 771) and a would-be member of the gentry, for 1897, was in a similar negative vein[66]. He complained that the latest Land Tax assessment was so 'heavy and oppressive[that it had] raised a Ferment ... which cannot be soon allay'd': farmers were faced with much reduced grain and cattle prices but higher food prices, so were struggling to survive.

When Land Tax returns for Westmorland are examined at parish level, the disparities are self-evident[67]. There is no correlation at all between the total number of land holders assessed, which goes some way to showing that, overall, some parishes were more prosperous than others; and minimal correlation between the total amount assessed and the number of landowners assessed at more than one pound. Yet comparing those two sets of data presents problems. For example, Dufton with seventy-eight people assessed at a combined total of only £28 would suggest it was not a particularly prosperous parish, yet it had six individuals assessed at over £1. There were clearly significant differences in wealth within Dufton, especially if one removes the six, leaving seventy-two people sharing a tax burden of only £22. There again, more were assessed at 2 to 5s than below 2s and only twenty-six between 5s and £1. The same general pattern is apparent for Kirkby Lonsdale, whereas in parishes like Rydal or

Parish	Total tax due	No. of individuals assessed for tax	No. assessed at >£1	No. at <5s	No. at <2s
Ambleside	£17 11 0	50	1	25	15
Barbon	£14 12 6	40	2	20	16
Bleatarn	£17 6 4½	37	1	12	4
Crosby Garrett	£18 2 2	53	5	24	17
Dillicar	£5 17 0	17	0	3	1
Dufton	£28 1 ?½	78	6	46	29
Grasmere	£9 15 1½	55	0	39	18
Great Ormside	£15 2 9¾	27	5	14	8
Hincaster	£17 10 0	34	7	22	16
Hutton Roof	£16 16 4½	47	3	24	8
Kentmere	£24 2 3	42	7	13	7
Kirkby Lonsdale	£35 0 6	178	10	138	104
Longsleddale	£23 15 6	45	1	6	4
Milburn	£20 9 7¼	48	2	18	7
Raisbeck	£25 11 0	48	6	18	9
Rydal	£9 10 10½	56	1	52	34
Troutbeck	£19 19 10½	55	1	31	9

Table 4: Selected Westmorland Land Tax data, 1773. (CAS[K]WQ/R/LT)

Dillicar there was on balance more parity, with only one or none respectively assessed at over £1 and in both cases the vast majority assessed at between 5s and £1.

Contrasting data from 1773 with those for 1831 shows that the rates of increase were broadly similar. For eight of the eleven parishes, the overall increase in the tax burden was approximately one-third; in Dillicar the increase was only half that, and in Ambleside it was a quarter. In Kirkby Lonsdale the increase was, by comparison, staggering, but is explained by the huge increase in the number of individuals assessed and the corresponding number liable to pay over 5s.

Despite the broad range of constraints that landowners and tenants faced, all of which were in effect beyond their power to obviate, and some of which acted in their favour, notably the long drawn-out French Wars, which kept farm-gate prices high, farming embraced huge changes during the period under review. If plotted on

Parish	Total tax 1773			Total tax 1831			% increase
Ambleside	£17	11	0	£22	4	0½	26
Barbon	£14	2	6	£19	9	6½	38
Dillicar	£5	17	0	£6	16	9	15
Grasmere	£9	15	1½	£13	0	2¼	34
Hincaster	£17	10	0	£23	8	0	34
Hutton Roof	£16	16	4½	£22	8	6	33
Kentmere	£24	2	3	£32	3	0	33
Kby Lonsdale	£35	0	6	£74	3	10¼	111
Longsleddale	£23	15	6	£31	14	10	34
Rydal	£9	10	10½	£13	4	2½	38
Troubeck	£19	19	10½	£26	13	2	33

Table 5: Westmorland Land Tax assessment for selected parishes, 1773 and 1831. (CAS[K]WQ/R/LT)

a graph showing change against time, however, the line would not progressively rise but would fluctuate, at times quite dramatically.

This chapter now moves on to consider some of the strategies employed in Cumbria that brought about improvement and change in farming.

Enclosure

In 1800 'waste' land still accounted for almost 80 per cent of the land area of Westmorland and, with Cumberland, it had the highest proportion of unenclosed land in England; in comparison the North and West Ridings had 29 per cent and Lancashire 9 per cent[68]. The national average was 21 per cent. Parliamentary-style enclosure in Cumbria began in 1760 and, over the ensuing seven decades, 20 per cent of the land area was enclosed and divided up. One set of calculations estimates that 470,000 acres (190,000 ha) of Cumbria had been enclosed by 1794, 670,000 (271,000 ha) by 1815 and 750,000 (303,000 ha) by 1850[69]. In Cumbria, unlike many areas in eastern England, the vast majority of newly enclosed land was on what had hitherto been set aside as common pastures on the Pennine moors, the Lakeland fells and coastal and estuarine marshes – all tracts of land that had not previously been considered worthy of enclosure.

Despite this, discrete areas of medieval open fields survived in the two counties into the early nineteenth century: the open townfields at Renwick, below the Pennine scarp, were only internally subdivided after enclosure was sanctioned in 1818; Murton's three open townfields were only gradually subdivided after 1764; and Longsleddale still had small areas of unenclosed townfields below Sadgill, at Stockdale and at Docker Nook as late as 1834[70]. Even later than these was the breaking up of the 52-acre (21-ha) Keisley Field in Dufton township, which survived as arable strips until its enclosure award of 1859[71].

With the likes of Arthur Young exhorting landowners to develop the 'moors and heaths' of this country, turning 'ling, whins and ferns' into crops and clover so that 'bread and beef will be plentiful', rather than migrating to the 'swamps and forests' of North America, and Sir John Sinclair asking 'why should we not attempt a campaign against our great domestic foe, I mean the unconquered sterility of so large a proportion' of the land[72], it was difficult for patriotic landowners in a time of rising international disquiet and ultimately outright war to resist such pressures. The aims of and rationale for enclosure have been well rehearsed elsewhere and it is not the intention to repeat it all here[73]. A few cogent points will suffice.

Landowners were constrained by the mechanics of customary tenure and their income was limited and unpredictable; if they were to embrace enclosure they could let their tenements on leasehold, securing a guaranteed annual income stream. Furthermore, if common land were parcelled out and worked on an individual basis rather than communally, landowners might feel it would be worked in a more sympathetic manner, rather than being over-stocked and thereby depleting resources. On the other hand, former customary tenants could invest time and finance in their allocated plots, as whatever they did would be for their own rather than the general good. They would also benefit from infrastructural improvements such as realigned and newly surfaced roads, watering points for their livestock, and improved drainage. In some instances it was the tenants who were the instigators and promoters of enclosure; in others, they opposed the wishes of the landed class to enclose.

The almost immediate visual impact of enclosure on the landscape was dramatic and permanent. Former common pastures and moorland were constrained within a grid pattern of dry stone walls, which tended to conform to a standard pattern as dictated by the

commissioners of each award, with ruler-straight roads changing direction at right-angled bends. Seen from the air the landscape looks as if it was designed by someone sitting at a desk, and in many cases this was indeed how it was done. Examination of modern OS mapping admirably illustrates these characteristics, as at Bleatarn, Newbiggin, Culgaith, Castle Sowerby, Skelton and, notably, Inglewood Forest. Typical of all these areas are the farmsteads that resulted from enclosure, as new farming units were created from former open pastures: it follows that, for the landowners, more units equated to more tenants and thus more rental income.

Landscapes of parliamentary-period enclosure contrast starkly with what commissioners termed 'ancient enclosures' – those small, irregularly shaped fields with curving boundary walls and hardly a straight line or right-angled corner in view, which had been created in a piecemeal fashion over preceding centuries. Very different, too, are the woods and copses that were first planted in 'ancient' times with their mix of species and unplanned nature, on the one hand, and the regimented plantations, woods, spinneys and hags of parliamentary enclosure, on the other. The latter were often planted for aesthetic purposes, or to ensure a regular supply of timber for the estate or, in many cases, to act as coverts for game birds like pheasant and partridge. For large estates, taking control of common land through the enclosure process also gave them sporting rights, and this became a significant extra source of income as the pastime gained in popularity in the late eighteenth century.

Game pursuits were not confined to the lowlands: large areas of moorland were included in enclosure awards, not with any intention of trying to reclaim them for farming but to develop them as grouse moors, another lucrative source of income for the landed estate from the late eighteenth century. These moors were let out as seasonal low-density sheep pastures but their essential purpose was to support as large a population of red grouse (*Lagopus lagopus*) as possible; this required moorland to be actively managed to create a patchwork quilt of heather at various stages in its growth cycle, providing food here and nesting habitat there. Lines of stone shooting butts were planted across open moors with the occasional shooting cabin or lodge. No doubt those landowners with grouse moor or pheasant coverts saw all this as improvement; birds were certainly more profitable than sheep; and what is beyond doubt is that such landscapes were changed immeasurably to accommodate

the needs of shooting parties. This was a phenomenon of change, if not of improvement.

Elsewhere, enclosure was undertaken with the specific purpose of planting vast swathes of coniferous trees. Some such plantations were created as a direct result of enclosure, whereas others were secondary land uses adopted when it became obvious that marginal land enclosed and put down to pasture or even crops was a mistake of sometimes epic proportions. Soil, climate, angle of slope and problems of access made farming a loss-making proposition; better to put it down to trees with the long-term aim of clear felling and selling the timber on the commercial market. This obviously involved long-term thinking, but that was all part of the philosophy of improvement: it required landowners to accept their responsibility and obligation to provide for their descendants and to build up an estate that would endure long into the future.

One such landowner was Richard Watson, born the son of a schoolmaster in 1737 at Heversham on the River Kent. He made good, becoming a Fellow of the Royal Society, a professor of chemistry and, ultimately, (absentee) Bishop of Llandaff from 1782 to his death in 1816. He bought various estates in Westmorland, including Calgarth Park at Troutbeck Bridge, where he kept a large flock of sheep and planted a number of woods, as well as extensive lands around Gummer's How at the south-east foot of Windermere where, again, he had large plantations created. He was a contemporary and social equal to John Christian Curwen (1756–1828) of Workington Hall, a major industrialist and prominent agricultural improver and tree planter. The traveller John Moore, whom we met earlier, commented on the bishop's 'extensive' plantations, mainly of larch, that clothed the hillsides on the approach to Keswick[74]. Both Watson's and Curwen's investments personify the broader improvement ideal as propagated by the Georgical movement.

The dukes of Buccleuch maintained a disparate estate in Furness, with much of the land they had earlier purchased in High Furness valued for its timber reserve and potential rather than for any hope of making a profit from farming. Account books list rental income from various manors and townships, and 'wood sold' or 'timber sold' occur again and again, with occasional payments for protective walling around areas of new planting, such as that around the 'great Coppice' at Sea Wood south of Ulverston coppiced in 1778, although 'Young Oakes' had been planted there in 1741–42[75].

Much of Torver Common was also clear-felled in 1778–79. It was this time, too, when the Appleby Castle Estate was busy with forestry work: in 1790 payments were made to labourers for tree planting, and for felling trees and peeling bark in large plantations at Hofflunn, south-west of Appleby, and in Flakebridge Wood to the north-east[76]. The sum of £15 19s 6d was disbursed to bark peelers in June for 223 days' work in that month alone. Accounts showing income raised from selling the bark to tanners are not extant.

For the purposes of this research, 121 enclosure awards and accompanying maps were examined – ninety-three in Westmorland, twenty-three in Cumberland, two in Furness and three in the former West Riding – to quantify decadal patterns of enclosure and to identify chronological trends in relation to changes in national legislation[77]. Prior to 1800, across Cumbria as a whole the scale of enclosure was very limited when compared to the surrounding counties, accounting for less than 9 per cent of all awards. Similarly, at the tail end of the long-drawn-out process of parliamentary enclosure, only 4 per cent of all Cumbrian awards were put into effect: thus, the first four and last three decades accounted for only 13 per cent. In stark contrast to this are the decades in between

Decade	Westmorland	Cumberland	Furness	% of total
1760-69	1	1		1.7
1770-79	8	1		7.6
1780-89				
1790-99	1			0.8
1800-09	2	2	1	4.2
1810-19	14	7	1	18.6
1820-29	14	1		12.7
1830-39	3			2.5
1840-49	9			7.6
1850-59	28	3		26.3
1860-69	8	8		13.6
1870-79	2			1.7
1880-89	2			1.7
1890-99	1			0.8
n =	93	23	2	

Table 6: Selected Enclosure Awards in Cumbria, by decade. (Note: The Dent and Garsdale Awards were both 1859.)

(1800–60), during which the rest were implemented; 40 per cent occurred between 1850 and 1869, a period during which much of the open and 'untamed' landscape of fells, moors and commons was transformed into the patchwork quilt of regular manicured fields to be seen today.

Three specific dates are of significance in the carving up of open land. The Inclosure (Consolidation) Act 1801 replaced the existing system of individual and expensive privately sponsored Acts with public Acts, which were largely responsible for the sudden increase in enclosure schemes brought before parliament in the 1810s. The General Enclosure Acts of 1836 and 1845 simplified matters further, arguably making the proposition more attractive to those likely to be involved in the process. Again, it was these Acts that led to the huge increase in the number of awards in the mid-nineteenth century.

What is of direct relevance to the current discussion is the extent to which individual awards made provision for improvement of newly enclosed land. The carving up of common land with walls, hedges or fences, the cutting of new drains, the laying out of new roads, and the provision of watering points for livestock all provided the wherewithal for allotment holders to manage their own stock on their own land. However, enclosure *per se* did not necessarily lead to the land being visibly improved; it was up to the individual to do as much or as little as (s)he wished or had the capacity for. William Fleming, in Low Furness, wrote in his diary that most of his home parish – Pennington – had been enclosed and divided up so that each allotment holder was able to use his newly awarded property 'in whatever Manner he thinks best calculated to promote his own Interest'[78]. That brief statement neatly sums up how enclosure was perceived by those who were awarded new plots.

Most, but no means all, awards designated areas as public quarries from which allotment holders could freely get stone for road building and maintenance, building new walls or field barns, and general building work at their farmstead. Some awards went further than this by allowing allotment holders to build lime kilns in public limestone quarries, so long as the lime so produced was used by them within the township concerned and not sold elsewhere. Within Westmorland analysis of awards by this writer has shown that 12 per cent made such provision without necessarily stipulating how the lime was to be used. Furthermore, field surveying has revealed

that lime kilns exist on the ground in two-thirds of all award areas: whether or not these kilns were in existence before enclosure or built as a result of it is very difficult to determine, although typological characteristics do enable the formulation of a tentative chronology for those kilns still standing.

More telling are clauses enshrined in five Westmorland awards, which made specific mention of the use of lime for agricultural purposes or improvement. The Orton, Great Musgrave Common and Maulds Meaburn Moor awards employed phrases like 'general agricultural purposes' or 'tilling of their lands', while the Casterton Moor and Burton-in-Kendal awards actually referred to the application of lime for the 'improvement' of their lands[79]. All five documents were doing the same thing, namely encouraging allotment holders to burn lime to spread on the land, bringing it into more productive use.

Twenty-three Cumberland awards were examined, of which six made direct reference to improvements and a further three to the use of resources within the new allotments. Two of the latter were implemented in 1769, early dates for parliamentary enclosure in Cumbria with both covering a vast area, the other in 1854: the wording of both 1769 awards was identical in that allotment holders were accorded the right to 'Stones, Slate, Marle and Clay for the improving of Lands'[80]. One can assume that the slate was intended for roofing and the stone for walling or building, with the marl and clay for soil inputs; if these two materials were calcareous, they would have provided a cheaper and readier source of calcium than buying in lime, which does not readily occur in those townships. The Award for Talkin Fell gave allotment holders the right to 'win and quarry and burn limestone' to use within their new allotments, which suggests liming was the intention[81]. Another early award, for Cumwhitton and Cumrew, gave allotment holders the right to get unlimited quantities of limestone for the 'improvement of their lands', as well as for any other use to which lime had traditionally been put; this, too, covered a huge area, much of it fell land at the north end of the Pennine chain. Two further awards from the closing years of the Napoleonic Wars also made provision for the use of limestone for improving their lands, without stating in what ways[82]. Three later awards – also extensive in area and along the Pennine edge – enshrined the right to burn lime for 'agricultural and other' purposes, with the Melmerby and Ousby awards restricting it to newly enclosed land; the Glassonby

Townhead lime kiln, Ousby.

award extended its permitted use to allotment holders' 'ancient enclosures'[83]. The Star Howes section of the Ousby award contains two lime kilns. One, at Star Howes itself above Ardale Beck, was in existence prior to the award but the other, Townhead Kiln, also above the beck at the foot of Rusby Hill, was not depicted on First Edition mapping surveyed in the late 1860s. Consequently it may well have been built as a result of the award, although its truly massive scale rules out purely local use of the lime. This one was beyond doubt a commercial kiln served by a long tramway starting above Ladslack Hill.

Reclaiming the Waste

Transforming unenclosed moorland into productive farm land was perceived as the most effective way of increasing food production on a scale sufficient to feed a burgeoning urban population, and to answer the call of the likes of Sir Robert Peel, prime minister from 1841 to 1846 and a key proponent of the Repeal of the Corn Laws in 1846, who urged all those involved in agriculture to produce the largest quantity of food in the shortest possible time at the lowest cost, without exhausting the land. One of those who responded to

the 'grow more' mantra was John Watson, a Kendal-based surveyor, who in the early 1840s put together an essay on how to go about successfully reclaiming moorland[84]. His basic premise was that too much 'waste' land had been enclosed and effectively ruined because it had been 'notoriously mismanaged' over the previous half-century; those who had effected the process had not understood it or been aware of the potential pitfalls. Watson advocated adoption of three key strategies – draining, then paring and burning, followed by liming – and set out a step-by-step schema.

His first step was to divide the area to be reclaimed into 10-acre (4-ha) plots, with one plot being started each year, the whole area enclosed by walls using stones grubbed from the soil. While the walls were being built, the plot was to be criss-crossed with a network of drains prior to paring and burning[85], preferably undertaken in April or May. This was a daunting task, whereby labourers used a shallow-angled paring spade or 'push-plough' to pare (scrape) off the surface vegetation cover; others piled up the parings (the sods or whatever was the dominant growth) in small heaps across the new enclosure. Once they were as dry as the weather would allow, the piles were burned in a controlled manner and the ashes raked out. This was followed by liming at the rate of sixty to eighty bushels per acre (equating to ten to sixteen cart loads of lime), the actual quantity depending on soil characteristics[86]. He advocated piling the lime in small heaps and ploughing it in as soon as practicable, but certainly before Martinmas (1 November). In his view that rate of application should be sufficient for the first two or three crops. The plot was to be left fallow over winter with the first crop sown in spring. He calculated the total cost of reclaiming each plot at £80. After the first harvest, he suggested, the plot should be deep-ploughed to re-mix lime with topsoil. In his essay, Watson went to considerable detail extolling the virtues of lime, displaying a credible understanding of the chemistry involved, and he used an anecdote to strengthen his argument. One tenant farmer, with only three years remaining on his lease, was loath to spend too much on bringing a new tract of land into use. He pared and burned, and presumably drained, but decided not to lime it, fearing the time he had left was too short for him to recoup the outlay. Intentionally or not, some patches were limed and their yield was more than double that of the unlimed majority, as were subsequent grass crops. Here was that tenant's Eureka moment.

Draining Improvements

As mentioned earlier, a key element of reclamation of moorland was draining: without careful attention to the minutiae of potential slope flow and rates of infiltration, there would have been no point expending time and money on paring and burning or liming. Nevertheless, it was not just moorland that was *watter-sick*. Large tracts of flat riverine or estuarine plains were too saturated with groundwater to be effectively used for any kind of farming; and significant areas of existing farmland, too, had a watertable uncomfortably close to the surface especially, but by no means exclusively, through the long winter months. Even if annual rainfall totals were not exceptionally high, persistent cloud cover and low average temperatures keep evapo-transpiration rates low. Cattle could not be turned out onto such wet pastures as their trampling would soon poach the turf, and tillage was out of the question.

Attempts have been made to drain farmland for as long as there have been farmers, and the practice is well documented in manor court records, where a frequent transgression was 'failing to scour' ditches. Until the mid-eighteenth century, open shallow ditches were the chief method of controlling the water table and of channelling excess water away, but rarely did they succeed on naturally damp ground. More effective deep drains were dug from 1764, although within Cumbria their widespread usage was delayed until later that century[87]. Really deep drains planned on the ground and laid out according to local circumstances were really only developed in its closing years, by a Warwickshire farmer called Joseph Elkington, whose name soon became synonymous with successful underdraining. This was in large part due to the support he received from prominent members of the Board of Agriculture. Its committee on draining, which included Sir John Sinclair and the duke of Bedford, a noted Improver, concluded that the Elkington method was 'highly deserving of attention'[88]. The board duly awarded him a prize of £1,000, and he was in demand from landed estates across the country, keen to solve their own drainage nightmares. The tenant farmer and small landowner could not rise to the expense of underdraining and were compelled to rely on traditional ditching. Tom Rumney's diaries, for example, have numerous daily entries in 1805–06 for 'ditching' through much of the year, in addition to walling, manuring and liming his newly drained fields[89].

The Mechanics of Improvement

The advent of buried tile drains took draining to a new level of effectiveness. Invented in the late eighteenth century, they were first introduced in Lancashire in the 1820s, although it was another two decades before they became a common feature in Lancashire and Cumbria[90]. Once the manufacture of tile drains was mechanised (probably in 1842 but with massive improvements in scale of unit output in 1843) and mole drains introduced in 1859, the business of draining rapidly spread across Cumbria; but these developments came right at the end of the period under review in this chapter[91]. When tithe commissioners' reports were correlated and analysed either side of 1840, however, neither Cumberland nor Westmorland had any parishes where underdraining or tile draining had been implemented[92].

Parliamentary enclosure, as we have seen, often went hand in hand with drainage improvement, and it is common for estate archives to include details of such schemes. On the shores of Morecambe Bay there is clear ground evidence of attempts to drain coastal and estuarine marshes: Foulshaw Moss[93], Meathop Marshes[94], Winder Moor and East Plain at Cark are just a few such areas contained within sea embankments and criss-crossed by broad, deep drains. Inland, major

Reclamed pastures on Brigsteer Moss in the Lyth Valley.

drainage schemes were initiated in, for example, Helsington, Levens and Underbarrrow as an integral part of the Helsington Enclosure Award of 1843[95]; and on the River Kent floodplain on the former Lyth, Levens and Brigsteer Mosses. Anthony Garnett, who farmed at Holeslack above the floodplain, was awarded just over 2 acres on the marsh in 1807 and was notified that a ditch was to be dug 'four Feet wide at the Top, six Inches at the Bottom, and three Feet deep; ...with] Quickwood to be planted one Foot from the Edge of the Ditch' to hold the soil together[96].

Not all drainage attempts were immediately successful: one that was described by the tithe commissioners as potentially disastrous – 'High Farming would be thrown away' – was the reclamation of Angerton Moss near the mouth of the Duddon[97]. The instigators of the process, around 1805, installed drains across much of the marsh and even built a lime kiln, although the nearest source of limestone was at least 2 miles (3km) to the south, but whatever they achieved in the short term did not repay the investment made and about half of the marsh was never dried out. Seen in the wartime context of 1805, however, it would have made perfect, patriotic sense.

One name stands out in Furness as the originator of much coastal reclamation: namely the ironmaster John Wilkinson (1728-1808). He purchased two small estates in coastal Furness – Castle Head and Wilson House near Lindale (SD426 809), on the lower reaches of the River Winster. His original intention had been to extract bog iron from the marshy areas of both estates, but this proved economically unviable, so he concentrated instead on trying to develop the agricultural potential of his new properties by reclaiming the marshland[98]. He started in a small way, in 1778, by reclaiming 5 acres (2 ha) and adopting the strategy of breast-ploughing the surface vegetation, then burning it and digging ditches. At the same time he had a series of clamp kilns dug to burn limestone brought from further inland to be spread on the surface. Unfortunately his attempts failed, largely because the ditches were set too far apart and his lime-burning venture was ill conceived. Not to be thwarted, he tried again, this time more successfully, cutting ditches close together and adding deep ploughing to the overall process, with a heavy dose of lime hot from commercial kilns inland spread in summer. Once completed, he had a mixture of clay, sand and mould added to the soil, which yielded a succession of crops including turnips and potatoes, oats, rye and barley, and even chicory (for horse

fodder) and, by the time he had gone as far as he felt able to, around 1000 acres (405 ha) had been fully reclaimed. When he took over the estates, he rented the moss land as peat cuttings for the derisory sum of 1*d* per acre; by 1805 he was earning rental income on the same land of between 30–40*s* and £3–4 per acre, depending on its quality. It should be added that he not only faced nature's opposition but also had to contend with local hostility from fishermen, who were afraid of losing their fishing grounds, as well as legal technicalities. His original intention had been to reclaim nearly 39,000 acres (15,665 ha), not just on his own lands, at a cost of £150,000, with one third of it from his own funds. However, he had to scale back his plans drastically and confine himself to his own estates[99]. He did not stop with the initial 1,000 acres, however: the Cartmel enclosure award of 1809 awarded him over 216 acres (87 ha) around Lindale, and his brother, William, 50 acres (20 ha) on Winder Moor, south of Flookburgh, all of it to be reclaimed[100].

His achievements were truly remarkable and he gained national recognition as an Improver. No less a person than Sir John Sinclair declared Wilkinson to be 'justly entitled to be ranked among the best friends to the agricultural interests' of the nation and suggested

The artificially straightened River Winster.

that one could 'hardly find a parallel in any part' of the country[101]. Within Furness, his success led to several schemes to similarly reclaim coastal and estuarine marshes, and to the diverting and straightening of the lower River Winster. John Holt, the Board of Agriculture's surveyor for Lancashire, also extolled Wilkinson's virtues and used his successes as a catalyst for encouraging landowners to embark on a similar crusade against the sea along the Leven at Ulverston and in the Duddon estuary at Millom[102]. Both schemes eventually went ahead.

The next chapter expands on the ways in which farming changed in the hundred or so years since 1750 by discussing more specifically the extent to which landed estates across Cumbria embraced innovation in the widest sense.

6

Agricultural Change in the Age of Enclosure: The Response of the Landed Estate

Building Improvements and the Model Farm

Aside from investment in the land itself, past improvements to estate building stock are also evident in today's landscape and from archival sources. There was nothing unprecedented in this, as we have seen

Nether Hoff Barn, Colby, built in 1811.

earlier, but the scale of late eighteenth- and early nineteenth-century redesign and building reached new heights. On some estates the emphasis was on erecting, or refashioning, individual structures on a larger and often grander scale than before. A classic example is the bank barn constructed at Nether Hoff (NY667 200) in Colby by the Appleby Castle Estate, in 1811. It had fourteen bays and contained two shippons, loose box, threshing floor, stabling, and space for a water-powered threshing machine. It is an aesthetically imposing building and was worthy of a high-status estate farmstead.

Bank barns, where the shippon is entered at one level and the hay mew on the opposite side at a higher level, are a common feature of Cumbria, with 749 surviving examples recorded, and concentrations along the Eden valley, Furness and the Grasmere area[1]. Some, as we noted earlier, date from the seventeenth century, but many were erected later, with examples known from the early twentieth. One such late bank barn, at Long Rigg Farm (NY139 006) in Mitredale, bears the date 1903. Elsewhere, more traditional barns were rebuilt, such as one attached to the seventeenth-century house at Glencoyne (NY384 186) on Ullswater, dated 1824 and built for the Greystoke Estate; or the new barn at that estate's home farm in Ulcat Row (NY40 22), Matterdale, built in 1832. In 1773 work commenced in

A bank barn at Long Rigg, Mitredale, dated 1903.

Culgaith parish for 'Improving both estates' at Skirwith Hall (NY610 326), where existing buildings of 1656 and 1679 were replaced and a new barn built, and at Kirkland Hall (NY647 325) where similar work was commissioned[2].

It is also possible to recognise the development of courtyard farmsteads, where all the farm buildings – barns, byres, cart sheds, and threshing rooms – were arranged around an enclosed but open yard with the house often closing off one side of the complex. This arrangement can be seen in medieval or early post-medieval complexes, where defence was perhaps a major consideration, with impressive examples visible at Yanwath Hall (NY508 281) near Eamont Bridge, Hardrigg Hall (NY425 362) near Ellonby, or Middleton Hall (SD627 874) in Lunesdale. Early-modern developments of the courtyard principle can be seen across Cumbria, including examples where eighteenth-century farm buildings were added to seventeenth-century, or earlier, farm houses: intact examples of this type of farmstead, in Westmorland, survive at Heltonhead (NY503 218) in Askham, Winder Hall in Barton, and Gaythorne Hall (NY649 132) in Asby.

Courtyard arrangements were further developed on larger estates during the late eighteenth century by the creation of completely new 'model farms'. The philosophy here was the desire, or compulsion in

Heltonhead courtyard farm, Askham.

some cases, of landowners to show their tenants, and others, what was deemed best practice in farming; in other words, to lead by example, and to show tenants that new-fangled methods did produce the desired results. At the same time, model farms can be perceived as a means by which landowners could make a statement about their commitment to and belief in the concept of improvement[3]. One researcher has compiled totals of model farms for counties across England, with twenty-two recorded for Cumbria; in reality there were more than this.

For grandiose schemes involving multiple model farms, the Lowther and Greystoke Estates stand out above all others; both schemes were conceived by their respective heads of family, namely

Farm	NGR	Estate	First known date
Mechi	NY174 411	Blennerhasset	1863
Holbeck	SD229 700	Buccleuch	
Far Old Park	SD230 770	Buccleuch	1878
Park House	SD495 826	Dallam Tower	1826
Dolphenby	NY577 311	Edenhall	
Home	NY559 318	Edenhall	
Honeypot	NY558 302	Edenhall	
Bunkers Hill	NY458 308	Greystoke	1797
Fort Putnam	NY452 309	Greystoke	1797
Spire House	NY462 312	Greystoke	1797
Home	NY434 312	Greystoke	1797
Flookburgh	SD367 757	Holker Hall	1800
Demesne	NY556 410	Kirkoswald	
Dallan Bank	NY572 223	Lowther	1801
Grandstand	NX990 185	Lowther	1798
Home	NY572 241	Lowther	1836
Low Moor	NY535 246	Lowther	1797
Rogersceugh	NY216 597	Lowther	
Sewborwens	NY491 303	Lowther	1800
Waterloo	NY118 287	Lowther	1816
Long Rigg	NY139 006	Mitredale	1903
Home	SD096 966	Muncaster	1780
Guards	NY332 667	Netherby	
Mossband	NY344 654	Netherby	
Rose Trees	NY354 667	Netherby	
Camp	NY044 373	Senhouse	
Home	NY608 799	Underley	
Schoose	NY015 280	Workington	1800

Table 7 Model farms proposed or built in Cumbria.

Spire House, Greystoke.

Charles Howard, 11th duke of Norfolk at Greystoke, and James Lowther, 1st earl of Lonsdale on Lowther Estates[4]. Howard was a noted eccentric, as well as a political rival of Lowther, and he engaged in one-upmanship, designing and seeing to fruition not only the very practical model Home Farm (NY433 311) at Greystoke but also three other model farms, each built as a folly around 1789. Fort Putnam (NY452 309) and Bunkers Hill (NY458 308) have mock castellation; Spire House (NY462 312) has what its name implies.

Lowther's plans were much more ambitious, if mostly less eccentric, but several of his schemes did not go beyond the draughting stage. In 1765 he had plans drawn up for a new dairy block at Lowther, which was never built[5], but the elevation drawings depict what would have been a rather romantic and stylised complex, hiding a mundane aspect of the estate's daily life[6]. His plans for a new home farm (NY527 241) were considerably modified in effect but, between around 1797 and 1816, several farms were rebuilt, or planned, as model farms at Lowther and Whitehaven, in addition to a new and imposing office block in 1709 and the remodelling of Lowther Village in the years 1765–73[7].

Lowther Estates' Grandstand Farm (NX990 185) at Whitehaven embodied the core essence of most true model farms, being designed so that all the buildings were conveniently arranged around a central courtyard. Here the complex measured 31m by 14m, considerably less than Low Moor (NY535 246) and Dallan Bank (NY572 223) Farms' 31m by 31m[8]. The most impressive proposals concerned what the records called 'Mr Lumb's House and Farm': William Lumb was engaged by Lowther to produce the various surveys and the farm where he lived, Sewborwens (NY491 303) in Cattterlen parish, was planned as a model farm[9]. It measured 39m by 24m, entirely surrounded by a wall with the house set towards one corner, separated from open yards for oxen, cattle and bulls by a long range containing a large hay barn, stabling for twenty-four horses, housing for sixteen cattle and cart sheds – an archetypal model farm[10]. It is clear, though, from looking at the complex today that the plans were considerably modified, and probably delayed, as the present house has an 1842 datestone. The estate felt a real urgency to redevelop many of its holdings as they were described in surveys from 1742 and 1765 as being in a poor state of repair, but it was only James Lowther's personal whim that caused them to be rebuilt, or proposed, on such a grandiose scale. Practicalities were not really on his agenda; what was more pressing was to build ornamental farm buildings that made a personal statement to his guests and to the nation about his status and wealth, and his patriotic actions in developing the farming potential of his vast estate[11].

Proposals on this scale were as rare as they were expensive or, in some instances, eccentric: much more common was the construction of individual new farm buildings and farm workers' housing. Every large estate had its own distinctive house style for cottages, offices and agricultural buildings, and those that could afford the professional fees brought in notable architects; the Websters of Kendal were engaged in this way by the Wilsons at Dallam Tower near Milnthorpe, and the Cavendish family at Holker Hall in Furness, and at Lowther[12]. Other estates were at liberty to make use of collections of generic designs, such as those of Bailey Denton or the impressive and painstaking designs of Daniel Garret, whose collection contains ten different designs for farm buildings and six for farm houses and cottages. Two of these two were advertised as being appropriate for Westmorland and three for Cumberland, although he did not explain his rationale here[13].

The Response of the Landed Estate

As technology developed and some laborious tasks were gradually mechanised, progressive farmers and landowners invested in the infrastructure needed to house the new machines and implements. Until the first quarter of the nineteenth century, cereal crops were still widely threshed in the age-old manner by men wielding flails separating grain from chaff or cattle tramping it underfoot. It was slow, soul-destroying work and expensive in terms of labour required. The introduction of horse gins or mills drastically reduced both the need for manpower and the overall costs. Where this process was adopted, the threshing machine was sited within the barn, where the flailing had been done, and this was linked by cogs, drive shafts and beams to the gin, which was housed in an attached roofed but open-sided structure, often referred to as a gin-gang. Horses spent their working days endlessly walking in a circle turning the gin, which powered the threshing machine. These gins began to appear in large numbers from around 1785, with numbers probably peaking in the thousands nationally between 1800 and 1830. This once-common farmyard feature is now relatively rare, but well-preserved examples have survived in Cumbria: for example, at Clifton Hall (NY531 271) near Penrith, Rogersceugh (NY216 598) near the Solway and Bank

The gin-gang at Bank Hall farm, Kirkland.

Hall (NY646 330) at Kirkland in Culgaith. Horse gins were versatile: not only could they power threshing machines but also, after 1800, turnip cutters, machines for crushing (or cracking) oats to be fed to horses, and malt and beans[14].

There was little point investing in expensive infrastructural improvements if the land was not managed in an effective and profitable manner by tenants, however, and each landed estate followed its own path to achieve this, as we will now explore.

Lowther Estates

The Lowthers owned lands at Bowness-on-Solway, including parts of Bowness Common, which was reclaimed from coastal marshland in 1765. Their main farm on the edge of the moss, Rogersceugh, was already in a state of disrepair when surveyed in 1742 so, after reclamation, the old buildings were replaced[15]. Over time the farm was developed into a productive arable unit, concentrating on potatoes and oats; at some point after 1765[16], Rogersceugh was remodelled as a classic model farm with a large farmhouse with barns and byres attached at both ends forming the south frontage,

A probable gin-gang at Rogersceugh farm.

and barn, shippons, loose box, housing for pigs, stables and a gin-gang arranged around the other sides[17]. Economic conditions were soon not conducive to large-scale investment: several estates found it hard to attract tenants to vacant holdings, given the somewhat depressed state of the economy. In 1779, for example, the estate had twenty farms without a tenant and, it was reported, 'allwere] likely to fall into his own hands'[18]. In other words, the terms offered by Lowther leases were not deemed attractive enough by prospective tenants, who feared they would not be able to turn a profit in such straitened circumstances, so the Lowther steward's only course of action was to have the vacant farms managed in-house. That situation did not last long, however, as the deteriorating situation in France through the 1780s and 90s stimulated economic revival in British farming.

A key element in the overall Lowther plan in the early nineteenth century was to undertake detailed surveys of all the estate's tenanted farms, starting in 1803. Sir James had died in 1802 and his successor, William, had a very different approach to running the estate, preferring to raise overall standards rather than erecting expensive and, he might have argued, grandiose edifices. His steward despatched agents to visit each area in turn, report on the current state of husbandry at each farm and make recommendations for effecting improvements. In many of the reports there is the clear semi-hidden agenda that farms would increase in (rental) value if certain approaches were adopted. The earliest set of extant reports concerned farms in Westmorland away from Lowther[19]. Various, unnamed farms in Ravenstonedale were said in 1803 to have 'remarkably good' soil and to be 'very Improveable' if older pastures were given a boost by liming. The implication here was that the tenants were coasting along, content with what they were making rather than wholeheartedly embracing change. Identical conclusions were drawn for a farm adjoining Wharton Hall, whereas the tenant at Wharton Hall itself was praised and encouraged as he maintained a 'very fine estate', which he had 'much improved' by the judicious application of lime on his meadows and old pastures. The clear, but unwritten, hope was that his success and praise would rub off on the lesser tenant. In 1808 Fell Farm in Casterton was found to be 'tolerable good' but the recommendation made was to enclose and reclaim Fell Close by draining and liming, as it had great potential for improvement.

During 1804 attention turned to estate farms in the north-west corner of Cumberland, between Workington and the Solway, where eighteen farms were surveyed by the agent, Robert Lumb[20]. Lumb was forthright in his report. Of nine farms at Abbeytown, he was favourable towards two – 'much improved' and 'something improved' – of three ambivalent, and of the remainder highly critical – 'not good', 'I see no improvement' and, most scathing of all, 'in a very slovenly state'. Elsewhere, at two farms at Flimby, Calvo Hall, near Silloth, at Ribton Hall (NY047 305) in Camerton parish, and at Stainburn Hall (NY027 294) nearby, he was also generally complimentary; however, he commented that the tenant at the last was rather recalcitrant. On the other hand, he was less than positive about the tenants at another Flimby farm and at three properties in Ribton: one was 'very poor', another with 'buildings in a poor state' and, at the other, in short, hopeless tenants. At Rubing House (NX995 295), long since swallowed up by Workington's sprawl, he found matters 'considerably worse' with some fields exhausted and the tenant a 'very bad farmer'. A follow-up survey of all the Abbeytown farms four years later found, to Lumb's obviously mixed emotions, that the formerly 'slovenly farm' was by now in 'tolerable good condition', but that one of the formerly improved farms had declined and was now 'much neglected' and in worse condition, while yet another had been ever so slightly promoted from 'not good' to 'little improved'.

It is difficult, so far removed from Lumb in years, to grasp fully his rationale and, by association perhaps, that of his predecessor. Unfortunately, surviving records do not tell us how many years had passed since the survey prior to 1804, so we have no means of knowing over what period the unsatisfactory tenants had been allowed to get away with slovenliness. One wonders if some tenants' attitudes derived from the fact that, being so distant from estate headquarters in Whitehaven or Lowther, they felt themselves to be neglected, and valued only on the twice-yearly rent days, or whether they had an out-of-sight, out-of-mind mentality. Conversely, one has to question why surveys were not scheduled more frequently. If several farms were found not to be following best practice in 1804, why did Lumb wait another four years before visiting them again? Unfortunate, too, is the apparent absence of any documentation outlining what actions had been taken by Lumb either in 1804 or 1808, or indeed after any later surveys that might have been made.

Very different emphasis was placed by William Lumb during annual surveys of fourteen Lowther properties in northern Westmorland some ten years later[21]. Here, details of acreage and land use of individual fields were recorded, with the occasional comment on quality of management. For example, Low Moor farm at Lowther itself was 'good managed', although too great a percentage of the farm was under grass, whereas Hesley Farm (NY587 232), Great Strickland, had too much under arable crops. Plumpton Head (NY502 350), north of Penrith, was deemed to be 'very well managed' but the unlocated Fell Hill Farm had 'landthat] appears dirty', whatever that may have meant. High Hall (NY564 194) at Little Strickland and Meaburn Hall both required attention to drainage and repairs to walls or buildings; the tenant at Murton Demesne (now Hall, NY729 217) complained to Lumb that his farm was 'too high', probably referring to his annual rent; but Naddle Farm (NY509 153), at Hawsewater, was to Lumb a 'very desirable tenement' based entirely on livestock. The tenant was able to maintain a flock of sheep 900-strong, enjoying the benefit of grazing rights on common land above Swindale and the now-drowned Mardale and on Toothmain in Rosgill. The frequency and distribution of crops varied from area to area but there was a definite imbalance between pasture and arable on and between the surveyed farms.

Farm	Grass	Oats	Other cereals	Roots	Seeds	Fallow	Altitude (m)
on Clifton Moor	12	5				2	170
Low Moor	4	5	1		2	1	190
Hackthorpe Hall	13		7				230
Gt. Strickland Hall	9	5	1	1	4	1	200
Hesley Farm	4	4	1			1	140
Cliburn Hall	13	6	2			2	120
Fell Hill	5	4	2			2	?
Plumpton Head	10	4	2			1	150
Plumpton Low Hse	4	3	1	1			140
Hilton Hall	8	3			1	1	230
Murton Hall	10	6					240
High Hall	7	4	1	1			240
Meaburn Hall	24	2	2			1	160

Table 8 Land use recorded on Lowther farms in north Westmorland, 1817. (CAS[C]D/LONS/L8/65)

Excluding Naddle Farm, nearly 60 per cent of all fields surveyed were under meadow or pasture in 1817, with a further 32 per cent under cereals, of which oats were by far the most frequently occurring. Root crops (turnips and potatoes) were almost conspicuous by their absence (1.5 per cent), while 4 per cent were under what was then commonly called 'seeds'. This is a term referring in its archaic sense to high-bred grass seeds or a mix of rye and grass seed. From the data shown in Table 8, no clear correlation between altitude and land use can be drawn, but detailed consideration of soil type and climatic variations does point towards a preponderance of grazing in areas with higher rainfall, lower average amounts of sunshine in the growing and ripening season, and heavier, less well-drained soils – as would be expected. Over the past two centuries, of course, farming regimes have changed quite dramatically and similar data today would lean more heavily towards grassland than arable. Nevertheless, today's patchwork quilt of pastures and harvested meadows seen all around Lowther is a direct reflection of centuries of husbandry that was mostly in tune with land potential.

A broadly similar survey was carried out in north Cumberland in the late 1830s, recording on a field-by-field basis the acreage and current land use, as in the 1817 survey, and with the course of rotation adopted by the tenants concerned[22]. The general pattern that emerges from these data is of traditional three-year rotations, except on those fields that could only support pasture[23], and except on Sandsfield Farm (NY33 61) at the mouth of the Eden and Cardew Demesne (now Hall, NY350 498) near Dalston, both of which were operated on a four-year rotation. From a sample across all the farms involved, over the full rotation period, pasture, fallow and oats had the greatest frequency with 19 per cent each, followed by meadow and wheat with 14 per cent each, and barley 12 per cent. All those farms are sited on lowland plains with generally rich soils and a climate well suited to grass and hardier cereals, so in times past mixed farming was very much the order of the day, although, again, wet or steep ground was permanently down to grass.

The Lowthers took an active interest in estate management and can rightly be included in any roll call of agricultural Improvers, and not just for infrastructural changes. William, created earl in 1807, is credited with introducing the Shorthorn breed of cattle to Cumberland in 1810. Initially developed by selective breeding in north-east England in the late eighteenth century, the breed was

originally kept for both beef and milk, although through further 'engineering' separate breeds appeared from around 1820. Shorthorns were considered more adaptable, as they grew more quickly with a greater quantity of milk or meat than the traditional Longhorns that were slowly squeezed out; Shorthorns were regarded as good mothers and rugged by nature[24]. Later in the nineteenth century Penrith came to be recognised as a national centre for Shorthorns[25].

The 2nd earl also furthered his predecessors' programme of developing the estate's forestry resource, for game cover, timber supplies and for aesthetic embellishment of Lowther Parks. A plan of 1805 shows a series of plantations between Lowther Newtown and Hackthorpe much as they are today[26]. When the Public Money Draining Act 1846 passed through parliament, the earl was quick to apply for funds for under-draining his demesne land, asking for £30,000, but only drawing one-third of that amount over ensuing years[27]: we shall return to this in the next chapter.

Edenhall Estate

Building up this outline of strategies followed by the Lowthers has mainly drawn on official estate surveys, which were formal, mostly objective and followed a time-honoured format. They left little room for off-the-cuff remarks or subjective asides. Bearing all this in mind, their value is somewhat constrained and the picture that emerges is necessarily partial. In complete contrast, the accessible archives for the Musgraves' Edenhall estate contain a wealth of letters from the steward, Christopher Dobson, to his employer, who spent much of the year at the family's main seat at Kempton Park in Surrey. They were business like, but informal in tone and gave the steward leeway to express his opinions; sadly, as with so many estate archives, the return letters from the landowners have either not survived or are not accessible. The letters span the years 1764–88, thereby providing an insight into the running of the estate during the first part of the period under review in this chapter. In addition to the letters, there are cash books and collections of farm leases extending into the early nineteenth century.

Cursory indications of estate management are presented in an account book, which itemised sales and deliveries of lime from an estate kiln: up to November 1758, 3,098 bushels of lime had been burned, of which 1,023 were entered under Sir Philip Musgrave's

name 'for the dunghill' with a further 130 bushels to him for other unspecified uses[28]. Three tenants took 665 bushels between them, with the balance sold to outside customers. There is no way of knowing how the tenants and outsiders intended to use the lime, but the first entry confirms that it was the practice on Edenhall demesne land to mix lime with dung, probably at the farmstead, prior to spreading the mix on the land. Arguments raged for decades concerning the most effective way of applying lime – hot from the kiln, piling in small heaps across the field leaving the rain to slake it naturally, spreading it cold and evenly without first heaping it, or as was done at Edenhall – but there was never any definitive answer. Different estates and farmers had their own preferences and they tended to be faithful to what they perceived to be best. Twelve months later, the accounts recorded the burning of 1,464 bushels, all but 166 for use on the estate: 687 went to six tenants, 296 were used in building work, twenty were applied in an unnamed close, and 295 were carted to middens at Celleron in Sockbridge parish and in Low Closes in Edenhall parish. The same proportions appear for the year ending October 1760, but in summer 1761 no lime was destined for agricultural use.

Obviously an account book would not contain an explanation for this sudden change but a possible answer appears in a letter of 1766, sent to Sir Philip's steward by a Mr Goldies[29]. The subject of the letter was the use of marl, a practice introduced from Galloway. Goldies wrote that he had laid seventy double cart loads of marl per customary acre on land, where he then sowed wheat followed by oats in the second year and a barley-seed mix in the third. He asserted that applying marl 'answers well', meaning that the subsequent harvest was good. Reading between the lines, it would seem that marling was relatively new to this part of Cumberland as, in his words, 'few people' had yet used it. The letter went on to explain that, in a large enclosure at Edenhall called the Mains, red marl had been dug in January and left in a heap until April, prior to being led to the fields, and white marl was dug in April and spread on the ground immediately. The two types of marl were laid on different parcels of ground adjacent to each other, and the intention was most definitely to compare the results after the first harvest. The letter was written in early spring 1766 and may have related to the previous three crops, which would take the start of the marling experiments back to 1763 at the latest. A letter like that displays a willingness to experiment and innovate.

From reading Dobson's fortnightly letters, it must have been the case that Sir Philip took a keen interest in his properties and wished to keep abreast of developments and issues at Edenhall; in a letter dated 20 May 1776, Dobson referred back to suggestions Sir Philip had made in one of his letters, assuring his patron that he intended to incorporate them into future leases with a binding stipulation that any tenant guilty of 'over plowing' would face a penalty of £5. The state of the weather, and its impact on estate work, featured in a number of letters[30]. In January 1765 the carting of sludge to the fields had been halted by unusually wet weather; severe weather had a detrimental effect from March to June 1770, to the degree that it was proving 'very discouraging to the Improvers' across much of Cumberland; and, throughout 1773, 1775 and 1776, Dobson made frequent mention of inclement weather. Yet again, in 1780 and 1782, he drew attention to continuing and unseasonably wet weather that never seemed to go away. He possibly had a hidden agenda here, not just gossiping about the weather in the time-honoured fashion but quietly preparing Sir Philip for reduced rental income, should harvests fail. There is evidence of this in several letters during 1782, in which Dobson reported that 'the black worm' was causing havoc to the turnip crop[31]. This must have been devastating for the farmers concerned, appearing to them as some kind of pestilence, and one feels in retrospect for one Edenhall tenant, Mr Lamb, who had produced 'as fine a field of Turnips as I ever saw' in Dobson's words, in 1770. If he had still been planting them a decade later, Lamb would have been distraught.

Most of the letters contain brief descriptions of improvements being made across the wider Edenhall estate. Dobson had men engaged through 1765 in ditching in Kirkoswald parish, stubbing gorse and whins at Sceugh Farm on the Eden plain, and straightening Brough Beck in Great Musgrave to improve water flow and therefore drainage of the surrounding land. In the same year he had enclosures covered with pond sludge to act as a fertiliser, and cashed in on the needs of cattle drovers by renting two meadows at Edenhall to have the grass 'eaten off'. It was a busy year for Dobson and an expensive one for the estate. He made a point of itemising in some detail, in a letter dated 30 May 1765, the costs that had been incurred so far that year, as in the previous year, by Sir Philip's 'Articles of Improvements': he was making demands on Dobson to get things moving and to make visible and positive changes to the home estate around Eden Hall itself. The

Dolphenby Rise, Edenhall.

area between the Hall and village on the one hand and the Eden on the other had mostly been open, gently rolling waste, grazed in common but it was now subjected to wholesale reshaping of the landscape based on Dolphenby, Honeypot, Bramery and Sceugh Farms. Dobson had the existing tenants at Dolphenby grubbing up ling and large stones, although they were soon to leave the farm, maybe feeling at odds with the improving zeal and the increased demands made on them. In May a new tenant had been found and, perhaps to entice him, Dobson set about building a new barn and shippon with integral crewyard and stackyard. This had the dual purpose of increasing the size of the herd and, as a by-product, 'breeding Dung' to be stored in the yard for spreading as fertiliser on the newly enclosed pastures. For his part, the new tenant was obliged to improve parts of the then Dolphenby and Bramery Moors. Naturally, he would become liable for increased rental on improved land.

If Dobson was a reliable rapporteur, the estate was in sound condition and the tenants supportive. He noted, in 1770, that tenant Mr Dawson was improving his farm as required, and was laying the stipulated quantity of lime; cropland and meadows were regularly dunged; and the two partners, Thomas Gibson and Thomas Slack, who worked Baronwood Farm (NY513 430) in Hesket parish, were

even allowed the requisite timber to construct a boat to convey lime across the Eden, lime that must have been carted to the river all the way from Renwick or Croglin. Work on Dolphenby Moor continued through the years and, in 1776, he still had labourers grubbing out stones and ploughing the new land in readiness for sowing a mix of clover and Rib-grass (*Plantago lanceolata*) or rye grass, Rib-grass being a plant known to be adept at lifting trace elements from deep within the soil and increasing the quality of the sward. In April 1776, Dobson had planned two weeks' work 'with all our strength', hiring in men and horses to lead and spread lime on 12 acres (4.8 ha) of Dolphenby Moor. In addition to this, he had six carts constantly fetching lime from the estate's own kilns high up in Kirkoswald parish, this time assisted by very cold weather, which prevented trackways from breaking up and slowing matters down.

Superhuman efforts at Edenhall came on the back of work done in February 1776 in Church Field, close to Eden Hall itself. Six men and horses led around 100 cartloads of 'White Marle and Pond sludge' to be spread on the field, carrying on work that had begun in 1775. It had been dug in what was called the 'Bason', where it occurred in layers from 'four inches to half a yard' thick, and Dobson described it in one letter as 'valuable stuff'. The Bason was itself put down to turnips having been reclaimed by filling it in again and liming it later that year; more marl was applied to a field called Mains, prior to sowing it with barley seed.

Dobson provided Sir Philip with some startling figures in a series of letters early in 1778: to improve Dolphenby Moor fully would require 6,000 Winchester bushels of lime at a unit cost of 12*d* at the kiln, plus the costs of leading it all; to enclose it with a wall would need 6,000 cart loads of stone, all to be quarried, loaded and carted. One can but admire the dedication to the cause. Apart from the walling, it was all done by August and the steward was able to cheer up his employer by saying he estimated overall income would rise by £200 per year. There is no indication in the letters to say what happened to the new tenant who took on Dolphenby in 1765 but, in November 1778, Dobson wrote that he had found another tenant, John Slack, who worked Winderwath Farm (NY592 287) across the Eden. Slack had proven credentials, having already carried out many improvements there, and intended to work both farms; this may have been the reason why Dobson urged Sir Philip to purchase Winderwath, which was then up for sale.

It may be that Slack regretted his move as, late in 1779, Dobson was having to report glumly that several farms across the estate lacked tenants and he was having trouble recruiting new ones. One tenant in arrears with his rent had petitioned to be released from his tenancy because, in the steward's words, 'the present prospect[was] ... so discouraging to Farmers he cannot pretend to pay the rent'. He did not explain the source of the problems in 1779, but two years later reported that corn prices had further tumbled, wool prices had halved, and that grain prices had been falling since 1776. Sir Philip can only have ignored his steward's advice in 1776 to reduce rental levels to avoid his tenants going bankrupt. Economic circumstances in England were hitting farmers hard. Yet he was still urging Sir Philip to buy up more properties and invest in building work 'as the best improvement for the Farmer at the lowest expense, and to tempt them to stay with you', and draining was underway on the demesne.

A crystal ball may have stood on Dobson's desk as, by the beginning of 1783, corn prices had shot up again and all was well, except that wool prices were lower than ever. At that time the balance between crops and livestock was more even than nowadays and high grain prices offset low returns from wool. One Musgrave tenant, John Dawson at Hartley near Kirkby Stephen, had gone to great expense to undertake improvements above and beyond those paid for by the estate, and that was in an area dominated by livestock farming. Similar estate-funded improvements were also being effected at Edenhall and at Bramery on the Eden, where women and children were employed grubbing up stones and piling them up ready to be carted away.

Improvement, as we have seen earlier, did not just involve farmland and buildings, and Dobson's letters provide hints of other infrastructural investments: he proposed straightening the Eden at Edenhall. Modern OS mapping shows an indentation in the protective river bank, east of the church, indicating that the river probably formerly meandered there. Also, he fully repaired and walled in what he described as a key road on the estate, leading to Bramery/Udford, a road that was 'scarce passable' in winter and wet weather.

Sir Philip died in 1795 and was succeeded by his son, Sir John. From surviving archival evidence, he took a less active role in running the estate, although improvement did continue apace. Account books for the period 1806–23 itemise annual disbursements for purchasing clover seed and rye grass and, in 1808, a turnip drill to speed up

Plough scratch marks on a stone in a wall at Newbiggin, Hutton Roof, built from field-clearance stone.

A large enclosure in Potts Valley, Crosby Garrett. The soil within the enclosure was drained and improved by liming. Everything in view has limestone bedrock.

The bank and ditch alongside a later wall, marking the bounds of Shap Abbey's demesne land, west of the abbey.

Part of Byland Abbey's estate at Bretherdale, Orton.

Milburn Pasture, looking towards Burney Hill, the subject of a dispute from 1579–89.

A flight of lynchets at Nateby, near Kirkby Stephen.

High-level woodland assarts in Dunnerdale, with the former farm of Thwang on the right.

Marked contrasts in vegetation at Green Quarter, Kentmere. The central enclosure has been improved and maintained.

Thrushgill Quarries, Milburn, with Milburn Pasture as a backdrop. Visible are two of the eight lime kilns here.

The decaying remains of a farmstead, or shieling, at Gaitscale, Wrynose Bottom.

Greenriggs, taken in and improved in the late seventeenth century.

The S. West Prospect of Thurston Water in Furness Lancashire. Inscribed, 'for Stephen Penn 1732. Pen and ink watercolour on paper.' (Reproduced with the permission of the copyright holder, The Whitworth, The University of Manchester, accession D.1941.9).

Lorton Vale along the River Cocker where, in 1819, John Moore questioned agricultural practices.

A bank barn at Rusland. The core building, with shippon and stable doors facing the road, is of a type built around 1800.

The barn adjacent to the farmhouse at Glencoyne on Ullswater has a datestone: '18HH24'.

The decaying buildings of Rogersceugh farm on Bowness Common, built by the Lowthers as a model farm.

Naddle Farm, Haweswater, described by the Lowther agent in 1817 as a 'very desirable tenement'.

Looking towards the patchwork quilt of Lowther Park from Heltonhead.

St Andrew's Church at Netherby, rebuilt by Robert Graham in 1775.

Workington Hall, home of the Curwens for centuries until 1929, but now a 'classified ruin'.

Brotherilkeld in Eskdale, described in the 1850s as 'perhaps the most extensive' sheep farm in the North, with Esk Pike in the distance.

The intensively farmed Petteril Valley today.

Mechi farm. The range at the rear and the clock tower are original to William Lawson's rebuilding.

Winder Hall, Barton, where the tenant Mr Lowthian was a prize winner in 1880.

The splendidly preserved nineteenth-century lime kiln at Winder Hall.

Enclosures at Windmore, Stainmore: once improved but now 'going back', with soft rush asserting its hold.

Bowness Common on Solway, now part of a protected lowland raised bog.

Harvesting barley at Cliburn with a combine, 2015.

Waters farm in Bretherdale, one of a dozen abandoned farms in the area. It has a recorded history from 1593 to the twentieth century.

A harvest scene in Westmorland painted in the mid-nineteenth century in the style of Joseph Wrightson McIntyre (1841–97).

A fieldscape at St Bees with a mix of cattle, sheep, wheat and barley.

West Scales, one of several farms in Grisedale abandoned between the depression years of the 1880s and the terrible winter of 1947.

that process[32]. From 1808 through to 1823, work was underway in reclaiming Edenhall Fell between Barbary Plains and Carleton Village, draining bogs, walling and tree planting and regularly purchasing large quantities of lime, some of it from Redhills Kilns west of Penrith or from the Pennine edge, and some of it destined for new-build offices and cottages on the former fell.

Earlier discussion of a substantial collection of farm leases offered an insight into the running of this estate, and they continued through the late eighteenth and early nineteenth centuries[33]. As in the previous period, there was no consistency in the length of leases: Bramery High and Low Farms were let on 17 April 1765 for fourteen years, yet Sceugh Farm was let on the 27th for only seven years. The contrast here may have been pragmatic: Bramery was let to new tenants, from Crosby Ravensworth, whereas Sceugh was retained by John Simpson, the existing tenant. Perhaps the steward's thinking was that something more had to be offered to entice new applicants to vacant tenements. There was no difference at all in the stipulations that bound each tenancy. In 1768 Townhead Farm at Edenhall (now Home Farm, NY775 098) was let for nine years to another external applicant, Edwin Cowin of Busk, while Simpson renewed his lease in 1772 again for seven years. The tenants who took on Bramery in 1765 renewed their lease in 1778, but only for seven years this time, and Richard Railton was required to accept additional stipulations. One such imposed a penalty of 40*s* per acre should he exceed the permitted 80 acres (32 ha) he was allowed to plough up; he was also obliged to grant wayleave to the tenant of Dolphenby to lead lime from Redhills to his farm across Bramery land; and, furthermore, he was to pay 5 per cent interest to the estate for any improvements made during his tenancy. The first two clauses would have been perfectly acceptable to Railton, but the third must have caused him to think twice. Bramery was then re-let, not to Railton but to William Jameson senior and junior, who renewed in 1793. They accepted all the same conditions imposed in 1778, except that the 40*s* fine was increased to £5. In the following year John Williamson and Isaac Monkhouse, both of Langwathby, renewed the lease they held on Farfield Farm, this time for twelve years.

In the meantime, in 1783 a farm had become vacant at Hartley and Sir Philip must have wanted to set the lease at only three years, as Christopher Dobson wrote to him warning him that one as short as that would attract no takers[34].

As the new century dawned, a new tack was adopted as inducements were offered when tenancy agreements became due for renewal[35]. In 1802 the tenants of Sceugh, John and William Westgarth, were presented with a choice: either renew for a further seven years on the same conditions or sign up for nine years. If they opted for nine, Sir John would agree to drain the 'new inclosed land and make it fit for plowing' and would build a new barn, stable and sheds. In return, they were not to plough more than 70 acres (28 ha) per year and were required to lay twenty bushels of lime on every acre of fallow. Their choice is unknown.

Further restrictive changes applied over the following decade. In 1810, for instance, David Hill took on the lease of several parcels of land in Edenhall, but only for one year and he was faced with a barrage of stipulations that lead one to wonder why he bothered. Firstly, he was to leave half of one of the enclosures fallow and to 'spread thereon two hundred and forty bushels of lime' to be delivered in spring 1811 to the demesne from the estate's kilns in Kirkoswald. The estate paid for the lime and for leading it, but it was still a major commitment for Hill. Secondly, in 1812, he was required to sow turnips on the other half of that enclosure and to apply the same quantity of lime. Thirdly, he was to spread dung during the winter and spring months. Finally, his first turnip crop was to be followed with barley or oats, then by grass or clover, and subsequently pasture, which assumes he intended to renew his lease on a rolling basis. John Marvell, tenant of Dolphenby, also took on a renewable one-year lease of 85 acres (34 ha) beyond his farm in 1810. He was obliged to sow one field with oats in 1811, then to leave it fallow for a year before sowing turnips in 1812, after laying 150 bushels of lime. On the fallow he must spread 'a full usual Quantity' of manure in 1812, sowing barley or oats in 1813, and pasture after that. Thus, even though the term of lease was one year, it was clearly taken for granted by the estate that he would automatically renew on an annual basis. Hill's rationale may have focused on the opportunities an annual lease offered him for pulling out if circumstances changed.

In 1812 some leases had reverted to four-year terms. William Dawson, a Musgrave tenant at Hartley, took on the lease of Townhead Farm at Edenhall. He was obliged to spread all his dung on the farm, which was common practice; not to plough more than 90 of the farm's 235 acres (95 ha) in any one year; to leave one third

of ploughland fallow each year; and to lay at least thirty Carlisle bushels[36] of lime per acre of fallow land as well as 'well rotten' dung, before sowing it with a mix of clover, rye grass and seeds. Another lease of that year, for Sceugh Farm, tied in the Westgarths to the same basic terms as Dawson – and for four years, not the seven they had previously enjoyed – but the agreement drawn up was more specific in its detail. They, too, were to lay the thirty bushels but it had to be 'well-burned shell or Clod Lime'. Why this was spelled out is puzzling, given that the estate stood the costs of purchase, unless they had been cutting corners and arranging for delivery of low-quality lime.

Examination of leases from estates across Cumbria, and the North and West Ridings, shows that, as time progressed, agreements gradually and incrementally became more demanding of tenants, as stewards or landowners sought to assert their authority and impose their husbandry philosophy. It was often the case, however, that the length of leases became more standardised, but this does not seem to have been the policy at Edenhall – not, at least up until 1812, when the series terminates. Here, nine variations were in use, ranging from one to twenty-one years, with two thirds being for seven or nine.

Netherby Estate

The Netherby Hall Estate on the River Esk had been in the Graham family since 1628[37], but it does not really come to the attention of agricultural historians until the Revd Dr Robert Graham inherited in 1757. He embarked on an ambitious journey to change the face of his property and was regarded as a pioneer agricultural improver, undertaking extensive draining work, reclaiming bog land, rebuilding houses, upgrading estate roads and the hall, and laying out Longtown as a planned new town. In 1775 he had the church across the River Esk completely rebuilt. By 1769 it was noted by one traveller that land at Netherby, formerly valued at only 6d per acre, had risen to 30s, all of it enclosed and parcelled out as ten discrete farm units that were each leased to whom he considered good men, who were given their first two years rent free. The value of the estate, in terms of annual rental income, had risen from £2,000 when he inherited it to £13,000 when he died in 1782, a noteworthy achievement indeed[38]. Robert Graham can be considered an Improver in the broadest sense of the term.

His son, the first Sir James, ran the estate from 1782 and, initially at least, followed his father's example, setting leases at a standard duration of fifteen years and ensuring farmland was liberally limed[39]. Sadly for the estate, his enthusiasm slowly waned and he left its management to his steward, Mr Ellis, who neglected just about every aspect of control, to the extent that it was reduced to a dire state. Farms were said to be exhausted through over-cropping and lack of fallowing; almost three-quarters of the land was in urgent need of draining; part of the remainder was low-quality pasture; buildings were in a terrible state; estate roads poor; and boundary walls and fences no longer stockproof[40]. As Sir James advanced in years, his son, also James, grew increasingly concerned and began to ease his father out from 1819 onwards, realising that such decline could not be allowed to continue.

Young James instructed Ellis to carry out a full survey of the estate and his findings were less than complimentary; one wonders if the irony was not lost on him as he was ultimately the architect of his own failure as steward. Rosetrees Farm (NY354 667), north of the Esk, was 'excessively' run down as were High- and Lowmoat Farms (NY397 737 and NY398 733 respectively)[41]. Perhaps Ellis was unaware of his own incompetence, as he himself described some tenants in derogatory terms, and had apparently not seen any problem in having farms subdivided into unviable units: Highmoat was 189 acres (76 ha) in total, but was worked by six different tenants, all trying to eke out a living – or lacking the enterprise to better themselves. Ellis must have seen the writing on the wall: in 1821, he was unceremoniously sacked by the young James, who brought in John Yule, a Scottish land agent of some repute, to run the estate.

Yule soon proved himself a sound choice, as was Graham's immediate investment in a tile kiln that was soon churning out tile drains by the thousand under the watchful eye of an expert, who had been brought in for three years to train up local men to run the kiln in the long term[42]. Graham provided the tiles free to his tenants in return for new leases, obliging them to lay the drains on their tenements.

Even before old Sir James died in 1824, his son and Yule initiated wide-ranging reforms across Netherby, getting rid of unsatisfactory tenants, repairing or replacing farm buildings and houses, sorting out roads and field boundaries and, to their credit, offering inducements

to tenants in the form of prizes for following best practice. Bull Galloway calves made up the earlier prizes but Graham soon adopted the new Shorthorn breed and the estate became a significant breeding centre for it. Regular meetings were organised, to which estate tenants and others from across Cumberland were invited to see what had been achieved at Netherby as well as to exchange ideas for mutual benefit; and he established Longtown Agricultural Society to spread the message further. Young Sir James was ahead of his time in many ways, not least in realising that nuances in microclimate and soil type should be taken into consideration when planning the husbandry of any given field, rather than trying to force every part of the estate into a rigid mould that in no way would have been suitable. He also consolidated tenements, reducing the total number from 300 to less than half that, and rebuilt Mossband Hall (NY344 654) and Guards Farm (NY332 667), near Gretna, and Rosetrees as model farms.

Beyond farming, this Sir James undertook large-scale tree planting on land deemed unsuitable for agriculture, so as to provide extra income in the long term as well as to establish shelter belts. He encouraged a local entrepreneur to set up a bobbin mill in 1837,

Mossband Hall on the Esk estuary.

supplied with coppice wood from Netherby. By 1845 he had planted over 1,300 acres (526 ha).

He spent a veritable fortune and borrowed enormous amounts of money to raise the estate to new heights, and feared neither he nor his son would ever recoup the overall investment, but he has gone down in history as the owner of one of the finest and best run estates in the North, exceeding 30,000 acres (over 12,100 ha). He was widely regarded in his own time as the pride of Cumberland, and he has been described as someone worthy of being accorded 'high rank' among England's agricultural reformers and improvers[43].

Naworth and Corby Estates

Branches of the Howard family owned estates based on Corby and Naworth Castles, and both were perceived as progressive in agricultural management in the late eighteenth and early nineteenth centuries. Philip Howard of Corby (1730–1810) can be seen as a particularly diligent and committed reformer, although it was Henry, 4th Earl of Carlisle (1693-1758), who perhaps set the scene for improvement[44]; his steward, John Nowell, oversaw the development of techniques new to the Naworth Estate from the 1730s. The Board of Agriculture's commissioners, Bailey and Culley, credited Philip Howard with introducing the large-scale growth of clover and turnips to Cumberland in 1752 and 1755 respectively[45], but these dates have since been placed ten to twenty years earlier. Nevertheless, a report published in the year of Howard's death credited him with doing more to bring the turnip to the county than anyone else, having been made successful by the judicious application of lime[46].

The same report praised the encouragement by Henry Howard of his tenants' work to improve Naworth properties by experimentation and forward thinking. He, too, had pushed turnip cultivation in a major way, appreciating the advantages they brought about: growing turnips, planted in rows, cut out the need to leave land fallow and ploughed to minimise weed infestation. In turnip fields weed growth between the rows could be hoed while the young turnips were growing, so those fields were kept in the production cycle. Furthermore, they are a cheap forage crop for sheep and cattle, which eat off the tops and roots late into the year; they are fast growing; they help reduce pests that build up in the soil; and, if foraged in the field, livestock

return nutrients to the soil in the form of dung. Landowners and their stewards would have learned all this by reading or exchanging ideas with their peers, but one can well imagine the initial reluctance of conservative-minded tenants to expend time, energy and money in something so totally new. It is for this reason that late eighteenth-century farm leases increasingly included turnips in the scheme of rotation that new or renewing tenants were bound into.

Henry Howard has also been credited with bringing the Southdown breed of sheep to the county, summering them on 5,000 acres (2,200 ha) of grazing on Skiddaw that the estate rented annually, and experimenting with Merino sheep – the one was a better meat producer than the traditional and ubiquitous black-faced horned sheep and the other a better wool producer[47].

During the time of Frederick, 5th Earl of Carlisle (1748-1825), efforts were maintained to improve the overall condition of the Naworth Estate, and Bailey and Culley reported on a novel and seemingly effective and relatively inexpensive way of reclaiming peat land, whereby ploughing created ridges around 6.5 m wide, separated by 0.45m-wide furrows that acted as open drains, and with an earth-lime mix added to the ridges to improve the workability of the soil[48].

A short-run set of accounts in the 1810s details quantities of lime carted by Naworth tenants from kilns at Clowsgill Limeworks, in

The crumbling remains of Clowsgill Limeworks.

Farlam parish, owned by the estate but leased to limeburners[49]. Altogether, twenty-two tenants, without kilns on their own tenements, were involved in carting lime, presumably mainly for liming rather than for building purposes. Annual totals ranged from 4,070 to 5,421 units: the accounts do not specify whether the quantities were bushels, chaldrons or cart loads; associated coal accounts were in cart loads, but lime accounts for the 1820s were in chaldrons[50]. Average quantities ranged from 254 in 1812 to 309 in 1810, certainly too small to have been chaldrons and probably too small for bushels; if the units were indeed cart loads, the data represent significant amounts of lime. One aspect of the data is clear: the limestone fired in Naworth's kilns was considered to produce 'first rate agricultural lime' with minimal waste[51].

Workington Hall Estate

The manor of Workington had been held by the Curwen family from the twelfth century, but it only became prominent in agricultural development when John Christian Curwen (1756–1828) inherited the estate in 1782. His work, too, bore all the characteristics of a true Improver in the widest sense. As he himself wrote, as a direct result of the impact of the French Wars on the national economy 'various patriotic individuals ... turned their attention to agriculture'[52]; as part of that response, the farming industry had been transformed from one of 'mere manual drudgery' by the application of science. It is often the case that zealots readily believe their own propaganda and hone in on those aspects of their personal philosophy that support their missionary zeal, to the exclusion of those that do not. In the long run, as we shall see, Curwen perhaps fell into this trap, as not all ended well in his agricultural world. Nevertheless, his enthusiasm cannot be underestimated and the range of his endeavours and experimentation is certainly worthy of praise.

As we saw earlier, he engaged the services of the prominent landscape designer Thomas White the Elder to redesign the 262-acre (106-ha) Curwen Park in Workington between 1783 and 1789, and of the prolific architect John Carr to rebuild Workington Hall between 1783 and 1791. He also bought much of the land between Windermere and Hawkshead and in the 1790s planted 700 acres (287 ha) of 'mountain land' at Claife Heights on the western side of Windermere with three million coniferous trees, undertaken

largely but not solely with economic motives. He favoured the larch (*Larix* sp.), although today's species list is much more varied[53]; and he also purchased and made landscape changes to Great Island on Windermere in 1774, renaming it Bell(e) Isle after his daughter Isabella. He was a philanthropist, with a genuine concern for the welfare of his estate and coal-mining employees. He established the Workington Agricultural Society and provided educational, social and welfare facilities for the community, as well as a dairy with the capacity to supply fresh milk to the 'poor' townsfolk of Workington, from 1805.

Much of Curwen's enormous energy was directed at Schoose Farm (NY014 280) on the outskirts of Workington, which he developed from 1804 as a model and experimental farm. This reached its final layout by 1807 at the latest[54]. His experimentation, however, began in 1801 in a very pragmatic way: over the years, he owned between sixty-seven and 100 working horses, carting coal from his mines to the harbour[55], and to satisfy their daily fodder needs was a challenge indeed. Traditionally hay was the sole source but, as he himself bemoaned, the vagaries of the weather on the west coast all too frequently adversely affected the hay crop. He sought a reliable alternative and this was by steaming potatoes so as to reduce them to a pulp suitable for a horse's digestive system, and by feeding them

Plan of Schoose Farm, 1807. (CAS[W]DCu.Catalogue. Reproduced courtesy of Mrs Susan Thorneley, and the Cumbria Archives and Local Studies Centre, Whitehaven.)

with carrots[56]. The foundation of his work in farming was a belief that landowners should set a good example for their tenants and other farmers to follow. If a major landowner could not run his own estate successfully and profitably, how could those of a lesser social status be expected to change their time-tested methods? He firmly believed that, if a landowner would not grant a tenant a worthwhile lease, why should that tenant invest in the holding when he had no long-term security of tenure and no guarantee of recouping his expenditure? Equally, however, long leases must not contain what he called 'irksome' husbandry stipulations, which is at odds with the terms of a lease for Lilly Hall (NY016 247) at Winscales agreed to in 1814 by Robert Mouncey. It was for fourteen years, so that was acceptable, and it required him to keep buildings and fences in good order, which was standard practice, but it included tight clauses relating to the value and ownership, when the lease came to an end, of crops in the ground – wheat, clover, hay and turnips[57].

At Schoose, Curwen and his steward developed what they considered to be a more effective way of farming[58] by deep ploughing, especially in the winter months, allowing frosts to penetrate the soil more deeply, thereby breaking up heavy clay soils, improving downward drainage and increasing oxygen content. Cropping on the 535-acre (216-ha) Schoose farm and the other

Plan of Schoose and Moor Close Farms, 1810. (CAS[W] DCu/5/18. Reproduced courtesy of Mrs Susan Thorneley, and the Cumbria Archives and Local Studies Centre, Whitehaven.)

demesne farm, the 314-acre (127-ha) Moor Close Farm (NY030 269), concentrated on potatoes, carrots (with the tops used as cattle fodder), Swedish turnips (swedes), winter-sown wheat and cole seed (rape). On Moor Close he grew flax in a big way and tried growing cabbages as a cash crop, but with little success. All fields were liberally treated with manure at the rate of up to 1,200 cart loads per 30 acres (12 ha), along with coal ashes and 'street-rakings' at the rate of 20 tons per acre[59]. Rather than adopting a traditional three- or a four-year rotation system, he experimented by alternating green crops (roots) with white (cereals, ideally wheat but oats where the ground was inclined to wetness). To improve the efficacy of the manure, he had liquid waste, slurry in today's parlance, pumped on to the farms' dung heaps, although his preference was to spread manure straight from the stockyard, piling up equal quantities of horse and cow dung in the fields, before having it all mixed with slurry and then ploughed in.

As for livestock, he maintained a mixed herd of Longhorn, Shorthorn and Devon cows, and thirty-two draught oxen fed on a combination of cereal chaff and straw, boiled to a pulp in a special tank, and on imported oil cake. The cattle were fed on hay derived from clover and rye grass, but he also pioneered the use of lucerne for cattle feed[60]. This proved to be economically unsound, however, and was discontinued. Curwen was also a pioneer in Cumberland of a revolutionary process known as *soiling*: instead of being allowed to free graze in the fields, cattle and horses were fed in the farmyard with fodder no more than 24 hours old[61]. It was believed at the time that this method led to larger quantities of dung being produced, which could be liberally spread on the fields, and was more economical, in the sense that the livestock could be fed at the end of their day's work without having to be, unproductively, turned loose in the fields to graze. On the other hand, it required more labour to handle the dung and a farmstead designed with the dung heap and slurry tank centrally placed to minimise time spent moving around.

A sense of the scale of his operations at Schoose is given by a surviving wages book[62]. In 1812, for example, ninety-five men and boys and sixty-eight women and girls were on the payroll, excluding those hired in for tasks such as leading manure, thatching haystacks and draining. It is a sign of the times Curwen lived in that, on average, most males were paid 2s or 2s 6d per day, whereas females only earned 1s.

Predictably, Curwen was a firm believer in the benefits of draining wet ground. It was, he wrote, the 'basis of all agricultural improvements in strong soil', meaning clay[63]. Within his first four years as a farmer, he had 500 acres (202 ha) drained, mainly with stone-filled open cuts 1–2m deep; in time he turned to sinking deeper drains, especially on Moor Close, where his labourers cut more than 23,000m. This was a massive investment.

He was equally passionate about encouraging farmers, and one means to achieve this was by offering annual premiums recognising best practice. Two such prizes from 1810 will illustrate the point[64]. The best-managed farm premium went to a farmer at Loweswater, who worked 130 acres (53 ha), of which about one-third was under crops, with the remainder supporting 500 head of sheep. The prize winner had deep ploughed, drained 30 acres (12 ha) of wet meadow ground and liberally applied lime, and the wherewithal for his being awarded the premium was the resultant quadrupling of the value of the farm, despite his lack of a formal lease and long-term security. He truly embodied the improving spirit, as Curwen might have added. The best owner-managed farm was Bothel Hall (NY182 391): it was only 40 acres (16 ha), but the owner, J. Gibson, produced good crops of cabbage, swedes, barley and turnips through his 'superior management'. Curwen was not just the sponsor of prizes but also, at times, the recipient[65]. In 1806 he was awarded a gold medal by the Society for the Encouragement of Arts, Manufactures, and Commerce for his success and inventiveness in growing carrots as cattle fodder. Two years later he was awarded its gold medal for his innovations in the growing of cabbages and potatoes.

In 1813, however, he reluctantly gave up working Schoose himself. He freely admitted it had all been a massive experiment and an expensive one, and that he had made mistakes and been too ambitious in some of his schemes, but his legacy was undoubtedly long-lasting. Whereas some of the model farms that were built in Cumbria have disappeared or been drastically downsized, Schoose today is more or less as he would have remembered it. The improvements he undertook on his own farms, or encouraged on others, laid the foundations for what today is a prosperous, mixed-farming region: this cannot be denied him. He wrote that, between 1793 and 1813, farming in Cumberland had made good progress, and that many more farmers had a theoretical knowledge previously lacking[66]: he knew he could justifiably claim at least some of the credit for himself.

Giving up working his two farms did not equate to abandoning the estate. Around 1814 he oversaw work underway at Lilly Hall on an enclosure that was underlain by peat. He had it pared and burned, drained and ploughed and even lost an argument with his bailiff over the wisdom of liming it. He said there was little point; the bailiff disagreed; but Curwen agreed to a small area being limed as an experiment. The harvest was very good, and the bailiff proven right. He had asserted that the distance from Schoose to Lilly Hall (over 2 miles/3km) made the costs of leading manure from one to the other prohibitive, but lime was more readily available. Curwen readily conceded that the resultant crop of wheat was 'admirable'[67].

Hutton John

Hutton John manor had been held by the Huddleston family from the late sixteenth century but, as with the Curwens, the estate only features in the agricultural record during the period under review in this chapter. Andrew was a recurring first name for heads of family. In 1768 Andrew Huddleston (1734–1822) devised to two local men a limestone quarry at Gospelhow in Penruddock for a term of seven years[68]. As part of the deal, both the estate and its tenants had the right to take limestone from the quarry and to burn it for their own use. This could have included lime for building purposes, but it is more likely to have been agricultural lime.

The next substantive document dates from 1816, when a Memorandum of Neglect was drawn up against an unidentified tenant[69]. The list of indictments was damning. He had totally neglected to maintain field drains and ditches, to the extent that one meadow was so terribly poached by cattle that the sward was effectively destroyed, with parts 'rendered sour rushy mossy and unproductive of sweet grass'. He had also abdicated his responsibility to keep field boundaries in good stockproof order; gates were either broken or propped open and could not be closed, so livestock were thus able to gain access to woodland that was not within his tenancy. The farm access road was also in a very poor state and he was accused of illegally taking large quantities of gravel from a field on the farm to be used on the nearby turnpike road: it has to be assumed that he was selling the material to the turnpike trust without Huddleston's authority. Furthermore, he had breached his tenancy conditions by ploughing up a 'vast number of acres' of pasture land,

and had 'destroyed' Gale Field by the injudicious application of lime. How matters had been allowed to sink so low and why he had not been called to account previously were not recorded, and neither has the record of action taken against him been located.

Andrew F. Huddleston (1796–1861) was attracted by the improvement ideal and a further legal agreement, dated around 1835, laid out in detail how a particular field was to be improved, itemising each stage in the process[70]. It is conceivable that the estate had adopted a prescriptive approach to avoid a repeat of the 1816 debacle, or it could be that Huddleston was laying out the predicted costs to avoid the possibility of escalation as work progressed. Work followed the accepted pattern for reclamation: it was first pared and burned and then limed. The first crop sown was oats and, once that had been harvested, the field was treated with a mixture of ashes and lime. The size of the field was not given, so there is no means of assessing whether or not the fifty cart loads of oats harvested would have been considered a good yield. Further accounts for 1837–38 itemised disbursements for work done on the estate, including in Hesket Pared Field, which may be the one reclaimed two years or so earlier[71]. William Jackson, and to a lesser extent others, undertook tasks that included 'scaling spreading] lime' and mould, 'at drains', 'mixing lime and mould', leading lime and coal, leading stone to be used in new drains, working at the lime kiln on the farm, in addition to forestry work, gardening at the hall and general estate maintenance. Most of the payments were made to male employees, but one entry in 1837 recorded payment to Mary Bell and Anne Green, who had been engaged in 'Burning pareings, 2 days and weeding, gathering stones grubbing up stones from the soil], scaling lime and mould, on drains'. There was little distinction between the genders in the type of work offered. Nor was much account given to the seasons: work across the range of jobs was recorded in those three years for every month except February. Huddleston clearly put great store in draining, as payment vouchers through to 1840 relate to work on Highgate Farm (NY444 275) and Dacrebank (NY455 271)[72].

The Huddlestons were sensible when it came to determining the length of farm leases. Highgate Farm was let in 1841 to Christopher Pears and John Graham for a term of fourteen years with the usual set of conditions[73]. Huddleston reserved to himself the right to get limestone and to burn lime on the kiln close to the farmstead, while the tenants were forbidden from ploughing specified fields without

Huddleston's express consent, and they were to leave fallow or under green crops (turnips or potatoes) not less than one third of arable land in any one season. Classifying green crops as equivalent to fallow followed in Curwen's footsteps – he had pioneered this practice. Tenants were also required to apply thirty Carlisle bushels of 'well-burned lime' per acre, along with a 'sufficient' quantity of manure, that was defined at the time. The lease also clearly pointed out that their husbandry regime must at all times be directed to the improvement of the land.

By 1858, when Dacrebank came up for re-letting, all Hutton John leases were in a standard printed format, with gaps to be filled in as appropriate to each farm[74]. As was common on most landed estates, the scheme of rotation to be followed was spelled out: it was to start with a cereal crop, followed by a year of fallow or green crops (turnips, potatoes, carrots or mangolds)[75], then a mix of clover and grass seed in the third year with pasture in the following two. This lease, also for fourteen years, required each field to be limed once during the term of the lease with 'good unfallen unslaked] lime', and each field under grass was to be top dressed with 'solid farm yard manure' after every third cutting at twenty cart loads per acre. The conditions were strict but clearly acceptable to most tenants.

Dacrebank farm, Hutton John.

Other Estates

Over at Muncaster progress was underway, albeit with no startlingly new developments. Potatoes were grown as fodder for cattle and pigs, with turnips gradually taking their place. Experiments had been made to see if carrots would prove a profitable crop, but they were abandoned as the climate was too wet for them to prosper. It might be assumed that it was also too wet for wheat but the estate had pioneered its cultivation in the 1760s, and was still growing it as part of the rotation system at the end of that century.

A full survey of the Buccleuch Estate in Furness, undertaken in 1814, concluded that much of it consisted of 'waste or common ground ... of very small value consisting merely of Rock and Mountain and no advantage is ever likely to be derived from it' – yet, were it to be sold *en bloc*, it would fetch more than average rental values might suggest[76]. It was deemed not to be worthy of enclosure or investment other than in forestry, which was a damning judgement given that the nation was still at war with the French and a dig for survival mentality was still uppermost among the landed classes. The estate, however, was not sold. Elsewhere in Low Furness, it was noted in 1808 that many farmers were ploughing up more grassland than usual to plant oats and potatoes due to continuing low sales prices for cattle, and because the rapid growth of Ulverston was providing new markets for both crops[77]. Other crops new to Furness were adopted: namely rape, which was recognised as a good fodder crop that was suitable for following turnips in rotation; and swedes, which, unlike turnips, were not prone to fly infestation[78]. It was the general opinion that agriculture in Low Furness had improved so markedly over the previous quarter century that output had grown fivefold and land values threefold, as farmers appreciated the financial benefits of taking on board new strains and new methods of husbandry: 'progressive Improvement' was the way forward[79].

William Fleming, who farmed at Rowe Head in Pennington, still favoured short leases coupled with stringent clauses: in 1809, he let out one field for three years and directed the lessees to sow oats for the first two years and barley for the third, at the end of which he was to allow them the cost of twenty bushels of lime, with tenants adding an equal quantity and spreading the whole amount on the field with fifty cart loads of manure. If they intended to renew the lease, their efforts would have been rewarded; if they declined to renew, the next

lessee would have benefitted. This insistence on liming appears time and again on landed estates throughout the late eighteenth and early nineteenth centuries[80].

The Appleby Castle Estate also used generic pre-printed leases from the 1760s to at least the 1790s, and all of those examined carried the same stipulation that lime was to be applied, although the actual amounts varied from lease to lease[81]. It was general practice here to admit tenants on nineteen-year leases, thereby affording them security of tenure and more of a guarantee of a decent return on their investments. Furthermore, the estate undertook building repairs on tenanted holdings, repairing a barn here and a farmhouse there. In 1797 the existing barn at Sunmoor Farm was pulled down and a new one erected in its place at a cost of over £78, a substantial sum of money, as well as a new barn at Hofflunn Farm (NY665 166) for £50, and at Milburn Grange (NY671 280) a new barn, cowhouse and stable for £36[82].

7
Innovation, Experimentation and Depression: The Changing Fortunes of Agriculture, 1850–1937

The three decades following Napoleon's defeat in 1815 were fraught with difficulties, with repeated bouts of poor weather, serious epidemics among livestock, high food prices but low farm-gate prices, and enduring rural distress. If these were not enough negatives, 1846 brought another blow to those who relied for at least part of their income on cereal crops: the Repeal of the Corn Laws, imposed in 1815, led directly to a flood of cheap grain into the country. However, the effects of this were short-lived and probably not of great significance in Cumbria, where livestock far outweighed cash crops in the overall economy. Cyclic tendencies came to the fore in the 1850s, with the development of what has been rather romantically called the period of 'high farming', a time of boom, and not just in agriculture, that persisted into the 1870s. The underlying, external forces that brought this about included ever-faster urban growth with its concomitant demands for food, coupled with the rapid growth of the rail network, which enabled produce – even that with a short shelf-life like milk and butter – to be despatched to distant markets from remote locations in Cumbria. Significant quantities of butter were exported to Manchester from Mardale, Ravenstonedale, Shap, Warcop and Orton, while milk found its way from Kirkby Stephen to Liverpool, Newcastle and even London[1].

Midtown Farm, Crosby Ravensworth.

By 1850 half of the British population was urban based, creating a huge and ever-growing market for produce. The slow development of science in farming gained pace, with a flood of new and improved machinery to make farming more efficient and profitable[2], new crop types and strains, improved breeds of sheep and cattle, much more underdraining, and better rotation regimes. These were key components of high farming in contrast to 'low farming', where age-old methods had persisted and a resistance to innovation was palpable[3]. Adoption of high farming led to more productive income streams, which in turn provided the finance for greater investment across the board, including building infrastructure. For example, the Dent family of Flass House in Crosby Ravensworth renovated or rebuilt four of their farmsteads: Brackenslack (NY632 168) in 1855, Low Row (NY623 149) and Midtown Farm (NY620 144) *c.* 1860, and Wickerslack (NY608 157) in 1868[4].

Previous reliance on manure and lime as soil inputs was whittled away by the development or importation of a range of soil additives, in large part through research work and field trials undertaken at the Rothamsted Experimental Research Station in Hertfordshire[5]. Bone-dust (pulverised animal bone) was available in Cumbria from

1833, supplied by a crushing mill in Carlisle[6]; in 1836, pulverised bones were successfully decomposed in sulphuric acid to produce superphosphates, which entered the market on a large scale in 1843[7]; nitrate of soda and ammonium salts were widely available from around 1840; a concoction of blood, bone and sulphuric acid also appeared around 1850; as did coprolites (natural fossilised faeces) and nitrates; potash became a favoured input in the 1860s; and sulphate of ammonia, a by-product of urban gas works, at about the same time. All of these were eclipsed by guano, which was first brought into Britain through Liverpool in 1840 when Peruvian export restrictions were lifted, and adopted in Cumbria around 1843, becoming the pre-eminent soil input by the mid 1850s[8]. In 1841 less than 1,200 tons were imported through Liverpool, but in 1858 the total was nearly 14,000[9]. Its promotion was in part due to RASE, in part due to a number of authors of farming treatises waxing lyrical about its benefits[10], and in part due to its lower cost compared to lime[11], and its total lack of volatility, unlike lime. Its heyday was short lived, as cheaper superphosphates soon began to squeeze it out, but it did remain in use in Cumbria into the following century[12]. Basic slag, a by-product of processing iron ore derived from limestone flux, was high in phosphates and encouraged the growth of clover meaning there was no need to apply nitrogen on pastures treated with slag, so it was a potential cheap multi-purpose soil additive. It was first trialled in 1885 and became available across the country in 1896[13]. The science of soil inputs had come a long way since 1851, when the matter of manures was 'still unhappily involved in considerable obscurity'[14].

Contemporary Views

It may have been pure coincidence that, while all these innovations were coming to the fore nationally, farming in Cumbria came under close scrutiny from various quarters. Two authors – one a farmer and assistant agricultural commissioner; the other a farmer, land agent and surveyor – produced reports on the state of farming in Lancashire. The first, Jonathan Binns, had relatively little to say about the industry in Furness, other than to report that the local limestone beds did not yield good-quality lime, so many farmers sourced it from elsewhere. The other, William Rothwell, was of the opinion that farmers in Lancashire (including Furness) were not, as others had

suggested, opposed to improvement and innovation or laggardly in their endeavours, although he did divulge the patronising idea that, if a landowner was to have good tenants or labourers, he should 'render them strict justice'[15]. A disparaging contemporary view, from 1866, pointed the finger at husbandmen, who as a body objected 'to innovation, and their stolid indifference, or rather, aversion, to what they termed "book knowledge"'[16]. In that writer's view, farming without science was doomed.

Published in 1847, one trade directory extolled the virtues of farming in Cumberland, although it can hardly be considered a disinterested source. Nevertheless, it must contain more than a hint of reality when it described farming as being in a 'state of perfection', with a range of improvements introduced – new soil inputs, more draining, 'excellent' potato crops (except in 1846), grain being widely exported out of county, and turnips all over the place. Two years later, however, another directory noted that much of Westmorland still lay in a 'state of nature', despite all the ongoing improvements[17]. More detailed analyses of farming in both Cumberland and Westmorland were provided by William Dickinson, a noted writer on agriculture, geologist and botanist, who lived at North Mosses farm (NY061 211), Arcledon[18].

He described some of the notable changes in livestock that had occurred since the late eighteenth century – Herdwick and 'Scotch black-faced' sheep being replaced by Leicesters and Cheviots, except in the high fells and Pennines respectively, with Southdowns and Shropshire Downs introduced on a smattering of innovative farms[19]; Shorthorns replacing Longhorns; Galloway and Highland ponies replaced by heavy horse breeds; greater mechanisation; and higher levels of relevant education among the farming classes. He distinguished between the classes, identifying larger farms belonging to yeomen and gentlemen, upland farms of medium size occupied by the statesmen in Lakeland, and smallholdings along the west coast plain, often worked by part-time farmers. He confirmed what we have already discussed about farm leases and their stipulations, and rotation systems in common use.

Dickinson also provided a more detailed discussion of particular farms that caught his attention. For example, Mr Harris farmed at Weary Hall (NY217 418) in Boltons and at Greysouthen, and produced 'heavy' wheat crops at both applying lime and fallowing in rotation, a practice deemed to be rare in that part of the county.

On the moss lands further north, fallowing was not observed and farmers there tended to pare and burn instead, at regular intervals interspersed between two years of oats followed by clover and seeds mixed together, and two of pasture, which practice seemed to Dickinson to work perfectly well. He accorded a farmer at Bassenthwaite, Richard Atkinson, the accolade of being the first to grow turnips in west Cumberland as early as 1793: at the time Atkinson had been scoffed at but, by 1849, there was hardly a farmer who did not grow them, with guano being the favoured treatment. Dickinson condemned the still-common practice of piling manure in uncovered heaps across the fields in winter, recognising that most of the nutrients were leached out long before the heaps were spread out across the field in the spring. Much better, in his opinion, was what had been pioneered at Gilgarran, east of Distington, where one farmer stored manure under cover in the farmyard, close to the cattle stalls, thereby minimising labour and preserving nutrients *in situ*. He wrote of the farmer at Croft Hill (NY988 197) north of Whitehaven, Mr Randleson, who had devoted his energies to mixing different soil types to achieve the optimum for his form of cropping. Elsewhere, underdraining was widely used, having been introduced

Millom Marsh embankment, built in 1830. The reclaimed farmland lies to the left, the tidal Duddon Estuary to the right.

to the area in 1824 when Robert Lucock commissioned his first tilery at Langrigg. Of special note to him was the £3,000 investment made by Lowther Estates at Millom, constructing in 1830 the very substantial embankment and inner ditch that enabled Millom Marsh to be reclaimed for farming. Though it is now down to pasture, in his day it successfully grew wheat and oats as well as grass. Dickinson also drew attention to Brotherilkeld farm (NY213 014) at the foot of Hardknott Pass, which he thought 'perhaps the most extensive' sheep farm in the north of England, with grazing on 14,000 acres (5,665 ha) between there and the Scafell massif.

Overall, he was very positive about the state of farming in west Cumberland, lauding a 'powerful agency at work ..., stirring up their hidden energies, directing their attention and developing their capabilities, in a manner, and with a force, of which themselves could have no idea until they experience its movements'[20]. He was, of course, talking of the farmers as he saw them around 1850 but he foresaw the full effects lying somewhere in the future. He was no less enthusiastic about the farming fraternity in east Cumberland, commenting that, even by 1825, hardly any of the lowlands remained in an unimproved state, with new enclosure roads making access to markets so much quicker, more draining completed, and new techniques adopted. In short, the 'listless lounge of the half-shepherd, half-husbandman' had been transformed into the 'active, industrious, and persevering qualities of the agriculturist', no less[21]. In both instances Dickinson was somewhat florid and over the top in his language but, stripping that out, in essence he was painting a realistic picture for much of Cumberland.

In east Cumberland, as in west, he had taken care to pick out those farms that had gone further than most in advancing technology. Mr Dixon of Ruckcroft (Ainstable), for example, had bought the east's first horse-drill for planting turnips and swedes, an action that brought him not derision from his peers but emulation, as he had enjoyed great success, dressing the fields with manure and some guano and crushed bone to provide a rich standing crop of fodder for his sheep and cattle. Cultivation of potatoes had soared since a gentleman farmer at Bewcastle had brought in the first suitable plough back in the 1780s, before which they were laboriously hand-planted in raised beds. It had by 1850 become common practice to keep manure heaps covered and to store slurry in tanks; it was accepted practice to plant peas and beans to smother weeds

instead of following what he described as the county's 'worst of all husbandry', namely growing crop after crop of cereals, which gradually became swamped with out-of-control couch grass[22]. He noted that lime was still the 'usual restorative' on old pastures, that many farmers used guano but would rather have stuck with lime, and he sounded surprised that no one in the east had yet taken up lucerne, even though the soil was eminently suitable.

Scaleby parish impressed him, in that some of the tenants had got together of their own volition to drain 1,000 acres (405 ha) along Brunstock Beck despite (unexplained) opposition from their landlords, which land was now producing succulent hay crops and aftermath. Several farm holdings were singled out by Dickinson[23]. W. E. James, a tenant at High Hesket in the Petteril Valley, worked a farm of 650 acres (263 ha), almost all of which he had drained. He ran a mixed farming regime with 700 sheep, 135 cattle, cereals, turnips and rape; he experimented with new ways of foddering and bought feed-milling equipment; installed a slurry tank; and applied guano, dissolved bone and manure to his fields. Perhaps most impressive of all is that he did all this without making a fuss – he just got on with it. The other farmer worthy of special note was Timothy Fetherstonhaugh at The College (Kirkoswald, NY555 411), who owned two farms. One at a higher altitude ran a six-course rotation, which was unusual, the lower one a four-course system on land that had been 'thoroughly' drained, resulting in vastly increased output. Both farms were treated with guano and manure, and he had built up a herd of eighty Shorthorns using imported breeding stock, and 120 sheep. Lowthian Gill (Hesket, NY465 483) was also managed according to best practice, based on liming, and had also increased its productivity.

Holme Eden Farm (Warwick Bridge) had managed to double its output since the late 1830s, owing to the efforts of the farmer to deep drain his land and to introduce four-course rotation with minimal fallowing. Turnips again featured prominently, as a standing fodder crop, as did wheat with depasturing of sheep and cattle.

Dickinson highlighted the practice of agistment that was in common use in Cumberland and would have developed out of the medieval system of transhumance. Upland cattle and sheep farmers could not over-winter their animals on the fells, for obvious reasons, and would have struggled to feed the entire flock or herd at the farmstead. Consequently they contracted with farmers possessing

suitable winter grazing, who looked after their animals from October to May in return for payment. Gowbarrow and Glencoyne Parks on the western side of Ullswater took large numbers each year; Greystoke Park took between 800 and 1,000 head of cattle; Burgh Marsh on the Solway, and much of Bewcastle, Nicholforest and Spadeadam in east Cumberland took agisted livestock. It helped both parties: the owners maintained their flocks and herds intact from year to year, while the host gained a useful extra source of guaranteed income.

Sir James Caird published a series of letters in 1852 on a county basis. Though there was none for Westmorland, east and west Cumberland each had one. Much of what he wrote echoed Dickinson's observations and conclusions. Generally speaking, tenants in east Cumberland were an 'industrious, hard-working, and economical class', whereas he identified a clear difference in attitude in the west between the younger statesmen, who were 'zealous' improvers, in contrast to the older generation, who seemed 'strongly prejudiced' against change[24]. As with Dickinson, Caird focused on specific estates and farms, which he felt were good examples for others to follow: Captain Walker at Gilgarran had overcome the perennial problem of rain leaching nutrients out of uncovered manure heaps by erecting sheds over his farmyard heaps. This incurred a large initial outlay, recouped through increased productivity year on year. He also built an underground tank to store liquid slurry, which was pumped onto the manure to keep it moist. This is but one instance of a middling sort of farmer taking the initiative and what many would have perceived to be a potentially hazardous leap in the dark.

Crayston Webster, land agent, surveyor and prolific enclosure commissioner, praised the efforts of Lowther Estates, which had brought into productive use much of Shap Fell and the northern parts of Orton parish, tile draining 1,200 acres (486 ha), liming 1,500 (607 ha) and walling the limed enclosures[25]. 'Numerous were the hostile critics and foreboders of failure', he wrote, but they were all proved wrong as ensuing harvests were 'beyond expectation'.

Innovation or Status Quo?

Archival evidence of estate management during the later nineteenth century is, on balance, less evident than for the preceding hundred years: whether this reflects a loosening of control of tenanted farms or merely a lack of survival of estate papers is a moot point.

Nevertheless, there is sufficient evidence to begin to address the issue of the extent to which landed estates in Cumbria continued to embrace innovation and change.

The Nunnery Estate (NY537 428) at Kirkoswald, under Henry Aglionby, was engaged in extensive drainage works on several farms in its possession, with a total of 811 acres (328 ha) improved at Fellend farm (NY534 510) in Cumwhitton, Springfield farm (NY547 437) in Staffield and Bascodyke (NY529 452) and Cross House (NY534 433) in Ainstable, between 1847 and 1854[26]. It had long since been proven that land properly drained increased in value, but the initial expense of undertaking the works was an impediment that smaller estates could not overcome. Government recognised this by introducing a series of Acts, and Aglionby took full advantage of the inducements offered by the Improvement of Land Act 1854 and the first of several Public Money Drainage Acts (1846-56): he took out a loan of £700 under the legislation to finance the proposed drainage work, beginning in 1847 and ending in 1854. By the time the tile drains were all installed, he had improved 1,226 acres (496 ha) at a total cost of £674 and it was estimated that the value of the treated fields and farms had increased by £46 over the eight-year period. Without the loan it is highly unlikely that the work would have been attempted, and the rationale for borrowing so heavily is, of course, not explained in the accounts.

Over the same period the Green Lane House Estate at Dalston (NY385 501), owned by the Inglis family, was also engaged in large-scale draining operations, but with no indications that loans were taken out[27]. The surviving accounts are mundane, mainly itemising daily payments for work done: in June 1853, William Pearson spent his time filling manure carts and spreading it on turnip fields; in July and August he thinned out the turnips, made hay and harvested corn crops; in September he worked in the potato fields, presumably weeding and maybe harvesting; while in the next two months he was once again spreading manure, cutting turnips, and cutting and re-setting drains; he ended the year by filling those drains with gravel and small stone, creating what are often called French drains, which was the cheapest method available. In 1854 and 1856–58, in addition to the same round of farming jobs, much more draining was underway, so Inglis may now have taken out a loan under the Acts. The estate had engaged the services of J. Harrington to superintend the process, which suggests they did borrow. In 1858 draining was

concentrated at Stoneraise (NY266 456) near Wigton, on which £201 was expended in addition to Harrington's salary of £10. Earlier accounts recorded payments to Pearson, probably a farm labourer rather than tenant, and his three sons for draining work at Stoneraise in 1831, but no indication was given in the later set of how this work related to that in 1858[28]. The accounts for 1858 make the only mention of soil inputs other than manure, namely 'spreading Lime Moor Platts' in August.

Kirkby Thore Hall (NY641 256) had been added to the Lowther portfolio around 1860 and very quickly the tenant, John Nicholson, embarked on an ambitious programme of improvements across the farm: a new farmhouse was built, land was drained, Trout Beck was straightened and embanked[29], new field boundaries were installed and realigned, and the whole property was put into much better condition.

Mid-century accounts for Hutton John are brief, but make frequent mention of leading or 'scaling' lime from February to August. However, there is a distinct difference in the amount of farm work paid for and the number of days worked during the late 1850s compared with sets of accounts from twenty years earlier[30]. Perhaps it had become the policy on this estate to devolve more day-to-day management to tenants instead of having a steward dictating policy. When it came to draining, however, the estate did come to the fore: a series of vouchers itemise the 'laying' of drains – thus tile not French drains – on Highgate and Lacet (NY430 268) farms[31].

Lowther Estates embraced draining on a truly heroic scale, not just laying tile drains but constructing their own tilery at Hackthorpe in 1847 and, as would be expected for an undertaking as large as this, detailed accounts are extant[32]. Sales data for the tilery emphasise the scale of draining that was underway across eastern Cumbria mid-century, with tiles despatched to customers as far north as Carlisle, as far south as Shap and Whitbarrow, and to all places in between. Judging by what they purchased, some customers were dabbling in tile draining – Richard Buck of Sleagill took delivery of just sixty-three tiles in 1857 – whereas John Bowstead of Sandriggs ordered 13,550 tiles and 11,500 collars[33].

Perhaps the most ambitious Lowther project was the complete draining and reclamation of Tarn Wadling at High Hesket. Still named as Tarn Wadling, it is now largely pasture land, although

Tarn Wadling, drained 1858–60.

Date	Cost of draining £	Cost of liming £	Cost of 'farm work' £	Item cost £		
1858 (Sep-Dec)	1183	294	39			
1859	2652	485	364			
1860 (Jan-Aug)	2212	958	98			
Sub-total	6047	1737	501			
1860 (April)	sowing grass seeds & applying superphosphates on 16 acres			65	9	3
1860 (June)	applying 2 tons superphosphates			15	0	0
1864 (June)	burning parings & spreading ashes			17	8	2
1864 (July)	paring & burning & spreading ashes on 50 acres			73	0	7½
Sub-total				293	17	1½
Total				8579 (rounded)		

Table 9 Costs of reclaiming Tarn Wadling, 1858–60.
(CAS[C]D/LONS/L3/5/107)

still inclined to be wet. Two sets of accounts detail expenditure on draining, liming and general husbandry of the reclaimed land, which included ploughing, weeding, stubbing tree roots, cutting thistles, gorse and soft rush, as well as walling, manuring and

sowing oats and rye grass[34]. The total labour cost of over £8,500, and the added cost of tile drains and collars at £826, can only be described as enormous and it is surely beyond belief that such investment could ever have been recouped, even taking into account increased rentals and land values. According to the accounts, work began in September 1858 and ended in August 1860; within that period only September 1859 saw no work underway.

On a much less grandiose scale, while impressive in itself, was draining and reclamation of the Bowness Flow (now Common) peat moss on the Solway, also owned by Lowther Estates. Formerly valued at a meagre 6*d* or less per acre, it was soon yielding good crops of oats according to a contemporary observer[35].

As seen earlier, Lowther applied for £30,000 under the Drainage Act of 1846 for draining demesne land, but only borrowed £10,000, so his expenditure on Tarn Wadling would have been covered by that. Repayments extended over a period of twenty-two years, which perhaps would have lessened the initial impact of going into serious debt. Even at such a late date, however, improvements were perceived not just in monetary terms (the loan and investment must return an increased and measurable income) but as a duty: firstly, as a social investment for the benefit of the tenants, a rather patronising attitude by today's values, perhaps; and, secondly as a duty to the land[36]. One of the roles of a major landowner was to ensure the succession of his line; another was to pass on to the next generation an estate in better condition and at a higher annual value than when inherited.

Beyond draining, Lowther Estates were still engaged in liming as a prime means of reclaiming land, and their accounts for 1858–65 indicate the faith placed in that process: in the first four years of the run over 15,000 (cart?) loads of lime were led from Wickersgill Lime Works, just south of Shap village, to be spread on the nearby fells where allotments were being reclaimed from open moorland. Over the whole eight-year period, over £9,500 was paid out to this end[37]. Work on a similar scale was underway at the same time on the Lowthers' Wickerslack Moor between Hardendale and Crosby Ravensworth village, which had been enclosed by Act of Parliament in 1858. In May 1862 alone, 2,560 loads of lime were spread on the newly created High Allotment, at a labour cost of £21; in the previous year, nearly £74 was spent on building a new kiln on the moor for reclaiming it[38]. These were not the only kilns constructed on the estate for bringing land into more productive use. Ten years

The lime kiln at Trantrams, Thrimby.

earlier, two existing kilns had been refurbished, one on Whale Moor near Lowther itself and the other at Brackenber at Great Strickland, at both of which the tenant farmer was required to undertake all the necessary carting of materials[39]. New-build lime kiln projects were in Warnell Quarries in Sebergham parish and at Thrimby near Lowther: each new kiln cost £20 to build. The Warnell site has mostly gone, but the Thimby kiln stands proud and intact, a monument to whoever designed and commissioned it – Lowther himself or his steward – because it goes far beyond the merely functional and utilitarian and is, by any judgement, a splendid edifice. This kiln was not just built to burn lime to improve the land thereabouts; it was put there to make a statement about the Lowthers' long-term vision. It is almost their mission statement in itself.

One branch of the Lowther dynasty had been based, in earlier times, at Whitehaven and their properties in west Cumberland remained part of the overall Lowther Estate after that branch of the family effectively died out in the 1750s. One of their farms was Moresby Hall (NY990 212) outside Whitehaven, a holding of 340 acres (138 ha) supporting eighty head of cattle, including forty dairy Shorthorns, and 300 sheep. It was the standard policy of the

estate in the mid-nineteenth century to base tenancy agreements on a rolling annual basis but, in return for an apparent lack of security, tenants far removed from Lowther Hall were left to manage their tenements as they saw fit with no interference or obligations to pursue any given husbandry regime[40]. The tenant there pursued a four-year rotation on his more fertile ground based on oats then swedes followed by yellow turnips and then wheat, while on the higher parts of the farm he grew turnips for sheep to eat off *in situ*. His reasoning was that, in wet conditions, there was a general tendency for pastures to become poached by sheep trampling, and leaving turnips in the ground prevented that. To maintain the quality and productivity of his cropland, he rested them for two years in each cycle and planted them down to a rich mix of Italian rye grass (*Lolium multiflorum*), perennial rye grass (*Lolium perenne*), Rib-grass, white clover and rape, all top dressed with a liberal dose of farmyard manure. The actions of this tenant, seen with the benefit of hindsight, justified the Lowther policy of leaving good tenants to get on with it, as the estate benefited from knowing they had a tenant who had put so much into the farm that he was hardly likely to give up the tenancy and, furthermore, they were secure in the knowledge that the holding was in good hands for the foreseeable future.

The introduction of new soil inputs before and during the 'high farming' era undoubtedly had a measurable impact on the production and use of agricultural lime. Naworth Estate's Clowsgill Limeworks saw a decline in output from the mid-1840s, as evidenced by a report produced by M. Liddell, who wrote that 'Nothing has been done ... at Clowsgill or Foresthead in the past year with demand remaining very low'[41]: This was despite a reduction in the sale price of almost one fifth. Liddell placed the blame at the 'very general use ... of Guano and other stimulating manures' in Cumberland.

Comparison of the relative demand for lime and guano is made possible from a twenty-year set of farm accounts for the Appleby Castle estate[42]. They did not identify the farms involved and merely listed payments for soil inputs over the period. Bone manure – that is, manure mixed with pulverised bones – appears once, in 1854; otherwise only lime and guano were purchased by the estate. If the Naworth experience can be extrapolated across Cumbria, the accounts should show a steady decline in lime purchases and a commensurate increase in those of guano, but this was not the case

at Appleby. The first entries for guano were in 1854, when there were frequent multiple entries, but in no other year in the sequence, whereas lime appears in every single year except 1856, with the greatest number of purchases made in the 1860s. Both tailed off during the following decade; the drop off in guano corroborated the observation made earlier concerning its short-lived dominance: a contributory factor may have been guano's higher price. This set of accounts does not quantify how much of each product was purchased, only the cost – so it is impossible to compare tonnages, but the highest single payment for lime was £90 in 1868. In contrast, ten payments for guano exceeded £100; the average purchase cost of lime was £18 and that of guano £79; just under £1,000 was expended on the former, compared to almost £2,000 for the latter. Guano and lime perform the same basic functions in soil – they have a similar pH count, and guano has the added advantage of containing nitrogen, phosphate and potassium – but the price differential was a key factor in its long-term usage.

If it can be assumed that payments for lime and guano more or less equated to when they were delivered to the farms and spread on the land, the Appleby accounts permit tentative analysis of the seasonality of their application, whether on land left fallow over winter or in spring along with or just prior to sowing or during the growing season. Both tended to be applied mainly in winter and spring with exactly half spread in winter to give time for the lime or guano to break down and be slowly absorbed into the soil, aided by rainfall: this would have related to both pasture and cropland. 15 per cent of both inputs was applied in summer and related more to pasture than cropland.

In 1850 the Cartmel Peninsula was reported to have excellent farms producing cereal crops, turnips, potatoes and livestock, especially Shorthorn cattle[43]. Much of the area lay within the Holker Estate, headed by the 2nd Earl of Burlington from 1834. He was elevated to become the 7th Duke of Devonshire in 1858 but his preferred residence remained Holker rather than Chatsworth, and he was noted for having taken a hands-on approach to managing the estate even before he became earl. He oversaw, and may have initiated, a wide range of farm improvements across Cartmel; he was regarded then as an Improver and was a founder member, aged only 31, of what became the RASE in 1840. The estate also developed a model farm at Flookburgh.

Not far from Holker Hall, Lawrence House Farm (SD497 854), home farm for the Levens Hall Estate, was managed according to the principles of high farming by the steward[44]. He had improved the estate's breeding stock, crossing Southdown ewes with Leicester rams, and building up a herd of Shorthorn and Galloway cattle. His preferred top dressing of mossland on Levens Marsh was superphosphates, and he was one of the first in the area to use horse-drawn mowing machines. He adopted a policy of leaving each arable field fallow over winter and then under grass for two years at the end of each five-year rotation period. Fallowed land was not just left to grow weeds but was ploughed, harrowed, weeded and rolled, and eventually planted to root crops: it was all carefully planned and executed, and meticulous accounts were kept.

Elsewhere in Cumbria, other examples of innovation can be discerned: the manual tasks of threshing grain and chopping and pulping root crops were replaced by steam-driven machinery; John Nicholson, at Kirkby Thore Hall, was possibly the first farmer in Westmorland to use a steam plough; and Mr Irving, who farmed at Shap Abbey Farm (NY548 151) and Wythop Hall (NY203 284), was a pioneer (around 1850) in the use of sheep dips instead of the age-old method of hand-salving that used a mixture of tar and rancid

Kirkby Thore Hall farm complex.

butter or oil and tallow to rid the animals of lice and ticks. This latter was a very slow process – a good man might salve a dozen sheep in a day – but dunking sheep in sunken troughs filled with water and dipping powders could treat many times that number[45].

Experimentation

No one personifies the absolute dedication to experimentation during the high farming era better than William Lawson, who owned and farmed Mechi (NY174 411) outside the small village of Blennerhasset, south-west of Wigton. Lawson was born into a family of the gentry at Brayton Hall in Aspatria in 1836 and developed a range of interests, including agriculture. This latter was to become an all-absorbing passion for him after visiting a farm at Tiptree Hall near Colchester, where John Mechi owned and worked a 130-acre (53-ha) holding that he developed into a model farm with all the accoutrements of a high farming establishment – deep draining, steam-powered machinery and piped slurry. Mechi wrote seven books on the business of farming, including one entitled *How to Farm Profitably*, published in 1847. On returning home Lawson tried, unsuccessfully, to persuade his father to experiment with

Mechi Estate in 1862. (Lawson and Hunter 1875)

Mechi's new technologies on their home farm, but he was informed that what was then called Blennerhasset Farm was soon to become vacant. It was 260 acres (105 ha) and in a semi-derelict state. Though Lawson knew absolutely nothing about the practicalities of farming, he took the farm on in 1862, renaming it 'The Model Farm' in anticipation of what he was minded to achieve.

He wasted no time in redesigning the farmstead, rebuilding the house in a grand style in 1863–64, erecting the necessary barns, shippons, piggeries, stores and whatever else a model farm should have; he installed a gas supply system, built new roads across the farm, drained wet land, removed unnecessary and derelict fences to increase the size of his fields, and grubbed out thousands of tons of stone from the fields, which were used in his building schemes. He kept his cattle indoors, using the soiling system pioneered by Curwen at Schoose, and stored the liquid waste in underground tanks so that it could be pumped through an extensive network of iron pipes laid across the fields. His ambition and vision are to be admired, but his lack of practical skills and empirical knowledge led him astray and, with the dubious benefit of hindsight, he crossed the threshold between realism and fantasy. He added neighbouring land to his model farm and, in 1865 and 1867, took on three other farms: Prior Hall (NY225 399), Park House (NY221 401) and Newbiggin Grange

Mechi Estate in 1872. (Lawson and Hunter 1875)

(NY214 406), thereby adding 569 acres (230 ha) to his estate. This would have been all well and good, except for the distance between Blennerhasset and the other farms, which made direct management of them by Lawson very difficult. He soon realised he had overextended himself and sold them in 1868.

Back at his model farm, which Lawson renamed Mechi Farm in honour of his agricultural hero[46], he laid out a commercial market garden between farm and village, and experimented with a wide range of crops not previously grown thereabouts, like onions, cabbages, leeks and carrots, in addition to the cereals and roots universally grown. Perhaps his greatest folly, one that earned him much derision locally, was to purchase a steam plough in his first year at Mechi. John Fowler's 'Patent Steam Ploughing Tackle', patented in 1856, was as cumbersome as its title and the doubting Thomases were ultimately proved right. The system involved a steam engine on one side of the field, linked to a mobile 'anchor' on the other, with the actual eight-share plough dragged back and forth by a steel rope wound on a windlass on each machine, with two men on the plough ensuring it followed a straight course. Each time the plough completed its run across the field, the whole apparatus

'Fowler's Steam Ploughing Apparatus as at Work', (Copland 1866, vol. 1).

advanced along the field. Sadly for Lawson's dreams, it broke down with annoying frequency, was much slower than horse-drawn ploughs, needed six people to operate it and fetch water to feed the boiler, and its running costs ensured it always ran at a loss. In 1871, he cut his losses and auctioned it off.

Lawson was a ceaseless experimenter, investigating how successfully varying quantities and mixes of farmyard manure acted on different types of soil across his farms, trialling a host of artificial soil inputs and monitoring the quality of succeeding harvests. The most effective in his view were nitrate of soda, sulphate of ammonia and Peruvian guano; the least effective were standard farmyard manure and muriate of potash[47]. He wanted to perfect the growing of potatoes, and so tried many combinations of inputs such as manure, guano, potash, salts, unslaked and slaked lime, coming up with eleven 'recipes'. He found that slaked lime was the best on the first year's crop but the worst on the third. From this he concluded that liming too generously and too frequently actually harmed the soil, a bone of contention that had exercised the minds of theorists and land managers since at least the eighteenth century.

Experimentation and innovation at Blennerhasset extended beyond the purely agricultural into the realm of philanthropy; his ambition and designs cannot be faulted, but here too he met with opposition from a sceptical labour force and could not achieve the social improvements he felt were needed. He acted out of genuine concern to improve the villagers' lot by providing new cottages, free schooling, a library and well-stocked reading room, a public bathroom, a post office and co-operative shop, and gas lighting through the village; he also laid on outings and occasional festivities – all of this at his own expense. He tried the revolutionary concept of having a local parliament so that villagers could have their say in the decision-making processes involved in running a small community.

In the ten years that he ran the enterprise, his expenditure totalled £45,410, but his overall income was only £38,931. He only broke even, or returned a small profit, in six of his nine full accounting years at Mechi. He gradually came to accept that his experiments were doomed to fail but it was a serious fire at the farm in 1871 and a devastating attack of potato blight that finally made him accept the inevitable. In 1872, he sold everything to his elder brother. In concrete terms he took away with him a profit of over 50 per cent on selling compared to what he had paid for the farm; in less

tangible terms he had the pride of knowing he had tried what very few other farmers had either the resources or the entrepreneurship to conceive. To some, Mechi was a folly – or even a collection of follies – and the plaything of a rich man, and he undoubtedly fell foul of distrust aimed against him, not least by some of those he had tried to help, who dismissed him as patronising and interfering. Though there are few, if any, documented cases of serious unrest by farm workers against their masters in the high farming decades, the gulf of misunderstanding and mistrust remained, with resentment not far below the surface. Perhaps Lawson's ultimate failure was being a man way ahead of his time. After selling up, he emigrated to North America: a clean break indeed[48].

From Golden Age to Depression

The thirty years from the mid-1840s can justifiably be regarded as a 'Golden Age' in British farming if the evidence collated above is valid: scientific and technological developments in livestock and crop strains, increased mechanisation, a more mature relationship between landlord and tenant, and a 'more intensive cultivation of the intellect' among farmers[49] all played a pivotal role in transforming low into high farming. Not everything was rosy in the high farming garden, however, and one contemporary observer urged a degree of caution to avoid lifetimes of practical experience being disdained in favour of newfound theoretical concepts[50].

Nevertheless, the period was not exclusively positive and untroubled and the repealing of the Corn Laws in 1846 did have a lasting impact. This may have been what prompted one 'old farmer', allegedly 'well lubricated', to stand up and speak his mind at the Earl of Carlisle's Rent Day dinner at Naworth Castle in 1851[51]. He let the assembled tenants and dignitaries know he had lost money in farming over the previous three years and challenged anyone present to deny that there was not 'a man at table but what can say the same'. He did not elaborate on the reasons because he was aware all his peers were facing the same problems.

The weather, as ever, did its best to augment the list of Cumbrian farmers' woes. Though the average annual rainfall for 1850–1911, measured at Kendal, was a respectable 50 inches (1,250 mm), and for 1788–1911 52 inches (1,300 mm), exceptionally wet summers were recorded for 1852, 1872, 1877–79 and 1781–83, making

average values meaningless[52]. A wet winter was not necessarily disruptive but heavy, persistent rain during harvest time was. Equally disheartening for the farmer was the opposite, and summer 1893 brought severe drought and high temperatures to the country, depriving crops of water during the crucial growing season[53]. The previous two summers, however, had proved exceptionally cold, as had the winters of 1878–79, when severe, long-lasting frosts just about wiped out the turnip crop in the Eden Valley[54]. Before anyone had time to recover from those winters, October 1880 witnessed what was referred to as the 'Great Snow', as winter arrived all too early and severely.

Let us give the final words on late-nineteenth-century weather anomalies to Ruskin, who was able to see it all developing in real time from his house overlooking Coniston Water[55]. He spoke poetically, and melodramatically, of 'plague-winds' that were 'dark, malignant and tremulous'; on 22 June 1876, according to his diary, he watched a storm develop that was more 'dirty, weak, foul' than any other he had seen; of 13 August 1879, he said the sky was filled with a 'sulphurous chimney-pot vomit of blackguardly cloud'; and he compared those times with earlier ones. Back then there had been bad – abominably bad – weather, but it was fleeting and soon passed over: it did not 'sulk for three months without letting you see the sun' nor deliver storm after incessant storm, as it was doing now. Something was going wrong in the atmosphere and he was fully aware of it.

Cumbria was not immune to spasmodic outbreaks of disease in livestock in the second half of the nineteenth century any less than in earlier times. Westmorland was beset by a serious incidence of pleuro-pneumonia in cattle in 1842 and this was to recur until around 1870, with 1860–65 being especially serious, but Cumbria as a whole escaped the country wide outbreak of cattle plague in 1866. It is possible that restrictions on cattle movements and the cancellation of all cattle fairs in the county saved it from further despair[56]. Foot-and-mouth outbreaks were recorded in 1845, on and off from 1849–52, and from 1861–72. Here, too, the so-called Cumberland System, which confined affected stock to their farms and banned all movement off-farm, prevented outbreaks from getting out of hand. Epidemics among sheep occurred in the county in 1853 and again in 1880–81, when cattle were also affected by foot-and-mouth and pleuro-pneumonia: Fog Close farm (NY564 412) at Kirkoswald was particularly hard-hit[57].

The degree to which the North was affected by late-century agricultural depression has been debated over the years. A statement made in 1897 confirmed that it had been in progress nationally for nearly twenty years and that the economic indicators for 1892–95 were worse than for 1875–82, but this referred to the nation as a whole[58]. The key issue is to what extent Cumbria was adversely affected, and to address this requires a consideration of the causes of depression. A steady slide in farm-gate corn prices from 1872–74 to 1892–94 of 40 per cent is said, rightly, to have hit arable farming regions hard and, more contentiously, to have left dominantly pastoral regions like Cumbria relatively unscathed. This does not tally with the recorded 50 per cent drop in wool prices (certainly in north-east Cumberland), a marked drop in fat-sheep prices between 1880 and 1885 (but with a slight rise in the early 1890s), and a fall in cattle prices in Lancashire of between 25 and 50 per cent. The decline in corn prices was almost entirely due to increased importation of grain from North America from the early 1870s, and even the succession of disastrous home harvests did little to boost prices. Meat prices were affected by the introduction of refrigeration, which allowed cheap imports of beef and mutton from Argentina and the Antipodes, even though per capita consumption of meat and dairy products rose slowly but surely up to 1914.

Landowners felt themselves under siege, not just from falling prices, but from failing tenants and tenancies they were unable to re-let, from lower annual rents and – of considerable significance – their being unable to pay back the huge amounts that had been borrowed during the French Wars and the high farming era, notably for underdraining.

Bankruptcy data in farming, published according to legal diktat in the *London Gazette*, have been used to contrast the situation across England[59]. For 1871–73, Cumberland, Westmorland and Lancashire, along with Devon and Cornwall, were the only English counties that fell within the least-affected category, whereas the South-East was the worst; 1881–83 showed a very similar pattern but, by 1891–93, only Lancashire remained in the least-affected class. Thus, looking at the issue using these data, Cumbria was not seriously afflicted by the downturn. Cumberland, in particular, saw very few farm bankruptcies in the 1870s[60]. Indeed, the demand for vacant tenements remained buoyant in much of Cumbria, although there was a surge in the number of newspaper advertisements for

farms to let or for sale in the county in the last three decades of the century. Through the second half of the nineteenth century in Westmorland, the number of dairy and store cattle increased as did the number of sheep, and overall farm output grew by over 10 per cent. A contemporary observer went on record in 1882 saying that depression in farming here did not exist[61].

Any decrease in the number of statesmen, or yeomen, through the century could be taken as evidence for agricultural decline, although the apparent drop may reflect not a fall in numbers but a linguistic process, with the descriptor 'farmer' replacing 'husbandman' and 'yeoman'. To take one small example, in the township of Bretherdale west of Tebay, parish records from 1776–1812 gave the occupations of most family heads. 'Husbandman' appears 204 times across the whole period; 'farmer' 105 times, from 1781–1812; but 'yeoman' only fourteen times, from 1794–1812. There is no obvious correlation between descriptor and size of holding. On the other hand, evidence to the Royal Commission of 1881 noted that many statesmen on the Underley Hall Estate near Kirkby Lonsdale had been pressurised by mounting debts into selling up or relinquishing their tenancies, thus representing a drop in numbers.

One set of statistics that cannot be misconstrued relates to farm size: in 1873 Westmorland had a far higher proportion of small farms compared to the national average – 47 per cent as opposed to 22 – but the following two decades witnessed a change in the balance between large and small[62]. In 1875, out of a total of 3,624 registered farming units, 2,134 were less than 50 acres (20 ha) and 669 above 100 acres (40 ha), whereas in 1895 the Westmorland totals were 1993 (a fall of around 7 per cent) and 749 respectively (a rise of around 11 per cent). Amalgamation and rationalisation account for these changing fortunes, yet in 1897 it was claimed that the number of farm labourers taking on small holdings had increased, notably on the Netherby and Lowther Estates[63].

If agriculture as an industry was in decline, or at the very least in a state of stasis, towards the end of the century, one might expect that there had been a decrease in the number of landed estates, but this was not the case. In a similar vein it has also been said that Cumbria was not a county noted for having many great estates: this, too, does not stand up to close scrutiny. A comprehensive tally of landed estates in the British Isles was published in 1879, with forty-two valued in excess of £3,000 per annum in Cumbria[64]. Sixteen fell

within the range of 2,000–2,999 acres (809–1,213 ha), fifteen within 3,000–9,999 acres (1,214–4,046 ha), six from 10,000–19,999 acres (4,047–8,092 ha) with three greater than 20,000 acres (8,093 ha). All was still well in Cumbria as the 1880s dawned and little discernible change happened for another decade.

Because of widespread concern about deepening depression in agriculture, the government convened a Royal Commission in 1881 to take evidence gathered by regional commissioners and to hear witness statements[65]. The very detailed submissions enable a mixed picture to emerge: on the one hand, there were some instances of distress but, on the other, investment in improvements had not slowed down during the early years of the depression. A summary of the situation in Cumbria was provided by John Coleman[66], who emphatically dismissed any notion of depression in the region: sale prices were generally stable, apart from 1879–80, farms were flourishing, and there was no shortage of prospective tenants. There were, however, matters that, in his view, needed addressing to improve farming even more than had happened during the high farming years – notably uncontrolled livestock numbers on common land and an absence of stinting arrangements, overstocking in general, too many illicit encroachments on common land, and a lack of liming.

Investment on the Earl of Bective's Underley Estate exceeded £118,000, of which the majority was expended on building work (renovations and new build) but draining, flood control along the Lune, liming, the application of crushed bones, new fencing, farm roads and machinery all figured in the programme of works. Some statesmen who had sold out to the estate stayed on as tenants, with rents kept low at £20 per year, and, according to evidence presented to the Commission, they benefitted from the improvements and prospered. One of Coleman's conclusions was that Cumbria had largely escaped the worst of the downturn precisely because landowners looked after their tenants, as Bective did, and relations between estate, tenant and farm labourers were good. Coleman spoke in a positive way about other estates that had continued to invest and improve through the century: under Sir Frederick Graham Netherby from 1861–88 had continued his predecessors' efforts to make it a showpiece estate. Edenhall, under the agent Mr Bowstead, had been transformed, having gone through a rough period, although he was still struggling to show a profit and some holdings were

less than exemplary. The tenant at Skygarth farm (NY612 261) at Temple Sowerby complained his rents were unrealistically high, and the tenant at Winderwath farm nearby claimed that most improvements in the area had been conceived and undertaken by tenants rather than landowners. Winder Hall farm, Barton, was well run on a five-year rotation with cropland top-dressed with manure and crushed bone, and pastures with heavy doses of lime applied at ten-year intervals. Its tenant, Mr Lowthian, had transformed the farm, even though he held it on an annual tenancy, and sound management had kept it free of economic problems; it is interesting to note that Lowthian blamed landlords for not investing in their estates and not encouraging tenants to improve: in his view this was a major cause of the downturn in farming. He had, however, invested in a threshing machine, turnip cropper and cake crusher, all powered by a portable engine, and so had clearly taken on board the benefits of mechanisation. Greenhead farm (SD517 839) at Hincaster, also held on an annual basis, managed to support 100 head of cattle and 200 sheep on its 201 acres (81 ha) by the use of superphosphates, guano and manure.

The main entrance to Underley Home farm, built as a model farm.

Winderwath farm, Brougham.

Henry Howard had continued his father's work on the Greystoke Castle Estate over a period of twenty years and a new steward had stepped up the process by draining more land, applying more lime, reseeding pastures with new grass species, and close-grazing. Even taking into account the terrible winters of 1878–79 and their aftermath, 'agricultural depressiondid] not exist' on this estate. The estate owned a small farm at Dockray called Parkgate (NY396 213), which was worked by a tenant and his two sons. They had drained much of the land of their own volition, initially treating it with lime but later with bones, but had received no help whatsoever from the estate and no rent remission.

At the foot of the Pennine escarpment in Murton, Harbour Flatt (NY721 232) continued to pay its way but was in need of more rigorous management and more emphasis on improvements. The tenant did manure his meadows every year and had the benefit of a lime kiln on the property but the whole farm required systematic draining to take it further – he could not afford to do that and told Coleman he needed his landowner's help. Lamplugh Hall (NY088 206) had seen many improvements since the present tenant took it on 1872 and he was doing well. Towards the west coast, Preston

Parkgate farm, Dockray.

Hows farm at Aspatria, tenanted from the Lowthers, was managed on an annual basis with no husbandry stipulations at all and was dominantly run as an arable unit concentrating on cereals and turnips. The current tenant was unusually innovative for the time by feeding his sheep on cotton cake and maize.

Coleman ended his submission to the Royal Commission of 1881 by summarising the current situation on a number of estates in Cumbria. On balance, all were still engaged in the business of improvement; all expected contributions from tenants for improvements made; and, across the county, arable farming was operated on a five- or six-year rotation based around oats, turnips, clover or new grass-seed varieties, and traditional pasture. The Penrith Farmers' Club, which he considered an influential organisation, maintained that, despite all the improvements made, there remained thousands of acres that would benefit from being 'enclosed, limed and improved' and with open fells that should be converted into controlled stinted pastures. Such reforms would bring about an end to whatever degree of depression was evident in Cumbria.

Royal Commissions on Agriculture continued their work into the 1890s as, if anything, the situation had tended to deteriorate since

the 1881 sittings. The interim report for 1894 contained a lengthy disposition from Frederick Punchard who, by then, had served as agent for Underley Estate for twenty-eight years[67]. It was a huge estate – 24,350 acres (around 9,859 ha) – of which the vast majority was let as 247 discrete farms. Punchard conceded that depression was a recent phenomenon in Lunesdale and reported that they had reduced annual rents in 1882 and 1883, with further reductions in 1886 and 1892, to try and keep tenants on their holdings, as he knew well that if farms became vacant the estate would struggle to find suitably qualified replacements. Rents in 1894 were mostly back at 1865 levels, although some were even 10 per cent lower than that. Nevertheless, tenants were keeping up with rental payments and some were able to drain more land. To assist the tenants, in 1882 and 1883, the estate made an allowance to the accumulated tenants of £12,000 in lime and crushed bones. To encourage them further, any tenant having to leave a holding knew he would be compensated for improvements he had made, but penalised if he left it in a worse state.

Depression peaked in Cumbria in 1892–93, but some improvem nt was discernible in the following two years; even so, it had not been as traumatic as elsewhere in the country[68]. Improvements had still been apparent through the worst times, draining was still widely undertaken and was regaining a degree of momentum, and only marginal land brought into use during earlier days of plenty was showing signs of neglect and abandonment. Farm vacancies were rare and few tenants were in arrears. On the negative side, however, rents were still depressed, land values had fallen commensurately, and livestock and wool prices were much lower than in 1870. The 1895 interim report for Cumbria was compiled by Assistant Commissioner Arthur Wilson Fox: in his view, six remedies were necessary. Cheap imports must be stopped, the high tax burden reduced, high rents reduced to realistic levels, outdated manorial fines and dues abolished, farm-gate prices raised, and those engaged in farming given more education and training. That was his reading of the situation, and it was broadly supported by estate stewards interviewed by the Royal Commission, but a litany of 'ordinary' farmers from across the county begged to differ, saying one after another that all was not well. The Royal Commission on Agriculture delivered its final report in 1897[69].

During the years of depression various pieces of legislation were passed by parliament, many designed to protect the farmer and

thereby make his lot a slightly easier one. The Agricultural Holdings Act 1875 made provision for limited compensation to be given to tenants at the end of their agreement for improvements they had made, such as in buildings, draining or soil improvement. It also enabled them to take with them any moveable fixtures they had installed. Because of obstructive practices by some landowners, this legislation soon became ineffective so a further Act was passed in 1883, strengthening the earlier one by allowing tenants to grow whatever crops they thought best for their holding and to farm it without interference or restrictive covenants from their landlord – something farmers' organisations in Cumbria had long been lobbying for – as long as fertility was maintained. Seven further Holdings Acts followed, culminating in the Act of 1923, which refined procedures and established a mechanism for arbitrating over rent disputes. Farmers were guaranteed protection from another quarter by the Fertilisers and Feeding Stuffs Act 1893: fraudulent practices like the adulteration of artificial feeding stuffs by merchants had become rampant. This was henceforth a criminal offence.

Evidence on the Ground

The various submissions to the Royal Commissions, while detailed, were made by people with a vested interest who may not have been totally dispassionate. Some points could have been biased or promulgated from a desire to make any given situation seem worse or better than it actually was. More neutral in nature is evidence contained in estate papers during the years of depression – what was actually being done, and paid for, on the ground.

It is difficult, even with the benefit of hindsight, to believe that depression could have set in during the 1870s without warning bells sounding, and the fact that they did not must add to the argument that Cumbria did not start feeling the pinch until after the end of that decade. In the 1870s there was still optimism. The founding by various landowners of Aspatria Agricultural College in 1874[70], to 'advance the science and teaching of agriculture', could not have happened if troubled times ahead were already looming. The second such institution in Cumbria, the Cumberland and Westmorland Farm School at Newton Rigg, had Henry Howard of Greystoke as its chief benefactor when founded in 1896. Though the 'great depression' was by no means spent by then, the mid-1890s did coincide with a slight

economic upturn. It has to be said, however, that both struggled to attract sufficient students in their early days, particularly Aspatria.

In the mid-1870s, Lowther Estates were draining land as enthusiastically as in earlier decades. Account books itemise payments to labourers on sixteen of the estate's Westmorland farms and there was no let up from 1873 to early 1878[71]. Such was the demand for tile drains that the estate had to supplement output from its own tilery at Hackthorpe with tiles bought in from Wetheriggs Pottery and Tilery.

Buccleuch Estate in Furness was similarly engaged in draining: in 1877, for instance, Ireleth Low Marsh, along the coast, was reclaimed for productive agricultural use[72]. From 1875–78 regular payments were authorised to drainers and for the purchase of tile drains for six tenanted farms in Low Furness. Over the same period new building work, some of it on a major scale, was underway, in addition to running repairs[73]. Had the estate been facing the possibility of tenants falling into arrears, these works would surely not have been commissioned – unless they were perceived as inducements to retain valued tenants. Also in 1878, detailed plans were drawn up for the complete redesign and rebuild of Far Old Park farm (SD230 770) in Ireleth[74]. Hitherto the farm buildings were loosely arranged with smaller buildings tagged onto the main shippon, but the new farmstead was planned as a model farm, with all the features of the idealised farm developed a full century earlier. Yet Far Old Park today is nothing like the plans, so it was either subsequently demolished or the idea was shelved as depression deepened. Maybe this is evidence that the downturn was beginning to bite, but there is contrary evidence exemplified in a Cumbria-wide farm competition in 1880, allegedly the worst year thus far[75]. Farms that entered were put into classes, with three awards per class. There is, of course, no way of knowing how typical the prize winners were but the commendations make interesting reading. Greenhead farm in Hincaster was the recipient of the first prize in Class 1. This was a 201-acre (81-ha) farm, half for livestock and half for arable, held on an annual tenancy. The tenant employed five live-in labourers, laid new hedges and walls across the farm and purchased machinery to speed up certain tasks. Concentrating on 100 dairy Shorthorn cattle and 200 sheep, with a five-year rotation of swedes, barley, grass seeds (two years) and oats, all either manured or treated with a guano-superphosphate mix, and selling much of his milk as

Proposals for rebuilding Far Old Park farm in 1878. (CAS[B]BD/BUC/FARM PLANS/21. Reproduced courtesy of Barrow Archive and Local Studies Centre, and the 10th Duke of Buccleuch).

butter in Kendal, Mr Handley the tenant impressed the judges with his profitable farm. Runner-up was Mr Lowthian of Winder Hall in Askham, who ran a 335-acre (135-ha) unit again on an annual tenancy. His farm was one-third arable and the rest pasture. He had extensive stone-built farm buildings, machinery, new 'straight' fences; he kept 100 Shorthorns and bought in each year 300 cross-bred sheep and forty Herdwicks rather than breeding and over-wintering breeding stock. His turnips and swedes were 'excellent', his oats 'very good'; he applied manure and dissolved bones as well as lime from the farm's own large lime kiln. Much of his milk was sold as butter in Penrith. The adjudicators noted that the 'whole farm has been relaid in new fields and limed', much had been drained, and water troughs had been installed in every field likely to house livestock. In short, he had carried out 'great improvements', much of it at his own expense. One might wonder why he did not scoop first prize. Other notable prize winners were William Atkinson's Burneside Hall (SD510 959) near Kendal and Moss End farm (SD535 820) near Crooklands, this latter being the only one to enjoy the security of a fourteen-year lease. Rowland Parker, the recently deceased tenant there, had been selling his butter in Bradford for forty years. His farm was described as the 'Garden of Westmorland ... perhaps the richest and best cultivated' in the county: it won second prize in his class.

There was also contrary evidence from the Naworth Estate, while Countess Rosalind managed affairs from 1888 (she died in 1921)[76]. She added 3,000 acres (1,214 ha) to the existing 56,000 (22,660 ha), although some of the new land was managed as Pennine grouse moor. She, along with her 'progressive' land agent, invested heavily in improvements, rebuilding and enlarging barns, building new ones, restoring field walls, rebuilding farm workers' cottages and, driven by their 'chief drainer', undertaking extensive underdraining. The sheer scale of expenditure on improvements is impressive: this estate was not suffering any form of distress, at least not in the 1890s, with the cost of improvements over the four years listed exceeding total income by more than 50 per cent.

The estate owned its own collieries – Black Dyke on the slopes of Talkin Fell – which fed its own limeworks with fuel at Clowsgill Quarries in Farlam parish. Both were let on long leases, from 1891 for thirty-one years, for example. It was enshrined in the agreement that Naworth farm tenants and the estate were to be supplied with 5,000 tons of 'Best Broad Lime', free from lime-ash and small-lime[77].

Furthermore, tenants were accorded the option of taking small-lime at 8*d* per cart load if it had remained unsold at Clowsgill for three months. The significance of this agreement is that both estate and tenants were still in a position to purchase lime, albeit at preferential rates, because they were still able to manage their holdings despite years of supposed depression.

At Edenhall, the end-of-century Estate Book, detailing twenty-three tenanted farms in Edenhall, Langwathby and Kirkoswald, as well as Blackwell Hall (NY398 528) in Cummersdale, made no mention of anything amiss[78]. George Richards, the land agent who compiled the book, inserted into it cuttings from a trade directory containing details and prices of 'approved' grass-seed varieties. Unless he was an inveterate hoarder of what might one day come in useful, he presumably kept – and annotated – them with intent to purchase some[79].

Humphrey Senhouse of Netherhall, Maryport, was presented with a report on one of his farms in 1892, namely Southwaite Farm (NY129 281)[80]. Reading between the lines suggests that the farm lay vacant and was in a rather sorry state. No draining had been done since around 1864 and some fields had never been drained while, in

Blackwell Hall above the River Caldew.

'Camp Farm Rotation' plan, 1879–81. (CAS[W]D/SEN/5/15. Reproduced with the kind permission of Mr Joe Scott Plummer)

others, the drains no longer functioned; buildings were in 'fair order' but old. The report writer provided a field-by-field list of work that was required to put the farm back into 'tenantable order', although the names of some fields would hardly have inspired confidence in prospective tenants: Bog Meadow, Poor Thorn Field, Sandy Meadow and Grubbs Field. To put all to rights entailed spending £404 on draining, £7 on essential building repairs, and £30 to close two breaches along the river banks. Sadly, the Senhouse archive contains little else of value on farming matters, but one other item to note is a rough, hand-drawn plan of the home farm at Maryport, Camp farm (NY043 373), noting the acreage of each field and its land use in 1879–81[81]. As was the practice across Cumberland at the time, oats, wheat, barley, potatoes, turnips and mangolds made up the rotation regime. Down the coast at Gosforth, a farm day-book

was maintained from 1870 to 1904, but this was mainly concerned with the daily routine of farming life and had little to offer on improvement other than one short note that 'turnipland generally set about 18 loads of dung per acre' on the Curwens' home farm there[82]. A separate register of crops on seven Curwen farms in the 1890s, including Schoose, merely listed the rotations on each farm and they are almost identical to those used on Senhouse properties, except that the Curwens' steward distinguished between 'old grass', 'grass', 'seeds' and 'meadow', whereas the Camp farm plan had only 'permanent' pasture or grass. In terms of infrastructural work on the Curwen estate, there is but one entry, that of completely rebuilding a barn, loosebox and stable at Harrow Slack (SD387 962) in 1894[83].

A profit and loss summary for the Greystoke estate's thirty-seven farms from 1893–1902 presents a picture broadly similar to that of other landed estates[84]. The accounts were restricted to two cost headings: draining (on thirty-five farms) and repairs (on all). Both can be perceived as improvements, for tenant and estate, and the level of expenditure at some of the properties shows that large-scale work had been commissioned. Again, it is not possible now to determine motives for the work, whether to retain good tenants or to attract new ones to vacant farms. The summary included annual rents at various times within the ten-year period: at two the rent increased, with no new land being added; at thirteen it was static; and at fifteen it fell, with no reduction in acreage. Nine farms, including Blencow Hall (NY449 326), had the annotation 'rent reduced' against their entries, thereby signifying that an official decision had been taken by the estate to cut those rents and, further, suggesting those tenants were suffering economic duress. One further aspect of innovation during the years of depression is worthy of mention. In the 1880s a new process then known as 'ensilage' had been trialled in Westmorland, especially so at Underley Home farm (SD608 799), which installed the system in 1883 and set it in motion two years later[85]. By 1886 thirty-one farms in Westmorland were ensilaging and by 1887 fifty-seven had adopted the practice. Today it is just known as silaging and, in wet summers when hay cannot be cut, it is a blessing for the farmer. The process was imported, from Germany and France, as a direct result of five dreadful summers between 1878 and 1883. Ensilaging involved storing in silos cut grass that was green and still wet, with a moisture content of 70-80 per cent, compared to below 20 per

cent for hay. It guaranteed farmers a supply of winter fodder. On the downside, it was very labour-intensive, not entirely reliable technically, and more expensive than feeding cattle with root crops; by 1900 Westmorland had no operational silos, a pattern repeated nationally, although it did come back into use during the First World War.

Reliable data for the turn of the century illustrate the changes that occurred in crop farming in Westmorland, trends that would have been mirrored in Cumberland too. Decline in acreages sown to all types of cereals is evident with dramatic falls in all but oats, while only mangolds showed a marked increase in area. Freed from restrictive tenancy stipulations, tenants gradually moved away from cropping in response to successive wet harvest times, perhaps as a response to continued bleak economic forecasts, and as other forms of feedstuffs became available. Westmorland farmers at the time were not unduly disadvantaged, however, as yield per acre for wheat, barley and potatoes exceeded the British average in 1910, as did that for hay/clover mixes.

Crop	Acreage 1895	Acreage 1910	% change
oats	16,580	13,799	−17
barley	978	452	−53
wheat	207	97	−53
rye	106	42	−60
beans	14	3	−79
peas	25	11	−56
potatoes	1646	1181	−28
turnips	7795	5754	−26
mangolds	317	608	92
cabbages & rape	110	68	−38
vetches	51	21	−59
other arable	39	41	5
clover, sainfoin, grass	16,909	14,935	−12
permanent grass	205,942	208,584	1

Table 10 Acreage under arable crops and pasture in Westmorland, 1895–1910. (Garnett 1912, 256 ff)

The Interwar Years

Wars have a wonderful habit of stimulating home production and economic growth and so, whatever signs of depression still prevailed in 1914, they were temporarily suspended. Yet there were recognisable causes for concern, even during the war years. A government committee sitting in 1917 concluded that measures to boost agricultural output after hostilities ceased should be formulated specifically to increase the nation's level of self-sufficiency in food by setting minimum prices and ploughing up pastures, a policy that began in earnest during the First World War. The Act that grew out of these recommendations did indeed fix prices, but also established minimum wages for farm workers and restricted increases in farm rents[86]. When war came to an end, doubts soon emerged over the likelihood of high prices being maintained, the difficulties of keeping the newly ploughed pastures in a productive state – given that many were beyond marginal anyway – and over a general shortage of capital to finance investments in new buildings, machinery and general maintenance and other improvements. Thus, yet another Royal Commission was convened, in 1919, to look into the state of the industry. Wartime labour shortages had deprived farms of manpower, so basic farm tasks had been neglected, leading to a deterioration in field drains, walls and buildings[87].

Among its key witnesses was W. T. Lawrence, principal of Newton Rigg Farm School, who summarised the state of farming on the school's working and demonstration farm[88]. There was no dearth of innovation there: dairy cattle were fed on earth-nut cake and swedes, rather than just pasture; milk yield was increased by selective breeding of Shorthorn cattle, which, like other Cumberland farms, they exported to Scotland. They produced a healthy surplus of butter, cheese, eggs, horses, root crops and fat-lambs that were sold on the open market, and were equipping a new generation of young skilled farmers. Other witnesses pointed out that, regrettably, many farmers had 'got out of the habit' of liming, as it was by then too costly, and the tradition had largely been forgotten: the government must do something to promote draining and liming, according to one witness. An expert called in to advise on this said that lime was indeed 'very dear, and the supply insufficient'; another confirmed that soils, especially clays, across the country suffered from lime deficiency; and yet another, when asked if he would encourage the reintroduction

of liming to revive farming, replied positively but only if lime were made available locally and produced on a commercial scale[89].

Given how many hundreds of lime kilns were scattered across Cumbria, even where there is no adjacent limestone, and that many were only built in the 1800s, it is bizarre that the practice of liming had largely been forsaken by 1919. The skills had been lost, the benefits of liming long forgotten. To have a working kiln then was aberrant and almost eccentric. One part-time farmer in Ravenstonedale, a professor of chemistry in real life, joined with two neighbouring farmers to reinstate a local kiln around 1912 to see if they could produce serviceable lime; and a kiln on Stennerskeugh Clouds was fired up again in the early 1920s by the farmer at Studfold Farm (NY729 000), but only because he had hired in for the season an Irish youth with experience of working a lime kiln elsewhere[90]. Anecdotal evidence from the same valley reinforces the long-term benefits of liming: at Bowber Head (NY741 031) and Piper Hole (NY726 033), again in the interwar period, farmyard manure, basic slag and lime were all applied. Slag was considered to be advantageous for a maximum of four years, compared to twenty for lime, so, despite the latter's purchase cost being much higher than slag, in the long run lime proved more cost-effective[91].

By 1920 or so, burnt lime was being eclipsed by ground or pulverised limestone, which was much quicker to produce and less environmentally harmful – raw limestone was simply fed through the crushing plant and reduced to powder. No burning was involved. This was a product pioneered in Cumbria at Flusco Limeworks, west of Penrith just after the war, and it received strong government backing mainly because it was three times cheaper than quicklime. As farming sank further into recession from 1921, it seemed a viable and affordable alternative. Various government schemes made crushed lime available to farmers, but on a loan basis, and few felt able to commit themselves to repaying a loan in their straitened circumstances. Nevertheless, the authorities were well aware that upland soils were in dire need of treatment to reduce increasing acidity levels and address what, by then, was widespread lime deficiency in soils. As soils deteriorated, so did the quality of pasture and thus livestock. As during the 1870s, Cumbria held out longer than most counties but eventually recession began to bite deeply, hitting many farmers hard as prices fell and markets shrank. The tenant at Julian Bower (Brougham, NY603 263) gave up his tenancy

Julian Bower farm on the River Eden.

in 1936 as he could not make ends meet: it was re-let but at a lower rent, and with a lime allowance of £20 for the incoming occupant[92]. On liming at that time, one percipient and witty writer was moved to amend the age-old couplet 'lime without manure makes both farm and farmer poor' by adding

> This old and oft repeated rhyme
> Hath little point at present time
> When farms are poor for want of lime[93].

Eventually, action was taken by government when the Agriculture Act 1937 introduced the Land Fertility Scheme, recognising that there was a 'widespread need for lime on all types of agricultural land', and that soil fertility had suffered because farmers felt unable to afford it. Under the scheme farmers could claim a 50 per cent rebate on the cost of purchasing lime or crushed limestone, and 25 per cent on basic slag[94]. The scheme was set to expire in July 1940. It was so successful that it was extended; in 1942 the subsidy was increased to 75 per cent on summer deliveries. It was then reborn

as the Agricultural Lime Scheme in 1947; withdrawn in 1951; reintroduced in 1953; and only finally abolished in 1976[95]. Further legislation either side of the war saw subsidies for purchasing basic slag, ploughing up grassland, cropping, and increasing the size of the sheep flock. One Act of 1946 introduced grants of 50 per cent on hill farms for draining, liming, basic slag and fertiliser application, and subsidies on sheep and cattle[96].

8

Epilogue: An Improving Prospect?

There has been some debate concerning the extent to which agricultural improvement occurred at various times in the past in Cumbria, and who the prime movers behind innovation and change were, whether landowners, stewards or tenants. Equally, there has been a lack of agreement about the depth of agricultural depression in the county after 1870, and whether there is any validity in looking for signs of an agricultural revolution here[1]. In this writer's opinion, the last of these is clear. By definition, a revolution involves far-reaching and drastic events that bring about noticeable change over a relatively short period, rather than a series of gradual, incremental developments leading to change over a long timespan. The latter can be identified in Cumbria, as elsewhere, from the monastic era onwards; the former cannot. Development of new bloodstock or crop varieties, the introduction of a new piece of equipment or machinery, or advances in the science of farming, were all significant developments and milestones along the way but, individually, they hardly deserve the accolade 'revolutionary', and they did not all occur around the same time: change was incremental.

In the Past

Evidence presented in the preceding chapters bears witness to the rate and scale of change over time, and to the emphasis placed on improvement, although this is not to suggest that innovation was apparent across the board. Strategies and commitment to development and change varied from estate to estate, from one

tenant farmer to another, and within estates, depending on the interests and priorities of the current landowner and the diligence of stewards or agents. It is also axiomatic that consideration of historical processes is limited by the availability of primary records; even contemporary observations may not be fully reliable, as we cannot know what particular agenda each enshrined. Estate accounts and day books may appear superficially dry and lifeless, but they contain facts that inform analysis and meaningful conclusions: they are objective not subjective, quantitative not qualitative, and thus all the more valuable. How meaningful of the development of Cumbrian farming are surviving archival sources is necessarily an unknown quantity, but arguably they can be perceived as a representative sample.

Starting in the monastic era, it was incumbent upon each foundation to develop its estate by reclaiming what had been waste, reforming existing peasant practices and introducing innovation. While these aims were not necessarily perceived as divine duty or, in the early days at least, as a means of boosting economic wealth[2], what was achieved across monastic estates can be justifiably regarded as improvement, even though neither the term nor the concept would necessarily have been recognised by monastic communities. It was in the immediate post-medieval centuries that the word 'improvement' became increasingly common in a practical (land management) and moral sense. Selective breeding of sheep and cattle was underway in the fifteenth century, as revealed by analysis of animal bone assemblages showing that average animal size increased. By the mid-eighteenth century, the whole business of agriculture had taken on a new dimension for the aspiring young landowning elite as that class came to regard estates as a 'locus of innovation' and husbandry as an integral component of their own educational journey[3].

Written in 1850, a report on farming in Lancashire made the point that improvement had not been the sole preserve of the landed classes: many lesser gentry and yeoman farmers (however its author defined a yeoman) had been involved in the process across all parts of the county, including Furness[4]. This perception is equally applicable to Cumbria more widely, as has been shown from documentary sources reviewed in this book. One more example will further illustrate this point: a letter from John Gibson at Rydal Hall to his master, in 1777, drew attention to one of their tenants – John Miller – who had at his own 'great expence' fallowed and

limed 'some poor ground'[5]. This does not suggest that all tenants were competent or trustworthy and another letter, of 12 April 1783, pointed the finger at John Jackson, who was an 'obdurate' man, who used the estate 'very ill' and, contrary to his lease stipulations, farmed 'without proper manuring'. Every estate would have had its mix of progressive and reactionary tenants.

John Grainger, tenant at Southerfield farm (NY163 486) in Holm Cultram, fell into the former camp, if his personal diary for 1826–28 is reliable. He farmed 100 acres (40 ha) of arable ground, which had been progressively and systematically improved by generations of his forebears, and he was aware of what Curwen had done at Schoose and was himself a 'serious-minded self-improver'[6]. Grainger was far from unique. Beckett has downplayed the role of small farmers as soil improvers, claiming that most had stuck to their age-old practices except during wartime[7]; however, given the documentary evidence, it is difficult to accept that this view is valid. According to one reading of the situation, the notion that tenants were resistant to change may be laid at the door of proselytising Improvers like Young and Marshall, who had a very clear politically driven agenda[8].

Turning to landlord-tenant relationships, Webster made the self-evident observation that no farm holding could be improved if the two parties did not see eye to eye – progress was necessarily based on 'hearty co-operation' between them[9]. Some years later, Allston Channing wrote that, across Cumbria, many (presumably go-ahead) farm servants had been assisted by their landlords to take on tenements in their own right, as on the Netherby and Lowther estates[10]. He also made the point that in good times a proportion of improvements was undertaken by tenants at their own expense, although, in times of economic stress, they tended to retrench. Bearing this in mind, it has been suggested earlier that tensions between landowner and tenant, and tenant and servant/labourer, were often just below the surface and the Agricultural Holdings Act 1885 came down on the side of tenants by strengthening their legal rights and preventing landowners from dictating how husbandry should be practised. This effectively opened the door for self-improving tenants.

Gradual decline in the number of Cumbrian statesmen has been well attested by modern and contemporary writers. As early as the 1860s, the class was said to have already become 'nearly extinct' except in the fells, as small and economically unviable holdings were amalgamated into ever-larger units. A contributory factor, however,

has to have been the abandonment of small farms established on marginal land during the 'Bonneypart time', when too much land was taken in, improved and worked to exhaustion during the Napoleonic Wars, and then left for 'Dame Nature' to reclaim[11]. Yet, in 1870, 35 per cent of farms in Cumbria were still less than 20 acres (8 ha) in size and, in 1851, only 5 per cent exceeded 300 acres (121 ha), contrasting with the overall English figures of 54 and 10 per cent respectively[12].

The extent to which Cumbria succumbed to depression, in the 1870s, 80s or 90s and after 1919, should not be overplayed. The 1894 Royal Commission, for example, concluded that estates where stock rearing was more significant than cropping were still investing in improvements across the board, as we have seen earlier: while prices had indeed fallen after 1885, demand remained buoyant as urban consumption of meat and dairy products continued to rise[13]. Furthermore, it has been suggested that gross farm output in the northern counties increased overall by more than 10 per cent from 1850–1914, especially in Westmorland[14]. Another, rather despondent, assessment, albeit for England in general, that 'nearly a century of depression' had taken its toll on farm infrastructure, may not be applicable to Cumbria to the same degree as in arable regions of the South[15]. The indisputable fact that there was a rebalancing in the ratio of cropland to pasture in Cumbria during the second half of the nineteenth century was one reaction to falling prices of cereals in particular. Arable acreage decreased, in contrast to a marked growth in permanent and ley pasture, even discounting extra land enclosed from upland commons. Depression did bite in Cumbria, but at a later date and to a lesser degree than in many other areas.

Similarly, examination of primary sources belies assertions made that Cumbria saw little improvement during the sixteenth and seventeenth centuries[16]. Equally, negative views promulgated about the extent of improvement in the county do not withstand scrutiny when a large body of archival sources is interrogated[17]. However improvement is defined – of the soil, livestock or new crop strains, buildings or infrastructure, plantations or grouse moor, or purely aesthetic – there is evidence aplenty across Cumbria. Not all attempts were successful in the long term: Curwen at Schoose and Lawson at Mechi both admitted defeat, and some of the ambitious architectural plans for Lowther farms came to nought. Nevertheless, there is no doubt that, across the board, soil and drainage improvements

made over the centuries, as well as building work, did leave a lasting legacy, forming the basis of today's farming and farmscape. Of individual farmers who have entered the record for initiating improvements, Slack at Winderwath, Dawson at Hartley, Atkinson at Bassenthwaite, James at High Hesket, Nicolson at Kirkby Thore, Lowthian at Winder, Randleson at Croft Hill, Dixon at Ruckcroft, the tenants who tamed Brunstock Beck, and the various prize winners are all worthy of mention. This does not mean that the majority of farmers were of the improving sort; indeed, those listed here may well have been the exceptions, but change did come about incrementally. It may have been top down, or achieved by tenants observing what their neighbours had found to be worthwhile, or, perhaps in some cases and especially during the last century, by farmers' sons wishing to innovate.

In the Present

Across the United Kingdom as a whole, farmland under pasture in one form or another now accounts for 72 per cent of the total farmed area, and cropland 27 per cent[18]; clearly in a county like Cumbria, cropland now makes up a significantly smaller proportion. What does make the county comparable to national trends are statistics that may not bode well for the long-term future of the industry. The median age of Cumbrian farmers in 2013 was fifty-nine, with 34 per cent aged over sixty-five and only 3 per cent under thirty-five; average farm income decreased by 4.4 per cent from 2013 to 2014 alone. Meanwhile, farm-gate prices for cereals fell by 21 per cent over the same period; for crops in general by 16.2 per cent; and for livestock by 3.7 per cent, with cattle numbers falling by 10.5 per cent. Milk prices have followed a downward trend since November 2013 and became a live issue among the farming community in summer 2015: Defra reported a massive drop of 25 per cent in farm-gate milk prices between June 2014 and June 2015 when they slumped to the 2007 level[19]. Lamb prices have also fallen. Not all is doom-laden, though, as overall productivity in the industry has increased by 52 per cent since 1973 and by 6 per cent in 2013–14 alone. Yet, in 1973 it was estimated that up to 39 per cent of the farmed area within Westmorland and up to 59 per cent in Cumberland and Furness were still in need of improved draining, despite over a century and a half of concerted efforts by farmers and land managers[20]. The same

statistics applied in 1983, when 30 per cent of Westmorland and 45 per cent of Cumberland were deemed to have heavy clay soils with impeded drainage[21]. If 2015 data were available now, they would show little significant difference. Indeed, the situation may even have deteriorated.

It is common now to see fields that had once been improved 'going back', reverting to their semi-natural state as drains fail, soils lose fertility, and patches of soft rush develop in what had been improved pastures. Moves away from payments for livestock headage to those based on environmental stewardship, under reform of the European Union's Common Agricultural Policy (CAP), and the devastating impact of the 2001 foot-and-mouth epidemic, have substantially reduced the size of the county's sheep and cattle populations. If a farm has fewer animals, it requires a smaller area of grassland so there is less incentive for the farmer to maintain drains, especially as farm incomes have resolutely declined in recent years and many costs have inexorably risen. In addition, it is now deliberate policy to 're-wild' or re-wet certain areas, to bring back wildlife to tracts of ground that were once (supposedly) 'natural' but have long since been 'improved' to create productive pasture land – although the term 're-wild' is emotive, highly charged and controversial. Much of Bowness Common has been incorporated into the South Solway Mosses National Nature Reserve, a 1,000-acre (405-ha) lowland raised bog (the largest in England), where 'improved' land is being handed back to 'Dame Nature'. Farms like Rogersceugh, perched atop a low drumlin and comprehensively drained in 1765, have been taken out of production other than for strictly controlled grazing under the watchful eye of Natural England and the RSPB; this is a case of from moss to farm and back to moss again.

Elsewhere in Cumbria Eycott Hill, a 530-acre (216-ha) low hill between Mungrisdale and Penruddock, is also having its management totally transformed, under the aegis of the Cumbria Wildlife Trust, from rough and semi-improved grazing to a mix of open woodland, scrub, heath and carefully managed grazing[22]. Priorities are changing; some may not like it, but it is an inescapable reality that bird numbers have plummeted in recent decades, virtually all wildflower meadows in England have disappeared since 1940, and other key elements of the natural order of life have been under severe threat, not least pollinating insects. Farming has always changed in response

to changing circumstances and it is changing now: it is neither a good thing nor a bad. It just happens.

From 1975, United Kingdom and European Economic Community legislation maintained a strategy of paying subsidies to hill and upland farmers in 'Severely Disadvantaged Areas' based on headage – the more livestock a farm had, the greater was its total subsidy and, understandably, numbers soared to the point where overstocking is not too strong a word to use, and where environmental degradation intensified. As a result, the Agriculture Act 1986 began to address these concerns by introducing a new term into the English language, namely 'agri-environment schemes'[23]. Six years later, CAP reforms imposed quotas on flock and herd sizes in an attempt to further mitigate the problem. Headage payments were, to a large extent, replaced by subsidies based on environmental considerations by the Hill Farm Allowance Scheme of 2001[24]; they were finally abandoned in 2005[25]. The concept of 'Environmental Stewardship' came into the farmer's world at this time but this, too, is currently being reformed.

A new scheme is being rolled out from 2016 and offers two levels of entry for farms with a range of options[26]: the reborn Countryside Stewardship scheme is designed to offer financial incentives to land managers to 'protect and enhance' the environment – flood control, limited protection of historical features, wildlife and conservation enhancement, and educational access are some of the key elements. Only time will tell how successful it proves to be in terms of uptake among farmers and achievement of objectives.

It would be a huge mistake and a gross simplification to think that farmers deliberately ever set out to milk the system by ignoring the environment and piling more and more sheep on the fells; hill farmers were, and still are, hard-pressed and, if their primary aim was to make a decent living and to grow their business (after all, farms *are* business entities), they can hardly be blamed for that. It is too naïve and ill-informed to claim farmers have 'sheep-wrecked' the uplands[27]. It is, in a sense, invidious to single out particularly good or bad examples, but Bowber Head and Piper Hole in Ravenstonedale have a long pedigree of working in harmony with nature. Both have meadows that were limed, between 1912 and 1940, and top-dressed with basic slag on five occasions from 1940–70: detailed records of application were kept and these have been analysed to contrast the productivity rates of their various traditional hay meadows[28]. Such

was the success at Piper Hole that one of its fields was designated a flagship wildflower meadow under the nationwide Coronation Meadows Initiative, established to create at least one in each county: Eycott Hill has Cumbria's other such meadow[29].

Further strategies to bring the general public closer to farming and food production include the LEAF scheme, established in 1991, which also had the aim of promoting sustainable farming[30]. It established a network of demonstration farms and innovation centres across the country and has close links with the government's agri-tech strategy, launched in 2013 and designed to develop new and appropriate forms of farm technology. Cumbria has one demonstration farm. In a vaguely similar vein is the Cumbria Hill Farms Charter, set up in 2008 to increase networking opportunities among hill farms and to develop community awareness, within the North West Upland Farming organisation[31]. The charitable Foundation for Common Land was also established in 2008 to protect and conserve common land in a sustainable manner for the benefit of ecosystems, commoners and the visiting public. The results of a recent survey of public awareness of farming make for sober reading and emphasise how much work needs to be done to bridge the gap between stereotypical views and reality: many people believe that farming is old-fashioned, farmers do not have degrees, and do not use technology, while a popular television soap is as near to farming as many people get[32]. There is indeed much work to do.

What is clear is that Cumbria's farmers, especially on its 500 upland and 200 hill farms[33], have to balance shrinking incomes and ever-tighter environmental controls with increased long-term costs of inputs, be they foodstuffs, veterinary services, buildings, machinery or technologically complex equipment. With computer-aided tractors and harvesters now costing tens of thousands of pounds, the level of investment required is out of all proportion to what their equivalents cost fifty years ago. It is not only rising inputs that present obstacles for potential young farmers – those not born on and likely to inherit a farm or its tenancy – but also the spiralling cost of land. In 2012 the average price of agricultural land nationally was £9,700 per acre (£24,000/ha), but some land in Cumbria was fetching nearly double that and the upward trend has continued[34]. Agricultural land values in the county doubled between 2005 and 2010. The relatively new phenomenon of non-farmers buying up farmland as an investment can only add to this problem. It is a fact that up to 40 per cent of

Epilogue: An Improving Prospect?

A horse-drawn hayrake, manufactured by Thomas Reay at Abbey Town after 1919.

A Bamford Royal 7 RTC mower, manufactured from 1940 to 1964 at Uttoxeter.

an upland farmer's income is derived from government and EU payments: these should not be seen merely as handouts but as recompense for their being guardians of the landscape.

As mentioned earlier, livestock farmers need more than ever to boost grassland productivity and, here again, the reality of rising costs of chemical inputs is an issue. To help address this, efforts are being made to reintroduce upland and hill farmers to the benefits of liming and basic slag, which effectively went out of use on a large scale in the mid-1970s when subsidies were scrapped. Today's basic slag is a cleaner product than that of old, and is regarded as an 'excellent' source of calcium; lime (now more often pulverised limestone than burnt lime) is making a comeback with claims that liming pastures can increase sheep stocking ratios by at least a factor of three[35]. Cheaper sources of calcium can now be obtained by spreading sludge from sugar plants, paper mills and sewage treatment plants, although their calcium content is low and the sludge can contain impurities[36]. There is, of course, another contentious issue with chemical inputs – their impact on environmental systems.

An Improving Prospect?

Addressing the question in this book's title, is it possible to say with conviction that farming in Cumbria has improved over the centuries and, if so, has the change been for the better or the worse? A number of points can be made. Firstly, the slow journey from labour to machines has changed farming beyond all recognition. Gone forever, decades ago, were the individuals who dug and maintained the ditches, the horsemen, the shepherd on foot, the carters, the farm and village craftsmen, the gangs of itinerant and ever-hopeful labourers looking for seasonal work on the land. Gone are the young women who worked within the farmstead – in the dairy milking, making cheese and butter, doing domestic chores, tending to livestock. No one can lament the disappearance of such labour-intensive, low-paid and fickle jobs. Also, how much easier it is now, and infinitely more efficient, for the farmer to get around on his quad bike or ATV in a fraction of the time his forebears took; how much better it is to load a sick ewe or one having difficulty birthing into a trailer; and how much more mindful of the farmer and the sheep stuck on a fellside in deep snow to be able to take hay bales up to them on a quad rather than over the shoulder bale by bale. On the one hand, while in 1921

Cumberland had ten to fifteen fulltime agricultural workers per 1,000 acres (25 to 37 per ha) of farmland, Westmorland slightly less and Furness double that, by 2013 only 1,063 people were employed as farmworkers across Cumbria as a whole – just 0.3 per cent of the total number employed in all sectors of the economy – along with 5,342 full-time and 3,672 part-time self-employed farmers[37].

Secondly, the dreadful demographc toll of the First World War had a profound impact on farming at all levels, part of which was permanent: social change, better-paid employment opportunities elsewhere and a reaction to war saw many young men not returning to the land as labourers. Meanwhile, problems faced by the privileged classes, not least the loss of male heirs, led to the sale and break up of landed estates. Between the 1920s and 60s, the Edenhall, Netherby, Workington, Whitehaven, Netherhall, Buccleuch and Rydal estates were broken up and, entirely in some instances or partially in others, sold off. Lowther Castle and its magnificent 130-acre (53-ha) ornamental gardens were allowed to go to ruin, but the estate still extends across 75,000 acres (30,350 ha), compared to 67,457 in 1879 and the eighteenth-century Home Farm is still Home Farm[38].

The consolidated shell of Lowther Castle, from the south, and the site of the formal gardens.

Meanwhile, the formal gardens at Levens Hall, first laid out in the 1690s, have been preserved and are as magnificent as ever.

Furthermore, the medieval process of engrossment – slowly enlarging a holding in a piecemeal manner – has returned since the 1960s, only now we call it amalgamation or rationalisation. Nowadays 32 per cent of Cumbria's farms exceed 100 ha and a further 23 per cent lie between 50 and 100[39]. If there are some 700 upland and hill farms in Cumbria now, how many more were there fifty years ago? Everywhere one goes in Cumbria there are farmhouses that are now just residences, often with no link to the land anymore; barns have been converted into housing; remote or inaccessible farmsteads have been abandoned and allowed to decay, as few want to live beyond the reach of the power line. This amalgamation represents a profound change that impacts on the economics of any given farming unit: small farms cannot survive. They are not viable in the modern, highly mechanised and sophisticated world. Of course, mostly long gone are the families who lived and worked all hours to make a living and, in so many instances, eked out an often perilous existence – although it is self-evident that farming is still hard work. Long gone, too, is the statesman class, whose decline set in during the early nineteenth century. Though Walker was able to write, in 1792, that the 'Mountain spirit of Independence and Liberty lingers yet among them', referring to the statesmen[40], little more than thirty years later Wordsworth was lamenting the demise of the 'community of shepherds, and agriculturists, proprietors, for the most part of the lands which they occupied and cultivated'[41]. They had assiduously worked the land for five centuries 'till within the last sixty years', he wrote; he described Lakeland as a 'perfect Republic' of shepherds and farmers. There surely are many farmers today who would profess a spirit of independence, but to think in Wordsworth's way is no more than a romantic and nostalgic invocation of an ideal that probably never really existed.

A further major change has been the undoubted loss of habitat and biodiversity, partly owing to past stocking pressures, partly to increased intensification and the use of chemical inputs and, quite possibly now, in part nature's response to climate change. Various environmental schemes have come and gone, and we now have Countryside Stewardship back, reborn in a different guise; subsidies have been introduced, redirected and reduced; bureaucracy has grown to keep abreast of all the changes. Over the decades farm-gate

prices have fluctuated and gross farm incomes have fallen except, perhaps, on the largest units; and urban folk today seem more divorced than ever from nature and wildlife, and (let us be kind and say stereotypically) some have no clue that there is a direct link between a cow and a glass of milk or a pig and a sausage.

In those romanticised, halcyon days of fifty years and more ago, farmers and their entire family would scythe and turn the hay, and harvest the corn with a reaper-binder under endless blue skies, and gather root crops by hand. It was actually grindingly hard work and took days to accomplish. Now, a massive contractor-owned, computer-guided combine does it all in no time; or, because the summer weather no longer knows how to behave, grass is often taken off as green silage with a moisture content of 70–80 per cent. If it rains, it does not matter. If the sun shines and the rain lets up for a day or two, they will get a decent crop of machine-wrapped haylage, with a moisture level of 30–60 per cent. Less commonly these days, it seems, they may be fortunate enough to harvest a crop of traditional square-baled hay with less than 20 per cent moisture content. Some larger dairy farms now practice 'zero grazing' – yesterday's soiling – whereby cattle are housed indoors rather than in the fields; others, on

Harvesting haylage in Celleron, 2015.

dryer soils, use 'on-off grazing', where dairy cattle are rotated from field to field on a daily basis[42]. Oats are little grown now but fodder maize is a significant crop. Farming has tended to become more specialised: many farms today that have both cattle and cropland grow the crops – cereals or roots – as on-farm fodder. On the other hand, rotation is still the general practice.

These are all significant and far-reaching changes to the farming scene, but one change may seem perverse. In 1919 the MAF was born – the Ministry of Agriculture and Fisheries – and in 1955 it became MAFF – the Ministry of Agriculture, Fisheries and Food. In 2002, after the foot-and-mouth fiasco, it was dissolved and its responsibilities subsumed within the new Defra: the 'f' here is not farming and the 'a' is not agriculture. We now have a department responsible for the farming industry (and fishing), whose name excludes agriculture. How strange.

Finally, is it possible or even desirable to say with conviction that these multifaceted changes equate to improvement? The point was made in the first chapter that the ecological/environmental lobby regards improved grassland differently from the farming industry. The former sees 'improved' grassland as deficient in species, as a monoculture, with a dearth of pollinators and other insect species and therefore of birds and small mammals; it sees diminishing biodiversity and a landscape stripped of its richness. To grow, or just to survive, the industry believes it has to boost grassland productivity and this cannot be achieved just with species-rich wildflower meadows. Both arguments are equally valid: one is no more correct than the other.

Looking beyond the confines of an argument based solely on biodiversity, the conclusion has to be that improvement of both arable and pastoral farming is visible, palpable and quantifiable. True, many formerly improved enclosures are reverting to their former unimproved state; others never were drained or limed and appear today as often wet, soft, rush-infested tracts of ground; bracken is visibly increasing its spatial extent further upslope and onto areas where it was not a problem even twenty years ago; many farmsteads have been abandoned or amalgamated into larger concerns; and hedgerows are crudely machine-flailed instead of laid by skilled hedgers. Nevertheless, taking the long view, farms are more efficient; the hard physical labour has to a certain degree been taken out by mechanisation and computerisation; more rare breeds of cattle are grazing 'poorer' pastures; Cumbria's iconic Herdwick sheep survived

A Riecam beet harvester in a fodder beet field at Cliburn, 2015.

foot-and-mouth and still grace the fells and moors, while 'softer' breeds mainly introduced in the nineteenth century graze lower pastures, yielding more in terms of meat and income than traditional breeds. 'Old' crops are back in fashion, notably clover and fodder beet[43]. On balance, farm buildings are in a better sate of repair *unless* they no longer have a role in modern farming systems and are not suitable for conversion to office or residential use, or are too remote. Farm diversification gathers pace with farm shops, camping sites, bunk barns, bed and breakfasts and self-catering facilities, on-farm ice-cream production, and open farms evident across the county, although there is necessarily a limit on how many of these any county can support. In short, it has to be an improving prospect.

Notes

Abbreviations

CAS (B)	Cumbria Archive Service, Barrow Archive and Local Studies Centre
CAS (C)	Cumbria Archive Service, Carlisle Archive Centre
CAS (K)	Cumbria Archive Service, Kendal Archive Centre.
CAS (W)	Cumbria Archive Service, Whitehaven Archive and Local Studies Centre
CW2	*Transactions of the Cumberland and Westmorland Antiquarian and Archaeological Society*, Series 2.
CW3	*Transactions of the Cumberland and Westmorland Antiquarian and Archaeological Society*, Series 3.
CWAAS	Cumberland and Westmorland Antiquarian and Archaeological Society.
JRASE	*Journal of the Royal Agricultural Society of England.*
KLSL	Keighley Local Studies Library
LRO	Lancashire Record Office
NAS	Northamptonshire Archive Service

Notes to Chapter One: Setting the Scene

1 Banham and Faith 2014, 292.
2 Hall 2014, 9.
3 Dodd 1992, 5.
4 Hughes 2003, 5–6.
5 www.metoffice.gov.uk/public/weather/climate, accessed 15 December 2014.
6 www.landis.org.uk/services/soilscapes.cfm, accessed 16 December 2014.
7 www.ukso.org/Cs/Cs_Soil_pH.html, accessed 14 December 2014.
8 www.publications.naturalengland.org.uk/publication, accessed 16 December 2014.

9 Natural England. Agricultural Land Classification Map North West Region. 2010.
10 www.publications.naturalengland.org.uk/category/587130, accessed 5 November 2015.
11 The Musgraves' seat in the North was Eden Hall in the civil parish of Edenhall.
12 Johnson, D 2013a, 191–213.
13 Johnson, D 2010a, 231–62.
14 Winchester 2000; 2005, 29–48.
15 Searle 1993, 126–53.
16 See, for example, Jones 1962, 198–223; Beckett 1982, 97–111; and Walton 1986, 221–33.
17 Whyte 2000, 77–89; 2003a; 2003b, 21–38; 2005, 46–61; and 2006, 97–115.
18 Tyson 1992, 161–82.
19 Erickson 1950, 170–74; Spring 1955, 73–81; Ward 1967; Tyson 2001; Crowe 2009.

Notes to Chapter Two: The Idea of Improvement

1 Fuller 1987.
2 Smith *et al.* 2008, 670–79.
3 Campbell 1981, 121.
4 Fryde 1996, 7, 25.
5 The work of the Ingleborough Archaeology Group has been paramount here. For excavation reports, see Johnson 2013b and 2015.
6 Quartermaine and Leech 2012, 38–39, 326; Matthiessen *et al* 2015.
7 Whaley 2006, 417–18.
8 Roberts 2008, 97–99.
9 Winchester 1987, 42.
10 Hair and Newman 1999.
11 For treatment of monastic ownership in Cumbria, see Newman 2014.
12 Winchester 1989, 80.
13 Todd 1997, 15–18, 21, 194–95.
14 Hawkins and Thorley 2012.
15 Grainger and Collingwood 1929, passim.
16 Burton 2004, *passim*.
17 Folding sheep was worth between 4s (in Scotland) and 5s (in England) per sheep per year in terms of extra grain harvested from folded land (Dudgeon 1814, 510–11). Fitzherbert advised husbandmen to only release their sheep from the fold after they had 'let them stand stylle … that they may donge and pysse' within the fold, but he warned of the dangers of sheep scab if folded too long (Fitzherbert 1534 folio 15).

18 Winchester 2000, 69.
19 Johnson, M. 1996, 1; Higham 2004, 81.
20 Hall 2014, 78–86, 334. Elliott (1960) calculated that 220 of Cumbria's 288 townships had open fields.
21 CAS (K). WQR/I/45. Keisley Field, Dufton.
22 Hoyle 1986, 230–31, speaking of Craven in particular, but the same trends would have been observable in Cumbria, where conditions and opportunities were similar.
23 Cantor 1987, especially 23–26; Winchester 1989, 85.
24 Gowling 2011, 59–65.
25 Searle 1993, 128.
26 Lancaster, K. J., 2001, 17.
27 Welch 1975.
28 CAS (K). WQR/I/67. Milburn Fell Pasture Enclosure Award 1857.
29 Healey 2011, 158–65.
30 Healey 2011, 171.
31 Jones 1962, 208, 211–12.
32 Hoyle 1986, 300.
33 Appleby 1973, 407–32.
34 Wrigley and Schofield 1981; Hatcher 1986, 28.
35 Hainsworth 1992, 13.
36 Lamond 1890, 91.
37 Dickinson 1853, 4.
38 Quoted in Copland 1867, vol. 1, 698; Miles 1994, xxxviii.
39 McRae 1992, 35–37; Wade Martins 2004, 41; Tarlow 2007, 12.
40 *Statutes of the Realm*, vol. 1, p. 2. 'Statute of Merton', 20 Hen 3, ch. 4. *Statutes of the Realm*, vol. 4, p. 102–03; 'Act of Improvements of Comons and Waste Groundes', 3 & 4 Edw VI, ch. 3.
41 CAS (K). WD/Hoth. Box 42. Drybeck and Hoff, Verdicts.
42 Hoskins 1953, 44–48; Winchester 1998, 88.
43 Marshall 1980, 511; Low 1985, 354; Wade Martins 2009, 81.
44 Prominent among these are Weston 1650, Hartlib 1655 and Worlidge 1675 and 1687.
45 A major reason why new ideas penetrated Britain at this time was the return of Royalist exiles from the near continent.
46 Marshall 1980, 511.
47 Mentioned in a talk, entitled '1652 and the foundations of Quakerism in the North; where did Quakerism take root and why?' by Angus Winchester at a day school, *Quaker Origins in the North of England*, 8 October 2011, at Airton in Craven.
48 Searle 1983; Winchester 1998, 109; Whyte 2007, 41.
49 Anon 1766, 581–82.

Notes to Chapter Three: Lime Burning and Agriculture

1. Johnson, D. 2013a.
2. Shippon and byre both refer to cowhouses or the sections of barns used for stalling cattle. In West Yorkshire the word 'mistal' is used.
3. Anon 1764, 569.
4. Redwater was a serious problem in Low Furness, as noted in the diaries of William Fleming of Pennington near Ulverston on 12 June 1809. See CAS (B) BDX 584. Redwater was associated, rightly or wrongly, with depasturing cattle on undrained wet pastures.
5. For a discussion related to the Central Pennines, see Johnson 2010b, 42–55.
6. British Parliamentary Papers, vol. XVI (Ag. 16), 2778-II. 1881. *Agricultural Interests. Digest and Appendix. Reports of the Assistant Commissioners*, p. 244.
7. I am grateful to James Bretherton of AgScope Ltd for explaining this link to me after his talk to the Lancashire and Greater Manchester Farmer Network on 'Soil improvement. The Importance of Lime', 10 February 2015.
8. Rothwell 1850, 89–91.
9. Webster 1868, 18.
10. CAS (C). D Lons/L/12/3/12/3. Memorandum 10 March 1785 between Michael Robinson of Gt. Ormside, yeoman, and John Metcalf Carleton of Hilbeck Hall, Esq.
11. *Cumberland Pacquet* 7 August 1798. Use of the word 'excellent' was a form of sales spin.
12. *Westmoreland* (sic) *Advertiser and Kendal Chronicle* 4 September 1813. NGR SD3897 7755.
13. *Carlisle Journal,* 7 September 1816.
14. CAS (C). QRE/1/41. Castle Sowerby Enclosure Award.
15. *The Westmoreland* (sic) *Advertiser and Kendal Chronicle,* 4 September 1824.
16. CAS (K). WD/PP, Box 2 (76). Messrs Pearson and Pearson, Solicitors. Notice, 21 January 1843. NGR NY373 392.
17. *Cumberland and Westmorland Advertiser,* 15 October 1861.
18. The Kendal and Carlisle Archive Centres hold dozens of examples.
19. CAS (K) WD/HH/1 Hothfield MSS, Kirkby Stephen 1695–1845, 10 December 1741, Clause 3.
20. Liming in Garsdale, Sedbergh and Dent has been dealt with by this writer (2010b, *passim*).
21. CAS (C) DHUD/3/62 Memoranda of Agreement 29 September 1768 and 2 February 1774. NGR NY4375 2745.
22. CAS (C) DHUD/9/24 Correspondence and Accounts, letter 27 February 1779.

Notes

23 CAS (C) DHUD/3/66/2 'Letters on running a lime-kiln', 26 September to 29 October 1845. NGR NY053 337.
24 CAS (C) DHUD/3/66/2 Indenture of lease for Highgate Farm 25 March 1841; copy of newspaper advertisement 'To Let Highgate Farm' 6 October 1857.
25 CAS (K) WD/Hoth Box 34, no. 17. 'A Plan of New Hall Farm' n.d. NGR NY8404 1134.
26 Johnson, D. 2010a, 240–41; 2013a, 200.
27 Calendar of Close Rolls 35 Edward I (28 June 1307), vol. 5, 539.
28 Mortimer 1712, 85; Hale 1756, 81. The key to a successful burn was to maintain an even temperature from start to finish.
29 Hodgson 1820, 11–12.
30 CAS (K) Levens Hall archive, Box 18 I/14 and /16. 'Banks Accounts' 29 June and July 3 1696, 6 May 1699.
31 Bagot and Munby 1988, 96 and 100.
32 Dodgson 1805, 331–34. There were eight lime kilns within 2 km of Graham's Onset.
33 Dickinson 1853, 20.
34 Kelly 2008; Brooks 2009.
35 Nicolson and Burn, 1777, 250; Ewbank 1963, 25–27.
36 Hodgson 1820, 234.
37 CAS (K) WD/PP Box 8, Underley Estates: draft depositions, 27 April 1843.
38 CAS (K) WDX 603 and 986. 'History of Hutton quarries and coal pits' by J. T. Atkinson, 1914.
39 Nicolson and Burn 1777, 547.
40 CAS (K) WD/Cat/Mus A 2173. Edenhall 1770s. Letters 10 November 1773, 22 February 1776, 10 June 1776, 7 March 1783 and 12 May 1788, from Christopher Dobson to Sir Philip Musgrave.
41 CAS (K) WD/Hoth Box 25. Coal Lease, 14 August 1763.
42 Robinson 1804, 105.
43 CAS (K) WDX/3/9. Notebook. Coals, Mallerstang 1830–31.
44 Smith 1967, 158.
45 CAS (K) WD Hoth. Box 5. Stainmore, 'Coal Leases, 1777–1845'; CAS (K) WD/Cat/Mus A 2173, Letters, December 1779, 22 July and 26 July 1783; Moore 1905, 382; *Carlisle Journal* 25 May 1811; Brooks 2009, passim.
46 Dickinson 1853, 6.
47 Hodgson 1820, 11.
48 CAS (K) D Mus/5/4/24. Edenhall Estate Colliery Accounts, March 1758 to May 1763.
49 CAS (K) WDRY/1/10/5/4 Box 108/4. Letters from John Gibson at Rydal Hall to Sir Michael le Fleming, 14 June 1773.

50 CAS (K) D/Lons/L12/3/12/9 Lowther Estates. 'Accounts Lime 1785 – 1786'.
51 A bushel is a measure of capacity that varied across the country. The standard Winchester bushel equated to 8 gallons but the nineteenth-century Westmorland equivalent was ten bushels to 1 ton, with the Carlisle bushel being different again.
52 CAS (K) D/Lons/L12/3/12/6 Lowther Estates, 'Lime Accounts 1785 – 1786'.
53 CAS (K) D/Lons/L12/3/12/7 Lowther Estates, 'Accounts of lime sold at Hillbeck 1784'; L12/3/12/8, 'Lime sold at Pease Hill 1784 – 1785'; L12/3/12/1, 'Lime sold at various kilns 1784-89'.
54 Lysons and Lysons 1816, cxxv.
55 CAS (K) WD/Cat/Mus A2173. Edenhall. Letter 27 October 1770.
56 CAS (K) WD/Cat/Mus A2173. Edenhall. Letter 13 May 1780.
57 CAS (K) WD/Cat/Mus A2173. Edenhall. Letters 20 May and 2 December 1775.
58 Dickinson 1853, 10.
59 CAS (K) WD/Cat/Mus A2173. Edenhall. Letter 11 June 1781.
60 CAS (K) WD/W/Box 13/3. Deeds of Stainton lands, 1670 – 1800. 'Lease of a lime kiln in Stainton for three years 15 March 1800'.
61 Hutton 1781, 12; Hodgson 1811, 11.
62 Curwen 1932 106.
63 CAS (C) D/Lons/L3/1/16 Estate Receipts 1694 – 1701. February and March 1696, 29 May 1699.
64 CAS (C) D/Mus/5/4/2 Cash Book 1698 – 1701. 4 April 1700.
65 CAS (C) D/Mus/5/4 7 Edenhall. Ledger 1734 – 1744. 12 September 1738, 15 March and 27 September 1739.
66 CAS (C) D/Lons/L12/1/6 'Robert Lowther Esq, His Booke of Accomptes 1710-24'. 29 July 1711, 8 June 1719, 8 August 1721.
67 Dickson 1807, 57; Dickinson 1853, 43.
68 CAS (C). D/Lons/L12/3/12/4. 'Bills for carrying coals to Kilns 1784'.
69 CAS (C) D/Lons/L3/5/48. Cash Book 1794 – 1802.
70 Tyson 1998, 69.
71 KLSL. BK354. 'An Act for repairing, amending, and widening, the Road from Keighley in the West Riding of the County of York, to Kirkby in Kendal in the County of Westmorland, 11 January 1753'.
72 Hodgson 1811, 11; Tyson 2001, 245.
73 LRO DDPa, Box 1. Parkinson of Hornby (uncat.). 'Thoughts on the design of making a navigable canal, from the vicinity of Kendal, to join some of the canals in the south parts of Lancashire, by way of Lancaster' 1791.
74 CAS (K) WD/Cr/4/275. Crewdson Papers. Lancaster Canal. Rates of tonnage duties, 1 January 1819; Priestley 1831, 405–06; Hadfield and Biddle 1970, 182–84.

75 The term 'burning' has always been used for the process of turning limestone into lime, and the workers who operated lime kilns have always been called limeburners, but it gives a wrong impression. Limestone cannot be burned as such. The correct terminology is 'firing' or 'calcining', whereby limestone is reduced by thermal decomposition into its constituent parts, calcium oxide and carbon dioxide, at a temperature of 800–900 degrees Celsius. The calcium oxide (CaO) remains as the residue while the carbon dioxide (CO_2) is given off; lime – also known as quicklime – is calcium oxide.

Notes to Chapter Four: Improvement and Change c. 1660 to 1760

1. See Hoskins 1953, 44–48, Marshall 1980, 511, and Winchester 2006, 82, for overviews; and Garnett 1987 for a detailed analysis of the situation in south Lonsdale.
2. Bouch and Jones 1961, 97–98.
3. Quoted in Lennard 1932, 23.
4. Low 1985, 354.
5. Wade Martins 2009, 81.
6. See Johnson, D. 2010b, 52–54 and 68–69 for a discussion of such treatises.
7. CAS (K). WD/KILV/3/7, Indenture 12 February 1579.
8. Blackett-Ord 1986, 133–35.
9. See, for example, CAS (K). WD/HH/82. Crosby Garrett manor court 1629–1630 and 1653; WDX/424. Asby Winderwath manorial record book 7 November 1647 and 16 November 1649; CAS (K). WDX/150. Manor court records Great Musgrave and Soulby 3 October 1690; CAS (K). WD/HH/3. Manor court books. Drybeck 21 October 1731, 10 October 1749 and 21 October 1756; WD/HH/4 Dufton 3 August 1775. The 1731 and 1775 rulings were against the cutting of holly on common land, holly being a valuable winter source of fodder.
10. CAS(B). BDX 116; and CAS (W). D/Pen/200. *The Commonplace Book of John Pennington of Muncaster 1491 – 1511*.
11. Within Gaitscale stand the ruins of a former farmstead (NGR NY255 022), with house, barns, outbuildings and small enclosures, all buildings clearly having been thatched. It is known to have been in occupation from 1686 to 1771 and ruinous by 1807, but the morphology of the structures implies a much older date. Could these be remnants of late fifteenth-century sheep management?
12. Ornsby 1878.
13. Huddleston 1958.

14 CAS (C). D/LONS/L/3/1/1. Estate and general memoranda book of Richard Lowther, and of Sir John Lowther (1640-73). Folio 181 lists the number of store cattle on the estate for 1564–80.
15 CAS (C). D/LONS/L3/1/1. 'Memorable observations and rememberances of the house, grounds at Lowther and the qualitie and Conditions thereof ... Taken by me J. Low: Kt. Bt. 1640'; D/LONS/L3/1/4. Account Book, Sir Christopher Lowther 1604–17, Sir John Lowther 1617–37, and Sir John Lowther 1637–55.
16 CAS (C). D/LONS/L3/1/5. '1656 – 1675 Account Book. Sir John Lowther's Long Vellum Book'.
17 The 1691 hall partially burned down. By 1806 it had been demolished and replaced by the present mock-medieval Lowther Castle.
18 CAS (C). D/LONS/L12/1/6. 'Robert Lowther Esq, His Booke of Accomptes 1710 – 24'.
19 CAS (C). D/LONS/W2/1/73. 'Letter John Spedding to James Lowther 26 February 1728'. Spedding served the Lowthers in west Cumberland as colliery steward from 1707–30 and then estate steward till his death in 1758. An indication of the closeness of his relationship with Sir James is the naming of two of Spedding's children – Lowther and James (Beckett 2006).
20 CAS (C). D/LONS/L5/1/22/1. 'A Survey of Buckholme Flatts as they were marled in the years 1732 and 1733'. n.d. (c. 1734).
21 CAS (C). D/LONS/L3/2/140. 'William Armitage's Acco' to Sir James Lowther 7 March 1759 to 7 March 1760'.
22 CAS (C). D/LONS/3/5/90. 'Account of Improvements at Rough Ground. Also at Burnt Earth', 26 February 1763 to June 1765.
23 Farrer 1924, 394.
24 Winchester 2003, passim.
25 Beckett 1978, 53–57.
26 Eden Hall was the Musgrave's northern seat.
27 CAS (C). D/MUS/5/3/2. 'Bundle of leases 1661 – 1812'.
28 CAS (C). D/MUS/5/3/1. 'Edenhall leases 1677 – 1812', Indenture of Lease 23 May 1752.
29 CAS (C). D/MUS/5/4, Box 80. 'Estate account, Hartley Book 1607 – 1731'; D/MUS/5/4/7. 'Ledger 1734–44'.
30 Humphries and Mossop 2000, 20.
31 CAS (K). WDRY/4/7/8, Box 24/23, 'Accounts 1656 – 1697', e.g. 27 January 1657; WDRY/1/8/4/25C, Box 107/33, 'Receipts 1762-64', e.g. 10 May 1762 and 22 February 1763.
32 Tyson 2001, 132.
33 CAS (K). WDRY/1/8/3/2, Box 107/8. 'Accounts of Sir Michael le Flemings' farmers 1758 – 69'; WDRY/1/8/4/25, Box 107/33, 'Receipts for manure, ashes and lime 1762–64'.

34 Bagot and Munby 1988, p. xiii.
35 Levens Hall Archive via CAS (K). Not fully catalogued. Box 18D Bundle 3/135, 136, 253, 1694 and 1696; Box 18I/2, 1690-91; Box 18I/4 Pentecost 1691.
36 Levens Hall Archive via CAS (K). Box 18I/2, 21 February 1696.
37 CAS (W). D/PEN/202. Pennington family of Muncaster Castle. 'Estate Account Books' 1660–94 and 1695–1708.
38 I am grateful to Crispin Powell, Buccleuch Living Heritage Archivist at Boughton House, for drawing my attention to certain documents held there and by NAS.
39 Pers. comm. Crispin Powell.
40 NAS. MAP 6057. Uncat. Volume of Estate Maps (Furness).
41 NAS. MAP 6057. 'An exact survey of Thurston Water and parts adjacent Furness Lancashire', 1732.
42 NAS. MAP 6057. 'An exact survey of Peelnears and the lands adjacent on Thurston Water n Furness Lancashire'. 1732.
43 NAS. MAP 6057. 'A plan of Becon Hill in the district of Blaythwith in Ulverstone Parish in Higher Furness Lancashire'. 1732.
44 Tyson 1979.
45 Tyson 2001.
46 CAS (K). WDRY/1/8/3/4. Box 110/29. 'Accounts of New Hall, Hollin Hall and Knott in Nether Staveley'.
47 Levens Hall Archive (see note 163).
48 CAS (C). D/MUS/5/4/2. Edenhall 'Cash Book 1698 to 1701'.
49 CAS (C). D/MUS/5/4. 'Estate Account, Hartley Book 1697 – 1731'.
50 CAS (B). 'The Commonplace and Account Book of Roger and Jeremiah Sawrey of Broughton Tower, Furness, Lancashire of 1657-8 to 1679/80'.
51 Tyson 1983.
52 Colvin, Mordaunt Crook and Friedman 1980.
53 Phillips 1973, 166.
54 CAS (B). 'The Commonplace and Account Book of Roger and Jeremiah Sawrey of Broughton Tower, Furness, Lancashire of 1657/8 to 1679/80'.
55 Farrer 1924, 394.
56 Morris 1982, pp. 165-72.
57 Copland (1866, vol. 1, vii) later wrote that a strong barrier to agricultural improvement was the attitude of landowners, who issued short-term leases and/or restrictive covenants drawn up by those with little practical knowledge of farming.
58 CAS (K). WD. NT/15. Helsington Bundle 1672–1901. 'Indenture 8 November 1681 between Thomas Thompson, Gent, Susanna his wife, and William Hutton'; 'Indenture 30 December 1681' between the same partners.
59 CAS (K). WD/D/SK/1. Skelsmergh. 'Counterpart of Lease of Skelsmergh Hall, 25 August 1722'.

60 CAS (C).DHN/C/170/55. 'Lease from Naworth Estate 17 November 1735'.
61 Manley 1974; Parker *et al.* 1992.
62 Rumney 1936, vii.
63 Curwen 1932, 225; CAS (K). WDRY/1/10/4/12, Box 80/1, Rydal, a letter of 1751. Variously called distemper, cattle plague or murrain and more latterly rinderpest, it is a highly infectious viral disease with no known cure, so slaughter was the normal recourse. Major pandemics occurred across England from 1709–20 and 1742–60.
64 CAS (C). SPC 26/27. 'Letter to the Right Honourable Lord Howard of Naward. The humble peticon of the poore and oppressed Tennts of Hutton John'. n.d. (*c.* 1655).
65 Marshall 1973, 211.

Notes to Chapter Five: Agricultural Change in the Age of Enclosure

1 Fox 1979, 54.
2 Johnson 2010b, 88–89.
3 Kent 1775.
4 Winter 1787; Parkinson 1798; Anon 1776.
5 Goddard 1990, 166; Wilmot 1990, 9; Tarlow 2007, 35.
6 See, for example, a letter sent by Lord Somerville, president of the Board of Agriculture, to major landowners. LRO. DDTO. Box UU, 1800.
7 Wade Martins 2004, 141.
8 Perry 1981, 162.
9 Gazley 1973, 693.
10 Rowe 1972, xiii.
11 Home 1762, 69.
12 Anon 1771, 124–25; Winter 1787, 30.
13 Donaldson 1796, 211.
14 Davy 1814.
15 Wade Martins 2004, 13.
16 Tarlow 2007, 41.
17 Williamson 2007, 5–6.
18 Marshall 1929-30, 56.
19 See, for example, Horn 1982, who cast doubt on the influence of propagandists and landowners.
20 Sinclair 1837, 111.
21 Young 1770, vol. 2 and 3.
22 Young vol. 2, 206.

23 Young, vol. 3, 117–90.
24 Young, vol. 4, 494–96.
25 Bailey and Culley 1794 and 1805 on Cumberland; Pringle 1794 on Westmorland.
26 Commissioners were not given enough time to do a thorough job. Holt, for example, received his orders late in 1793 and his final report was completed in less than two years – British Museum, Towneley Archive TY 7/140, 7 September 1793.
27 Holt 1795.
28 Marshall 1808/18, 247.
29 Marshall 1808/18, 205–06.
30 Hutchinson 1794–97.
31 Housman 1800.
32 Anon 1803.
33 Robinson 1803.
34 Whyte 2003b, 25.
35 Robinson 1804, 104; 1805, 215.
36 West 1805, originally published 1774.
37 Moore 1819.
38 CAS (K). WDX/668. Waller Family of Winton, Lease 9 June 1784.
39 CAS (K). WDX/140/138. Memorandum of Lease, Cecily Strickland of Sizergh Castle to James Garnett, 26 December 1770.
40 CAS (K). WDX/94/acc. 463/63. Lease, 11 February 1779. The ruins of a farm called Hall Intack lie above the River Rawthey. Though it is just outside Ravenstonedale parish, it is assumed this was the farm in question.
41 CAS (K). WDRY/1/8/3/4, Box 110/29. Accounts of New Hall, Hollin Hall and Knott in Nether Staveley. 'Farm to let' notice, 26 November 1792.
42 Gowling 2011, 111.
43 CAS (K). WD/Whelp/T53. Gibson of Whelprigg. Lease 19 September 1817 to William Langstroth of Barbon and John Langstroth of Ireby, husbandmen, effective 1818.
44 CAS (K). WD/MG. Metcalfe-Gibson Archive. Lease, 16 November 1835, Mary Scarborough of Kirkby Stephen, widow, to Thomas Guy of Bleaflatt, husbandman, effective 25 April 1836.
45 Pringle 1794. 304-05; Bailey and Culley 1794, 182.
46 www.metoffice.com
47 La Rochefoucauld 1988, 30, 98, 107; Highwood and Stevenson 2003.
48 Grove 1988, 415. For an offbeat link between weather and eruptions, see Clarke 1834.
49 Dickinson 1850, 60.
50 CAS (K). WDX 341/1. 'Bell Family of Brough. Financial Papers, 1758–1930'; www.metoffice.com; Wigley *et al.* 1984.

51 Moore, 1819, 201.
52 Bailey and Culley 1794, 173.
53 CAS (K). WDX/450/19/5. Richard Rigg's Pocket Book; Webster 1868, 12.
54 Need-fire involved driving cattle through the smoke of a slow-burning bonfire with lime added for good effect, with the intention that by breathing in the smoke and fumes the disease would be purged. Tradition dictated that the fire had to be passed from farm to farm without being allowed to go out. In 1839 a fire was lit at Killington in Lunesdale and passed throughout the whole of that part of the county. Another was lit at Crosthwaite, west of Kendal, on 15 November 1840 where an inquisitive onlooker wrote, 'such was the thickness of the smoke that I could scarcely perceive the actors in this strange ceremony – men and cattle', Curwen 1926, 71-72. Arguably a more sensible course of action than that during the 2001 foot-and-mouth outbreak.
55 CAS (K). WDRY/7/4/1/24, Box 97/4. Letter from Lord Carrington, 26 June 1800.
56 British Parliamentary Papers (BPP). *Report from the Select Committee on Labourers' Wages*, 1824. Command Paper 392, p. 5.
57 BPP. *Reports of the Select Committee on Agriculture for 1833*. Vol. 5, Command Paper 612, pp. 303–25.
58 BPP. *Report from the Select Committee of the House of Lords, appointed to Inquire into the State of Agriculture in England and Wales; with Minutes of Evidence, Appendix and Index*. Session 1837. Vol. 5. Command Paper 464.
59 *Westmorland Gazette and Kendal Advertiser* 13 November 1830.
60 'Answers to Rural Queries' from the Poor Law Commission. Reports on the Administration and Operation of the Poor Laws, Appendix B.1. 1834.
61 See Grigg 1963, Mingay 1964, Unwin 1982, and Ginter 1992 for detailed analyses of the Land Tax system, its benefits and drawbacks.
62 Beckett 1977, 130.
63 Ginter 1992, 250–51.
64 For a detailed account of local machinations and problems in Cumbria, see Beckett 1986.
65 Anon 1766.
66 CAS(B). BDX 584. 'Diaries and Commonplace-book of Wm. Fleming of Pennington 1798 – 1821', 12 volumes, vol. 5, p. 1428, 6 August 1807.
67 CAS (K). WQ/R/LT. Westmorland Land Tax returns.
68 Williams 1970, 58; Whyte 2003b, 22.
69 Williams 1975, 83.
70 Winchester 1987, 72–73; Tyson 1992; Atkin 2013.
71 CAS (K). WQR/I/45. Keisley Field, Dufton. Enclosure Award.
72 Young 1773, 38–39; Williams 1970, 57.

73 For enclosure in general see, for example, Williams 1970, Turner 1980 and 1984, Dent 1983, Wordie 1983, Williamson 2000, and Kain *et al.* 2004. On enclosure in Cumbria see Searle 1993, and Whyte 2000, 2003a and b, 2005 and 2006.
74 Moore 1819, 195.
75 NAS. Furness Estate Records. Furness Trust Accounts 1749–1820.
76 CAS (K). WD/Hoth/ Box A1. Various Receipts relating to repairs etc on the Estate, 1790.
77 Enclosure files for Cumberland are housed at CAS (C), mostly referenced under Q/RE/1/ except for the Renwick Fell Award of 1864 (SPC/35/2/1 and D/AR 143); for Westmorland at CAS (K), mostly under WQR/I/ except for Brough Intack Award of 1842 (WDX 753), Brougham Moor Award of 1776 (WD/K/322), and Milburn Grange Common of 1819 (WPR 47); and for Furness at LRO, under AE 4.
78 CAS (B). BDX 584, vol. 7, p. 2262, 16 July 1810.
79 CAS (K). WQR/I/19 Burton, Holme and Dalton Award 1815; CAS (K). WQR/I/14. Casterton Moor Award 1816; CAS (K). WQR/I/32. Great Musgrave Common Award 1859; CAS (K). WQR/I/64. Maulds Meaburn Moor Award 1858; CAS (K) WQR/I/73 and WPR/9/211. Orton Award 1779.
80 CAS (C). Enclosure Acts Vol. 1, Skelton Act and Castle Sowerby Act.
81 CAS (C). Q/RE/1/119. Enclosure Award. Talkin Fell 1854.
82 CAS (C). Enclosure Acts Vol. 1, Greystoke 1812 (Act); CAS (C). Q/RE/1/32. Ainstable and Croglin Award 1815.
83 CAS (C). Q/RE/1/115. Melmerby Moor and Low Fell Award 1858; Q/RE/1/117. Ousby Infell, Low Moor, Star Howes, Fell Green, The Mires etc Award 1863; Q/RE/1/121. Glassonby Fell, Viol Moor and Maughanby Common Award 1867.
84 CAS (K). WDB/35, Box 16. 'An essay on the best method of Reclaiming Heath Land by John Watson Junr, Surveyor in Kendal', n.d. but pre-1845.
85 One theory attributes the introduction of paring and burning in Britain to the influx of Huguenots, who fled to England from the near continent after 1685, many settling as farmers in the Fens (Copland 1867, 723).
86 This application rate seems to be at odds with data from Lowther accounts for lime bought in 1787 from Rudd Hills Kilns (later Redhills Limekilns, now within the Rheged Centre). Lime from here was spread at the rate of 1 peck (¼ bushel) over an area 16.5 inches square and 8.5 inches deep: this would mean that Watson's sixty bushels would only treat 100 m². CAS (C). D/LONS/L/12/3/12/6. 'Lime Accounts'.
87 Kerridge 1967, 37; Bailey and Culley 1794, 36.
88 British Sessional Papers, House of Commons, vol. 60, 1794/5, no. 796, 5 June 1795.

89 Rumney 1936, 208–12.
90 Beesley 1849, 38; Davis and Davis 2013, 9–10. The latter work provides a comprehensive and detailed description of underdraining in Cumbria.
91 Hoelscher 1963, 77–78; Kerridge 1967, 37; Phillips 1989, 9, 17; Phillips 1999, 53, 56.
92 Kain 1986, 570, 622.
93 CAS (K). WD/D/Acc 512/59. Plan showing drains cut in Foulshaw Moss by George Braithwaite in 1826–27 for the Dallam Tower Estate.
94 Further reclamation, of up to 600 acres (*c.* 240 ha) on Meathop Marsh and Castlehead, was undertaken in the 1850s for construction of the railway through Grange.
95 CAS (K). WQR/I/43. Helsington Drainage Award.
96 CAS (K). WD.NT/15. Helsington Bundle, Notice to Anthony Garnett, 9 October 1807.
97 I am grateful to Dr Bill Shannon for bringing this to my attention.
98 Chaloner 1957.
99 Marshall 1958, 65.
100 LRO. AE 4/2. Cartmel Enclosure 1809.
101 Sinclair 1806, 8.
102 Holt 1795, 90–92.

Notes to Chapter Six: The Response of the Landed Estate

1 Whittaker 2001, 4.
2 Tyson 1981.
3 Wade Martins 2002, 1.
4 Robinson 1983.
5 Colvin *et al* 1980, 38.
6 CAS (C). D/LONS/L11/3/7-8. 'Plan and elevation for a new dairy by Robert Adam, Architect, 1765' for Sir James Lowther Bart.
7 Pevsner 1967, 274.
8 Messenger 1975.
9 Messenger 1975, 330.
10 CAS (C). D/LONS/L11/9/23. Architectural Plans. 'Mr Lumb's House and Farm', n.d.
11 This style of ornate design is known as *la ferme ornée,* a term coined in 1715 by Stephen Switzer. John Plaw (1796) composed a book full of ornate styles for buildings, garden features and even gates.
12 Taylor 2004, 99, 120.
13 Bailey Denton 1865; Garret 1772,1.

14 Fussell, 1981.
15 Messenger 1975, 333–34.
16 A plan of 1765 for building work at Rogersceugh shows a house with attached barns but this design is definitely not what stands today.
17 Rogersceugh was purchased by the RSPB in 2004 and the future of the farm complex is currently under review.
18 CAS (K).WD/Cat/Mus. A2173. Edenhall Correspondence, 1770s. Letter from the Edenhall Estate steward, Christopher Dobson, to Sir Philip Musgrave 18 October 1779.
19 CAS (C), D/LONS/L8/50. 'A valuation of the estates in Westmorland', n.d. (1808).
20 CAS (C). D/LONS/L8/43. 'Robert Lumb's Report of the management of part of Lord Lowther's Estates in the County of Cumberland taken in December 1804'.
21 CAS (C). D/LONS/L8/65. 'Account of farms in the neighbourhood of Lowther viewed April 1817 by W. Lumb'.
22 CAS (C). D/LONS/L8/95. 'State of cultivation of the Burgh Barony Estates', 1836–39.
23 Three-year rotation had applied in Cumbria for centuries consisting of two years of grain followed by one of fallow, repeated time and again. It began to die out when turnip cultivation arrived in the county in the eighteenth century. Turnips replace nutrients taken out of the soil by cereals, so fallowing was no longer strictly necessary.
24 Copland 1866, 377.
25 Humphries and Mossop 2000, 35.
26 CAS (C). D/LONS/L5/3/2/15/2/ 'Plan of Hackthorpe High' 1805.
27 Phillips 1989, 9.
28 CAS (C). D MUS 5/4/46. Account Book 1750–1806. 'An Account of Lime Burnt' November 1758 to July 1761.
29 CAS (C). D MUS 5/4/46. Letter 6 March 1766, from Mr Goldies to the estate steward at Edenhall.
30 CAS (K). WD/Cat/Mus. A 2173. Letters, Edenhall 1770s.
31 This was said to be a black cankerworm that ravaged turnip crops across the country from the 1770s to the 1790s, according to Clarke 1834.
32 CAS (C). D MUS 5/4/24. Edenhall Estate Cash Book 1806–23.
33 CAS (C). D MUS 5/3/1. Edenhall leases 1677–1812.
34 CAS (C). WD/Cat/Mus. A 2173. Lease 24 March 1783.
35 CAS (C). D/MUS 5/3/1. Lease 5 April 1802.
36 One Carlisle bushel equated to three standard Winchester bushels.
37 Ward 1967, 49.

38 Mawson 1980, 140.
39 Ward 1967, 54.
40 Erickson 1950, 171.
41 Spring 1955, 74.
42 Yule 1829, 389. According to Yule, by 1828 the kiln was producing 260,000 tiles per year, the equivalent of 40 miles (*c*. 65 km).
43 Erickson 1950, 174; Ward 1967, 70.
44 Evans and Beckett 1984.
45 Bailey and Culley 1794, 191–92, 196.
46 CAS (W). D/CU/5/18. 'The rules and the proceedings of the Workington Agricultural Society; and the reports to that Society by the President'. 1810, p. 177.
47 CAS (W). D/CU/5/18, p. 177.
48 Bailey and Culley 1794, 208.
49 CAS (C). DPH/1/127/3. 'Account of Lime lead by Lord Carlisle's Farmers in the years 1810, 1811 and 1812.'
50 CAS (C). DPH/1/127/7/1. 'Accounts of Cumberland Mines' 1823–1830.
51 Harris 1977, 149.
52 CAS (W). D/CU/5/18. 'The rules and the proceedings of the Workington Agricultural Society; and the reports to that Society by the President'. 1810.
53 Curwen 1809, 243.
54 CAS (W). D/CU/5/21. 'The report of the Workington Agricultural Society for the years 1813 & 1814, comprising a full detail of the proceedings at the Schoose'. 1815, pp. 36–37.
55 CAS (W). D/CU/3/43. 'William Swinburn's Letter Book, 1805–17'.
56 Curwen 1809, pp. 3, 11.
57 CAS (W). D /CU/3/43. Memorandum of Agreement, 30 July 1814.
58 CAS (W). D/CU/5/18, *passim*.
59 One method of improving the quality of old permanent pastures was to spread road-scrapings, and gleanings from ditches and ponds, mixed with lime and left to mellow for a year before being mixed with dung (Copland 1867, vol. 2, 769).
60 Lucerne (*Medicago sativa*), or alfalfa, is a hay crop and not a crop for foraging cattle, with a generally guaranteed high yield and a protein content of *c*. 20 per cent. It is relatively uncommon in Britain nowadays.
61 Rham 1845.
62 CAS (W). D/CU/Additional/244. 'Schoose Farm Pay Bill Book 1812–1814'.
63 Curwen 1809, 207–10.
64 CAS (W). D/CU/5/18, p. 188–89.
65 Curwen 1809, 261, 267.
66 CAS (W). D/CU/5/21, p. 98.
67 CAS (W). D/CU/5/21, p. 105–09.

68 CAS (C). D /HUD 3/62. Memorandum of Agreement 29 September 1768 with William Pollock and Isaac Mayson.
69 CAS (C). D/HUD 3/64. 'Memorandum of Neglect of the tenant of Hutton John 1816, Mid Summer. List of mismanagements'.
70 CAS(C). D/HUD 3/21. 'Special Works Day Book 1835–39. Memorandum about the improvement of Hesket High Field' n.d. but *c.* 1835.
71 CAS (C). D/HUD 3/20. Estate Day Book, 1837–38. 'An Account of Work done at Hutton John'.
72 CAS (C). D/HUD 3/70/1. Drainage vouchers, *c.* 1840.
73 CAS (C). D/HUD 3/66. Indenture of lease for Highgate Farm 25 March 1841.
74 CAS (C). D/HUD 3/66. 'Conditions of Letting Dacre Bank Farm, 132 acres, from 25 March 1858'.
75 Mangolds, or mangelwurzels (*Beta vulgaris*), is a root crop, a type of beet, used from the eighteenth century as a fodder crop. As with turnips, both tops and roots are eaten by livestock.
76 NAS. Box X8782. Survey of Furness 1814.
77 CAS (B). BDX 584, vol. 5, p. 1572, 7 April 1808.
78 CAS (B). BDX 584, vol. 5, p. 1610, 13 May 1808; vol. 7, p. 2180, 15 July 1810. Swedes were brought to Scotland in 1777 and then to England.
79 CAS (B). BDX 584, vol. 7, pp. 2180–81, 16 July 1810.
80 See Winchester 1994, for liming from 1756 to 1781 in the Cockermouth area; and CAS (K). WDRY/1/10/5/4, Box 108/4. 'Letters from John Gibson at Rydal Hall to Sir Michael le Fleming, 1773-84' for liming on that estate.
81 CAS (K). WD/Hoth/Box 26 (uncat.). Misc. Westmorland leases.
82 CAS (K). WD/Hoth/Box B2/Bundle A1. Receipts relating to repairs on the estate, 2 July to 10 November 1797.

Notes to Chapter Seven: Innovation, Experimentation and Depression

1 Humphries and Mossop 2000, 21–23. In 1855 1,360 kg of butter were sent each week from Mardale Green to Manchester (Humphries 1996, 24).
2 Slight and Scott Burn (1858) went into incredible detail on almost every type of farm machine and implement, with illustrations and advice on how and where to arrange them within the well-managed farmstead.
3 The concept of high farming was disseminated in a pamphlet by Sir James Caird, who believed that it boiled down to having a landowner keen to invest in his estate and able to select tenants with the abilities and resources to put improvements into effect, and who would be compensated by 'moderate' annual rents. See Caird 1849, 32.

4 Whittaker 2001, 27.
5 Carne 2006.
6 Garnett, 1912, 207–08. Copland (1866, vol. 1, 717) claimed that 'bone-dust' was first used in Cheshire c. 1750.
7 Though one source gives its origins in Britain in 1809 (Copland 1866, vol. 1, 692).
8 Prothero 1912, 369; Goddard 1990, 179.
9 Garnett 1849, 42.
10 See, for example, Stephens 1852, 1235.
11 Caird 1852, 463.
12 Cordle 2007, 130.
13 Stratton and Houghton Brown 1978.
14 Binns 1851, 57.
15 Rothwell 1850, 126, 159.
16 Copland 1866, vol. 1, iii.
17 Mannix and Whelan 1847, 35; 1849, 47.
18 Dickinson 1850; 1852; 1853.
19 Webster 1868, 13, 16.
20 Dickinson 1850, 71.
21 Dickinson 1853, 11.
22 Dickinson 1853, 19.
23 Dickinson 1852, 223–24; 1853, 49–50.
24 Caird 1852, 358, 360.
25 Webster 1868, 35.
26 CAS (C). DBS 4. Aglionby. Estate improvement.
27 CAS (C). D/ING/12. Inglis of Dalston. 'Estate Account Book 1853–1859, Dalston'.
28 CAS (C). D/ING/23. Inglis of Dalston. 'Farmworkers' Day Books 1831–32'.
29 The parish boundary wanders either side of the beck, following its original meandering course.
30 CAS (C). D/HUD/3/37. Huddleston of Hutton John. 'Estate Day Book 1858–60'.
31 CAS (C). D/HUD/3/33. Farm drain-laying vouchers 1858–61.
32 CAS (C). D/LONS/L15/1/9. 'Hackthorpe Tilery Sales and accounts 21 April 1852–2 November 1865'; D/LONS/L14. Drainage Records 1847-76; About 10,000 acres (c. 4,050 ha) were drained using tile drains on Lowther lands (Keates 2002, 44).
33 There is a Sandriggs in Dufton parish (NY684 265), in Soulby (NY743 115), which had its own tilery from 1860–69, and in Little Strickland (NY563 212).
34 CAS (C). D/LONS/L3/5/107. 'Summary of monthly payments for draining etc'. 1858–60.

35 Dickinson 1850, 31–32.
36 Phillips 1989, 17.
37 CAS (C). D/LONS/L3/5/107. Wickersgill Lime Works, 4 September 1858–31 October 1865.
38 CAS (C). D/LOND/L3/5/108. 'Limeburning on Wickerslack Moor'. This kiln has long since been demolished, but it was a substantial structure utilising firebrick as a lining for the firing bowl and with a cast-iron door to the aperture, through which burnt lime was drawn. Many kilns were purpose built for a particular reclamation project and never fired up again once the task was complete, more particularly with late-period enclosure awards like this one.
39 CAS (C). D/LONS/L15/1/1/28. 'Estimate for Building and repairing Lime Kilns upon the Estate of the Rt. Hon. the Earl of Lonsdale, 12 February 1852'.
40 Caird 1852, 360–64.
41 CAS (C). DPH/1/127/6. 'Report on Naworth Mines 6 July 1844'.
42 CAS (K). WD/Hee. Heelis of Appleby. 'Farm Account Books 1852–73. Purchases'.
43 Rothwell 1850, 9, 107.
44 Webster 1868, 21–24.
45 Dipping became compulsory in 1905.
46 He changed its name again in 1865, to Blennerhasset Farm. It has since reverted to Mechi. For a detailed account of Mechi see Lawson and Hunter 1875.
47 This is an alternative name for potassium chloride, which is still an important artificial fertiliser.
48 In America he made good, but not in agriculture.
49 Binns 1851, 4.
50 Rothwell 1850, Appendix p. 66–67.
51 'Earl of Carlisle's Rent Day 9 June 1851'. *Westmorland Gazette* 14 June 1851.
52 Garnett 1912.
53 Allston Channing 1897, 2.
54 Royal Commission 1881, 243.
55 John Ruskin gave two lectures at the London Institution on the subject. The first, delivered on 4 February 1884, was entitled *The Storm-Cloud of the Nineteenth Century*.
56 Garnett 1912, 210; Curwen 1926, 71–72.
57 Brown 1987, 6; Royal Commission 1881, 241–42.
58 Alston Channing 1897, 1. He was a member of the Royal Commission.
59 Perry 1973, 134–40.
60 Brown 1987, 19.
61 Hallas 2000, 405, 409.

62 Shepherd 2003, 119, 131.
63 Allston Channing 1897, 287–88.
64 Bateman 1879.
65 Royal Commission 1881, pp. 234–57.
66 Coleman lived at Riccall Hall near York.
67 Royal Commission 1894.
68 Royal Commission 1895.
69 Royal Commission 1897. Unfortunately, the commissioners could not agree among themselves, so two conflicting reports were published, making different recommendations.
70 One of the founders was Sir Wilfrid Lawson, brother of William Lawson of Mechi. Aspatria closed in 1914.
71 CAS (C). D/LONS/L3/5/62. 'Acct of Day Work on the Lowther Estate' 1 January 1873–23 November 1880.
72 CAS (B). BD/BUC/39/67. Ireleth Marsh 1877.
73 CAS (B). BD/BUC/23/5/7; 23/6/7; 23/7/8; 23/8/8. Repairs and Estate Expenses and Expenditure Vouchers 1874–1878.
74 CAS (B). BD/BUC/FARM PLANS/21.
75 Little 1880, 505–29, 553–59.
76 Roberts 1962, 136ff.
77 CAS (C). DHN/C/590. A/2. 'Drafts for New Colliery Lease 1889–1891'. Small-lime was the residue of a firing event after the best quality hand-picked lime had been removed. It was adulterated with ash, dust and lime not fully calcined, so was sold at a lower price for surfacing floors (where quality of lime did not matter) or as a cheap soil input.
78 CAS (C). CBME/Box 4. Acc. 664 9/1. 'Edenhall Estate Book 1891–1918'.
79 Of the nine varieties, he marked one 'finer grass' (*Poa trivialis*), one 'for permanent pastures and leys' (*Lolium perenne*) and one 'for a good forage crop and temporary pasture' (*Lolium italicum*).
80 CAS (C). D/SEN/5/15. 'Report on Southwaite Farm 29 November 1892 to H.P. Senhouse Esq.
81 CAS (C). D/SEN/5/15. Plan 'Camp Farm rotation'.
82 CAS (W). D/CU/5/35. 'Curwen of Workington Hall. Account book of crops 1870–1904'.
83 CAS (W). D/CU/5/45. 'Specifications – repairs to Harrow Slack Farm, Windermere, belonging to H. F. Curwen', 1894.
84 CAS (C). D/HG/214. Howard of Greystoke. 'Summary of Income and Outgoings for each farm etc, 1893–1902'.
85 Garnett 1912, 209.
86 Royal Commission 1919, Interim Report 1, 4–5.

87 Crowe 2009, 136–40.
88 Royal Commission 1919, vol. 1, 89–96.
89 Royal Commission 1919, vol. 3, 15, 36; vol. 5, 72–73.
90 Pers. comm. Helga Frankland, August 2004.
91 Pers. comm. Helga Frankland, February 2006.
92 Crowe 2009, 172–73.
93 Corrie 1926, ii.
94 Agriculture Act, 1937. Memorandum L. F. C. 1. 'Guide to the Land Fertility Scheme'. London: Land Fertility Committee, August 1937.
95 MAFF 1981, 6; Johnson, 2010c, 229–31.
96 Hill Farming Act 1946.

Notes to Chapter Eight: An Improving Prospect?

1 Dilley 1991 concluded that Cumberland witnessed no revolution in farming.
2 Tarlow 2007, 11.
3 Tarlow 2007, 41.
4 Rothwell 1850, 115.
5 CAS (K). WDRY/1/10/5/4, Box 108/4. 'Letters from John Gibson at Rydal Hall to Sir Michael le Fleming, 1773–84', 23 February 1773.
6 Marshall 1971, 136–37.
7 Beckett 1982, 103.
8 Winchester 2005, 41.
9 Webster 1868, 37.
10 Allston Channing 1897, 119, 287, 294. A farm servant normally lived with the farmer's household, and was engaged by the year, and was deemed to be of a higher social status than farm labourers who did not live in and were often hired by the day or for specific tasks.
11 Webster 1868, 7–8.
12 Overton 1996, 175.
13 Perren 1970, 36.
14 Hallas 2000, 409.
15 Wade Martins 2002, 207.
16 As made, for example, by Bouch and Jones (1961), 97–98.
17 Dilley 1991 was too damning in saying that, in Cumberland, he had found little evidence of landowners influencing tenants in good practice, that selective breeding was not widespread, that innovation in the early post-medieval era was minimal, that many tenants between 1700 and 1850 viewed innovation with suspicion, that Cumberland was 'distinctly backward' (pp. 224–25) in field management, and that the county was not noted for 'high farming' at any time.

18 Defra. *Agriculture in the United Kingdom 2014.* www.gov.uk/government, accessed 29 August 2015.
19 www.gov.uk/government/statistics/uk-milk-prices. Accessed 4 August 2015. *Agriculture in the United Kingdom 2014.* (Defra 2014).
20 Phillips 1999, 56.
21 Phillips 1989, 37–39.
22 wtru.st/eycotthill. Accessed 10 August 2015.
23 Condliffe 2009, 70–73.
24 adlib/everysite.co.uk/adlib/defra. Accessed 28 August 2015.
25 The Hill Farm Allowance Regulations 2005. Statutory Instrument 2005 No. 154.
26 https://www.gov.uk/guidance/countryside-stewardship-manual. Accessed 29 August 2015.
27 As claimed by the environmental activist George Monbiot in 2013.
28 Edwards 1999.
29 www.coronationmeadows.org.uk. Accessed 28 August 2015. Coronation Meadows have two main objectives – to preserve, or create, flower-rich hay meadows and to increase public awareness and involvement.
30 www.leafuk.org. LEAF (Linking Environment and Farming). Accessed 28 August 2015.
31 www.cumbriahillfarming.org.uk. Accessed 28 August 2015. The initiative also strives to preserve significant historical features, such as dry stone walls and vernacular farm buildings.
32 'Idiosyncratic views on farming'. *The Westmorland Gazette* 4 June 2015.
33 There is no statutory designation for an upland or hill farm. Rather the distinction is based on the stocking regime: hill farms produce breeding stock with most female lambs retained, with much of the year spent on the fells or moors, whereas upland farms tend to concentrate on rearing ewes to be cross-bred with lowland breeds. Lowland farms produce fat lambs for sale. See *Farming Delivers for the Hills and Upland*, a report published by the National Farmers Union.
34 *The Cumberland News* 29 March 2013.
35 Lancaster and Greater Manchester Farmer Network, Burnley and Pendle Branch meeting on 10 February 2015, 'Soil improvement. The importance of lime' – talk delivered by James Bretherton of AgScope Ltd. Similar presentations have been made to Cumbrian farmers. See also Andrews 2011.
36 Andrews 2011.
37 Defra. *Structure of the Agricultural Industry.* October 2015.
38 Bateman 1879, 271.
39 MAFF 1968, Map XVII; ONS Business Register Employment Survey 2013.

40 Walker 1792, 85.
41 Wordsworth 1835, 45-46, 54–55.
42 I acknowledge Jonathan Fisher, manager of Newton Rigg College's Sewborwens Farm, for generously giving up his time with me.
43 Fodder beet is part sugar beet, part mangold and is more nutritious than turnips or swedes.

Bibliography

Primary Sources

Allston Channing, F., *The truth about Agricultural Depression. An Economic Study of the Evidence of the Royal Commission* (London: Longmans, Green, and Co., 1897).

Anon., 'Improvements in Agriculture' in *The Gentleman's Magazine* (1764) 34, pp. 568–70.

Anon., 'The Land-Tax Explained and Considered' in *The Gentleman's Magazine* (1766) 36, pp. 581–82.

Anon., *The Farmer's Letters to the Landlords of Great-Britain*, Vol. 2. (London: W. Strahan and W. Nichol, 1771).

Anon., 'Instructions. The methods of improving the whole arable lands within the said bounds' in *Transactions of the Honourable Society for the Encouragement of Agriculture*. Gilbey Pamphlet No. 4 (1776).

Anon., 'Statistical account of Colton' in *The Gentleman's Magazine* (1803) 73, pp. 929–31, 1200–03.

Bailey J. and Culley G., *General View of the Agriculture of Northumberland, Cumberland and Westmorland* (Newcastle: Frank Graham, 1972, facsimile edition). Originally published 1794.

Bailey Denton, J. (ed.), *The Farm Homesteads of England* (London: Chapman and Hall, 1865).

Bateman, J., *The Great Landowners of Great Britain and Ireland* (London: Harrison, 1879).

Beesley, G., *A Report of the State of Agriculture in Lancashire* (Preston: Dobson & Son, 1849).

Binns, J., *Notes on the Agriculture of Lancashire, with Suggestions for its Improvement* (Preston: Dobson & Son, 1851).

Caird, J., *High Farming under Liberal Covenants, the Best Substitute for Protection* (Edinburgh: William Blackwood & Sons, 1849).

Caird, J., *English Agriculture in 1850–51* (London: Longman, 1852).

Clarke, W. B., 'On certain recent Meteoric Phenomena, Vicissitudes in the Seasons, prevalent Disorders, etc., contemporaneous, and in supposed connection, with Volcanic Emanations', *The Magazine of Natural History* (1834) 7, pp. 193-202.

Copland, S., *Agriculture, Ancient and Modern: A Historical Account of its Principles and Practice, Exemplified in their Use, Progress, and Development* Vol. 1. (London: Virtue and Company, 1866).

Copland, S. *Agriculture, Ancient and Modern: A Historical Account of its Principles and Practice, Exemplified in their Use, Progress, and Development* Vol. 2. (London: Virtue and Company, 1867).

Curwen, J. C., *Hints on Agricultural Subjects, and on the Best Means of Improving the Condition of the Labouring Classes* (London: J. Johnson, 1809).

Davy, H. *Elements of Agricultural Chemistry in a Course of Lectures to the Board of Agriculture* (London: Longman; Edinburgh: Constable, 1814).

Dickinson, W., *Essay on the Agriculture of West Cumberland* (London: Whittaker; Whitehaven: R. Gibson; and Callender and Dixon, 1850).

Dickinson. W., 'On the Farming of Cumberland' *JRASE* Old Series (1852) 13, pp. 207–300.

Dickinson, W., *Essay on the Agriculture of East Cumberland* (Carlisle: A. Thurnam; Whitehaven: R. Gibson; London: R. Groombridge, 1853).

Dickson, R. W., *Practical Agriculture; or, a Complete System of Modern Husbandry*, vol. 1. (London: Richard Phillips, 1807).

Dodgson, J., 'On burning lime with peat' in *Communications to the Board of Agriculture; on Subjects Relative to the Husbandry and Internal Improvement of the Country* vol. 4, no. 12. (London: W. Bulmer, 1805).

Donaldson, J. *Modern Agriculture, or, the Present State of Husbandry in Great Britain* vol. 2. (Edinburgh: Adam Neill, 1796).

Dudgeon, Mr. 'Of manures' in Sir John Sinclair (ed.). *General Report of the agricultural state, and political circumstances of Scotland,*

vol. 2. (Edinburgh: Archibald Constable; London: Longman, 1814) pp. 508-53.

Fitzherbert, Master, *The Boke of Husbandrie* (London: English Dialect Society, 1882. Transcript of 1534 edition).

Garret, D. *Designs, and Estimates, of Farm Houses, etc., for the county of York, Northumberland, Cumberland, Westmoreland, and Bishoprick of Durham* (London: R. Sayer; and I. Taylor, 1772).

Garnett, F. W., *Westmorland Agriculture 1800–1900* (Kendal: Titus Wilson, 1912).

Garnett, W. J., 'Farming of Lancashire' in *JRASE* (1849) 10, pp. 1-51.

Hale, T., *A Compleat Body of Husbandry* (London: T. Osborne and J. Shipton, 1756).

Hartlib, S., *His Legacy of Husbandry* (London: Richard Wodnothe, 1655).

Hodgson, Rev Mr., *A Topographical and Historical Description of the County of Westmoreland* (London: Sherwood, Neely, and Jones, 1811 and 1820).

Holt, J., *General View of the Agriculture of the County of Lancaster* (London: G. Nicol, 1795).

Home, F., *The Principles of Agriculture and Vegetation* Gilbey Pamphlet no. 67. (London: A. Millar; Edinburgh: A. Kincaid and J. Bell, 1762).

Housman, J., *A Topographical Description of Cumberland, Westmorland, Lancashire and a part of the West Riding of Yorkshire* (London: C. Law, 1800).

Hutchinson, W. A., *The History of the County of Cumberland* vol. 1. (Carlisle: F. Jollie. 1794–97 Facsimile edition, Wakefield: EP Publishing, 1974).

Hutton, J., *A Tour to the Caves in the Environs of Ingleborough and Settle in the West-Riding of Yorkshire.* (London: Richardson and Urquhart, and J. Robson; Kendal: Pennington, 1781).

Kent, N. *Hints to Gentlemen of Landed Property* (London: J. Dodsley, 1775).

Lamond, E., (translator). *Walter of Henley's Husbandry* (London: Longmans, 1890. First published in the thirteenth century).

La Rochefoucauld, François de., *A Frenchman's Year in Suffolk 1784* (Suffolk Records Society 30. Woodbridge: The Boydell Press, 1988). Translated and edited by N. Scarfe.

Lawson, W. and Hunter, C. D., *Ten Years of Gentleman Farming at Blennerhasset* (London: Longmans, 1875).

Little, H. J., 'The Cumberland and Westmoreland [sic] Farm-Prize Competition, 1880' in *JRASE* Second Series (1880) 16, pp. 486–582.

Lysons, D. and Lysons, S., *Magna Britannia: Being a Concise Topographical Account of the Several Counties of Great Britain. Volume 4 Cumberland* (London: T. Cadell and W. Davies, 1816).

Mannix and Whelan, *History, Gazetteer and Directory of Cumberland* (Beverley; W.B. Johnson, 1847).

Mannix and Whelan, *History, Topography and Directory of Westmorland* (London: Simpkin, Marshall, 1849).

Marshall, W., *The Review and Abstract of the County Reports to the Board of Agriculture. Volume the First. Northern Department.* (York: Thomas Wilson, 1808, 1818).

Moore, J., 'Remarks (chiefly agricultural) made during a short excursion into Westmoreland [sic] and Cumberland in August 1815' in *Transactions of the Manchester Literary and Philosophical Society* Second Series (1819) 3, pp. 179–203.

Moore, R. W., 'Coal mining' in J. Wilson (ed.) *The Victoria County History of the County of Cumberland*, vol. 2. (London: James Street, 1905) pp. 331–84.

Mortimer, J., *The Whole Art of Husbandry or, the Way of Managing and Improving of Land.* (London: Mortlock and Robinson, 1712).

Nicolson, J. and Burn, R., *The History and Antiquities of the Counties of Westmorland and Cumberland.* (London: W. Strahan; and T. Cadell, 1777).

Ornsby, G. (ed.), *Selections from the Household Books of Lord William Howard of Naworth Castle.* Surtees Society 68. (Durham: Andrews & Co, 1878).

Parkinson, R., *The Experienced Farmer*, vol. 2. (London: G. G. and J. Robinson, 1798).

Plaw, J., *Ferme Ornee; or Rural Improvements. A Series of Domestic and Ornamental Designs.* (London: I. and J. Taylor, 1796).

Priestley, J. J., *Historical Account of the Navigable Rivers, Canals, and Railways throughout Great Britain.* (London: Longman, 1831).

Pringle, A., *General View of the Agriculture of the County of Westmoreland* (Newcastle-upon-Tyne: Graham, 1794)

Prothero, R. E. (Lord Ernle), *English Farming Past and Present* (London: Heinemann and Frank Cass, 1912).

Rham, W. L., *The Dictionary of the Farm* (London: Charles Knight, 1845).

Robinson, Mr., 'Statistical account of the Parish of Orton, in the 'County of Westmoreland' in *Monthly Magazine* (1803) 98 (10), pp. 109-13.

Robinson, Mr., 'Account of Kirkby Stephen in Westmoreland' in *Monthly Magazine* Part 1 (1804) 119 (Part1), pp. 103–06; (1805) 127 (Part 2), p. 215.

Rothwell, W., *Report on the Agriculture of the County of Lancaster with Observations on the Means of Its Improvement.* (London: Groombridge & Sons, 1850).

Royal Commission, *Reports from Commissioners, Inspectors, and others. Agricultural interests. Digest and Appendix. Reports of the Assistant Commissioners (2778-ii), vol. xvi.* 'Mr Coleman's report on the state of agriculture in Cumberland and Westmorland', p. 243. (Agriculture 16, 1881).

Royal Commission, *Reports from Commissioners, Inspectors and others. Agriculture, vol. xvi, Part 2*, pp. 31–43. (Agriculture 27, 1894).

Royal Commission, *Report by Mr Wilson Fox on the County of Cumberland*, pp. 473–531. (Agriculture 32, 1895).

Royal Commission, *Final Report of Her Majesty's Commissioners Appointed to Inquire into the Subject of Agricultural Depression* Vol. xv. (London: HMSO, 1897).

Royal Commission, *Interim Report of His Majesty's Commissioners Appointed to Inquire into the Economic Prospects of the Agricultural Industry in Great Britain* Cmnd 473. (London: HMSO, 1919).

Royal Commission. *Minutes of Evidence. 1919,* vol. 1, 5 August 1919 to 20 August 1919 (Cmnd 345); vol. 3, 16 September 1919 to 24 September 1919 (Cmnd 391); vol. 5, 15 January 1920 to 29 January 1920 (Cmnd 665).

Sinclair, Sir John, 'An account of the moss improvements of John Wilkinson, Esq. of Castle Head, in Lancashire' in *Communications to the Board of Agriculture etc*, (1806) vol. 5, part 1, pp. 1–8.

Sinclair, Rev. John, *Memoirs of the Life and Works of the Late Right Hon. Sir John Sinclair, Bart* vol.2. (Edinburgh: William Blackwood; London: T. Cadell, 1837).

Slight, J. and Scott Burn, R., *The Book of Farm Implements and Machines* (Edinburgh and London: William Blackwood, 1858).

Stephens, H., *The Book of the Farm* (Edinburgh: William Blackwood, 1852).

Walker, A., *Remarks Made in a Tour from London to the Lakes of Westmoreland and Cumberland in the Summer of M,DCC,XCI* (London: G. Nicol, 1792).

Webster, C., 'On the farming of Westmorland' in *JRASE* Second Series (1868) 4, pp. 1–37.

West, T., *The Antiquities of Furness* (Ulverston: George Ashburner, 1805. Originally published 1774).

Weston, Sir R., *Discours of Husbandrie used in Brabant and Flanders* (London: Wm Du-Gard, 1650).

Winter, G., *A New and Compendious System of Husbandry* (Bristol: W. Routh, 1787).

Wordsworth, W., *A Guide through the District of the Lakes in the North of England* (Malvern: The Tantivy Press, 1835, facsimile edition).

Worlidge, J., *Systema Agriculturae. The Mystery of Husbandry Discovered* (London: John Worlidge, 1675).

Worlidge, J., *Systema Agriculturae Being the Mystery of Husbandry Discovered and Laid Open* (London: Thomas Dring, 1687).

Young, A., *A Six Months Tour through the North of England*, four volumes (London: W. Strahan, 1770).

Young, A., *Observations on the Present State of the Waste Lands of Great Britain.* (London: W. Nicoll, 1773).

Yule, J., 'An account of the mode of draining, by means of tiles, as practised on the estate of Netherby, in Cumberland, the property of Sir James Graham, Bart. MP' in *Prize-Essays and Transactions of the Highland Society of Scotland* (1829) 7 (New Series vol. 1), pp. 388–99.

Secondary Sources

Andrews. J., 'Finding the right liming product for your soil' in *Farmers Weekly* (8 April 2011), pp. 48–49.

Appleby, A. B., 'Disease or famine? Mortality in Cumberland and Westmorland 1580–1640' in *Economic History Review* (1973) 26 (3), pp. 403–32.

Atkin, M. A., 'Medieval land-use in the ancient parish of Kirkby Kendale' *CW3*, (2103) 13, pp. 117–37.

Bibliography

Bagot, A. and Munby, J. (eds.), 'All Things is Well Here' in *Letters from Hugh James of Levens to James Grahme, 1692–95* CWAAS Record Series 10 (Kendal: Titus Wilson, 1988).

Banham, D. and Faith, R., *Anglo-Saxon Farms and Farming* (Oxford: Oxford University Press, 2014).

Beckett, J. V., 'Westmorland's "Book of Rates"' in CW2 (1977) 77, pp. 127–37.

Beckett, J. V., 'The Lowthers at Holker: marriage, inheritance and debt in the fortunes of an eighteenth-century landowning family' in *Transactions of the Historic Society of Lancashire and Cheshire* (1978) 127, pp. 47–64.

Beckett, J. V., 'The decline of the small landowner in eighteenth and nineteenth century England: some regional considerations' in *Agricultural History Review* (1982) 30, pp. 97–111.

Beckett, J. V., 'Land Tax administration at the local level 1693-1798' in M. Turner and D. Mills, *Land and Property: the English Land Tax 1692–1832* (Gloucester: Alan Sutton, 1986) pp. 161–79.

Beckett, J., 'Estate management in eighteenth-century England: the Lowther-Spedding relationship in Cumberland' in J. Chartres and D. Hey (eds.) *English Rural Society 1500–1800. Essays in Honour of Joan Thirsk* (Cambridge: Cambridge University Press, 2006) pp. 55–72.

Blackett-Ord, M., 'Lord Wharton's deer park walls' in CW2 (1986) 86, pp. 133–39.

Bouch, C. M. L. and Jones, G. P., *A short Economic and Social History of the Lake Counties, 1500–1830* (Manchester: Manchester University Press, 1961).

Brooks, G., 'The East Cumberland Coalfield' in *British Mining* (2009) 88, pp. 124–36.

Brown, J., *Agriculture in England. A Survey of Farming, 1870–1947* (Manchester: Manchester University Press, 1987).

Burton, J. (ed.), *The Cartulary of Byland Abbey*. (Woodbridge: The Boydell Press, 2004).

Campbell, B., 'Commonfield origins – the regional dimension' in T. Rowley (ed.) *The Origins of Open-Field Agriculture* (London: Croom Helm, 1981) pp. 112–29.

Cantor, L., *The Changing English Countryside* (London: Routledge and Kegan Paul, 1987).

Carne, R., '100 years of fertilizers' in *JRASE* (2006) 167, pp. 32-39.

Chaloner, W. H., 'The agricultural activities of John Wilkinson, ironmaster' in *Agricultural History Review* (1957) 5 (1), pp. 48-51.

Colvin, H, Mordaunt Crook, J. and Friedman, T. (eds.), *Architectural drawings from Lowther Castle, Westmorland* (Leeds: Society of Architectural Historians of Great Britain, 1980).

Condliffe, I., 'Policy change in the uplands' in A. Bonn, T. Allot, K. Hubacek and J. Stewart (eds.) *Drivers of Environmental Change in Uplands* (London: Routledge, 2009).

Cordle, C., 'The guano voyagers' in *Rural History* (2007) 18 (1), pp. 119–33.

Corrie, F. E., *Lime in Agriculture* (London: Chapman and Hall, 1926).

Crowe, H. *Farming the Margins. 'Upland' Agriculture in Westmorland, 1910–1947* (Unpublished PhD thesis, University of Sussex, 2009).

Curwen, J. F., 'Records relating to the Barony of Kendale', vol. 3 in *CWAAS Extra Series 4* (Kendal: Titus Wilson, 1926).

Curwen, J. F., *The Later Records Relating to North Westmorland or the Barony of Appleby* in CWAAS Record Series 8 (Kendal: Titus Wilson, 1932).

Davis, E. and S. B., *Draining the Cumbrian Landscape: a Revolution in Underdraining with Tiles* (Kendal: CWAAS, 2013).

Dent, J. G., 'Mechanics and effects of parliamentary enclosure of common grazings' in *Folk Life* (1983) 21, pp. 83-99.

Dilley, R. S., *Agricultural Change and Common Land in Cumberland 1700–1850*. (Unpublished PhD thesis, McMaster University, 1991) http://hdl.handle.net/11375/13559, accessed 25 August 2015.

Dodd, M., *Lakeland Rocks and Landscape. A Field Guide* (Maryport: Ellenbank Press, 1992).

Edwards, A., *The Productivity of Traditionally Managed Hay Meadows in the Pennines* (Unpublished MRes dissertation, Lancaster University, 1999).

Elliott, G. 'The system of cultivation and evidence of enclosure in the Cumberland open fields in the 16th century' in *CW2* (1960) 59, pp. 85–104.

Erickson, A. B., 'Sir James Graham, agricultural reformer' in *Agricultural History* (1950) 24 (2), pp. 170–74.

Evans, E. J. and Beckett, J. V., 'Cumberland, Westmorland, and Furness' in J. Thirsk (ed.) *The Agrarian History of England and Wales, Vol. 5 (1) 1640–1750*. (Cambridge: Cambridge University Press, 1984).

Ewbank, J. M. (ed.), *Antiquary on Horseback* (Kendal: Titus Wilson, 1963).

Farrer, W. (ed.), *Records Relating to the Barony of Kendale* (Kendal: Titus Wilson, 1924).

Fox H. S. A., 'Local farmers' associations and the circulation of agricultural information in nineteenth-century England' in H. S. A. Fox and R. A. Butlin (eds.) *Change in the Countryside: Essays on Rural England 1500–1900* (London: Institute of British Geographers, 1979) pp. 43–63.

Fryde, E. B., *Peasants and Landlords in Later Medieval England c. 1380–c.1525* (Stroud: Allan Sutton, 1996).

Fuller, R. M., 'The changing extent and conservation interest of lowland grasslands in England and Wales: a review of grassland surveys 1930–84' in *Biological Conservation* (1987) 40, pp. 281–300.

Fussell, G. E., *The Farmer's Tools. The History of British Farm Implements, Tools and Machinery AD 1500–1900* (London: Orbis, 1981).

Garnett, M. E., 'The Great Rebuilding and economic change in South Lonsdale 1600–1730' in *Transactions of the Historical Society of Lancashire and Cheshire* (1987) 137, pp. 55–75.

Gazley, J. G., *The Life of Arthur Young 1741–1820* (Philadelphia: American Philosophical Society, 1973).

Ginter, D. E., *A Measure of Wealth: The English Land Tax in Historical Analysis* (London: Hambledon, 1992).

Goddard, N., 'Information and innovation in early-Victorian farming systems' in B. A. Holderness and M. Turner (eds.) *Land, Labour and Agriculture, 1700–1920: Essays for Gordon Mingay* (London: Hambledon, 1990) pp. 165–90.

Gowling, M. E., *The Story of Brough-under-Stainmore* (South Stainmore: Hayloft, 2011).

Grainger, F. and Collingwood, W. G., *The Register and Records of Holm Cultram.* (Kendal: Titus Wilson, 1929).

Grigg, D. B., 'The Land Tax returns' in *Agricultural History Review* (1963) 11 (2), pp. 82-94.

Grove, J. M., *The Little Ice Age* (London: Routledge, 1988).

Hadfield, C. and Biddle, G., *The Canals of North West England*, vol. 2 (Newton Abbot: David and Charles, 1970).

Hainsworth, D. R., *Stewards, Lords and People* (Cambridge: Cambridge University Press, 1992).

Hair, N. and Newman, R., 'Excavation of medieval settlement remains at Crosedale in Howgill' in *CW2* (1999) 99, pp. 141–58.

Hall, D., *The Open Fields of England* (Oxford: Oxford University Press, 2014).

Hallas, C., 'The Northern Region' in E. J. T. Collins (ed.) *The Agrarian History of England and Wales Vol. 2 1850–1914 (Part 1)* (Cambridge: Cambridge University Press, 2000) pp. 402–10.

Harris, A., 'A traffic in lime' in *CW2* (1977) 77, pp. 149-55.

Hatcher, J., 'Mortality in the fifteenth century: some new evidence' in *Economic History Review* Second Series (1986) 39 (1), pp. 19-38.

Hawkins, H. and Thorley, J., 'The Premonstratensian House of Canons at Preston Patrick' in *CW3* (2012) 12, pp. 107–22.

Healey, J., 'Land, population and famine in the English uplands: a Westmorland case study, *c.* 1370-1650' in *Agricultural History Review* (2011) 59 (2), pp. 151-75.

Higham. N. J., *A Frontier Landscape: The North West in the Middle Ages* (Macclesfield: Windgather Press, 2004).

Highwood, E. J. and Stevenson, D. S., 'Atmospheric impact of the 1783–1784 Laki eruption: Part 1 chemistry modelling' in *Atmospheric Chemistry and Physics* (2003) 3, pp. 1177–89.

Hoelscher, L., 'Improvements in fencing and drainage in mid-19th century England' in *Agricultural History* (1963) 37, pp. 75–79.

Horn, P., 'The contribution of the propagandist to eighteenth-century agricultural improvement' in *The Historical Journal* (1982) 25, pp. 313-29.

Hoskins, W. G., 'The rebuilding of rural England, 1570–1640' in *Past and Present* (1953) 4, pp. 44-59.

Hoyle, R. W., *Land and Landed Relations in Craven, Yorkshire, c. 1520–1600* (Unpublished PhD thesis, University of Oxford, 1986).

Huddleston, C. Roy., *Naworth Estate and Household Accounts 1648–1660* (Durham: Andrews, 1958).

Hughes, R. A., *Permian and Triassic Rocks of the Appleby District* (Nottingham: British Geological Survey Research Report PR/02/01, 2003).

Humphries, A., *Seeds of Change. 100 Years Contribution to Rural Economy, Society and the Environment* (Newton Rigg College, 1996).

Humphries, A. and Mossop, B., *Guardians of Eden* (Penrith: Penrith Agricultural Society, 2000).

Johnson, D. S., 'Lime kilns in the Central Pennines: results of a field survey in the Yorkshire Dales and contiguous areas of North and West Yorkshire' in *Yorkshire Archaeological Journal* (2010a) 82, pp. 231–62.

Johnson, D. S., *Liming and Agriculture in the Central Pennines: The Use of Lime in Land Improvement from the Late Thirteenth Century to c. 1900*. (Oxford: Archaeopress, 2010b).

Johnson, D., *Limestone Industries of the Yorkshire Dales* (Stroud: Amberley, 2010c).

Johnson, D., 'Lime burning and the uses of lime in the historic county of Westmorland and along the Pennine edge of Cumberland' in CW3 (2013a) 13 pp. 191–213.

Johnson, D., *Excavation of Two Anglo-Saxon-Period Farmsteads in Brows Pasture, Chapel-le-Dale, North Yorkshire* (Kettlewell: Yorkshire Dales Landscape Research Trust, 2013b).

Johnson, D., *The Crummack Dale Project. Excavation of Three Early Medieval Steadings and a Medieval Lime Kiln* (Ingleton: Ingleborough Archaeology Group, 2015).

Johnson, M., *An Archaeology of Capitalism* (Oxford: Blackwell, 1996).

Jones, G. P., 'The decline of the yeomanry in the Lake Counties' in CW2 (1962) 62, pp. 198-223.

Kain, R. J. P., *An Atlas and Index of the Tithe Files of Mid-Nineteenth-Century England and Wales* (Cambridge: Cambridge University Press, 1986).

Kain, R. J. P, Chapman, J. and Oliver, R. R., *Enclosure Maps of England and Wales 1595–1918* (Cambridge: Cambridge University Press, 2004).

Keates, T., 'Field drainage techniques and their development in Cumbria' in *The Cumbrian Industrialist* (2002) 4, pp. 35–51.

Kelly, M., 'Geology of the Lune Valley and Upper Ribblesdale coalfields' in *British Mining* 85 (2008).

Kerridge, E., *The Agricultural Revolution* (London: George Allen & Unwin, 1967).

Lancaster, K. J., 'Intacks and lotmunds, encroachment and enclosure' in *The Sedbergh Historian* (2001) 4 (4), pp. 15–25.

Lennard, R., 'English agriculture under Charles II: the evidence of the Royal Society's "Enquiries"' in *Economic History Review* (1932) 4, pp. 23–45.

Low, A., *The Georgic Revolution* (Princeton: Princeton University Press, 1985).

MAFF, *A Century of Agricultural Statistics: Great Britain 1866–1966* (London: HMSO, 1968).

MAFF, *Lime and Liming* (London: HMSO, 1981).

Manley, G., 'Central England temperatures: monthly means 1659 to 1973' in *Quarterly Journal of the Royal Meteorological Society* (1974) 100, pp. 389-405.

Marshall, J. D., *Furness and the Industrial Revolution* (Barrow-in-Furness: Barrow-in-Furness Library and Museum Committee, 1958).

Marshall, J. D., *Old Lakeland: Some Cumbrian Social History* (Newton Abbot: David & Charles, 1971).

Marshall, J. D., 'The domestic economy of the Lakeland yeoman, 1660–1689' in *CW2* (1973) 73, pp. 190-219.

Marshall, J. D., 'Agrarian wealth and social structure in pre-industrial Cumbria' in *Economic History Review* (1980) 33 (4), pp. 503-21.

Marshall, T. H., 'Jethro Tull and the "New Husbandry" of the eighteenth century' in *Economic History Review* (1929-30) 2, pp. 41-60.

Matthiessen, P., Cooper, M., Cove, S., Day, K., Gallagher, J., Harrison, L. and Taylor, P. *Longhouses in the Duddon Valley, Cumbria. A Study of Building Remains and Their Surrounding Landscapes* (Duddon Valley Local History Group, 2013).

Mawson, D. J. W., 'Agricultural lime burning – the Netherby example' in *CW2* (1980) 80, pp. 137-51.

McRae, A. 'Husbandry manuals and the language of agrarian improvement' in M. Leslie and T. Raylor (eds.) *Culture and Cultivation in Early Modern England* (Leicester and London: Leicester University Press, 1992) pp. 35-62.

Messenger, P., 'Lowther farmstead plans: a preliminary survey' in *CW2* (1975) 75, pp. 327-51.

Miles, D. (ed.), *The Description of Pembrokeshire*. Facsimile edition, first published 1603 by George Owen of Henllys. (Llandysul: Gomer Press, 1994).

Mingay, G. E., 'The Land Tax assessments and the small landowner' in *Economic History Review* (1964) 17 (2), pp. 381-88.

Morris, C. (ed.), *The Illustrated Diaries of Celia Fiennes 1685–c. 1712* (London: Macdonald, 1982).

Newman, C., *Mapping the Late Medieval and Post Medieval Landscape of Cumbria* (Unpublished PhD thesis, Newcastle University, 2014).

Overton, M., *Agricultural Revolution in England: the Transformation of the Agrarian Economy 1500–1850* (Cambridge: Cambridge University Press, 1996).

Parker, D. E., Legg, T. P. and Folland, C. K., 'A new daily central England temperature series, 1772–1991 in *International Journal of Climatology* (1992) 12, pp. 317–42.

Perren, R., 'The landlord and agricultural transformation, 1870–1900' in *Agricultural History Review* (1970) 18, pp. 36–51.

Perry, P. J., 'Where was the "Great Agricultural Depression"? A geography of agricultural bankruptcy in late Victorian England and Wales' in P. J. Perry (ed.) *British Agriculture 1875–1814* (London: Methuen, 1973) pp. 129–48.

Perry, P. J., 'High Farming in Victorian Britain: prospect and retrospect' in *Agricultural History* (1981) 55 (2), pp. 156–66.

Pevsner, N., *Cumberland and Westmorland.* (Harmondsworth: Penguin, 1967).

Phillips, A. D. M., *The Underdraining of Farmland in England during the Nineteenth Century* (Cambridge: Cambridge University Press, 1989).

Phillips, A. D. M., 'Arable land drainage in the nineteenth century' in H. Cook and T. Williamson (eds.) *Water Management in the English Landscape* (Edinburgh: Edinburgh University Press, 1999) pp. 53–72.

Phillips, C. B., *The Gentry in Cumberland and Westmorland 1600–1665* (Unpublished PhD thesis, Lancaster University, 1973).

Quartermaine, J. and Leech, R. H., *Cairns, Fields, and Cultivation: Archaeological Landscapes of the Lake District Uplands* (Lancaster: Oxford Archaeology North, 2012).

Roberts, B. K., *Landscapes, Documents and Maps: Villages in Northern England and Beyond AD 900–1250* (Oxford: Oxbow Books, 2008).

Roberts, C., *The Radical Countess: The History of the Life of Rosalind Countess of Carlisle* (Carlisle: Steel Brothers, 1962).

Robinson, J. M., *Georgian Model Farms: A Study of Decorative and Model Farm Buildings in the Age of Improvement 1700–1846* (Oxford: Clarendon, 1983).

Rowe, D. J. (ed.), *General View of the Agriculture of Northumberland, Cumberland and Westmorland* by J. Bailey and G. Culley. Facsimile edition, originally published 1805. (Newcastle upon Tyne: Frank Graham, 1972).

Rumney, A .W. (ed.), *Tom Rumney of Mellfell (1764–1835) by Himself* (Kendal: Titus Wilson, 1936).

Searle, C. E. 'The Odd Corner of England': a Study of a Rural Social Formation in Transition, Cumbria c. 1700–c. 1914 (Unpublished PhD thesis, University of Essex, 1983).

Searle, C. E., 'Customary tenants and the enclosure of the Cumbrian commons' in *Northern History* (1993) 29, pp. 126–53.

Shepherd, M. E., *From Hellgill to Bridge End: Aspects of Economic and Social Change in the Upper Eden Valley 1840–95* (Hatfield: University of Hertfordshire Press, 2003).

Smith, A. H., *The Place-Names of Westmorland* Part 2. (Cambridge: Cambridge University Press, 1967).

Smith, R. S., Shiel, R. S., Bardgett, R. D., Millward, D., Corkhill, P., Evans, P., Quirk, H., Hobbs, P. J. and Komera, S. T., 'Long-term change in vegetation and soil microbial communities during the phased restoration of traditional grassland' in *Journal of Applied Ecology* (2008) 45, pp. 670–79.

Spring, D., 'A great agricultural estate: Netherby under Sir James Graham, 1820–1845' in *Agricultural History* (1955) 29 (2), pp. 73–81.

Stratton, J. M., and Houghton Brown, J., *Agricultural Records AD 220–1979* (London: John Baker, 1978).

Tarlow, S., *The Archaeology of Improvement in Britain, 1750–1850* (Cambridge: Cambridge University Press, 2007).

Taylor, A., *The Websters of Kendal: A North-Western Architectural Dynasty*. J. Martin (ed.) (Kendal: CWAAS, 2004).

Todd, J. M. (ed.), *The Lanercost Cartulary* (Durham, 1997).

Turner, M., *English Parliamentary Enclosure* (Folkestone: Dawson; Hamden, Conn.: Archon Books, 1980).

Turner, M., *Enclosures in Britain 1750–1830* (London: Macmillan, 1984).

Tyson, B., 'Low Park Barn, Rydal: the reconstruction of a farm building in Westmorland in the seventeenth century' in *CW2* (1979) 79, pp. 85–97.

Tyson, B., 'Skirwith Hall and Wilton Tenement (Kirkland Hall): the rebuilding of two Cumbrian farmsteads in the eighteenth century' in *CW2* 81, pp. 93–112.

Tyson, B., 'Building work at Sockbridge Hall, its farmyard and neighbourhood, 1660–1710' in *CW2* (1983) 83, pp. 107–24.

Tyson, B., 'Murton Great Field, near Appleby: a case study of the piecemeal enclosure of a common-field in the mid-eighteenth century' in *CW2* (1992) 92, pp. 161–82.

Tyson, B., 'Transportation and the supply of construction materials: an aspect of traditional building management' in *Vernacular Architecture* (1998) 29, pp. 63–81.

Tyson, B. (ed.), *The Estate and Household Accounts of Sir Daniel Fleming of Rydal Hall, Westmorland from 1688–1701* (Kendal, 2001).

Unwin, R. W., *Search Guide to the English Land Tax* (Wakefield: West Yorkshire County Record Office, 1982).

Wade Martins, S., *The English Model Farm* (Oxford: Windgather, 2002).

Wade Martins, S., *Farmers, Landlords and Landscapes* (Macclesfield: Windgather, 2004).

Wade Martins, S., *Coke of Norfolk (1754–1842): A Biography* (Woodbridge: The Boydell Press, 2009).

Walton, J.K., 'The strange decline of the Lakeland yeoman: some thoughts on sources, methods, and definitions' in *CW2* (1986) 86, pp. 221–33.

Ward, J. T., *Sir James Graham* (London: Macmillan, 1967).

Welch, D., 'Three Elizabethan documents concerning Milburn Fell' in *CW2* (1975) 75, pp. 136–49.

Whaley, D., *A Dictionary of Lake District Place-Names* (Nottingham: English Place-Name Society, 2006).

Whittaker, T., 'The bank barns of Cumbria – an overview' in *Historic Farm Buildings Group Journal* (2001) 15, pp. 4–61.

Whyte, I. D., 'Patterns of parliamentary enclosure of waste in Cumbria: a case study from north Westmorland' in *Landscape History* (2000) 22, pp. 77–89.

Whyte, I. D., *Transforming Fell and Valley* (Lancaster: Centre for North West Regional Studies, 2003a).

Whyte, I. D., '"Wild, barren and frightful" – parliamentary enclosure in an upland county: Westmorland 1767–1890' in *Rural History* (2003b) 14 (1), pp. 21–38.

Whyte, I. D., 'Taming the fells: parliamentary enclosure and the landscape in northern England' in *Landscapes* (2005) 6 (1), pp. 46–61.

Whyte, I. D., 'The costs of parliamentary enclosure in an upland setting: south and east Cumbria c. 1760–1860' in *Northern History* (2006) 43 (1), pp. 97–115.

Whyte, I. D., 'Revolution! Agricultural improvement' at 'People and the land: settlement in the Eden Valley, prehistoric to the present day'. (Day conference 6 October 2007). Appleby Archaeology Group, www.applebyarchaeology.org.uk/conferenceindex.htm. Accessed 29 June 2015.

Wigley, T. M. L., Lough, J. M., and Jones, P. D., 'Spatial patterns of precipitation in England and Wales and a revised, homogeneous England and Wales precipitation series' in *Journal of Climatology* (1984) 4, pp. 1–25.

Williams, L. A., *Road Transport in Cumbria in the Nineteenth Century* (London: George Allen and Unwin, 1975).

Williams, M., 'The enclosure and reclamation of waste land in England and Wales in the eighteenth and nineteenth centuries' in *Transactions of the Institute of British Geographers* (1970) 51, pp. 55–69.

Williamson, T., 'Understanding enclosure' in *Landscapes* (2000) 1, pp. 56–79.

Williamson, T., 'Archaeological perspectives on landed estates: research agendas' in J. Finch and K. Giles (eds.) *Estate Landscapes: Design, Improvement and Power in the Post-Medieval Landscape* (Woodbridge: Boydell and Brewer, 2007).

Wilmot, S., *'The Business of Improvement': Agriculture and Scientific Culture in Britain, c. 1770–c. 1870* (Bristol: University of Bristol, 1990).

Winchester, A. J. L., *Landscape and Society in Medieval Cumbria* (Edinburgh: John Donald, 1987).

Winchester, A., 'The farming landscape' in W. Rollinson (ed.) *The Lake District: Landscape Heritage* (Newton Abbot: David and Charles, 1989) pp. 76–100.

Winchester, A. J. L. (ed.), *The Diary of Isaac Fletcher of Underwood, Cumberland, 1756–1781* (Kendal: Titus Wilson, 1994).

Winchester, A. J. L., 'Wordsworth's "Pure Commonwealth"?: Yeoman dynasties in the English Lake District, c. 1450–1750' in *Armitt Library Journal* (1998) 1, pp. 86–113.

Winchester, A. J. L., *The Harvest of the Hills* (Edinburgh: Edinburgh University Press, 2000).

Winchester, A. J. L. (ed.) with Mary Wane, *Thomas Denton: A Perambulation of Cumberland 1687–1688* (Woodbridge: Boydell and Brewer, 2003).

Winchester, A. J. L., 'Regional identity in the Lake Counties: land tenure and the Cumbrian landscape' in *Northern History* (2005) 42, pp. 29–48.

Winchester, A. J. L., *England's Landscape: The North West* (London: English Heritage/Collins, 2006).

Wordie, J. R., 'The chronology of English enclosures, 1500–1914' in *Economic History Review* (1983) 36, pp. 483–505.

Wrigley, E. A. and Schofield, R. S., *The Population History of England 1541–1871* (London: Edward Arnold, 1981).

Index

Abbeytown, 152, 229
Adam, Robert and James, 101
agger lapidus, 28
agistment, 185
Aglionby family, 187
Agricultural Holdings Act 1875, 208, 223
Agricultural Land Classification, 16, 17
Agricultural Lime Scheme, 219
Agricultural Societies, 108–9, 169
Agriculture Acts 1937, 1980, 1986, 218, 227
Aikbank, 52
Ainstable, 28, 117, 184, 187
Ambleside, 20, 93, 128
Angerton Moss, 140
Appleby, 12–13, 16, 41, 62–3, 74, 133, 177, 192–3
Applegarth, 123
Applethwaite, 50
approvement, 41, 44
Armitage, William, 87
Asby, 26, 30, 32, 71, 73, 145
Ash Fell, 79
Askham, 145, 211

Aspatria Agricultural College, 208
assarts, 32, 34, 44
Atkinson, George, 61
Atkinson, Richard, 183
Atkinson, William, 211
Atkinsons of Dalefoot, 62

Bacon, Jane, 104
Bailey, J. and Culley, G., 19, 114–15, 122–3, 166–7
Bampton, 28, 50
bank barn, 99, 144
Bank Hall Farm, 149
Bank House, 122
Banks, Tim, 95
Banner Rigg, 113–14
Bannisdale, 30
Barbon, 60–1, 75, 122
barns, 81–3, 90, 98–101, 162, 177, 196, 211
Baronwood Farm, 158
Barrowfield, 100
basic slag, 181, 217–19, 227, 230
Bassenthwaite, 69, 183, 224
Baugh Fell, 60
Bective, earl of, 203

Bell, Mary, 174
Belle Isle, 169
Bent Hill, 78–9
bercary, 28–9
Bewcastle, 104, 184, 186
Birks, 80
Blamire, William, 125–6
Blane, Christopher, 91
Blawith, 98
Bleaflatt Farm, 122
Bleatarn, 30, 73, 131
Blencarn, 32, 69
Blennerhasset, 195–7
Board of Agriculture, 19, 110, 114, 124, 138, 142, 166
Bolton, 33, 90
Borrowdale, 29, 30
Borrowscale, 55
Bothel Hall, 172
Bowber Head, 217, 227
Bowness, 150
Bowness-on-Solway, 79, 150, 190, 226
Bowscale, 26–7, 35, 55
Bowstead, John, 188, 203
bracken, 58, 83, 92, 96, 120, 234
Bramery, 92, 158, 160–1
Brampton, 16
Bretherdale, 30, 202
Brigsteer, 95, 139
Brotherilkeld, 184
Brough, 13, 30, 34, 93
Broughton in Furness, 118
Broughtonmoor Brick & Tile Works, 55
Broughton Tower, 101
Buccleuch Estate, 96–8, 132, 176, 209, 231
Buckholme, 86
Buck, Richard, 188

Bunkers Hill, 147
Burlington, 2nd earl of, 193
Burrells, 65
Burton in Holme, 115
Burton-in-Kendal, 135
Burton-in-Lonsdale, 71, 75
Buttermere, 28
Byland Abbey, 27, 30–1

Caldew, 29, 212
Calgarth Park, 132
Calvo, 152
Cark, 139
Carlatton, 81
Carleton, John Metcalfe, 52
Carleton, Samuel, 91
Carleton Village, 161
Carlisle, 93, 102, 181, 188
Carlisle, earls of, 63, 166–7, 199
Carnforth, 75
Carr, Anthony, 91
Carr, John, 168
Carrington, Lord, 124
carrots, 42, 172, 197
Cartmel, 12, 16, 27, 90, 141, 193
Casterton, 61, 75, 135, 151
Castle Carrock, 69
Castlehead, 115, 140
Castle Sowerby, 52, 131
cattle, 33, 37, 42, 48, 50, 81, 85, 96, 99, 154–5, 165–6, 171, 176, 181–2, 185, 191, 193–4, 202, 211, 222, 233–4
Cavendish of Holker, 148
Celleron, 156, 233
cereals, 81–3, 86, 92, 96, 102, 114, 117–20, 140, 149, 154, 156, 162, 173, 176, 183, 185, 187, 190, 213, 215
Claife Heights, 168

Cliburn, 42, 83, 235
Clifford of Appleby Castle, 34–6
Clifton Hall Farm, 149
climate, 10, 13–4, 33, 64, 96, 104–5, 123, 125, 157, 199–200
Clints Quarry, 63
clover, 42, 114, 160, 162, 175, 181, 183, 192, 206
Clowsgill Limeworks, 167, 192, 211–12
Cocklake Quarry, 63
Cockley Bridge, 80
coal (mining), 60–4, 69, 72–3, 75
Coalpit Hill, 61, 63
Cockermouth, 120
commodification, 32, 38, 44
Coniston Hall, 99
Coniston Water, 97–8, 200
Corby Estate, 166
Corn Laws, 136, 179, 199
Coronation Meadows, 228
Countryside Stewardship, 227, 232
courtyard farmsteads, 145
Cowin, Edwin, 161
Crag House, 52
Craven, 24, 26, 41, 43
Croglin, 63, 159
crops 26, 28, 42, 81, 87, 89, 96, 117, 119, 121, 140, 153–4, 157, 162, 166, 169–73, 175–6, 182, 184–5, 187, 192–3, 197, 206, 211, 234–5
Crosby Ravensworth, 30, 50, 63, 73, 180–1, 190
Crosdale Beck, 27
Cross Fell, 63
Crosthwaite and Lyth, 37
Culgaith, 69, 131, 145, 150
Cumberland System, 200
Cumrew, 57, 117, 135

Cumwhitton, 27, 52, 135, 187
Curwen of Workington, 101, 132, 168–73, 214, 224
customary tenure, 34, 43, 54

Dacre, 50
Dacrebank, 174–5
Dalefoot Farm, 62
Dallam Tower, 102
Dallan Bank, 148
Dalston, 56, 154, 187
Dargue, John, 120
Davy, Humphry, 111
Dawson, John, 160, 162, 224
Dawson, Mr, 158
Dawson, William, 162
Defra, 9, 225, 234
demesne land, 94, 190
Denney, Richard, 91
Dent family, 181
Denton, 69
Denton, Thomas, 90
Dillicar, 128
disease, livestock, 33, 105, 123, 200
distress, agricultural, 37, 122, 124–6, 160, 201–9, 217
Dobson, Christopher, 70–1, 155, 157–61
Dodd, Henry, 72
Dolphenby, 70, 91–2, 158–9, 161–2
draining, 39, 42, 88, 137–42, 153, 155, 160–1, 171–4, 181, 183, 185, 187–8, 190, 203, 209, 211, 214, 225–6
droving of cattle, 93, 157
Drybeck, 41, 73
Duddon Valley, 24, 80, 140, 142, 183
Dufton, 69, 127, 130
Dunnerdale, 12, 25, 80

Eamont, River, 91
Eden Hall, Edenhall, 18, 29, 70–2, 90–3, 100, 117, 155–63, 203, 212, 223, 231
Eden, River and Valley, 10, 13, 15–16, 27, 29, 40, 42–3, 90, 144, 157, 200, 218
Elkington, Joseph, 138
Ellis, Mr, 164
enclosure process, 32, 34, 40, 129–36
encroachment, 26, 34–5, 41, 44
ensilage, 214–5
Esk, River, 163, 165
Eycott Hill, 226, 228
Farfield Farm, 161
Farlam, 52, 69, 168, 211
Farleton, 52–3, 61
Fawcett, Mr, 121
Fell Farm, 151
Fell Gate Farm, 54
Fertilisers & Feeding Stuffs Act 1893, 208
Fiennes, Celia, 19, 102
Fleming of Rydal, 64, 93–5, 99, 126
Fleming, William, 127, 134, 176
Fletcher, Mr, 55
Flimby, 152
Flookburgh, 141, 193
Flusco, 217
Fort Putnam, 147
Foulshaw Moss, 139
Foundation for Common Land, 228
Fountains Abbey, 27, 29
Furness Abbey, 18, 27, 29–30
Furness, High and Low, 12, 16, 30, 32, 37, 42–3, 79, 96, 115, 118, 132, 142, 144, 176, 181, 209, 222

Gaitscale, 80
Gamblesby, 28, 32
Garnett, Anthony, 140
Gatesgarth, 28
Gaythorne, 73, 145
Georgic Movement, 41, 44, 77, 83, 132
George III, 111
Gibson, J., 172
Gibson, John, 64, 222
Gibson, Thomas, 158
Gillalees, 104
Gilpin, Thomas, 104
Gilsland, 28
gin-gang, 149–51
Gisburn, 85
Glassonby, 28, 135
Glencoyne, 144, 186
Goldies, Mr, 156
gorse, 58, 75, 189
Gosforth, 50, 213
Gospelhow Quarry, 55, 173
Gowbarrow, 186
Graham, John, 174
Graham of Netherby, 163–66, 203
Grahams Onset, 59–60
Grahme of Levens, 94–5
Grainger, John, 223
Grandstand Farm, 148
Grange-in-Borrowdale, 29
Grange-over-Sands, 115
grass, 23, 154, 157, 159–60, 175, 185, 192, 206–7, 212, 230, 234
Great Island, 169
Great Rebuilding, 77
Green, Anne, 174
Greenriggs, 30, 84
Greystoke, 147, 186, 205, 208, 214
Grisdale, 26
grouse, red, 131, 224

guano, 181, 183, 185, 192–3, 209
Guards Farm, 165

Hackthorpe, 74, 82, 188, 209
Hall Intack Farm, 121
Handley, Mr, 211
Hardendale, 30, 190
Hardrigg Hall, 145
Haresceugh, 28, 63
Harrington, J., 187–8
Hartley, Castle and Fell, 61–2, 71, 90, 100, 161–2, 224
Hartside, 63
Hartsop, 101
Haweswater, 33, 153
Hayclose House, 83
Heggerscales, 26
Helbeck/Hillbeck, 52, 65–7, 69, 73, 102–3
Helsington, 140
Helston, 100
Helton, 82
Heltonhead, 145
Hesket, 158, 185, 188, 224
Hesley Farm, 153
Heversham, 100, 132
Hewer Hill, 52
High Farming, 179–80, 192, 194, 199
High Fell Gate Farm, 52
Highgate Farm, 56, 174, 188
High Hall, 153
Highmoat Farm, 164
Hill, David, 162
Hill Farm Allowance Scheme, 227
Hill Farms Charter, 228
Hilton, 32
Hodbarrow, 69
Hoff, 13, 41
Hofflunn Farm, 133, 177

Holeslack Farm, 104, 140
Holker Estate, 90, 148, 193–4
holly, 95, 118
Holm Cultram (Abbey), 27, 29, 44, 223
Holme Scales, 94
Holmes, John, 35
Holt, John, 19, 115, 142
Honeypot Farm, 92, 158
Housman, John, 18, 117
Howard of Corby, 166
Howard of Greystoke, 147, 205, 208
Howard of Naworth, 81, 105, 166–8
Howgill Castle, 35
Howgill Fells, 10, 12, 16, 27, 118
Huber Hill, 31
Huddleston of Hutton John, 55, 173–5
Hutchinson, William, 18, 117
Hutton John, 56, 61, 105, 173–5, 188
Hutton Roof, 61–2

Improvement of Land Act 1854, 187
Inglewood, Forest of, 29, 131, 232
Ingleton, 71, 74
Inglis family, 187
Ireby, 69
Ireleth, 209–10

Jackson, John, 223
Jackson, William, 174
James, Hugh, 95
James. W. E., 185
Jameson, William, 161
Jonston, William, 93
Julian Bower, 217–8

Kaber, 26, 71
Keisley, 33, 130
Kellet, 75
Kendal, 12, 33, 37, 43, 71, 74–5, 102, 113, 119, 199
Kent, River, 59, 94, 140
Keswick, 29, 132
Kirkby Lonsdale, 61, 115, 127–8, 202
Kirkby Stephen, 12, 13, 33, 54, 61, 64, 118, 160, 179
Kirkby Thore, 69, 188, 194, 224
Kirkland, 145, 149
Kirkoswald, 26, 70, 157, 159, 162, 185, 187, 200, 212

Lancashire, 85, 139, 142, 181, 222
Lancaster-Kendal Canal, 74
Land Fertility Scheme, 218
Land Tax, 126–9
Lanercost Priory, 27–8
Langley Park, 95
Langstrath, 29
Langwathby, 91, 161, 212
Late Maunder Minimum, 104
Latrigg, 119
Lawson, William, 195–99, 224
LEAF scheme, 228
leases, 18, 91–2, 103–4, 114–5, 120–3, 137, 151, 155, 161–4, 166, 170, 172, 174–7, 211
Levens Hall, 59, 94–5, 100, 194, 232
Levens Moss, 140
Lilly Hall, 170, 173
lime kilns, 19, 47, 51–76, 84–5, 87, 102, 134–5, 155, 167, 172, 174–6, 190–1, 217
liming, 19, 40, 42, 47–76, 82, 84, 93–4, 96, 104, 110, 114, 118, 122, 135, 137, 156–7, 159, 161–3, 168, 174–5, 177, 182, 186–91, 193, 198, 203, 211, 216–7, 223, 227, 230
Little Ice Age, 104
Llandaff, Bishop of, 132
Loadman Ground, 73
Long Marton, 69, 126
Long Rigg Farm, 144
Longsleddale, 130
Longtown, 163–4
Lorton, Vale of, 120
Loughrigg, 37
Low Closes, 156
Low Farming, 181
Lowmoat Farm, 164
Low Moor Farm, 148
Lowther Estate, 18, 64, 69, 73, 81, 84, 101, 113, 148, 150, 152–3, 155, 184, 186, 188, 190–2, 202, 209, 223–4, 231
Lowther Newtown, 86, 101, 155
Lowther of Lowther, 71, 81–90, 101, 126, 147, 154
Lowther of Meaburn, 72, 84
Lowther Village, 74, 88, 147
Lowthian, Mr, 204, 211
lucerne, 42, 185
Lucock, Robert, 55, 184
Lumb, Robert, 152
Lumb, William, 148, 153
Lunesdale, 10, 60, 69, 116–7, 123, 145, 207
Lupton, 71
Lyth Moss, 42, 140

Mallerstang, 26, 37, 62, 79
mangolds, 213, 215
manor courts, 26, 38–9, 44, 79, 91
Mansergh, 89

manure, 39, 49, 81, 83–4, 92–6, 104, 114, 162, 171, 173, 176, 180, 183–4, 186, 189, 192, 198, 211
Mardale, 153, 179
marl, 39–40, 42, 49, 85–7, 89–90, 156, 159, 223
Marshall, William, 108
Martindale, 33
Marvell, John, 162
Maryport, 12, 60, 212
Matterdale, 144
Matthew, Richard, 91
Maulds Meaburn, 32, 72–3, 135
Mayson, Isaac, 55
Meaburn Hall, 153
meadow, 31, 101, 151, 154, 172, 227
Meathop, 139
Mechi, 195–99, 224
Medieval Warm Period, 25, 33, 44
Melkinthorpe, 83
Mell Fell, 105
Melmerby, 32, 117, 135
Merton, Statute of, 41
Middleton Hall, 145
Milburn, 28, 35–7, 64, 67–9
Milburn Grange, 177
Miller, John, 222
Millom (Marsh), 69, 142, 183–4
Milner, Edward, 79
model farms, 143–50, 172, 196, 209
Monkhouse, Isaac, 161
Moor Close Farm, 170–2
Moor End Farm, 61
Moore, John, 18, 118, 123, 132
Morland, 64
Mossband Hall, 165
Mouncey, Robert, 170
Muncaster, 79, 176

Murton, 27, 32, 130, 153, 205
Musgrave of Eden Hall, 18, 61–3, 70, 72–3, 90–3, 100, 155–63

Naddle Farm, 153–4
Napoleonic/French Wars, 124, 128, 135, 168, 179, 201, 224
Nateby, 112
National Character Areas, 17
Natural England, 9, 226
Naworth Estate, 81, 104, 166–8, 192, 199, 211
need-fire, 48, 123
Netherby, 20, 163–6, 202–3, 223, 231
Netherhoff, 143–4
Nether Staveley, 99–100
Newbiggin, 57, 69, 131
Newby, 90
New Hall Farm, 57
Newton, 82
Newton Rigg Farm School, 208, 216
Nibthwaite, 98
Nicolson, John, 188, 194, 224
Nowell, John, 166

Old Hutton, 94
Ormside, 52, 65–9
Orrest Head, 114
Orton, 10, 12, 71, 118, 135, 180, 186
Ousby, 28, 117, 135–6

Papcastle, 90
paring and burning, 88, 118, 120, 137, 173–4, 183
Park House, 59, 100, 196
Parker, Rowland, 211

pasture, 15–16, 26, 28–9, 31, 91, 102, 104, 151, 154, 216, 224–5
Patterdale, 101
Pears, Christopher, 174
Pearson, William, 187–8
Pease Hill Lime Kiln, 65–7, 69, 73
peat, 59–60, 75, 114, 167
Peck, Mr, 85
Penn, Stephen, 96, 98
Pennines, 10, 13–16, 26, 32, 48, 60, 161
Pennington, 127, 134, 176
Pennington of Muncaster, 79, 81, 95–6
Penrith, 16, 85, 91, 93, 102, 113, 119, 155, 206, 217
Penruddock, 55, 173, 226
Peterril Valley, 10, 15–16, 41, 77, 185
Piper Hole, 217, 227–8
plantations, forestry, 15, 85, 92, 95, 98, 132, 161, 165–6, 168–9, 224
ploughland, 30–1
Plumpton Head, 153
potatoes, 169, 172, 175–6, 182, 184, 187, 193, 198, 213, 215
Preston Richard, 79
prices, farm-gate, 179, 201, 207, 224–5, 232
Pringle, A., 19, 115, 122
Public Money Drainage Act, 155, 187, 190
Punchard, Frederick, 207

Railton, Richard, 161
Randleson, Mr, 183, 224
Ravenglass, 115
Ravenstonedale, 37, 45, 78, 105, 121–2, 151, 179, 217, 227
Rawthey, River, 10, 60–1

Reagill, 28, 72, 84
Redhills Limekilns, 161
Renwick, 26, 63, 72, 130, 159
Restoration of the monarchy, 41, 44, 77–8, 81, 98, 102, 105, 107
Ribton Hall, 152
Richards, George, 212
ridding, 26
Rigg, Thomas, 123
Robinson, James, 72
Robinson, Michael, 52
'Robinson, Ralph', 111
Rogersceugh, 149–50, 226
Rosalind, Countess, 211
Rosetrees Farm, 164–5
Rosgill, 153
Rough Ground, 87–9
Routlidge, John, 104
Rowe Head Farm, 127, 176
Rowland Field, 82
Rowley Wood Quarry, 65
Royal Commission, 202–3, 208, 216, 224
Royal Society, 41, 77
Rubing House, 152
Rumney family, 105, 138
Ruskin, John, 200
Rutter Mill, 73
Rydal Hall Estate, 20, 99, 121, 222, 231

Sadgill, 130
St Bees Abbey, 27
St John's in the Vale, 119
Sandsfield Farm, 154
Sawrey, Roger, 101
Scale Houses, 26
Scales, 26
Sceugh Farm, 91, 158, 161–3

Index

Schoose Farm, 169–73, 196, 214, 224
Seathwaite Fell, 115
Sebergham, 72, 191
Sedbergh, 35, 48, 54
Sedgwick, 104
Senhouse family, 212–4
Sewborwens farm, 148
Shankend Farm, 104
Shap (Abbey), 10 ,18, 27–8, 30, 74, 113, 186, 188, 190, 194
sheep, 29, 31, 37, 51, 80, 115–9, 123, 153, 166–7, 179, 182, 184–5, 191–5, 211, 222, 227, 234
shieling, 26–7
Shipherd, William, 41
Simpson, John, 161
Sinclair, Sir John, 110, 138
Sizergh, 100, 120
Skelbeck Bottoms, 41
Skelsmergh, 104
Skelton, 131
Skiddaw, 167
Skinburness, 29
Skirwith Hall, 145
Slack, John, 159–60
Slack, Thomas, 158, 224
Sleddale, 28, 30
Sockbridge, 101, 156
soft rush, 37
soil (inputs), 15–16, 49, 180–1, 184, 192, 194, 198, 294, 211
soiling, 171, 196
Soulby, 33, 71
Sourlands Hill, 30
Southerfield Farm, 223
Southwaite, 26, 52, 212
Spadeadam, 104, 186
Spedding, John, 85–6
Spire House, 147

Spittle House, 52
Stainburn Hall, 152
Stainmore, 30, 57, 63, 71–3, 75, 84, 102, 122
Stainton, 71
statesmen, 20, 42
steam plough, 104, 197–8
Stennerskeugh, 217
stewards, 18, 38–40, 59, 93–4, 151, 155–6, 159, 161, 164, 166, 170, 188, 205, 222
Stonethwaite, 29, 94
Strickland, 90, 153, 191
subsidies, 227, 230
Sunbiggin Tarn, 71
Sunmoor Farm, 177
Swainson, Ellen, 95
Swindale, 102, 153

Talkin Fell, 135, 211
Tarn House, 102–3
Tarn Wadling, 188–90
Tebay, 202
Thanet, earl of, 124
Thextone, Robert, 71
Thrimby, 30, 83–4, 191
Thrushgill Quarries, 65
Thurston Water, 97
thwaite, 26
Tickell, Thomas, 101
tile drains, 139, 164, 186, 188, 190, 209
timber, 85, 88, 93, 98, 131–2
topography, 10
Torpenhow, 55
Torver, 98, 133
townfields, 32
Townhead Lime Kiln, 136
transhumance, 26, 44
Troutbeck, 132

turnpike roads, 74

Udford, 92, 160
Ulcat Row, 144
Uldale, 69, 114
Ullswater, 33, 74, 102, 105, 144, 186
Ulpha, 26–7, 80
Ulverston, 132, 142, 176
Underbarrow, 140
Underley Hall, 61, 202–4, 207, 214

vaccary, 27–9

Waberthwaite, 96
walling, 81–2, 88, 130, 137–8, 159, 161, 186, 211
Walmsley, Mr, 89
Walter of Henley, 39
Warcop, 30–1, 179
Warnell, 72, 90, 191
Warren House, 87
Warton Crags, 75
Wasdale, 28, 30
Watendlath, 29
watering of meadows, 42, 83–4, 115
Watermillock, 105
Watson, John, 19, 137
Watson, Richard, 132
Webster of Kendal, 19, 148
West, Thomas, 118
Westgarth family, 162–3
Wetheral Priory, 27
Wetheriggs, 209
Whale, 82–3, 191

Wharton Hall, 78, 151
Wharton, Lord, 78–9
Whinlatter, 120
White, Thomas the Elder, 168
Whitehaven, 12–13, 60, 85, 147–8, 183, 191, 231
Whitwall, 79
Whyber Hill, 71
Whygill Head, 71
Wickersgill, 190
Wigton, 16, 69, 188, 195
Wilkinson, John, 115, 140, 142
Wilkinson, Thomas, 91
Williamson, John, 161
Wilson, Edward, 102
Wilson Fox, Arthur, 207
Wilson of Dallam Tower, 148
Winder Hall, 51, 145, 204, 211
Winder Moor, 139, 141
Windermere, 12, 37, 74, 102, 114, 132, 168–9
Winderwath Farm, 159, 204–5, 224
Windle, James, 61
Windmore Edge, 73
Winster, River, 140–2
Winton, 53, 71
Wood, Wilson, 55
Workington (Hall), 101, 152, 168–9, 231
Wrynose, 80

Yanwath Hall, 145
Young, Arthur, 19, 110, 113–4, 130, 223
Yule, John, 164